Figure Drawing
for Fashion Design

Elisabetta 'Kuky' Drudi | Tiziana Paci

Pepin

Amsterdam & Singapore

ISBN 978 90 5496 150 5

The Pepin Press BV
P.O. Box 10349
1001 EH Amsterdam, The Netherlands
mail@pepinpress.com

www.pepinpress.com

This book is an expanded, newly designed and edited version of *La Figura nella Moda* © Ikon Editrice srl, Milano

Direction & cover design: Pepin van Roojen
Editorial & translation co-ordination: Femke van Eijk
Layout: Alisa van Spronsen and Pepin van Roojen
Translation from the Italian: Vanessa Round
Text editor: Rosalind Horton of Cambridge Editorial
Technical advice: Lucy Hunter

10 9 8 7 6 5 4 3
2016 15 14 13 12

This book is produced by The Pepin Press in Amsterdam and Singapore.

Printed and bound in Malaysia

About the authors

Elisabetta 'Kuky' Drudi worked as a stylist and illustrator for Italian and international fashion brands, while completing her studies at the F. Mengaroni Art Institute in Pesaro, Italy. At present, she works as a fashion and textile designer for world-renowned fashion labels. This book was produced together with her former tutor Tiziana Paci.

Tiziana Paci has been an all-round artist and fashion- and costume design tutor for many years. She works as a painter, stylist, theatre costume designer, stage designer and musician. She also runs advanced workshops on figure drawing for fashion design and on colour techniques.

Contents

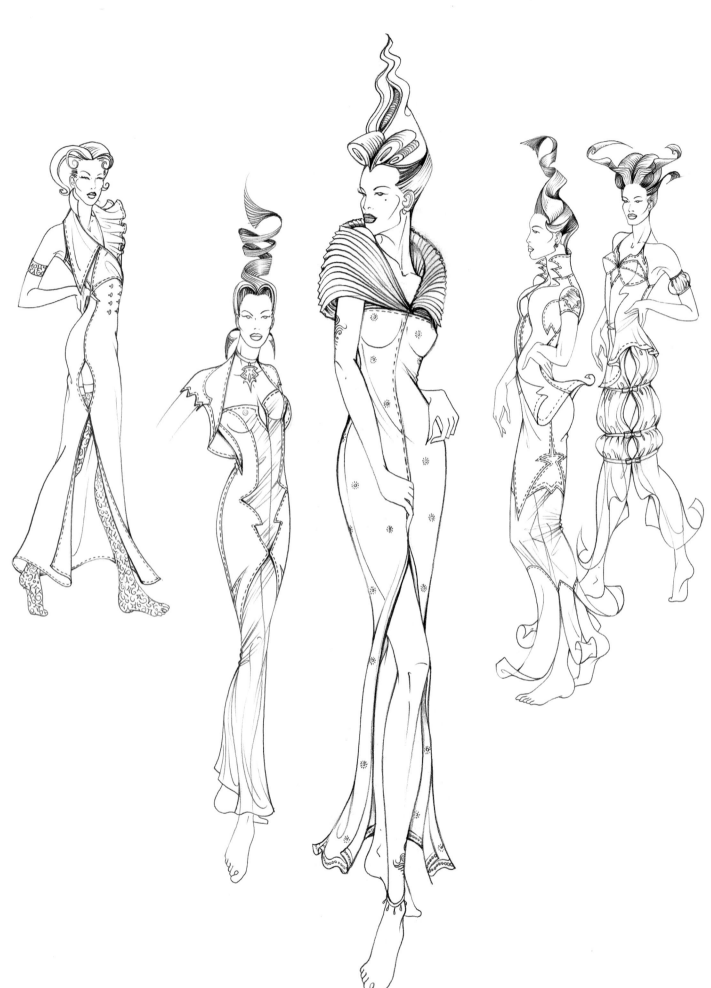

Decorative dresses with elaborate necklines and collars.
For poses used, see pages 154-155.

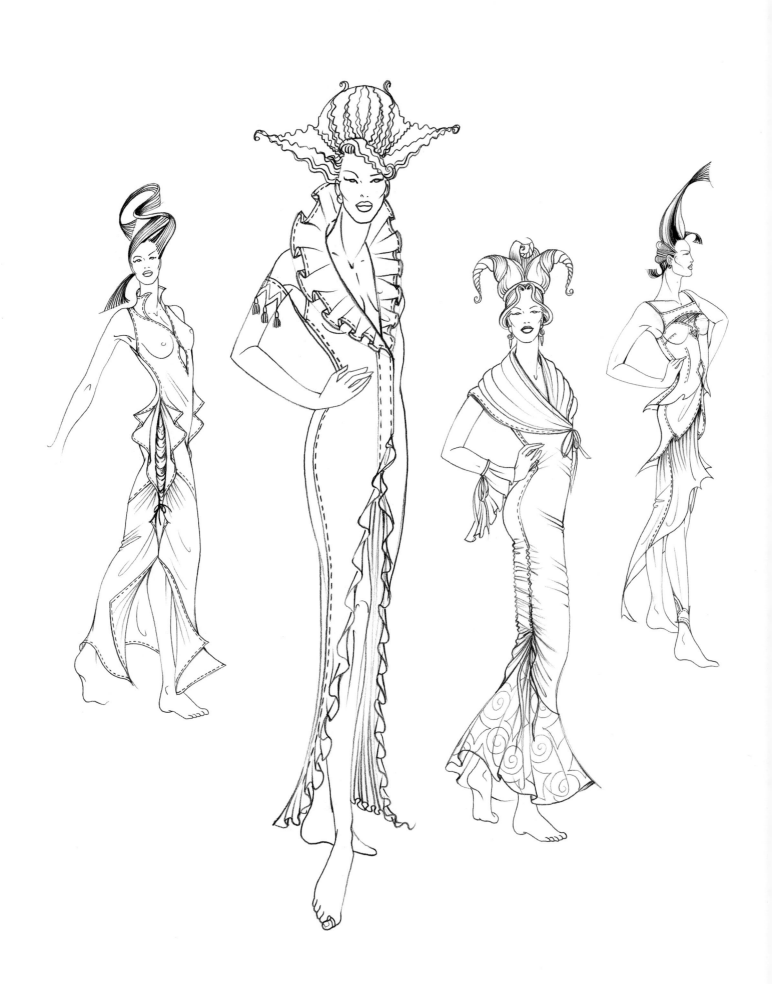

Foreword

Elisabetta Drudi and Tiziana Paci have a distinctive approach to figure drawing, involving all of the aspects and movements of the female figure. The method and analysis give an in-depth understanding of the female body in a wide-ranging array of poses and provides an invaluable base for those entering a career in fashion design.

The great skill, elegance and indeed pleasure that these two illustrators put into their work, come across on every page. The texts accompanying the illustrations are clear and detailed and will further help students in planning their work.

Since there is no material quite as specific or detailed as this on the market, I believe it meets the need for a drawing book on female fashion that covers the breadth of the subject in an analytical and thorough way: it provides an ever-increasing group of consumers with a comprehensive visual and written grounding in fashion illustration.

Franco Fiorucci

Artist and fashion and costume design tutor

Introduction

The success achieved by the first edition of this book was extremely satisfying, and we are grateful to all those who contributed to making this manual truly special. First, we would like to thank all the teachers and students at the many prestigious fashion schools that have adopted our text. Such widespread distribution convinced us that a book focused on figure drawing was necessary, and indeed essential, for a systematic study of the female body and of everything concerning its movements and clothing.

All of this led us to review the first publication and reflect on what could be added, replaced and discussed in more depth. This is why we decided, after several years, to come up with a more up-to-date and comprehensive edition, which would also take into account all the advice we have received over the years.

When we set to work, new ideas took shape and others grew from them. As a result, our desks were increasingly cluttered with drawings done, discarded and redone. Not to mention the battlefield that our offices soon turned into, with stacks of books, magazines and whatever else was useful for an idea, a new pose or a new topic. All this went on for months but, in the end, we finally finished the new book. We can scarcely believe that we have got this far unscathed!

We hope that an initial browse through the book will reveal it to be comprehensive. There may be a little too much content for beginning fashion illustrators, but it was precisely our intention to give our students everything they might expect from this new edition and we sincerely hope that we have succeeded.

Sections on ancient rules of proportion and the evolution of beauty through the ages have been added, the collection of basic and stylised images has been extended, and (as you requested) we have expanded the section on technical drawings with some helpful explanations.

We have replaced many drawings with new, more dynamic poses, suitable for more creative garments. We have added a new section on movement and folds, represented both in theory and graphically, using pencil shading techniques. Finally, we touch briefly on the concept of design preparation, with studies aimed at developing patterned fabric drawing skills, and interpreting some contemporary trends. We do not go into this in great detail, as the design process involved in creating a sample collection is so vast that this topic could easily be a book on its own.

If this new edition proves to be another success, it will also be thanks to you and to all the feedback you have given us over the years.

All that remains is to wish you the very best in your work. Drawing is an art that requires time, devotion and love, so do not be tempted to rush through the topics. Practise copying and applying the right amount of pressure on the paper; remember that, just like a musical instrument that needs tuning, the drawing hand must be "tuned" through endless practice to produce fluid and effortless strokes.

Over to you now. Have fun practising!

Tiziana Paci
Elisabetta Drudi

Beauty through the ages

Since the aim of this book is to provide an analytical study of the figure for fashion purposes, we thought that it would be appropriate to begin with a brief overview of the different attitudes towards beauty through the ages. The word "beautiful" is often used to describe things that we like, love, desire and admire. But what is the universally accepted definition of beauty? Something that is perfectly harmonious can be said to be beautiful and, when speaking specifically about the female body, it may be said that a beautiful body is one that reflects a given age's ideal of beauty. This ideal can be observed in the infinite representations seen in the media and in the art world.

In his book *History of Beauty*, Umberto Eco states that "beauty has never been absolute and immutable but has taken on different aspects depending on the historical period and the country".

Female grace depicted by the Egyptians, for instance, was very different from that conceived by the Greeks in the 5th century BC, or by the 19th century Romantics or by 20th century society. It is quite a leap to comprehend these different if not opposing ideals of beauty. Works of art created by civilisations throughout history have always idealised the female figure. The drawings shown here briefly illustrate how the ideal of beauty has been interpreted and expanded over the centuries.

The aim here is not to provide a comprehensive historical guide, but rather to illustrate just how much the concept of beauty has changed with the times. It is interesting to note how the well-rounded woman who inspired so many extraordinary works of art, and remained the ideal for many centuries, was replaced in the 20th century because it was in clear contrast to the ideals proposed by the mass media. Contemporary ideals of beauty are imposed by glossy magazines, movies, television, sport and fashion itself. Femme fatale, the girl next door, tomboy, rebel biker chick and sex kitten are just some of the examples of female stereotypes.

The emancipation of women, the sexual revolution of the 1960s and growing financial independence have established many varied and new ideals of beauty. Some of these may well contradict one another but they still manage to coexist, perhaps because they mirror the very diverse and globalised society that created them.

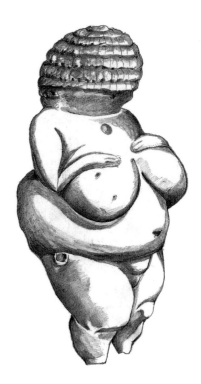

Venus of Willendorf 20.000 BC.

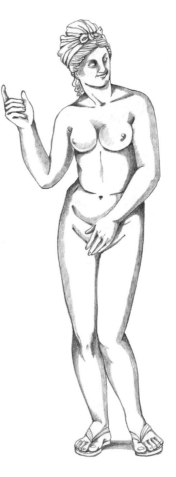

Aphrodite, 1st century AD.

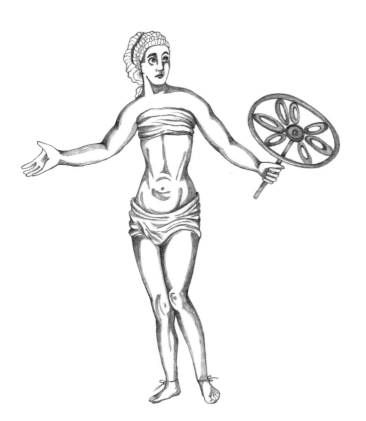

A representation of Venus, 3rd century AD.

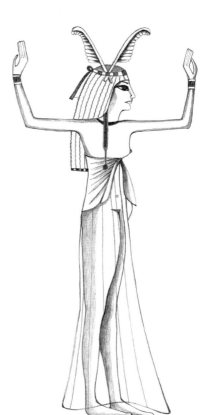

Ancient Egypt, 2,000 BC.

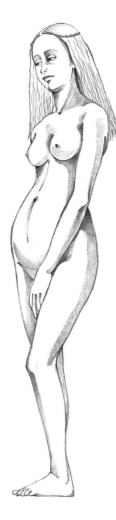

Eve by Hubert and Jan van Eyck, 15th century.

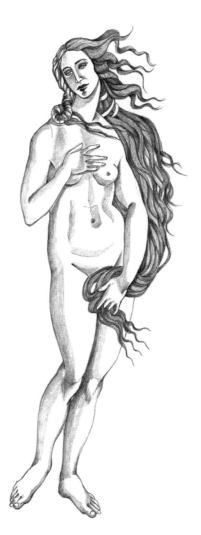

Venus by Sandro Botticelli, 15th century.

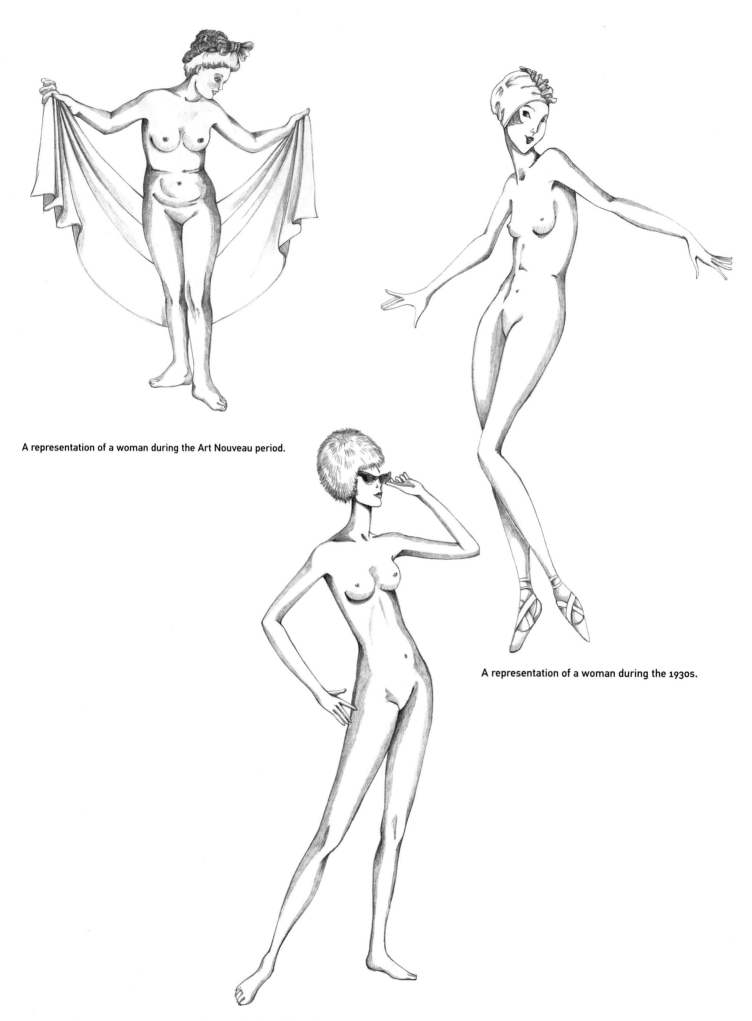

A representation of a woman during the Art Nouveau period.

A representation of a woman during the 1930s.

A 1950s fashion silhouette.

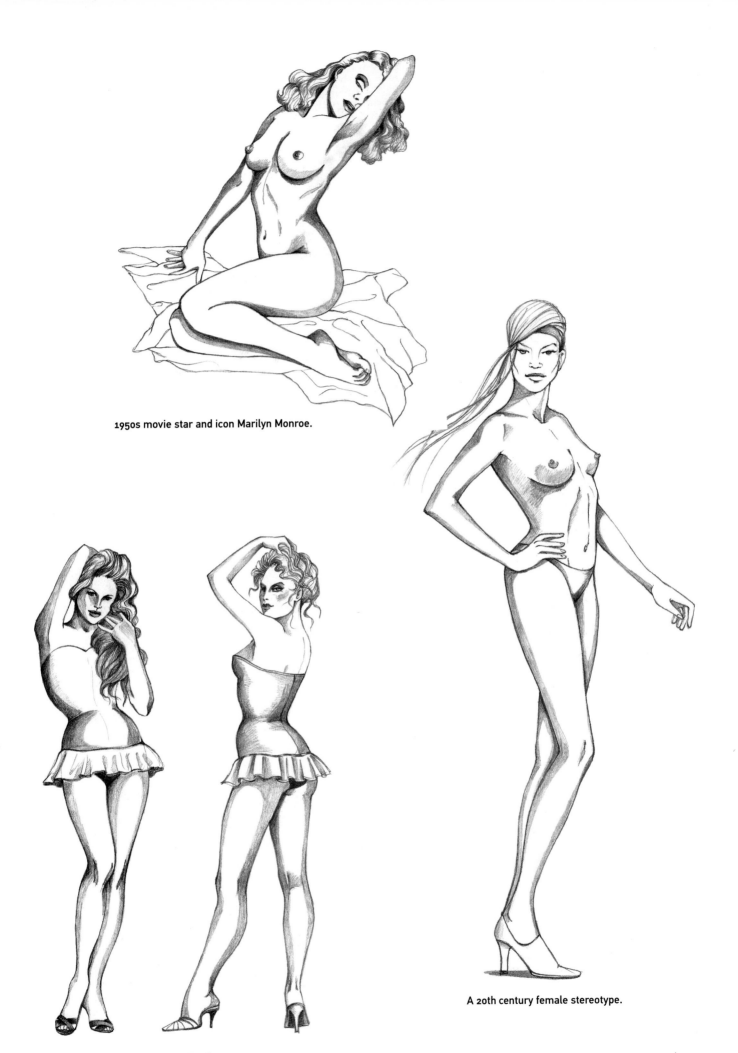

1950s movie star and icon Marilyn Monroe.

A 20th century female stereotype.

1960s movie star and icon Brigitte Bardot.

Chapter 1
Drawing the female figure

Historical rules of proportion

Before we begin to study the body in relation to fashion, it is important to illustrate some of the classical rules of proportion, used in the course of history. These rules or principles have established the ideal proportions of the human body, using mathematical ratios, dividing it into sections or standard units of measure. From ancient times, the body has been the subject of careful observation by scientists and artists who have attempted to depict it. First, the representations were described instinctively, but then increasingly using mathematical proportions, harmony and perspective.

The earliest examples we have of rules of proportion being applied to the body come from the Egyptians. Their illustrations were formal and stylised, but nevertheless very effective for the type of image conceived at that time. Not until the Greeks invented foreshortening did the study of reality take a noticeable leap. The concept of 'beauty' in art became one in which everything was interpreted according to a higher order and harmony, thus respecting an ideal of absolute perfection. As always, the discoveries of the great thinkers are connected beyond time barriers. So, in the Renaissance, as in Ancient Greece, the proportional rules of the human body that had already been defined by Polykleitos (5th century BC) in his statue of Doryphoros were set out scientifically. Many treatises passed down instructions for the construction of optimal architectural works, some of which also discussed the human body, including *De Architectura (On Architecture)* by Vitruvius (1st century BC), *De Prospectiva Pingendi (On Perspective for Painting)* by Piero della Francesca, *De Divina Proporzione (The Divine Proportion)* by Luca Pacioli, *De Symmetria Partium in Rectis Formis Humanorum Corporum* by Albrecht Dürer and the many studies on proportion carried out by Leonardo da Vinci and Michelangelo, up to more recent times with Fritsch's rule (1895) and *Le Modulor* by Le Corbusier (published in 1948).

The rules that we have selected here are a brief overview of the many drawings that can be found in various primary sources. They appear here with some notes to help anyone interested in this specific area carry out their research.

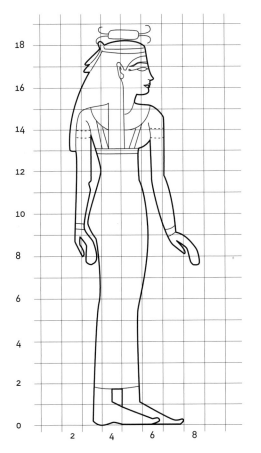

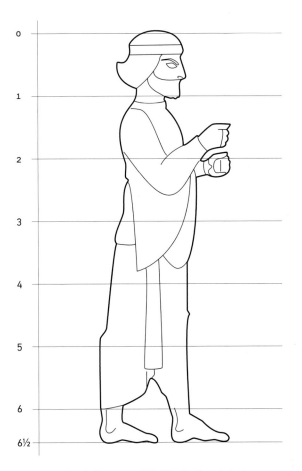

Egyptian rule (New Kingdom, about 1539 to 1075 BC). The figure was enclosed in a grid made up of squares, resulting in the body measuring 18 squares. The head is shown in profile, the shoulders and bust are viewed from the front, and the lower body, legs and feet are shown in profile.

Persian rules (4th century BC). The basic unit is the measurement of the head. In these stylised drawings, the entire body measures six and a half units. The human body was shown in profile.

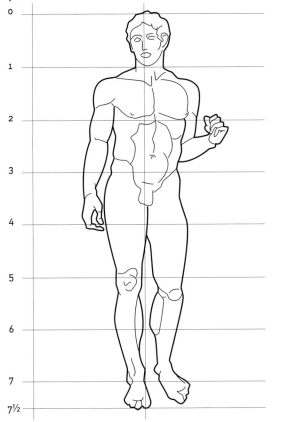

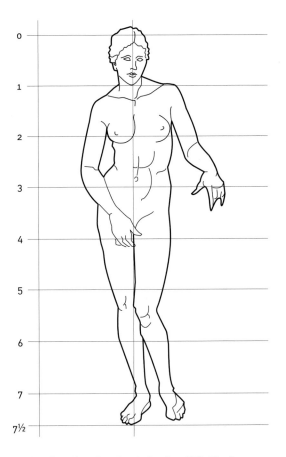

Polykleitos' rules (5th century BC). The statue of Doryphoros represents the first rule of proportion. The figure measures seven and a half units, and the head is the basic unit of measurement.

Aphrodite of Cnidus, Praxiteles (350 BC). The figure measures seven and a half units, and the head is the basic unit of measurement.

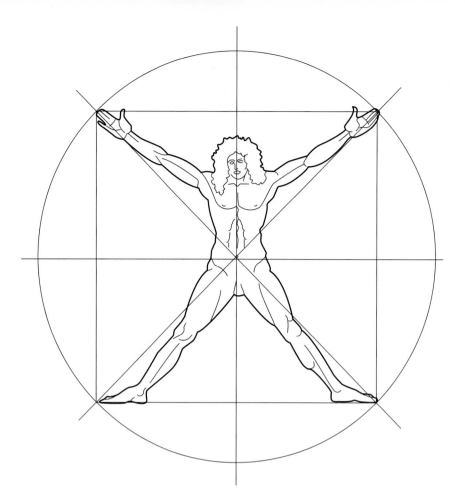

The Vitruvian Man (27 BC). The Roman architect Vitruvius studied the conventions of Greek art and eventually established his own rules of proportion by drawing the human body inside a square and a circle. This principle was later perfected by Leonardo da Vinci. In his treatise, *De Architectura*, Vitruvius claims that the human body is the model of perfection and harmony. With the arms and legs extended, it fits perfectly into the perfect square and circle shapes.

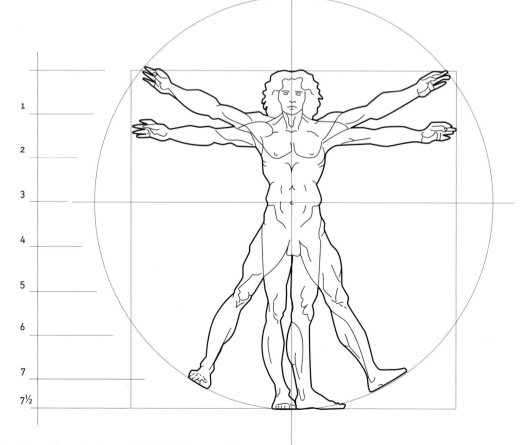

The Vitruvian Man perfected by Leonardo da Vinci (1452–1519).

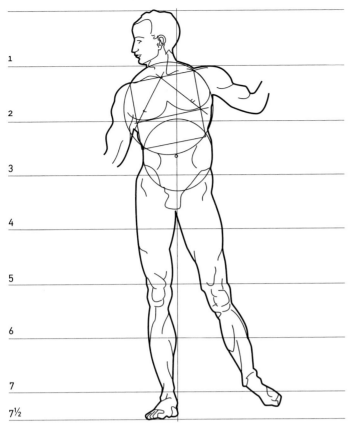

1
2
3
4
5
6
7
7½

Albrecht Dürer, male nude and its proportions (1500).

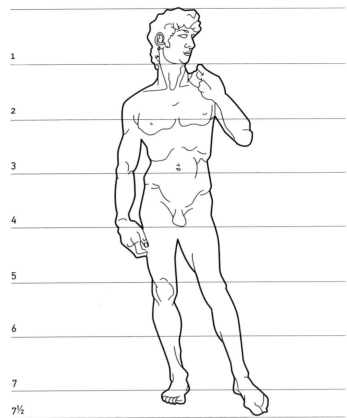

1
2
3
4
5
6
7
7½

When sculpting the David, Michelangelo Buonarroti (1475–1564) took inspiration from Polykleitos' rule, establishing the height of the head as the basic unit.

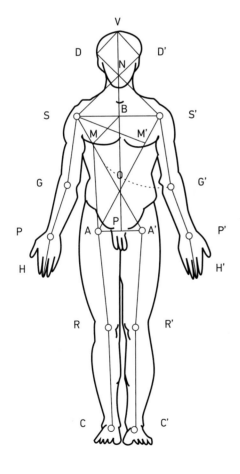

Fritsch's rule (1895). Fritsch used the distance between the nose and the upper border of the pubic symphysis as a unit. Segment NP represents this unit.

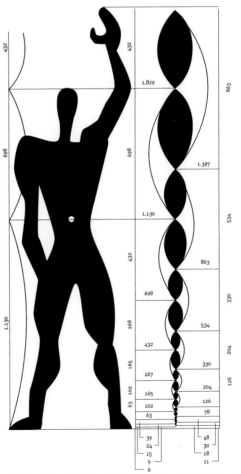

Devised by Le Corbusier in 1948, *Le Modulor* is a study of modular coordination based on the measurements and movements of a 1.83 m (6 foot) tall man.

17

Greek rules of proportion

These conventions refer to the principles that have established the ideal proportions of the human body, using mathematical rules to divide it into sections called units.

Of the many rules studied in antiquity, we have chosen those of the Ancient Greeks because we felt that they were the simplest and most appropriate for our needs. In these rules of proportion, the head is used as a unit of measurement to establish all the other dimensions. As you can see in the illustration, the total height of the body is equal to eight times the length of the head. In order to reproduce the kind of female figure used for fashion illustration, the body length is altered slightly, but the proportions are basically unchanged.

1 The head measures one eighth of the total length of the body and constitutes one unit of measure.

2 The distance between the temples forms the basis of the width of one shoulder; from the base of the neck to the shoulder joint (AB = A'B').

3 When the figure is viewed from the front, the central line divides the figure perfectly in half.

4 The shoulders are as wide as the pelvis; the waist two-thirds the width of the shoulders.

5 The shoulders are drawn extending beyond the torso. The joint is indicated by a small circle.

6 The elbow is in line with the waist, the wrist is in line with the pubic bone and the hand with the mid thigh.

7 The length of the thigh is equal to that of the legs.

8 The foot is one unit long. If we divide the height of the body into two equal parts, the head and the torso will take up four units and the legs the other four.

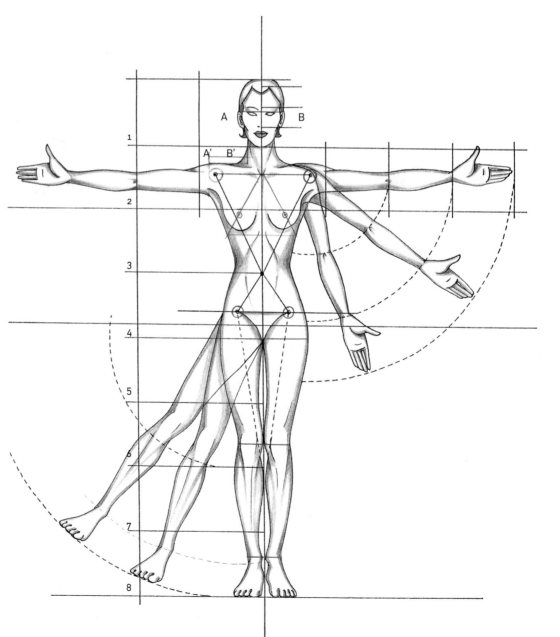

The rules of proportion in fashion drawing

By comparing the two illustrations shown here, it is evident that the one on this page is half a unit taller. This is due to the foot being extended, so that footwear can be shown properly. This particular posture is not very realistic, but it gives a sleek, more elegant look to the leg. Another slight modification is the raised waist and pubic bone, which shortens the bust and pelvis. This makes the leg looks longer, but not unnatural. The length of the arms is left unchanged. Finally, the whole body has been made slimmer to accentuate the total height even more.

In the section on stylisation (pages 148-152), the proportions have been elongated by one or two units. This is because fashion models are generally much taller than the average woman and therefore fashion drawings require a slimmer body.

This illustration divides the figure into geometric blocks, resulting in a robot-like figure. The body is made up of cylinders (upper and lower limbs), truncated cones (bust and pelvis) and spheres (head and joints). The rotation of the arm and leg are shown in the rotating movement of the joint spheres. N.B. The measurements of this set of rules act as a guide to establishing the ideal proportions. They are rare in real life, but they are essential to an understanding of the relationships and correspondences between the various parts of the body, in order to end up with an accurate and harmonious depiction of the female form.

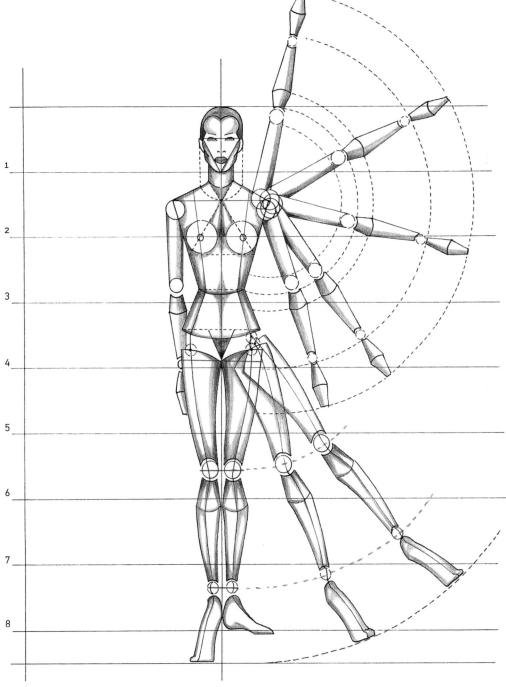

Robotised fashion figures from different angles

1 Draw the vertical height line H at the side and divide it into eight equal parts, then draw the horizontal lines.

2 Draw the central line, which in the front and back figures, is parallel to the height line.

3 To construct the figure, begin with the oval for the head, making sure the distance between the temples is not too wide, as this is the measurement for establishing the width of the shoulders.

4 The measurement of the shoulders is projected to line 4, to establish the width of the pelvis, which has been reduced a little to obtain a slimmer figure.

5 Draw the chest, waist and pelvis.

6 Finally, draw the upper and lower limbs as shown in the drawing, paying particular attention to the joints.

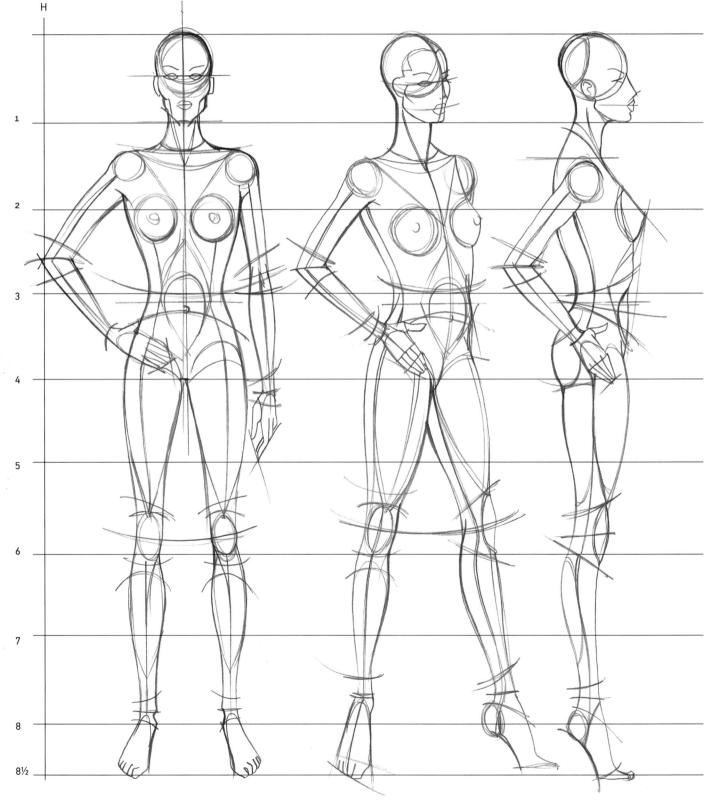

This series of illustrations (pages 20-21), shows the body gradually turning round. Each area of the figure is aligned to the next, highlighting the key anatomical features of each view. It is evident that the units corresponds to:

1 The head;

2 The neck and shoulders;

3 The breasts, the lower part of the chest and the waist;

4 The pelvis and the pubic area;

5 The central part of the thighs;

6 The bottom of the thighs, the knee;

7 The central part of the lower leg and the calf;

8 The bottom of the lower leg, the ankle and the feet;

8 1/2 The foot extended forward.

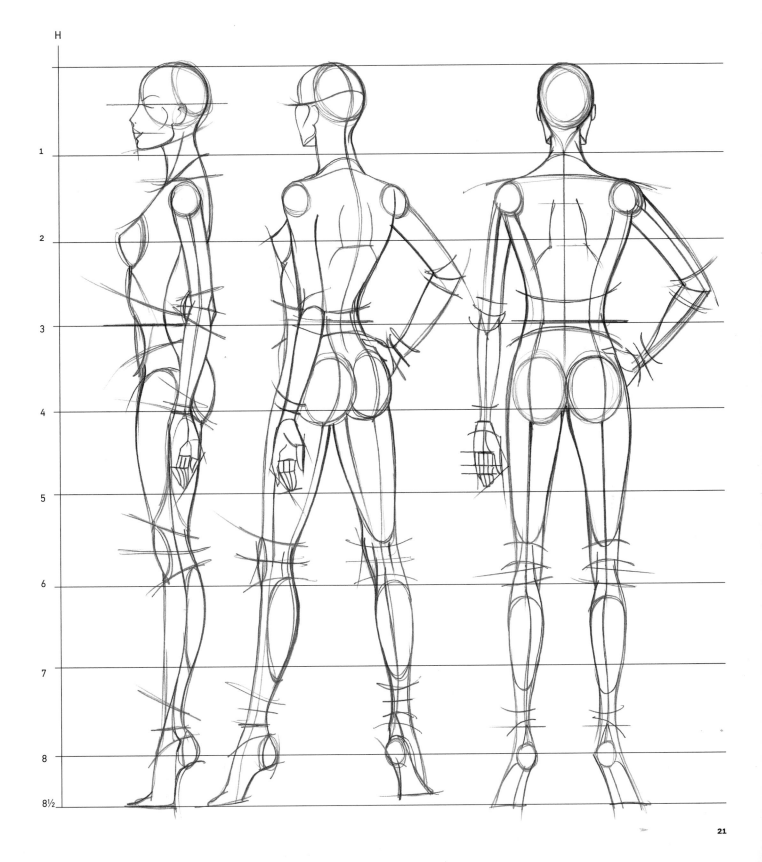

Three-dimensional figures in perspective

This is the same series of poses as on pages 20-21 drawn using the essential lines that make the figures look three dimensional and therefore more lifelike.

Notice how all the constructed parts are perfectly indicated in the horizontal alignments, and how the body reveals its changing anatomy as it turns. Study these characteristics and examine every detail. These first lessons are vital and cannot be replaced at a later stage. Practise copying repeatedly; your drawing skills will only develop once you are familiar with the rules of proportion.

In the illustrations on page 23 movement is added to the limbs so that the volume of trousers, a skirt, top or shirt and various types of sleeves can be shown.

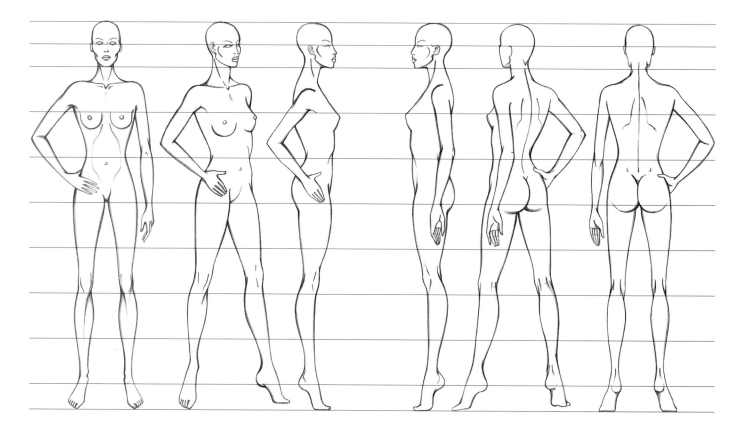

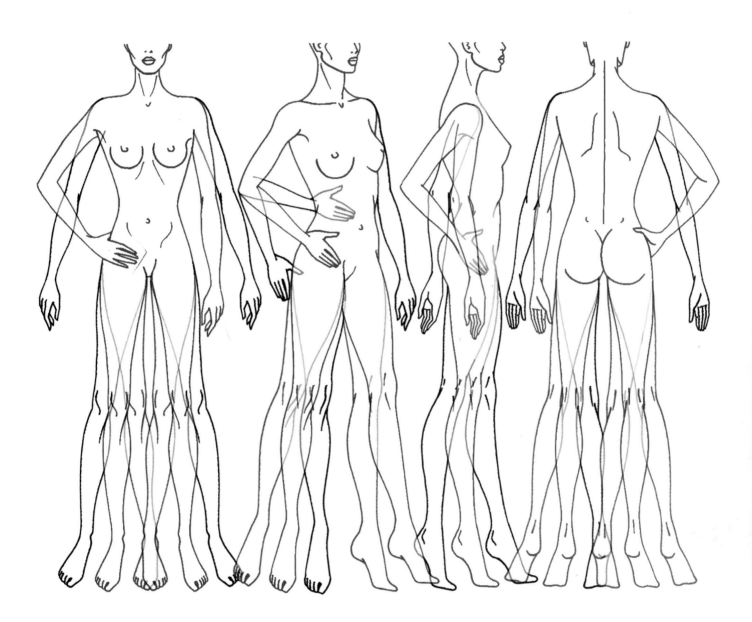

The mannequin

These illustrations show a static figure from the front and back. The joints and the internal structure are included to enable closer examination of the chest and pelvic areas. The two smaller illustrations are matchstick figures showing the main joints.

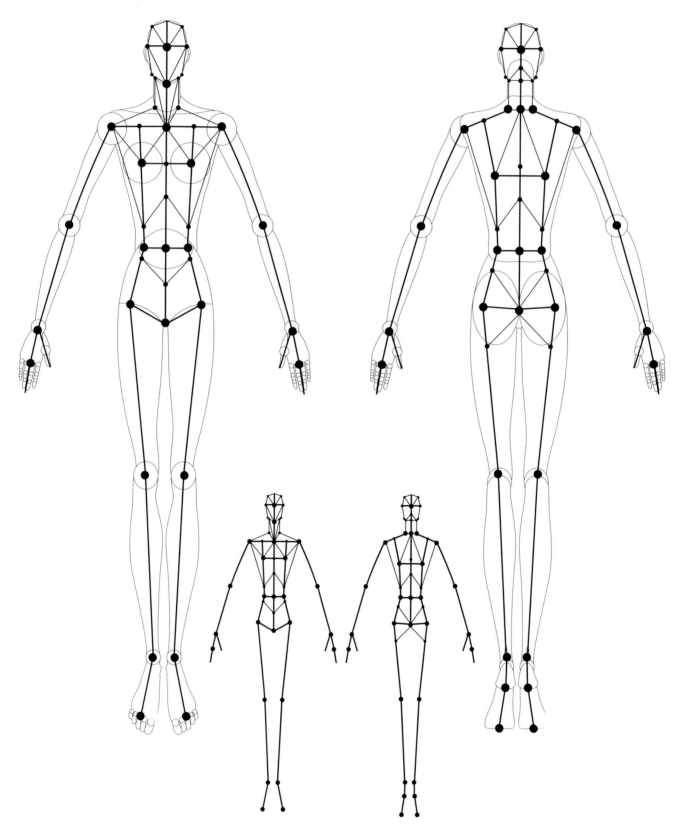

Tone mannequins

The tone mannequins show the different parts of the body. These have been pulled apart in the smaller images, so that the parts in the various shades can be used to make up bodies of different sizes. These can then be used to trace the various poses you can create by moving the bust and limbs, as seen on the next page. It is an enjoyable and useful exercise, and will enable you to get to know the body and its movements.

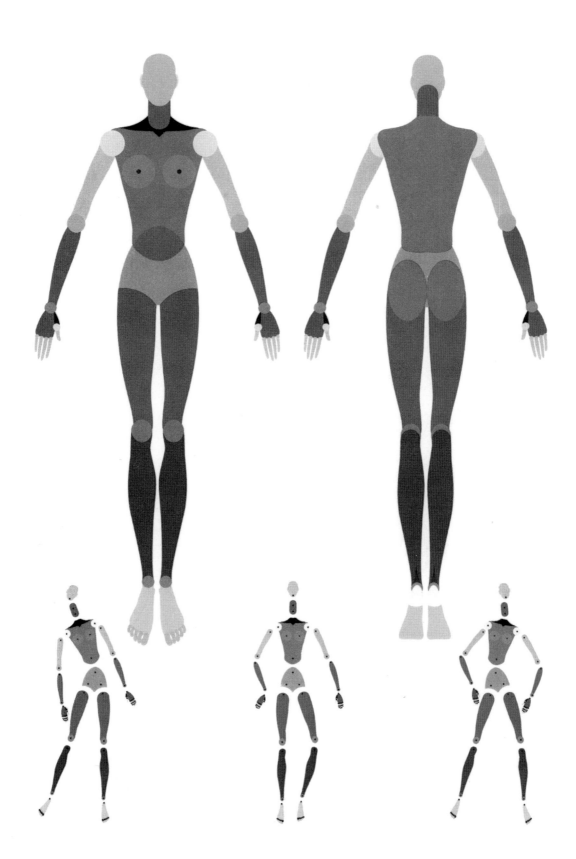

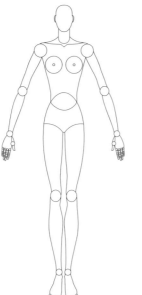
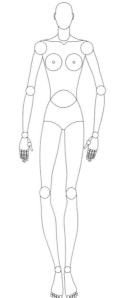
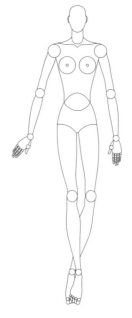
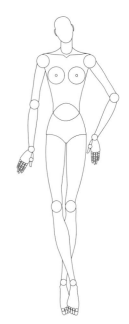

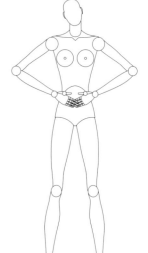

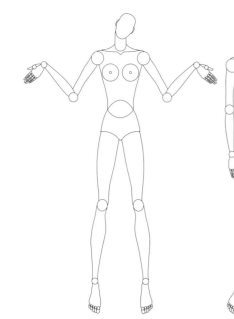

Various static and dynamic mannequin poses.

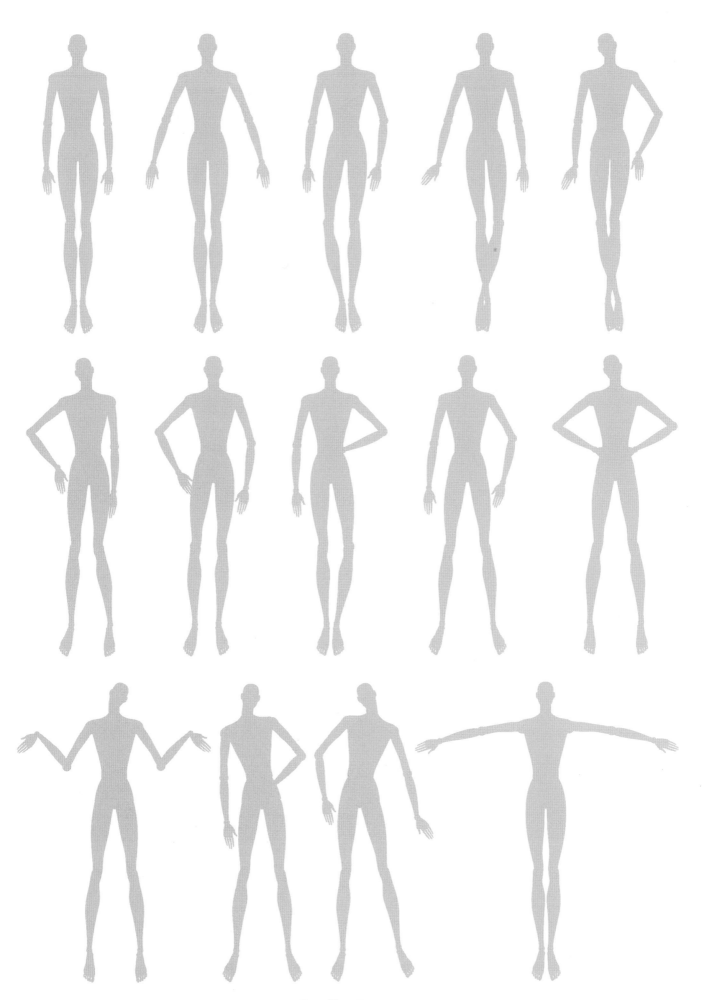

Grey silhouette poses.

Facial features

The eyes

Now that we have analysed the human body according to Greek rules and those of fashion, let's move on and examine all the individual anatomical components, beginning with the details of the face.

The eyes are the most expressive part of the face, conveying an infinite number of emotions. They are without any doubt the most important part of the face, and should always be included in fashion drawings, even stylised drawings.

In technical terms, the effect of light is obtained by leaving small white circles inside the iris and pupil, while giving greater prominence to the shadow that the upper eyelid projects onto the eye. Practise reproducing various expressions by adding light to the gaze.

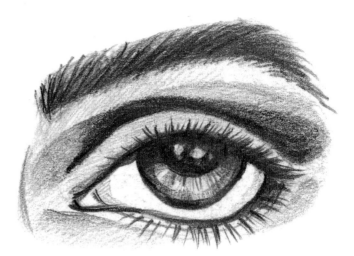

In this drawing the eye is realistic, with darker shadows and more marked half shadows.

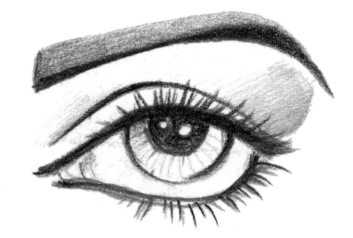

The second eye is less realistic, as it has no half shadows.

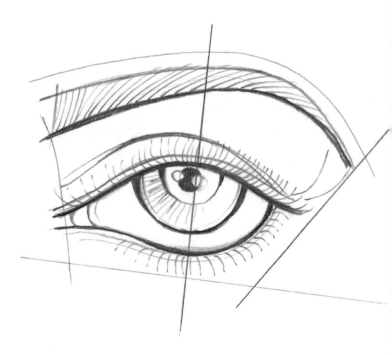

The third eye is more stylised and has a more clearly defined outline.

Proportional analysis

From an anatomical point of view, the eye is made up of the eyeball, which is perfectly round, inside which we find the iris in its various colours, and the black pupil.

The eye is protected by the eyelids. The upper eyelid is thicker and wider than the lower lid.

Seen from the front, the eye is almond shaped, while in profile, it looks triangular.

The distance between the eyes corresponds to the width of one eye (AB = A'B').

The eyelashes and eyebrows are key parts of the eyes, and can give depth depending on their shape and length.

To draw the eye accurately, accentuate the lower edge of the upper eyelid and cast a slight shadow onto the iris, as shown in the drawings.

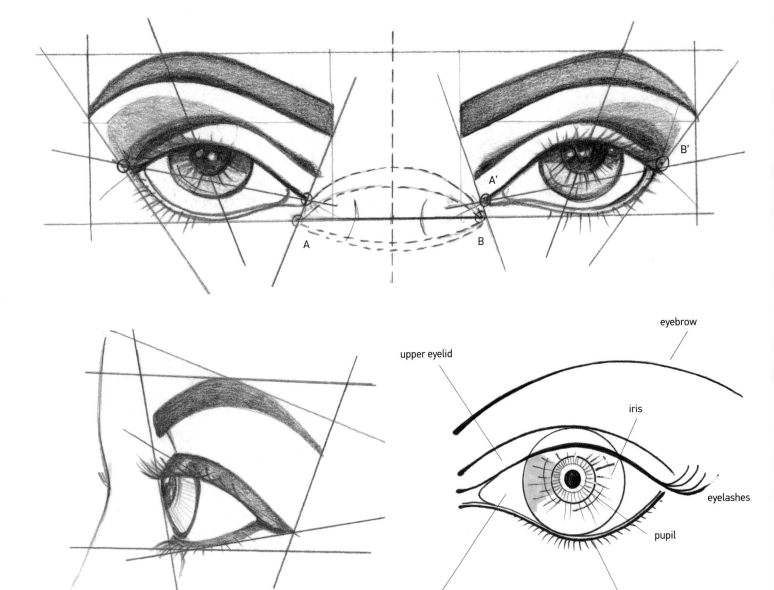

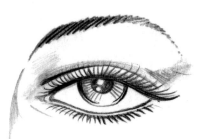 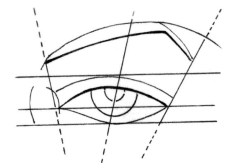 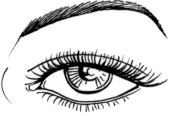

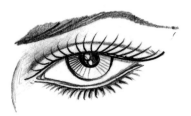 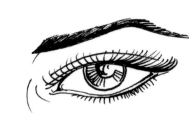

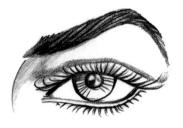 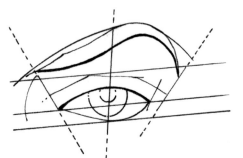 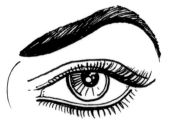

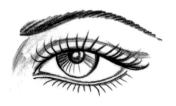 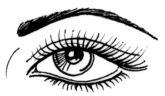

1 2 3

Form and structure

These drawings show the differences between a natural eye,
a geometrised and a stylised drawing.

1 Realistic depiction of the eye, drawn using 2B pencil shading.

2 Structural analysis of the eye, drawn with an 0.05 felt-tip pen.

3 Stylised drawing of the eye, drawn with an 0.2 felt-tip pen.

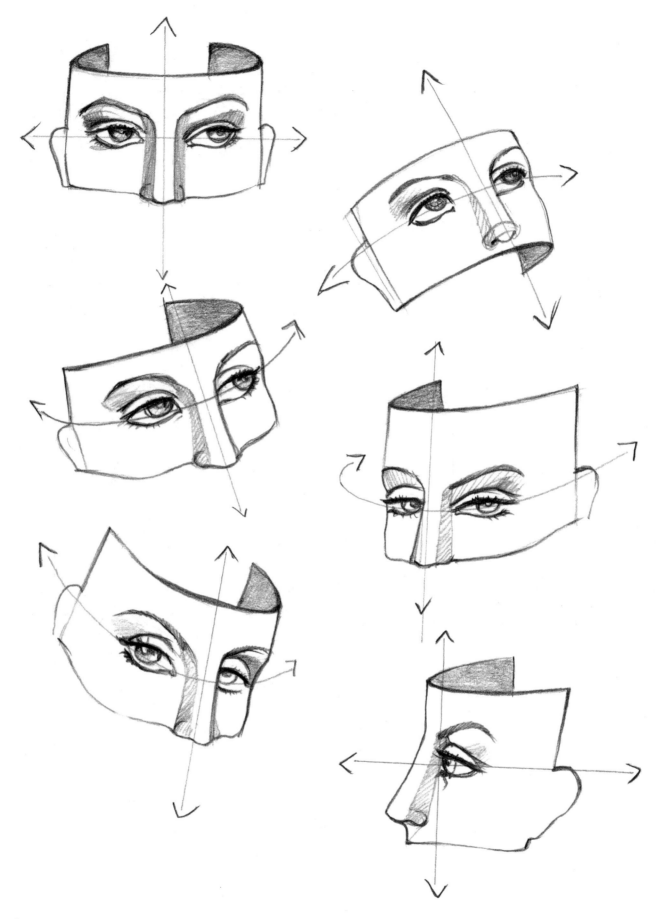

Sections

The face in these drawings has been reduced to a cylinder-shaped 'mask', to highlight the position of the eyes viewed from different angles. The vertical and horizontal axes show the correct alignment of the eyeballs in each movement.

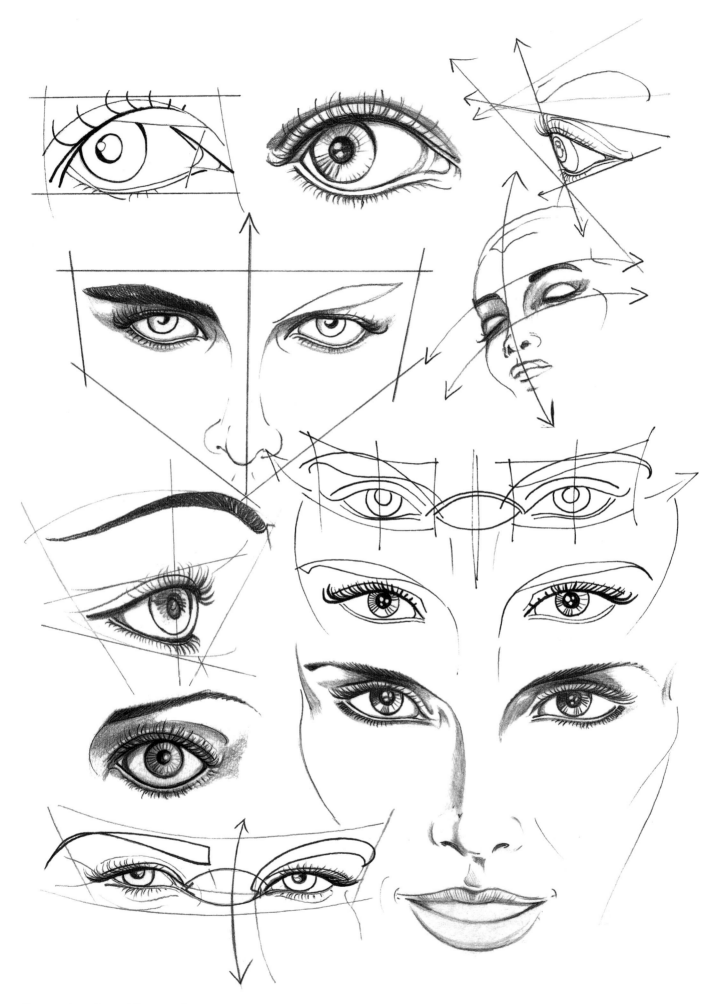

The eyes viewed from different angles.

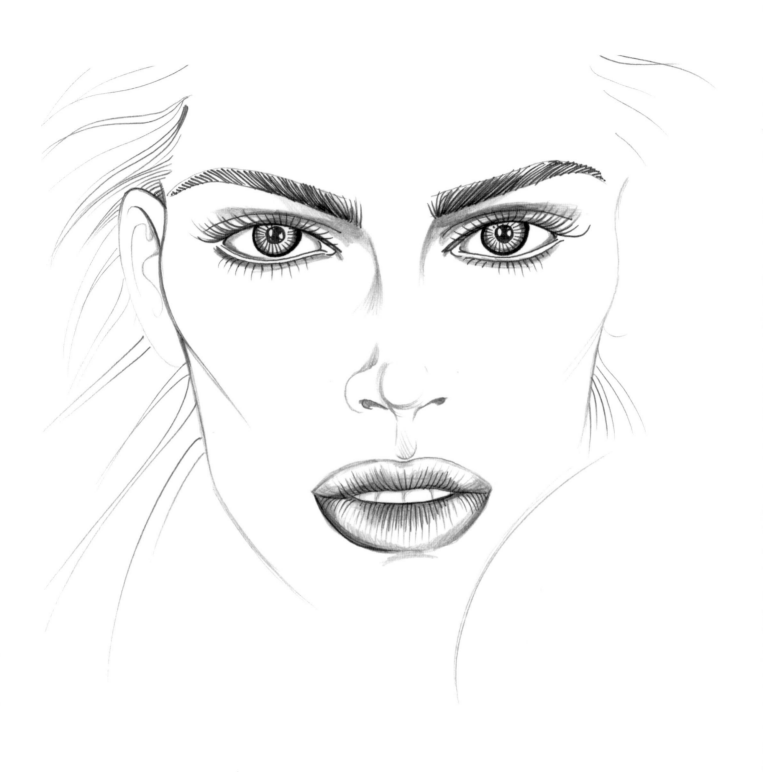

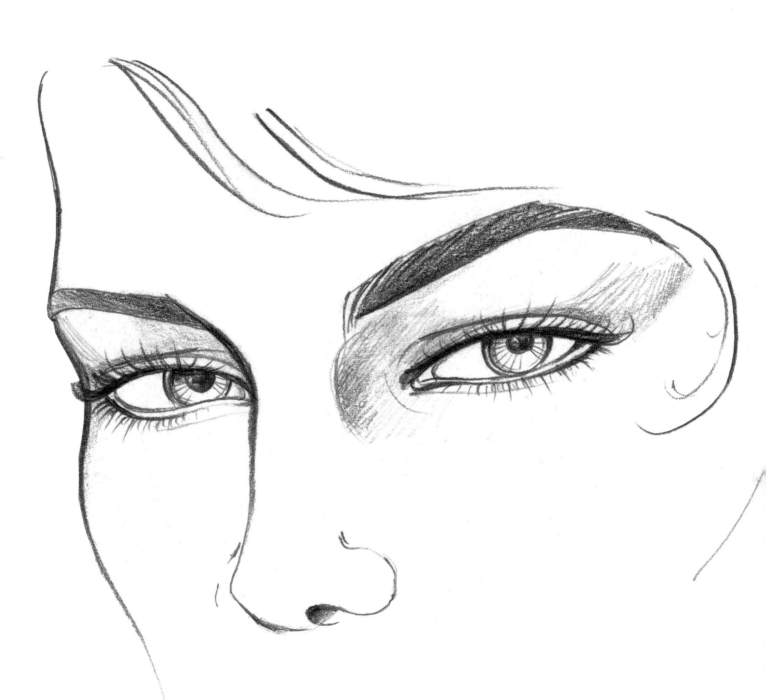

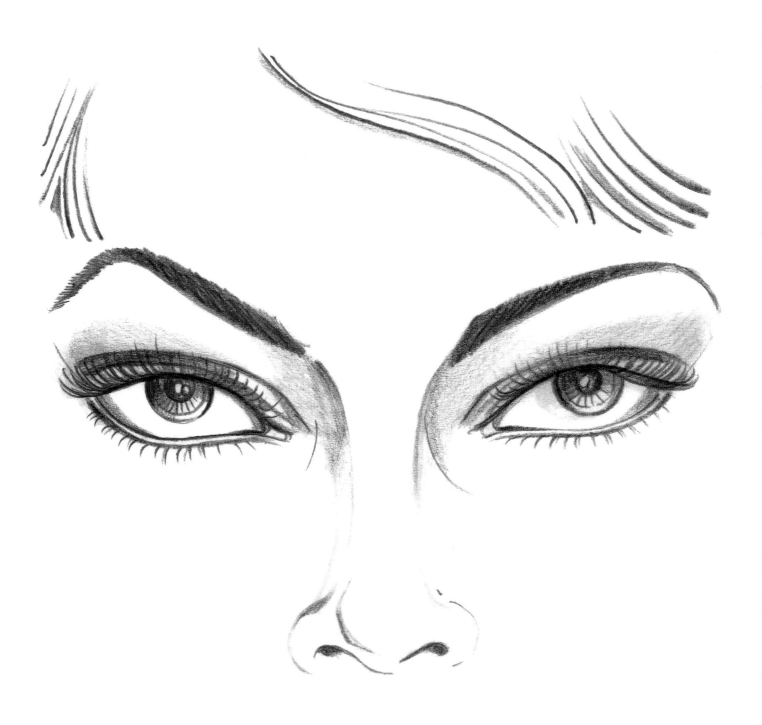

The nose
Proportional analysis

As far as the head is concerned, the nose is the most prominent anatomical feature. Every face has a different shaped nose, which gives it its characteristic appearance. In order to analyse the proportions, we will choose a well-proportioned, average shaped nose. To draw it accurately from the front, we will enclose the nose in an elongated trapezium with three circles at the base. The middle circle is slightly larger than the two on the outer sides. The length of the nose, from top to bottom, is more or less the same as the height of the ears. The distance between the alae nasi, is equal to the width of one eye (AB=A'B'). The nose is made up of the septum (bridge of the nose) and the nostrils.

The nose is connected to the mouth by the philtrum or infranasal depression (D), which in profile corresponds to the recess below the base of the nose. In profile the recess at the top of the nose is on the same line as the groove below the lower lip (CE). In a face with regular features, the length of the nose is equal to the distance between the base of the nose and the chin (CD=DF).

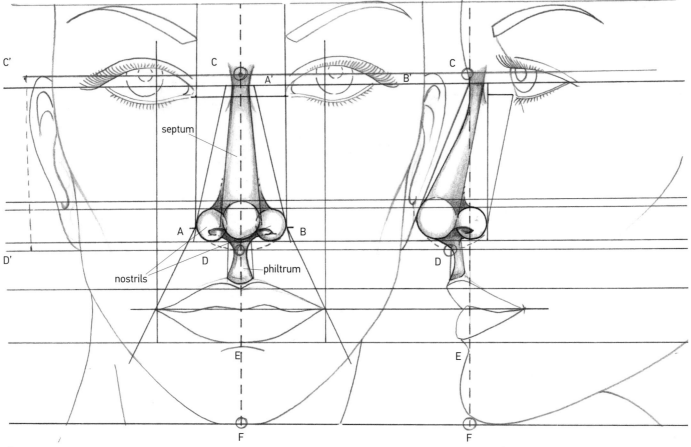

The nose viewed from different angles

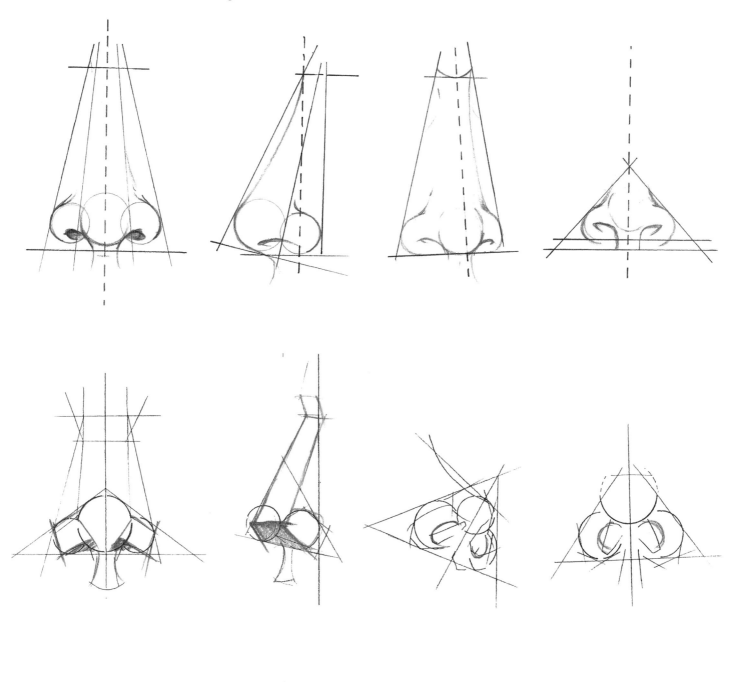

front view side view foreshortened view view from below

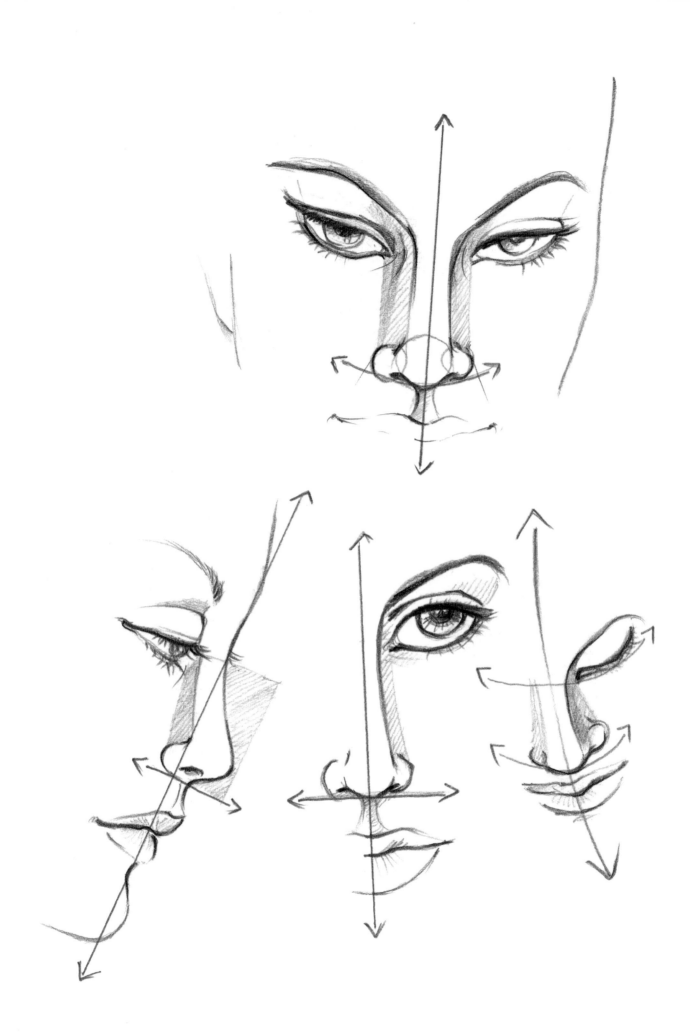

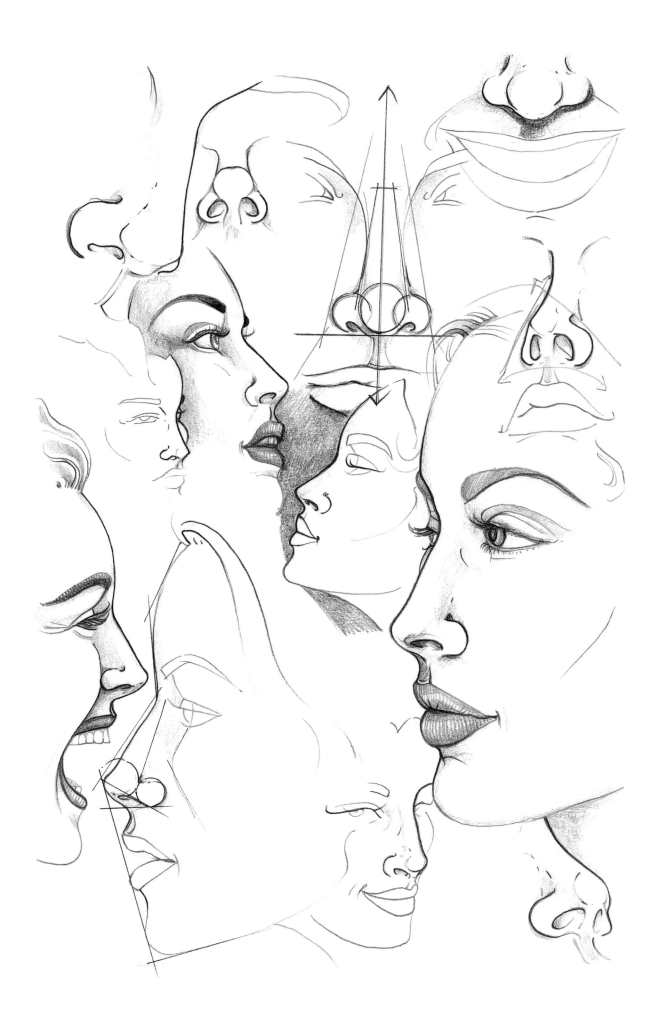

The nose viewed from different angles with light shading.

The ear
Analysis and structure

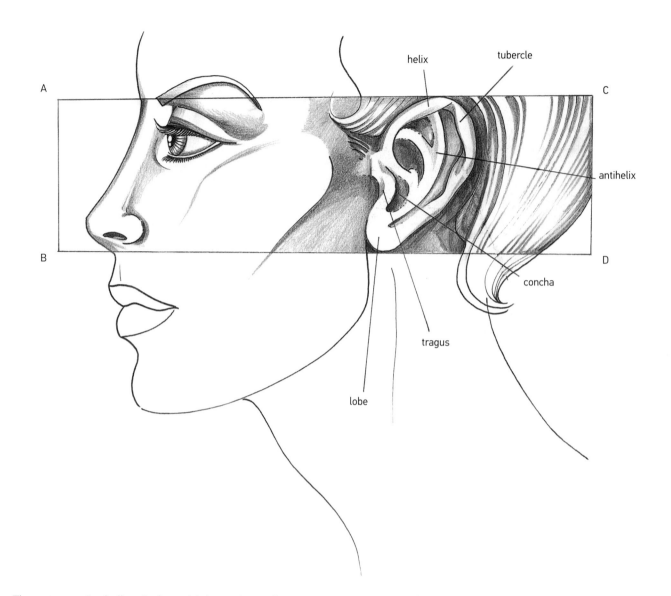

helix

tubercle

A

C

antihelix

concha

B

D

tragus

lobe

The outer ear is shell or C-shaped. It is made up of an outer part (the helix) an inner part (the antihelix), a softer lower part (the lobe) a small bump (the tragus) that protects the inside of the ear, a small projection on the curve of the helix (the tubercle) and, finally, the hollow next to the ear canal (the concha). The height of the ear corresponds to the length of the nose (AB=CD). The top horizontal line AC aligns the recess of the nose, the upper eyelid and the tip of the ear; the bottom line BD aligns the base of the nose with the base of the ear.

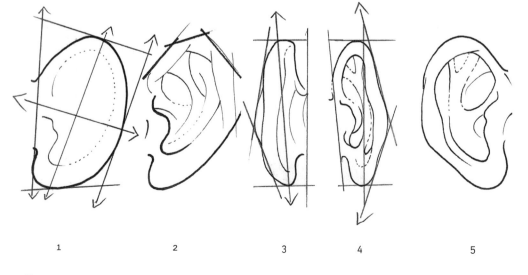

1 2 3 4 5

Sequence of drawings

1 Schematised shape of the ear.

2 Outline of the ear area.

3 Rear view.

4 Three-quarter view.

5 Right profile.

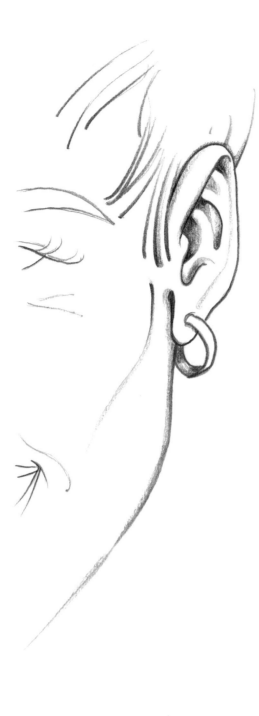

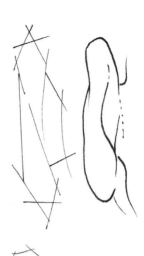

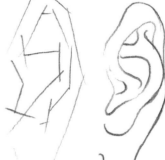

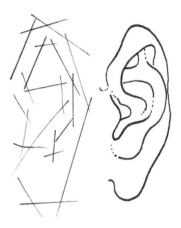

Schematised drawings of the ear.

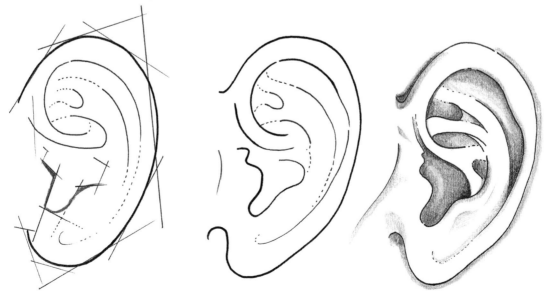

Series of drawings: from outline sketch to final drawing.

Sequence of drawings

fig. 1 Outline sketch.
fig. 2 Structural analysis with
construction lines.
fig. 3 Three-dimensional drawing
showing the contrast between light
and shade on the mouth.
fig. 4 Drawing showing the visual
relationships between space and
anatomical parts.

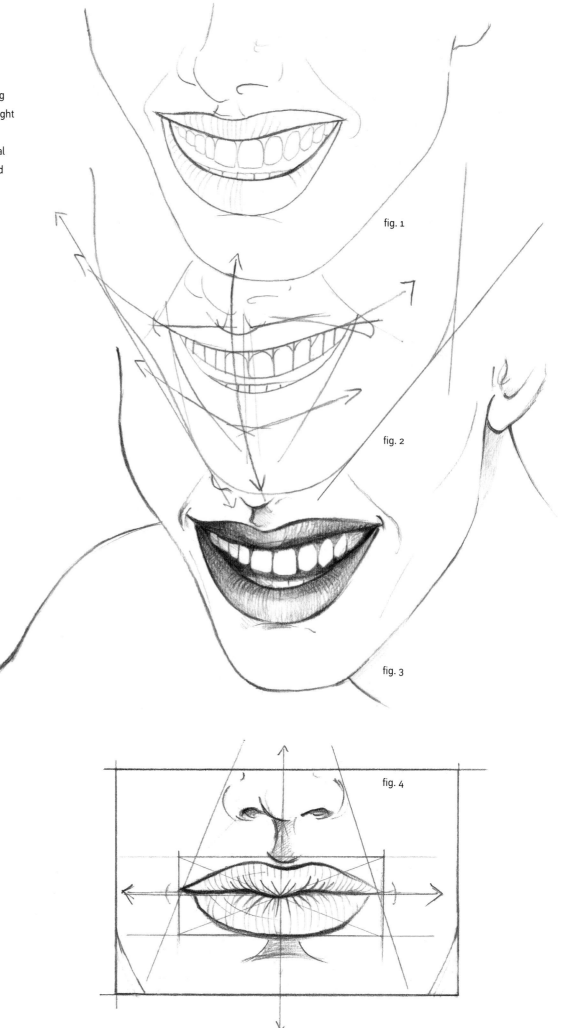

fig. 1

fig. 2

fig. 3

fig. 4

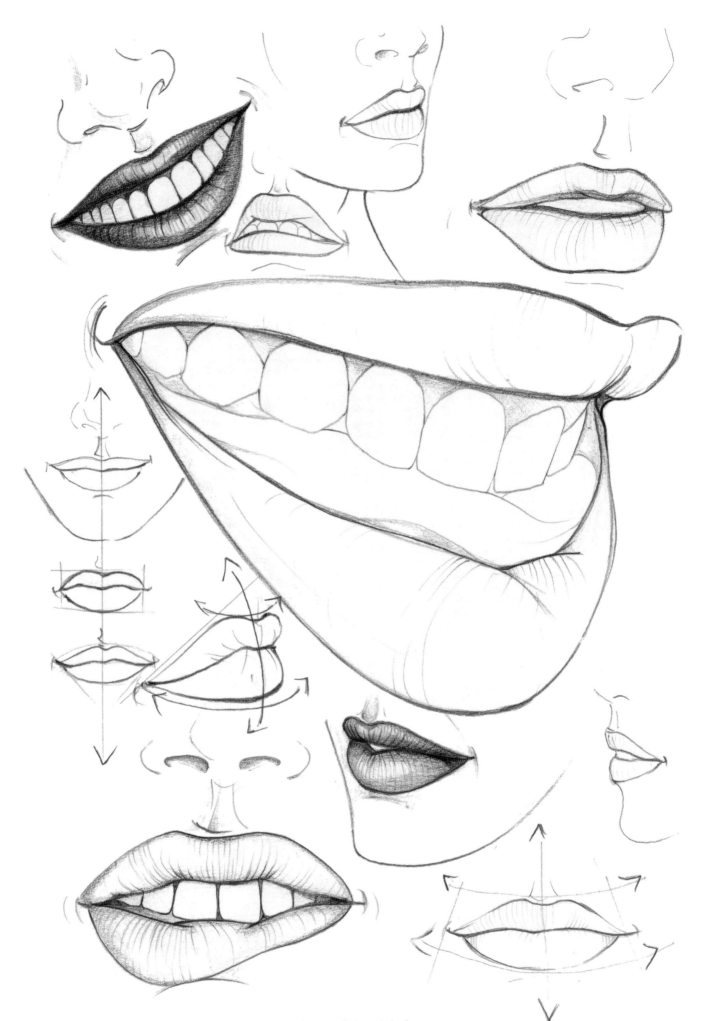

Stylised drawings from different angles, showing the contrast between light and shade.

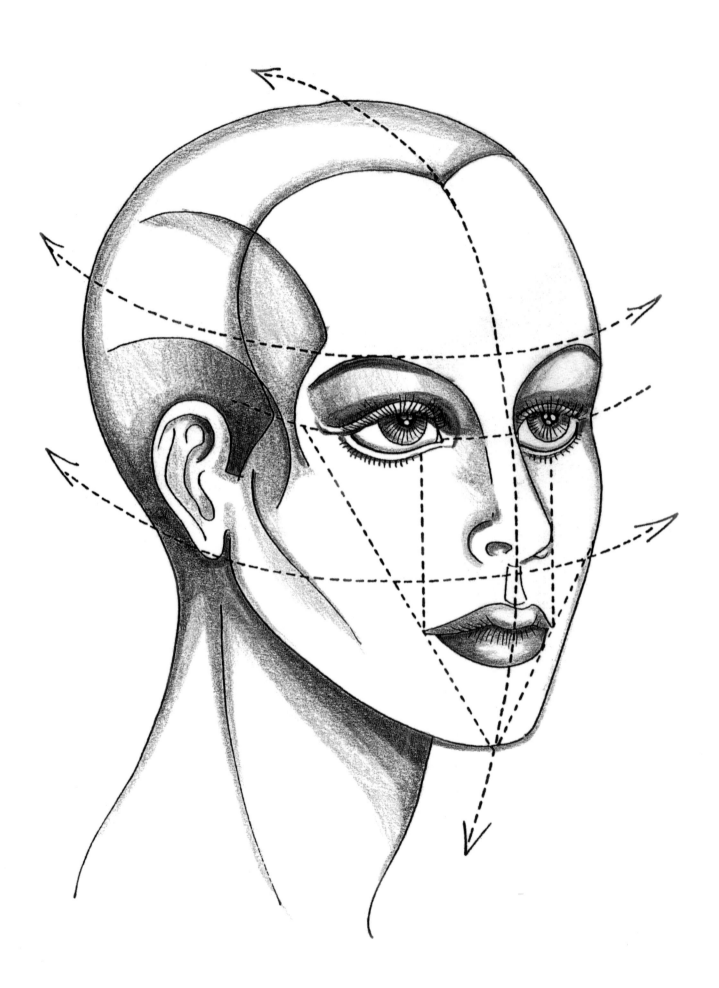

The head
Analysis and structure

For the up-and-coming fashion illustrator, drawing the head is probably the most complex area of study. No other part of the body is so varied in shape, size, proportion and expression. The head must therefore be studied extremely carefully. All the exercises need to be done correctly before you can acquire the necessary skills to draw the head from memory in its countless angled views.

The overall structure of the head is similar to an egg, the upper part of which is the cranium and the lower part, the face and jaw.

The illustrations below show three simplified drawings of the head The horizontal line AB and vertical line CD have been drawn to divide the oval shape into four sections. The horizontal line AB divides the upper part, the cranium, from the lower, facial part. The vertical line CD divides the face into two parts.

cranium

face

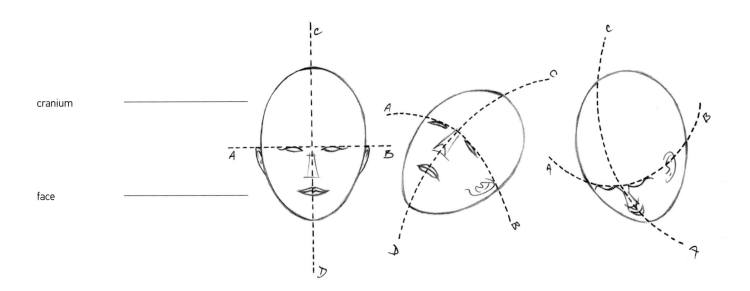

Rules of proportion

The head has been studied by eminent artists since antiquity. Of the many rules proposed, we have chosen those established by Leonardo da Vinci, who divided the total length of the head into three equal segments: from the hairline to the upper eyelid, from the upper eyelid to the base of the nose and, finally, from the base of the nose to the tip of the chin, as shown in figure 1.

fig. 1

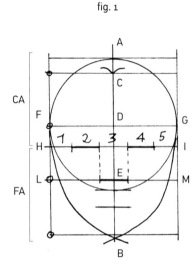

fig. 2

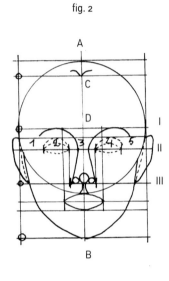

fig. 3

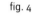

fig. 4

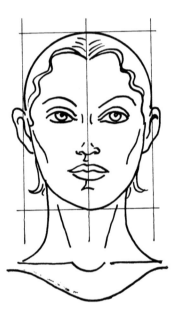

The oval (fig. 1)

1 Draw the vertical line AB and the hairline C.

2 Divide line CB into three equal parts to give points D and E.

3 Draw a circle with the radius DA, and construct the relative rectangle (fig. 1), which is to be divided into two equal parts with the straight line HI.

4 Construct the corresponding oval using a soft curve for the chin. This establishes the width of the temples HI, the cranium, and the face.

The eyes and nose

5 Divide the line HI into five equal segments to find the space between the temples and the eyes, including the gap between the eyes; extending segment 3 to line LM indicates the width of the nose and its length.

The mouth

6 The base of the initial circle denotes the position of the upper lip. To find the lower lip, divide the last section of the rectangle into two equal parts by drawing a small horizontal line to indicate the base of the mouth.

Structure (fig. 2)

7 In the corresponding areas, sketch in the ovals for the eyes, the trapezium for the nose with the alae nasi, the eyebrows and the ears.

8 To establish the width of the lips, extend two lines downwards from one third of the way into the eyes to the mouth line; the resulting area is then divided into two equal areas. As you can see, the jaw has been slightly narrowed at the height of the temples in fig. 2.

Details of the face and neck (fig. 3)

9 The facial features are finished off more realistically as shown in this drawing and highlighted with a curve.

10 The points where the neck meets the face are found by drawing a straight line across; from the base of the lips to the jaw line (NO).

11 A straight line BP is drawn downwards from the tip of the chin (point B); this line is as long as a section of the rectangle, and establishes the pit of the neck and its cylindrical shape.

The complete head (fig. 4)

12 The final stage involves tracing the shape without all the construction lines, and defining the shape of the facial features, neck and hair.

fig. 5

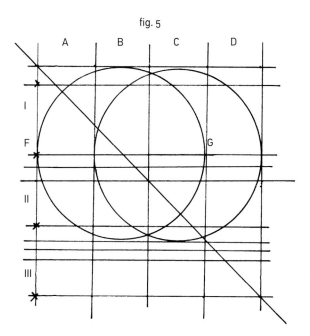

fig. 6

fig. 7

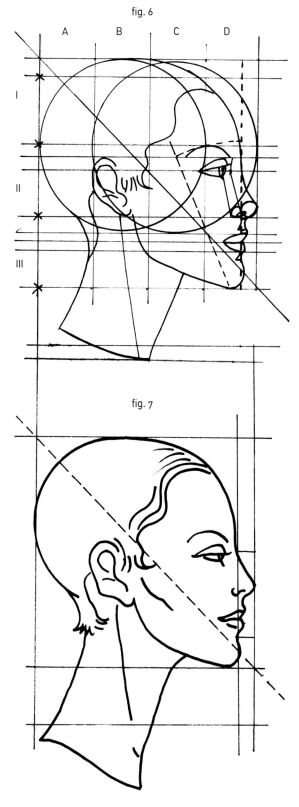

The head in profile (fig. 5)

1 Draw a circle with the diameter FG equal to that established for the cranium (fig. 1). Extend the diameter by one third and draw a second overlapping circle of the same size.

2 Draw a square tangent to the circumferences, the sides of which are equal to the length of both diameters, then divide it into four equal sections A, B, C and D.

3 Transfer all the construction measurements from fig. 3. This grid is the basis for drawing the profile, including the neck. Zone 1 head and forehead, zone 2 nape and nose, zone 3 neck and chin.

Structure and shape (fig. 6)

4 The female head is smaller than the male one. To draw the forehead, bring zone 1 about a third of the way further into section D.

5 In profile, the bridge of the nose lines up with the recess below the mouth. Highlight this line and draw the entire profile, making sure each part is the correct height.

6 The jaw ends a third of the way into section B, and the ear is drawn at an angle behind it.

7 Draw the cylinder shape of the neck at an angle, and fit it into the nape (section A) and under the chin (section C).

Complete profile (fig. 7)

8 Trace the head without the construction lines and define the shape of the profile and hair.

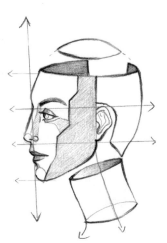
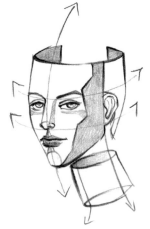
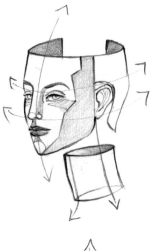
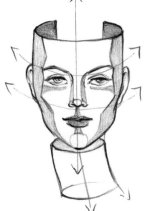
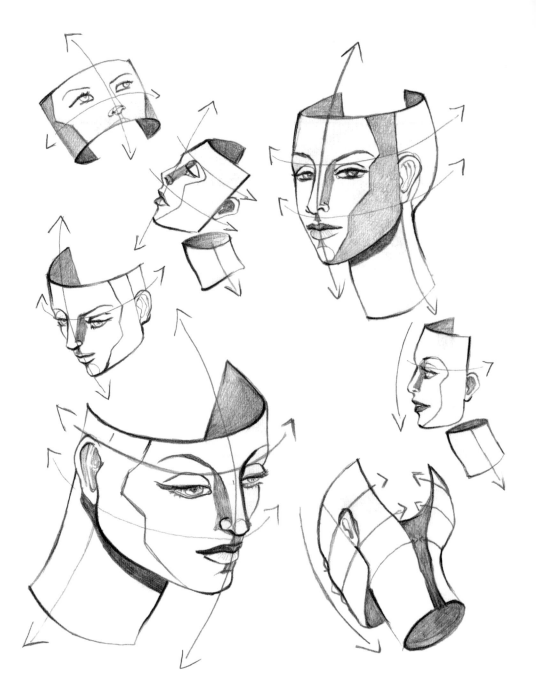

Rotation and drawing in sections

These drawings show the head as if it were a round mask, to highlight its inner volume. You should try and get used to considering the figure as something with volume to avoid drawing flat, lifeless images. Construction lines and slight shading show the dimensions of the structure more clearly. The various angles accentuate the cylindrical shape and the angle of the neck under the chin.

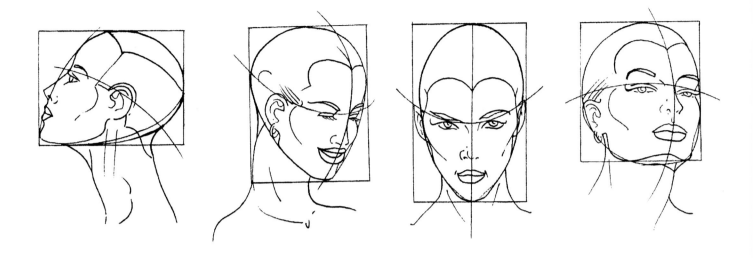

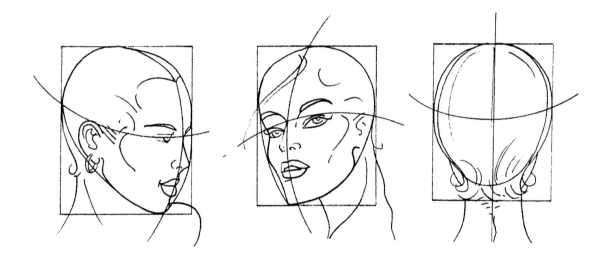

Foreshortened views

A foreshortened view is the angled drawing of a shape, or part of
it, which shows depth. Each time the head rotates, the shapes and
proportions are newly defined.

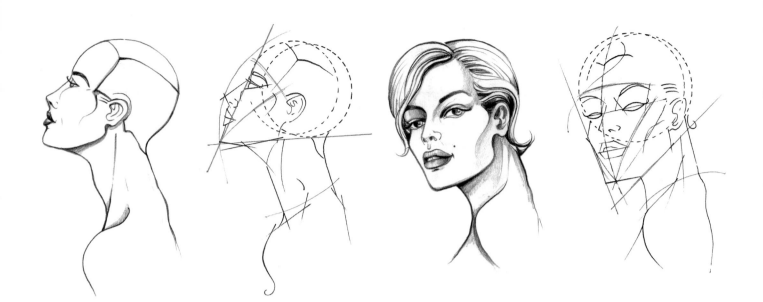

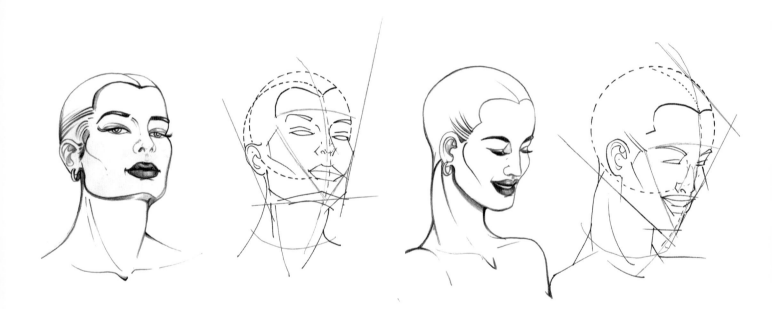

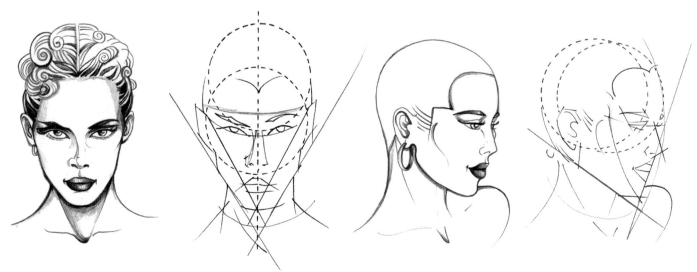

Faces from different angles with construction lines.

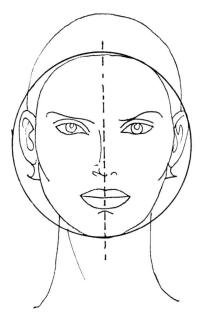

round face

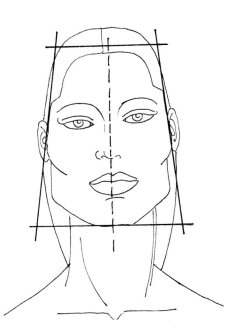

trapezoidal face

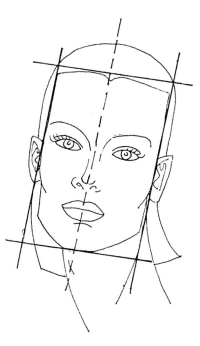

rectangular face

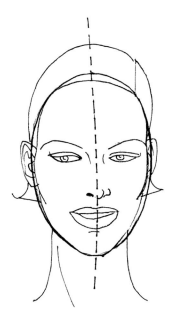

oval face

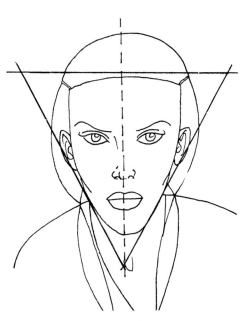

triangular face

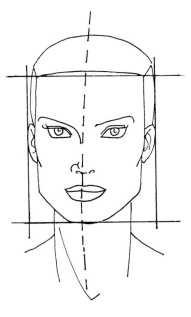

square face

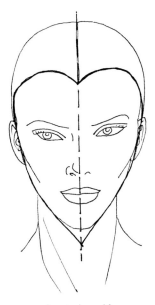

heart-shaped face

Different types of faces

The shape of the face varies from person to person. These drawings illustrate the most common characteristics among women, divided into seven main facial types. The basic structures are highlighted geometrically here.

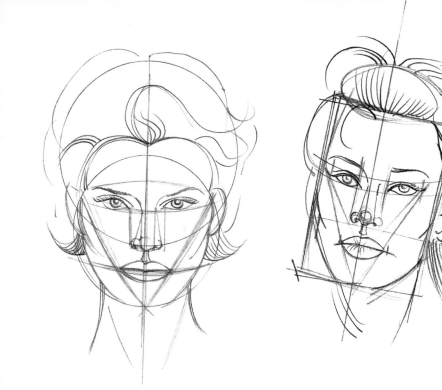
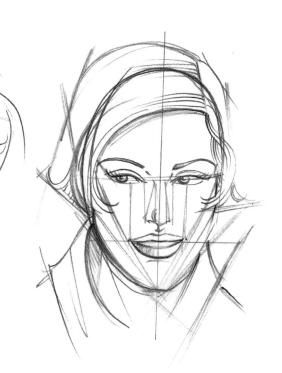
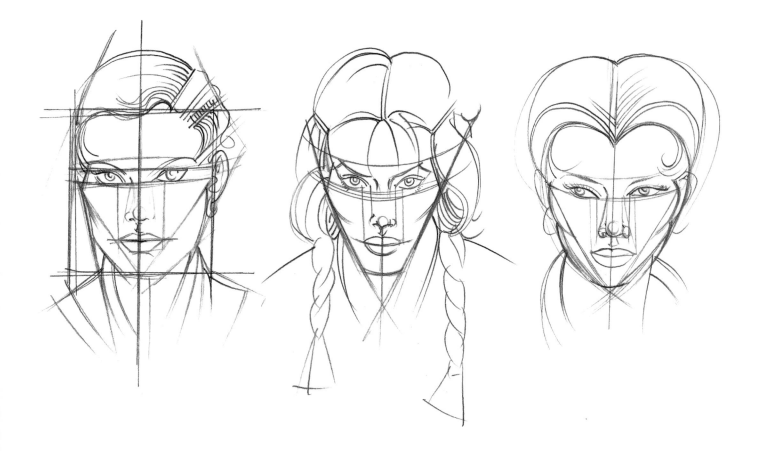

Different types of faces with construction lines.

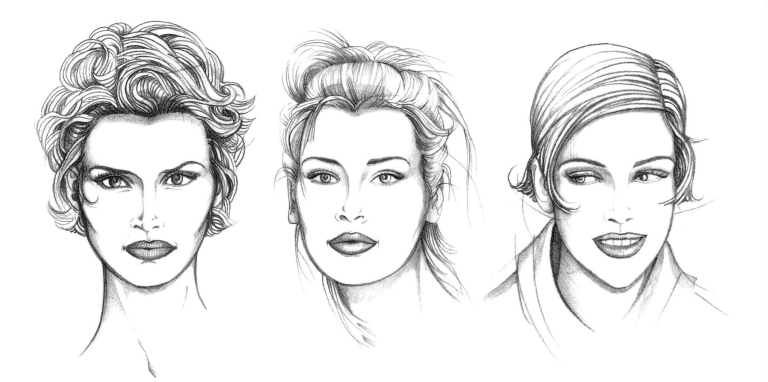

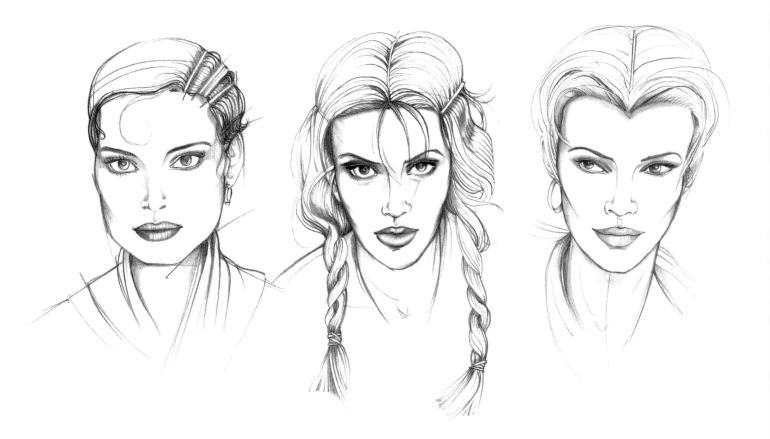

Three-dimensional drawings with complex shading.

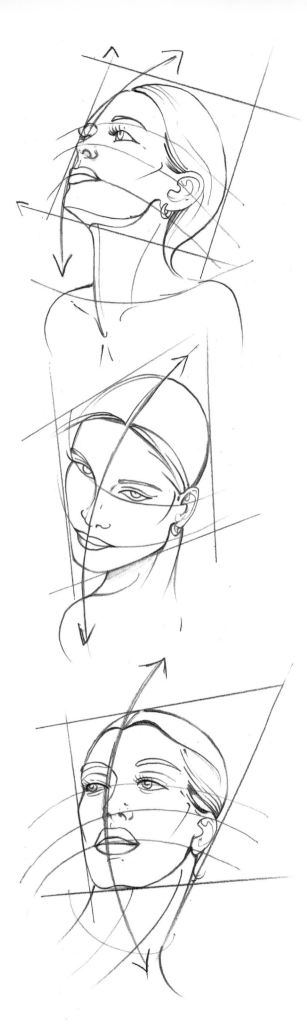
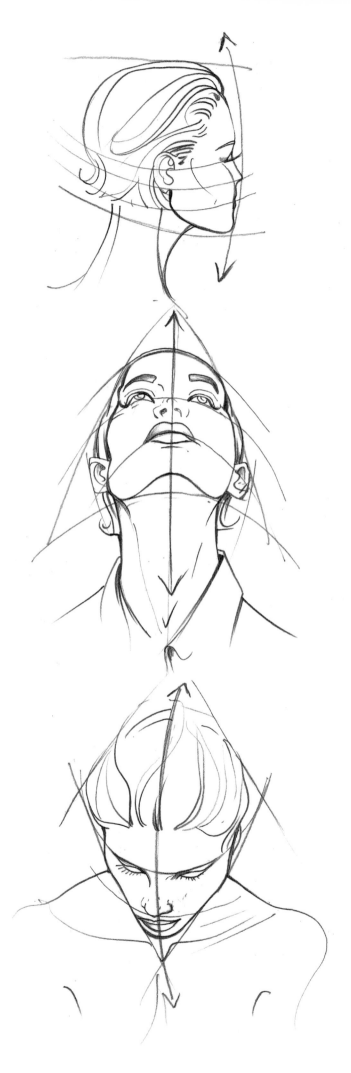

Dynamic views of faces with construction lines.

Faces and hairstyles

A woman's hairstyle is a very important part of her appearance. The right hairstyle can completely transform a person's face and even convey their character, style and social class, long before the facial expression. Fashion designers surround themselves with the best hairstylists, beauticians and make-up artists, and if a catwalk show makes the front page, it's often thanks to the creativity of these back room workers. In real life, most girls and women like applying make-up, and having their hair cut and styled in the latest fashion. In the same way, fashion illustrators must take care of their "paper" models as though they were real, and style the hair according to the type of woman being drawn.

Drawing techniques

The drawings shown here give a brief but indicative overview of various hairstyles. Look carefully at the drawing techniques used. Try to reproduce them with a tactile line, using different grades of pencils, and 0.2 to 0.4 black felt-tip pens.

Accentuate the areas around the hairline and behind the ears with closer-set lines to highlight the mass of hair, then use a single line to outline the overall volume.

N.B. Where the hair is full or is tied up, the lines are drawn closer together; on the other hand, where there is no particular movement, a single line can be used, which should be thicker in a shaded area and finer in the light.

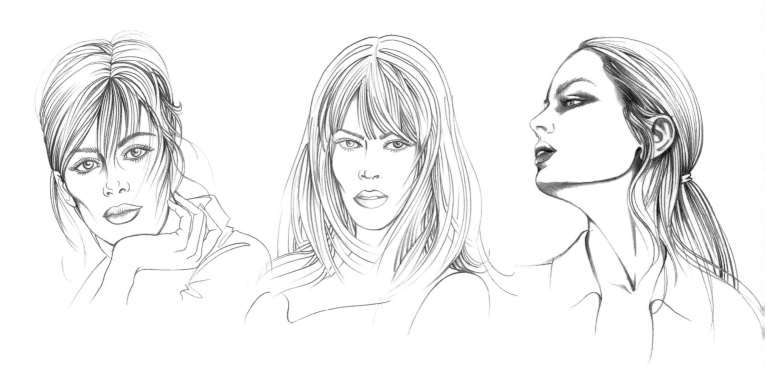

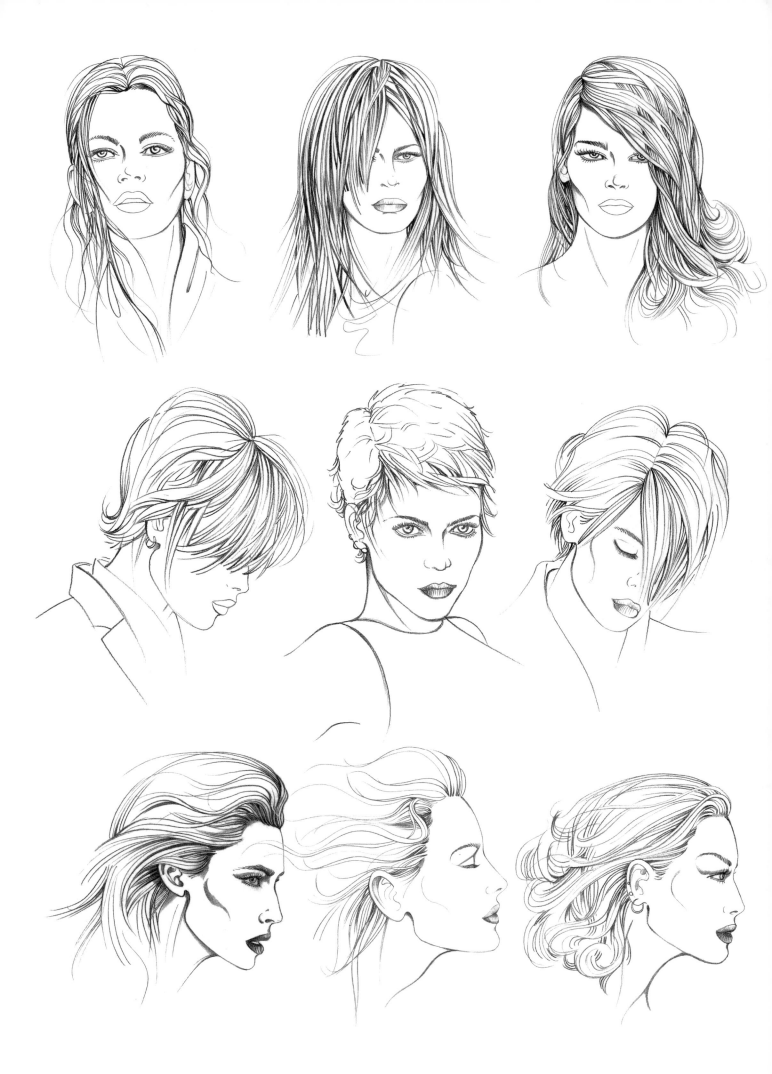

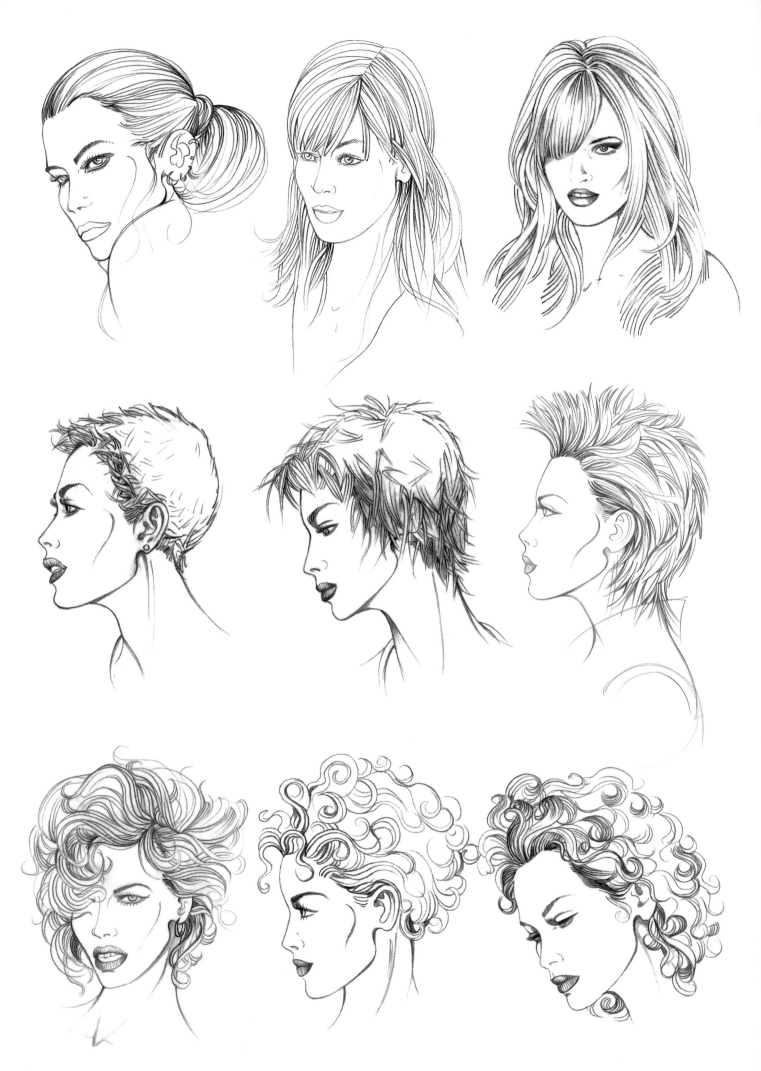

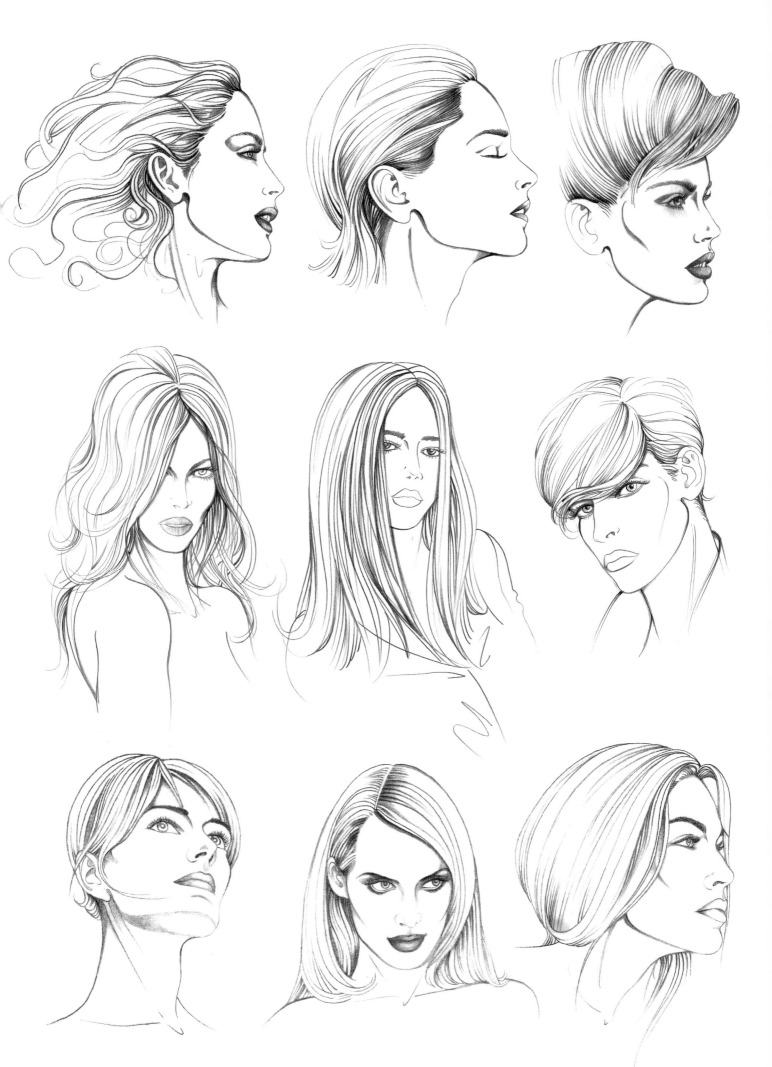

Variations in hairstyles on the same face

In this section, the same face is shown with twelve different hairstyles. As you can see, the face takes on different characteristics, depending on which hairstyle is drawn. It may appear younger, more classic, more glamorous or more ordinary. This means that it may not always be necessary to change the face of a model; simply altering the hairstyle may be enough to interpret a trend, fashion or style. Adding make-up and accessories will further enhance the required effect. After all, that's exactly what catwalk models do: a quick change of clothes, hairstyle and accessories, and they come out with a whole new look.

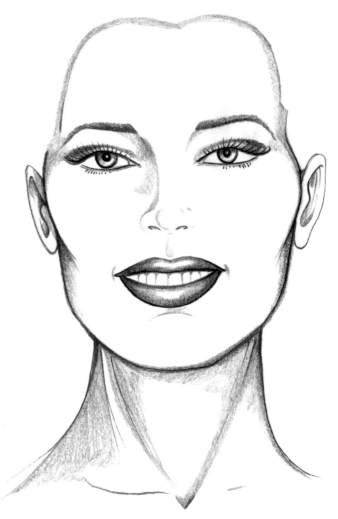

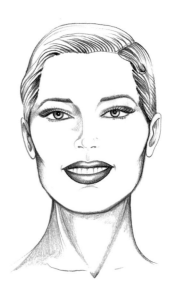

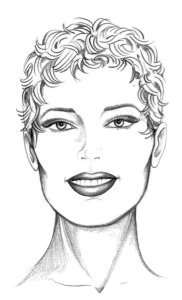
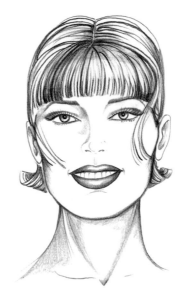
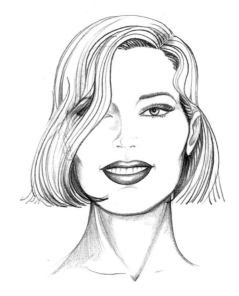
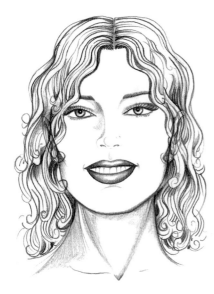
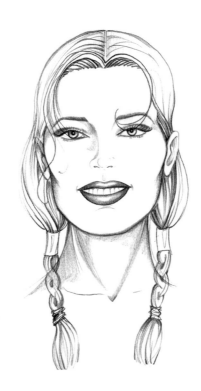
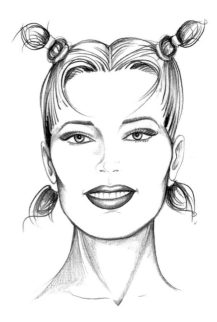
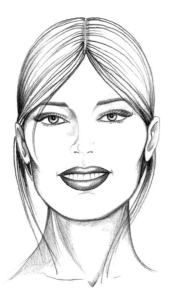
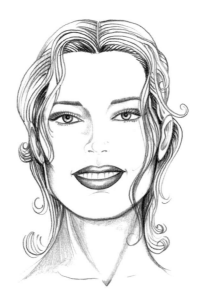
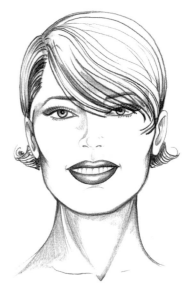

Light and shade close-ups of hats

We wanted to include these images because we realised that drawing a figure or a close-up with a hat is often problematic, mostly because students often lack practice or simply due to a belief that they are difficult to draw. They definitely aren't the easiest garment to draw, but they can be mastered with a little practice.

Start by copying some of these faces, and then move on to black and white photographs. They were roughly sketched with a 2H pencil, then drawn over with a slightly wider lead (2B pencil), and finally shaded with 2B, 3B and 4B pencils. To begin adding shade, we recommend starting with the lighter tones and gradually working up to the darker shaded areas.

These are not totally precise shading techniques but they are appropriate for fashion illustration, which must always be light and fresh. Just enough shading is applied to show the depth.

If you want to ensure that you will produce the right shape, make certain that your pencil strokes follow the anatomical movement of the hat. In other words, adapt gradually to the volume of the hat by crosshatching, to darken the parts with greater depth. If the hat contains a hollow, the strokes must be concave; whereas if it is convex or flat, the strokes must do likewise. The more realistic the light and shade, the more graceful, three-dimensional and beautiful your drawing will be.

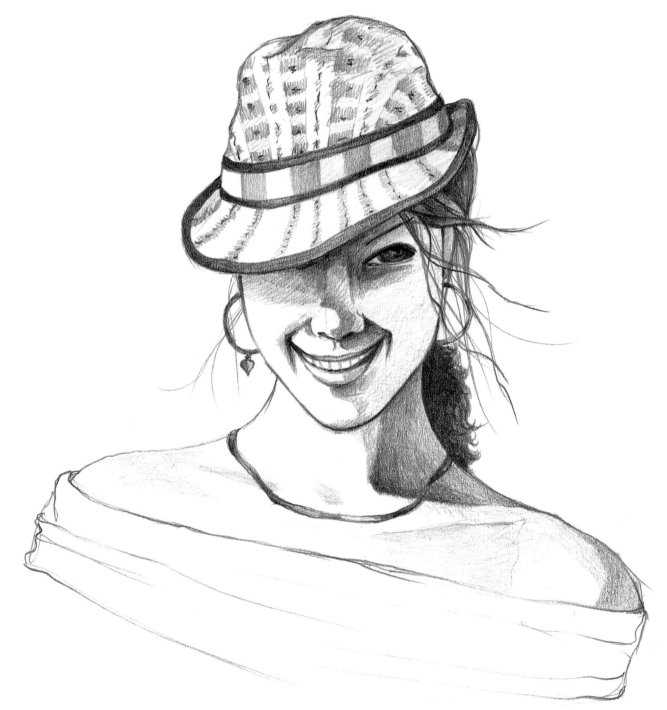

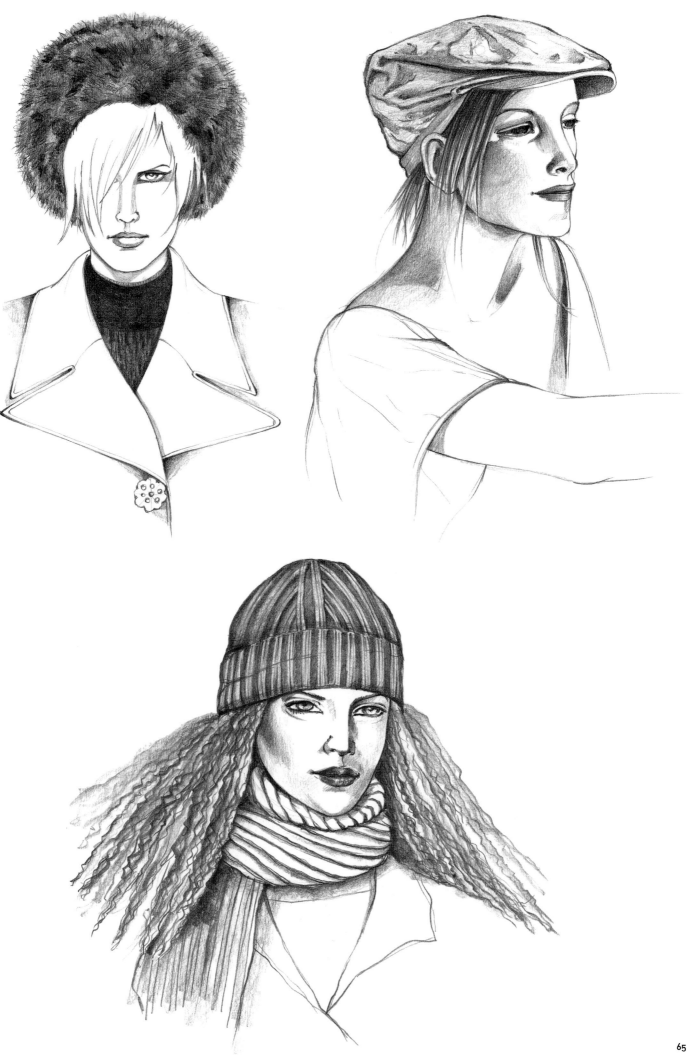

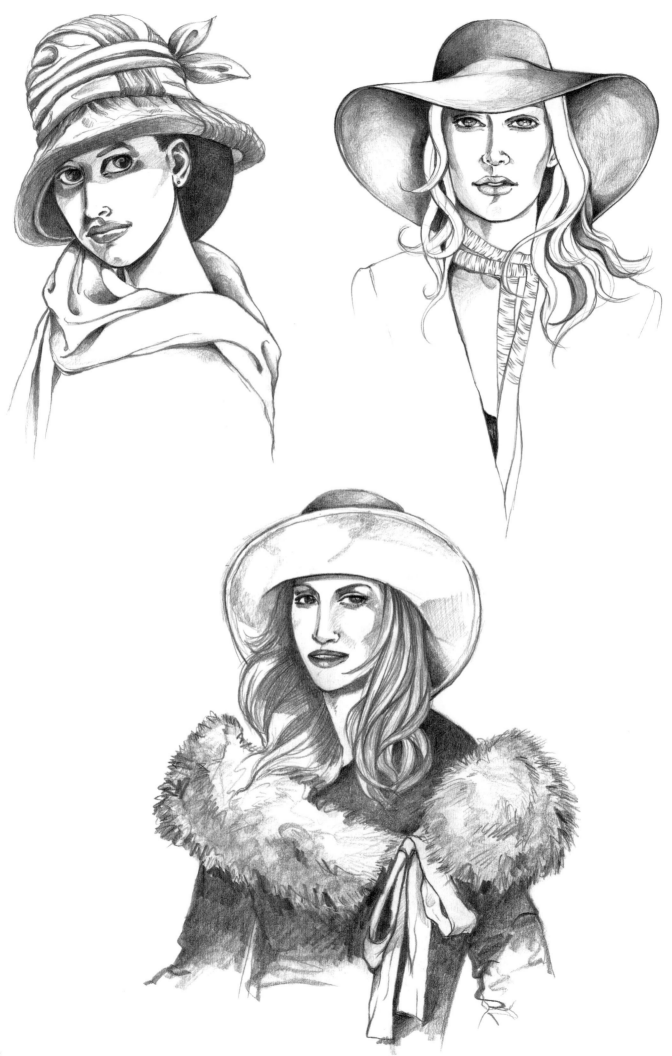

The hand
Analysis and structure

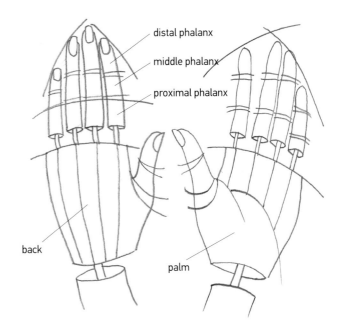

Along with the head, the hand is one of the most important and difficult parts of the human body to draw correctly.

Students have to spend many hours drawing them from life and from memory, so that the hand's many movements, joints, proportions and various angles can be reproduced accurately.

A well-drawn hand makes the figure more graceful and feminine. If drawn badly, however, the harmony of the whole drawing will be affected.

Proportionately speaking, the hand is as long as the face. Its main parts are: back, palm and fingers.

The fingers are made up of the thumb, (thicker and shorter than the other fingers and made up of two phalanges), the index finger, the middle finger (the longest), the ring finger and the little finger, which is almost as short as the thumb.

The last four fingers have three phalanges, namely: proximal phalanx, middle phalanx and distal phalanx.

Each finger is of different lengths. The various joints and movements make the hand into a prehensile tool. Its particular form, structure and expressiveness also helps to communicate the person's character and sensitivity.

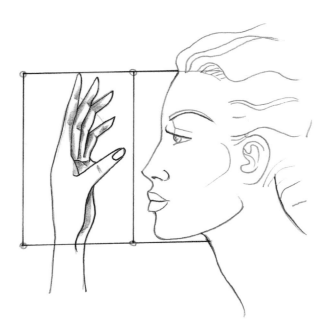

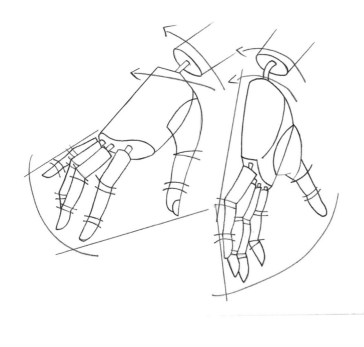

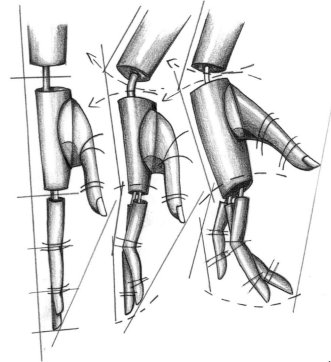

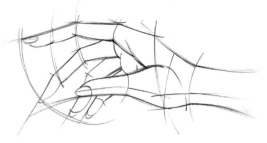

Sequence of construction

It is very difficult for student illustrators to reproduce this part of the body correctly.

To better understand the dimensions, the drawings on the left show a sequence of construction. In the top drawing, the volume of the hand is enclosed within a geometric shape, delimiting the external space. The joints inside the hand are joined together with lines. In the second, the anatomical shape is reproduced by drawing a rough sketch that highlights the volume and the structure of the hand. From the third drawing down, the hand is fleshed out with a tactile line and a little light and shade.

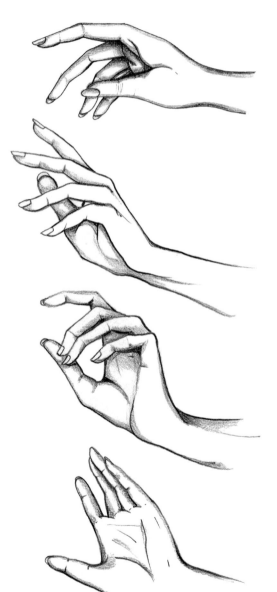

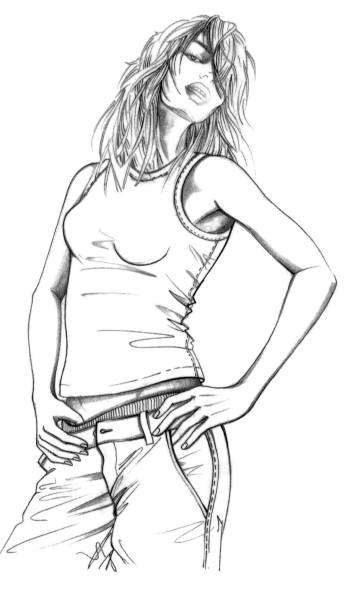

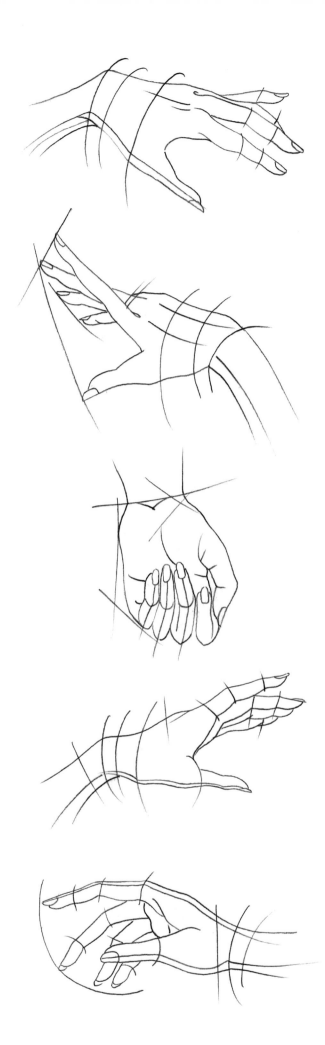
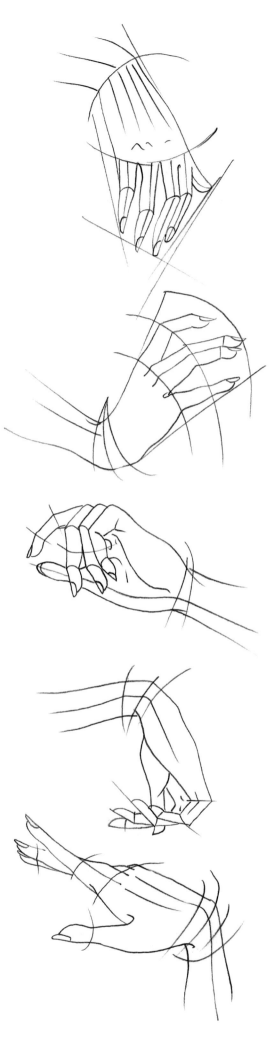

Examples of hands drawn at various angles showing segments and outer contours.

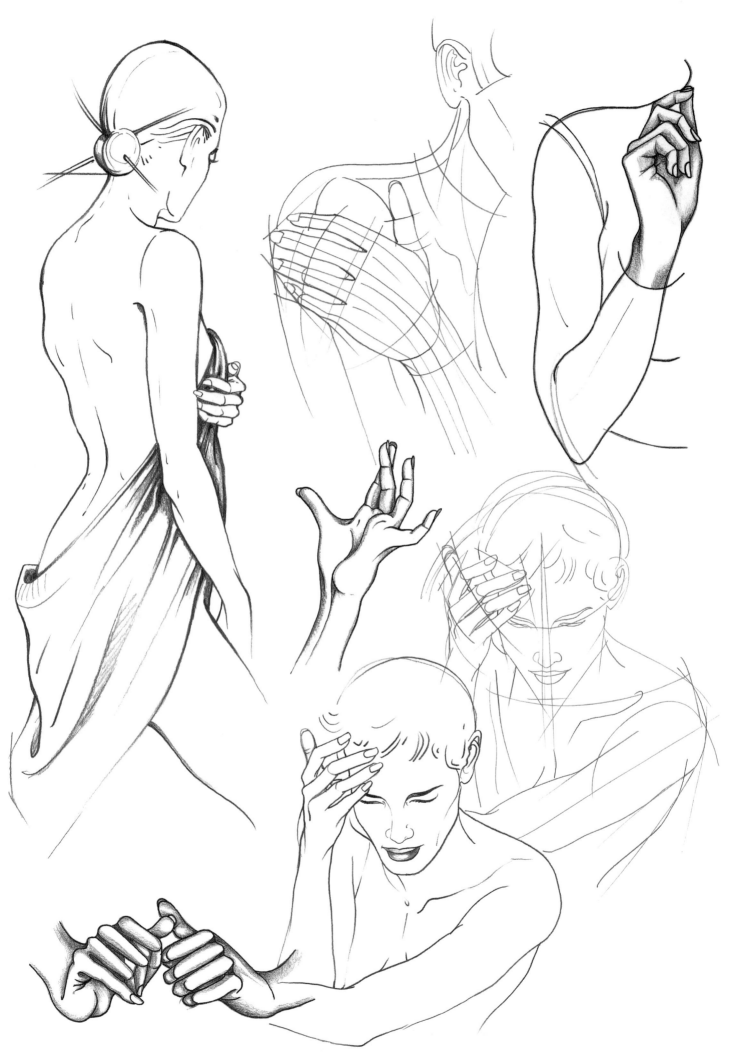

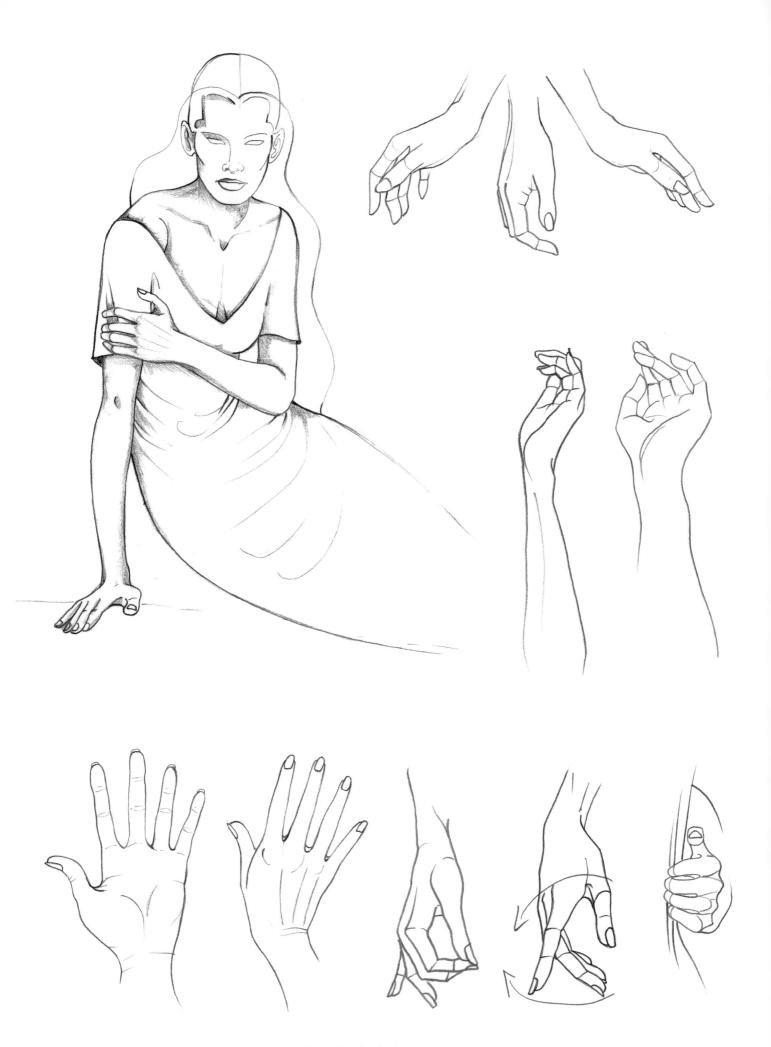

Line drawings of hands at various angles with a little light and shade added.

Hands carrying bags

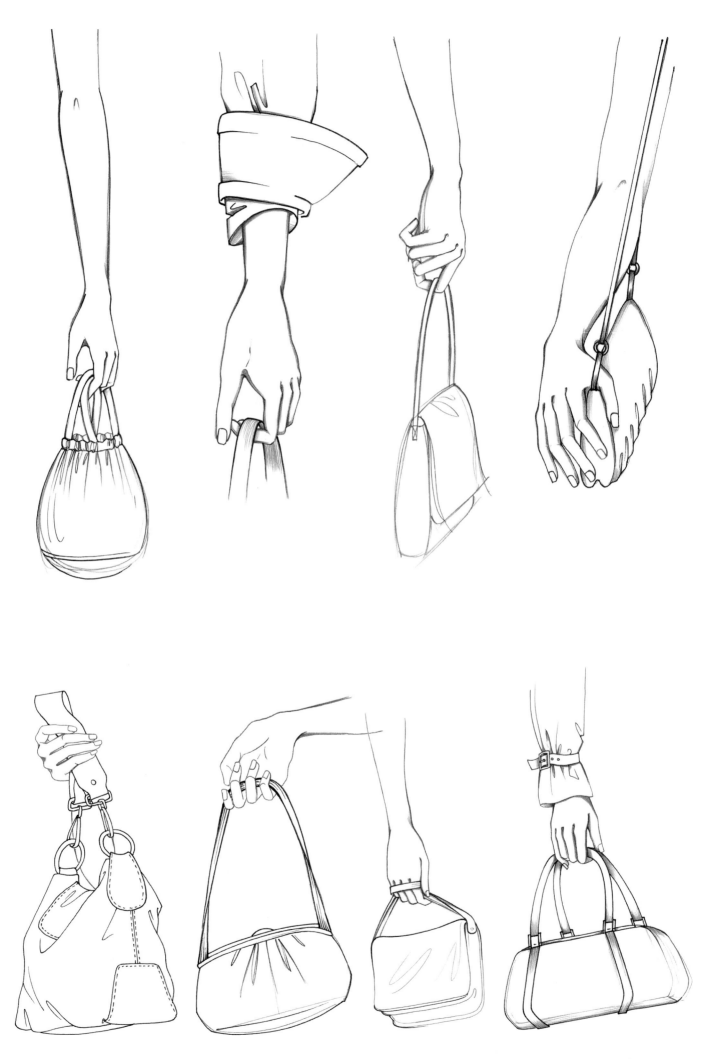

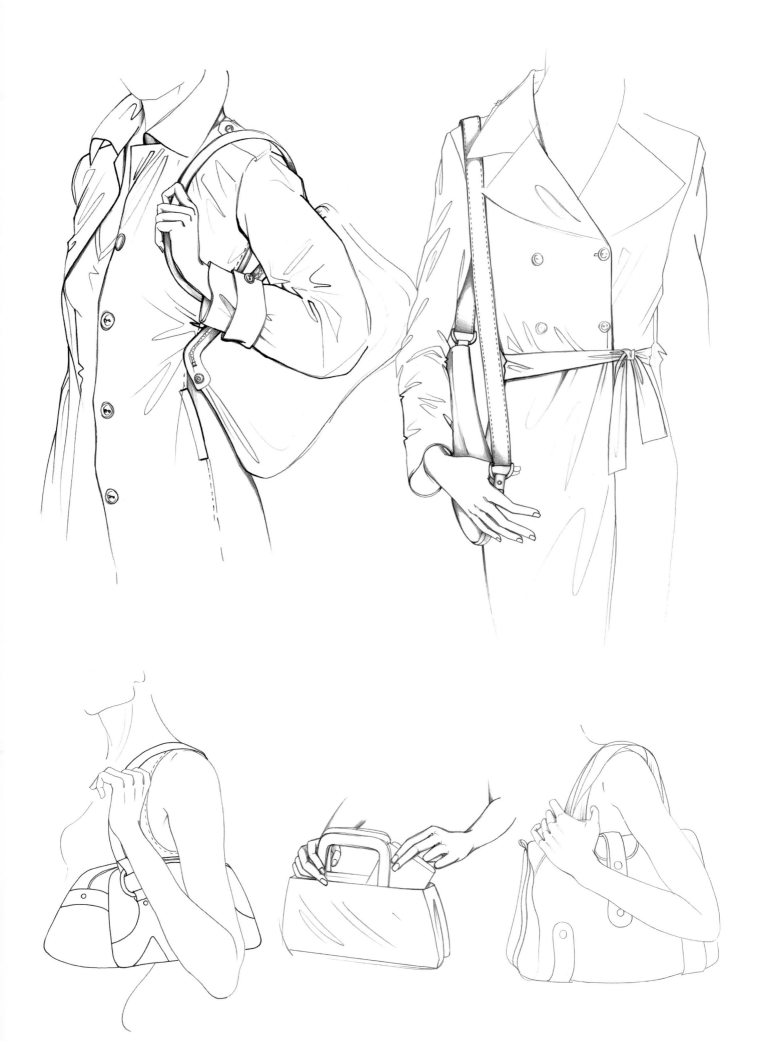

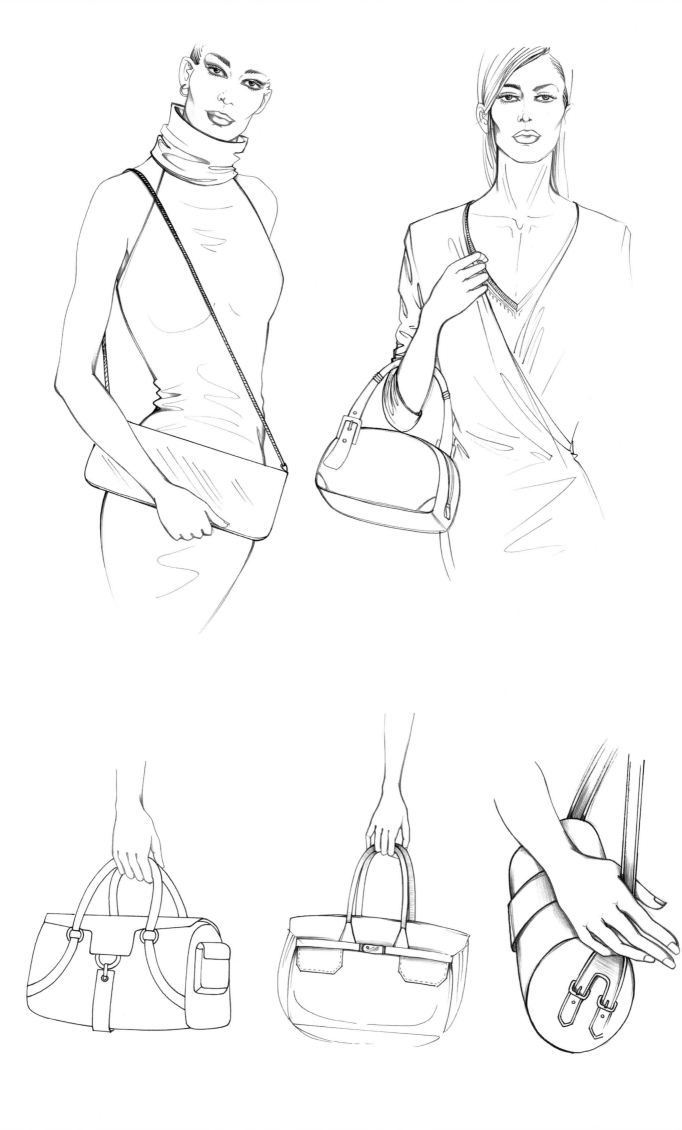

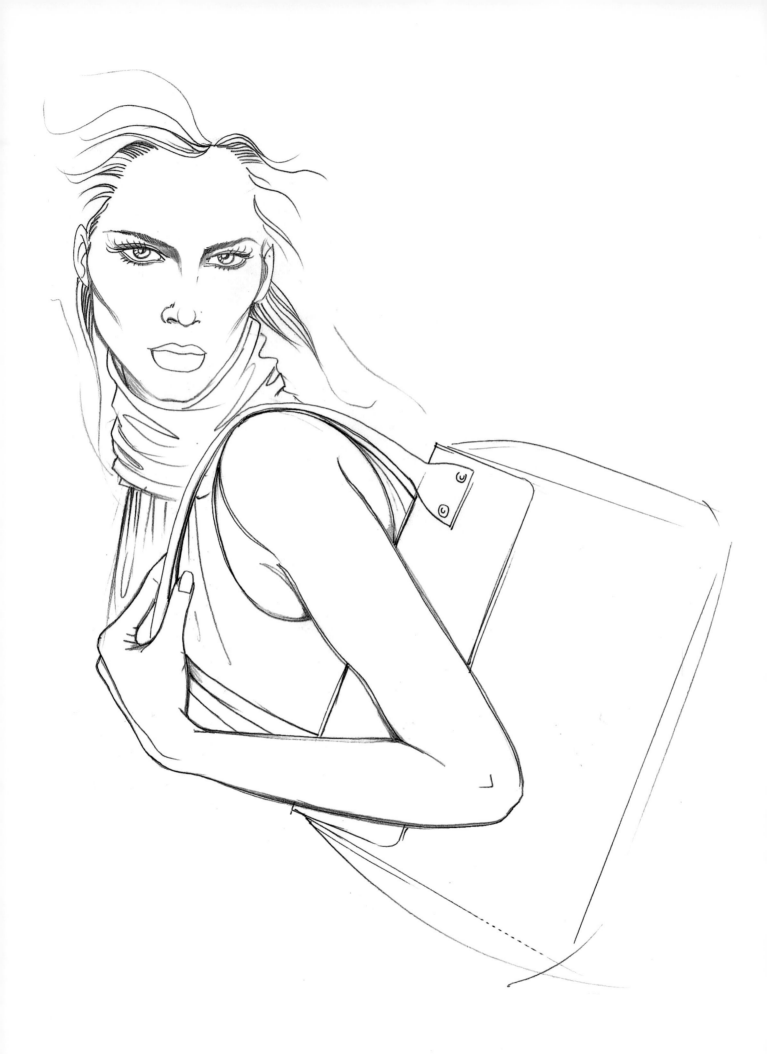

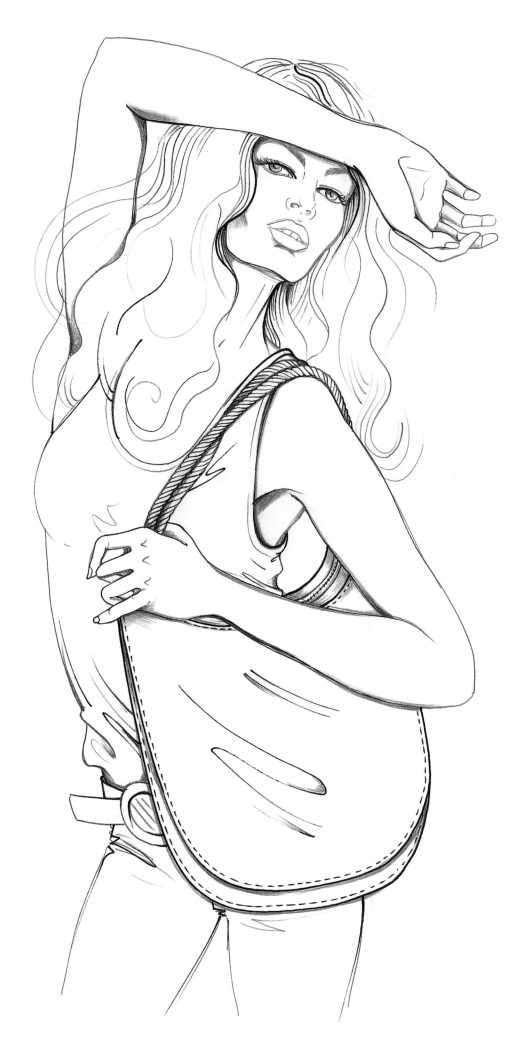

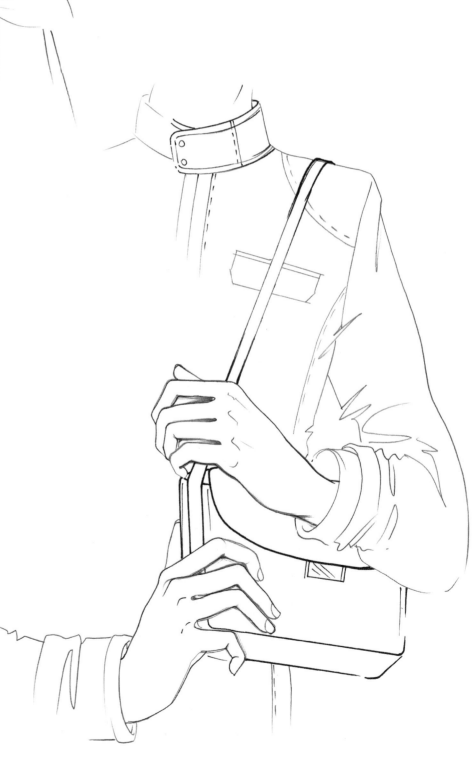

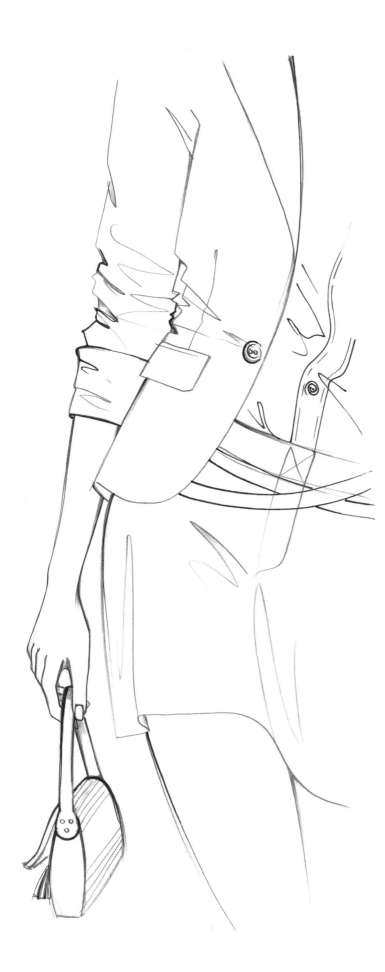
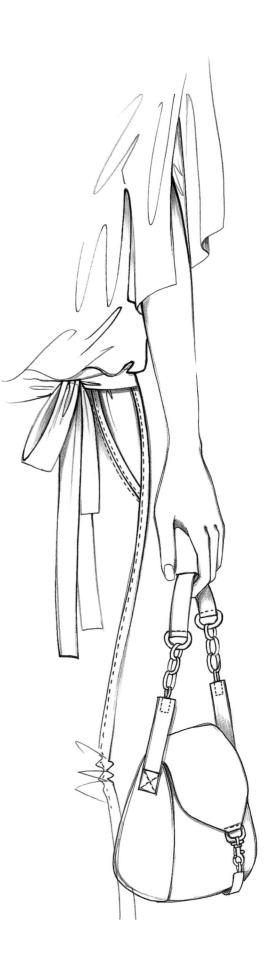

Hands in pockets

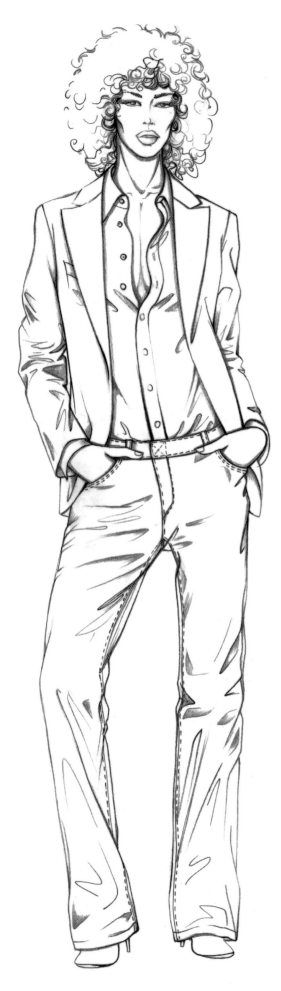

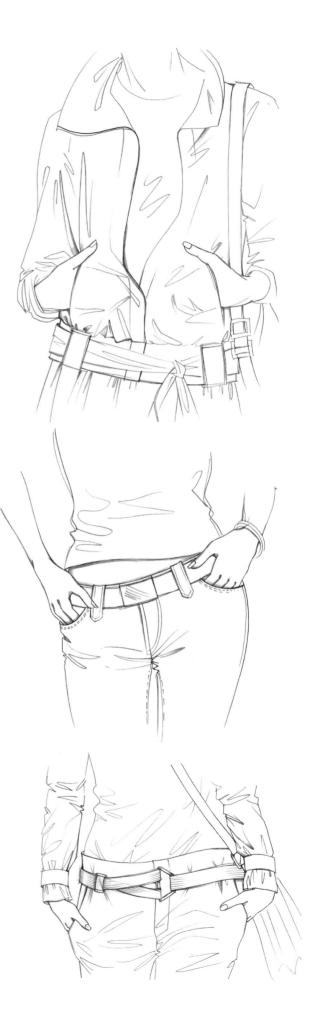

The arm
Analysis and structure

The arm is the upper limb of the body and is made up of four moving parts: shoulder, upper arm, forearm and hand.

Each part has a joint that allows great flexibility, mobility and rotation.

A rough sketch of an arm can be done by drawing two cylinders tapered at the base. The top of the forearm will be similar to an elongated truncated cone. The hand with the fingers extended is drawn as a diamond shape.

Three different-sized spheres indicate the shoulder, elbow and wrist joints.

The upper arm extends from the shoulder to the waist, the forearm from the waist to the groin, while the hand reaches about halfway down the thigh.

As with the rest of the body, the best way to understand the arm's shapes and joints is to study them on mannequins and in real life.

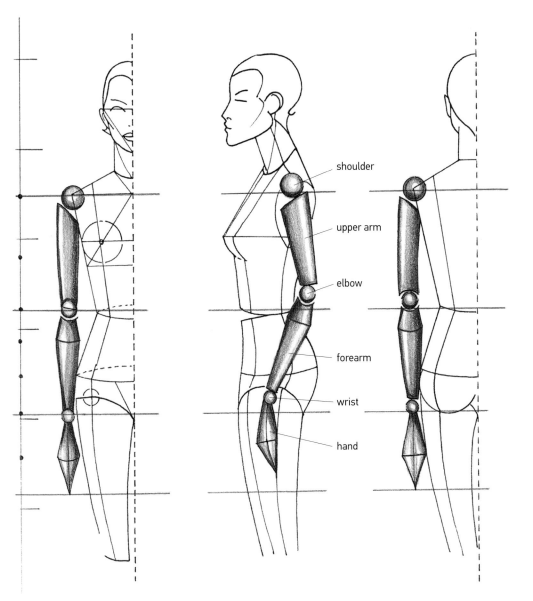

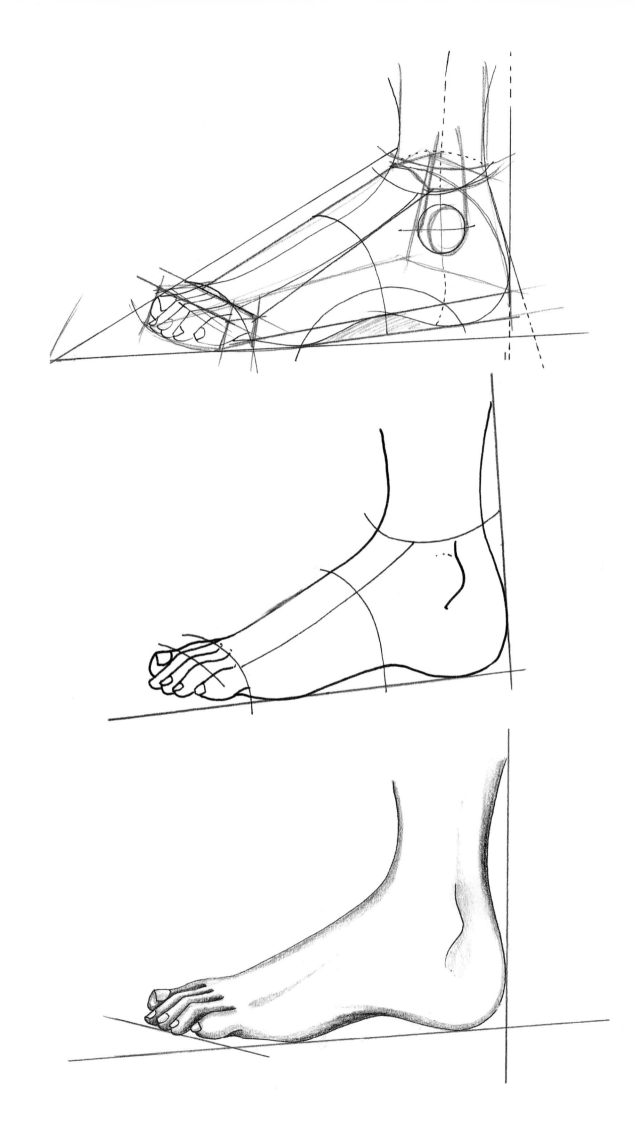

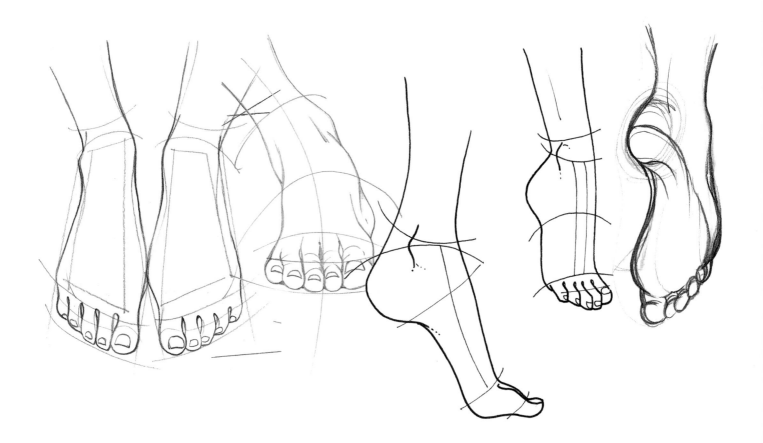

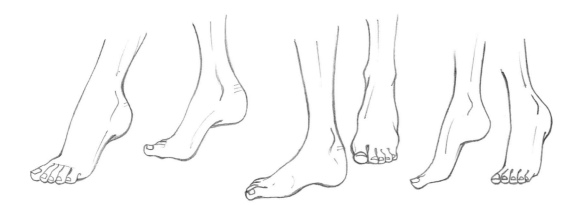

Sketches of feet drawn in angled views and with construction lines.

Line drawings of a rotating foot.

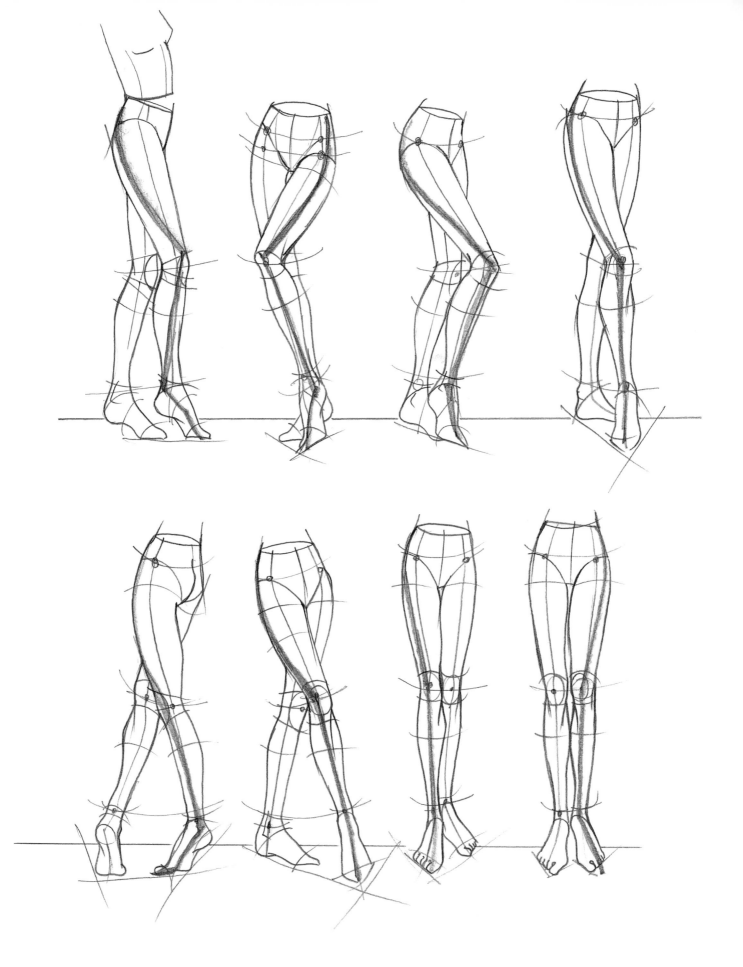

Legs drawn at various angles with structural flows, points of articulation and bending. Even perfectly straight legs have an elongated 'S' shape in profile, as the thigh protrudes forwards, while the knee and lower leg recede a little.

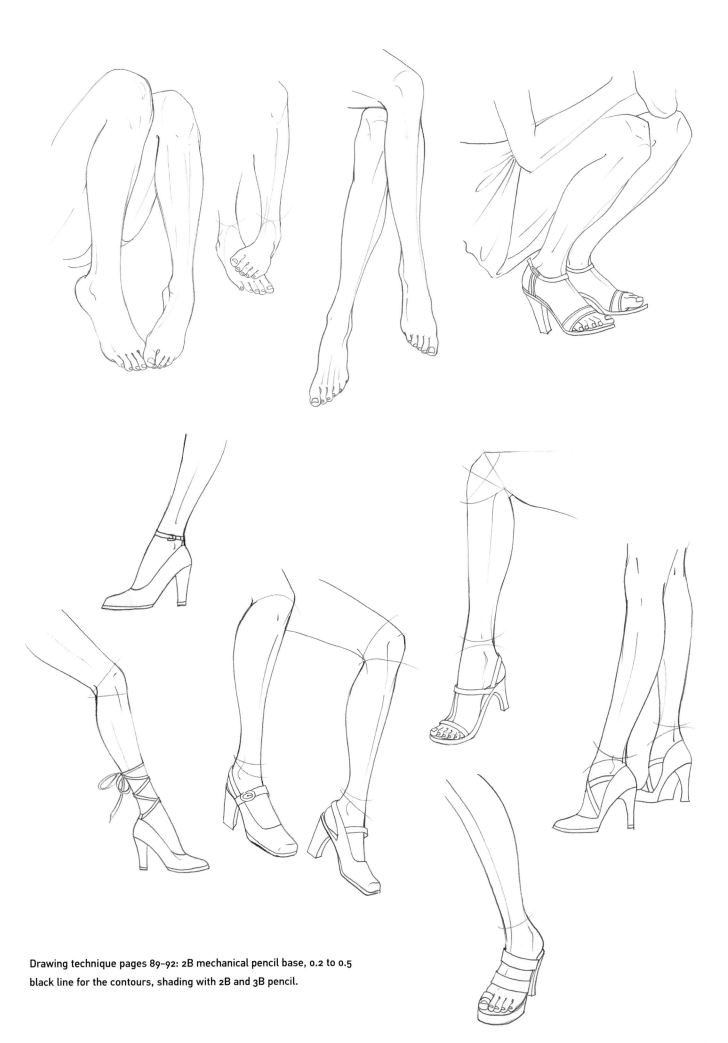

Drawing technique pages 89-92: 2B mechanical pencil base, 0.2 to 0.5 black line for the contours, shading with 2B and 3B pencil.

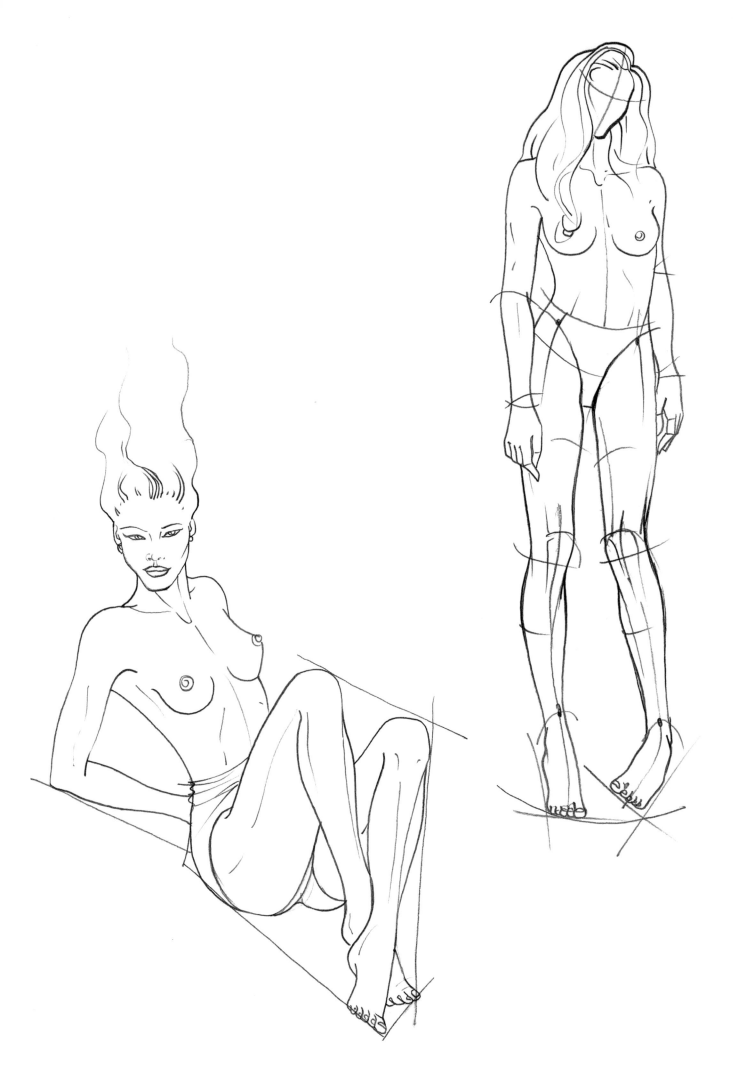

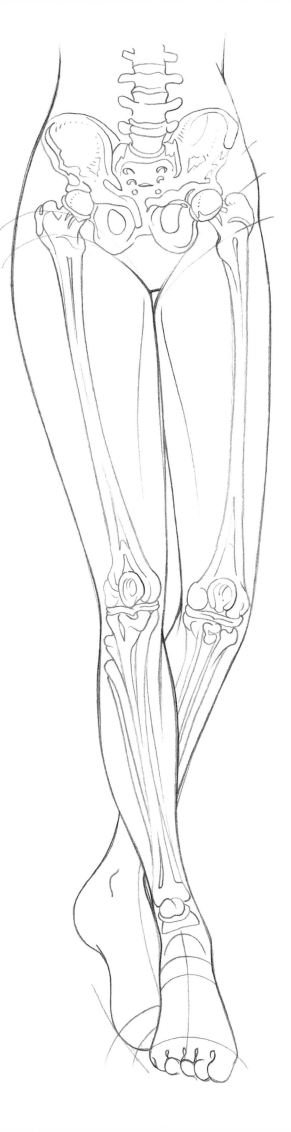

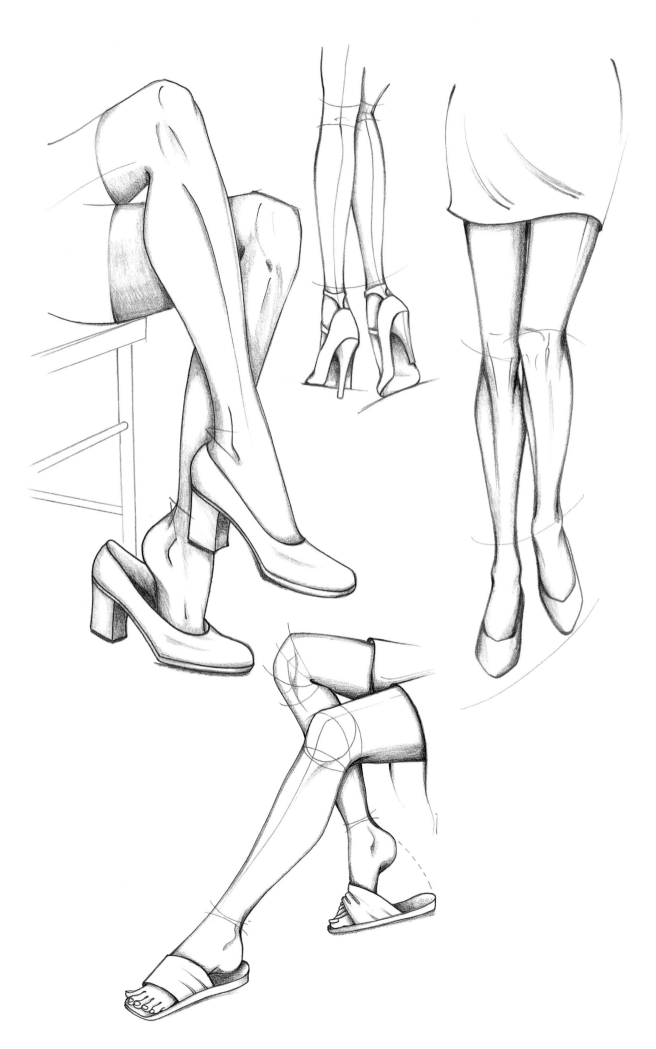

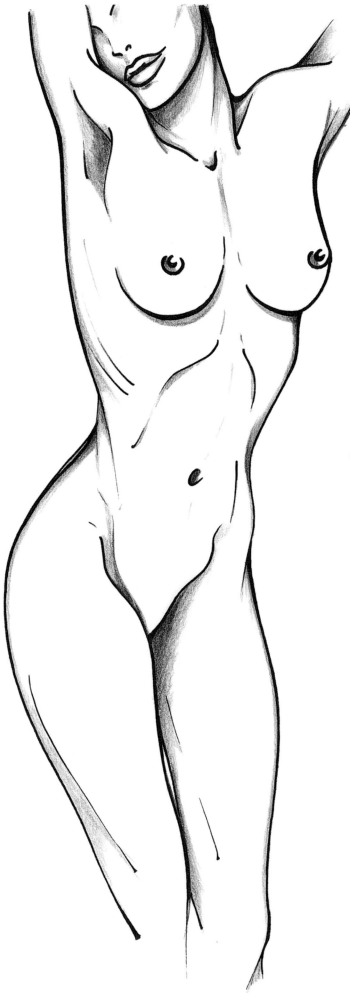

The upper body

From an aesthetic point of view, the upper body, or torso, is the most seductive part of the female body. Its sculptural shape makes it the focus of many close-up shots in magazines, and fashion designers, well aware of its appeal, like to enhance it with a range of tight-fitting and revealing outfits. The torso is the central part of the body. Knowing how to draw it accurately is a sign of great skill. Due to its particular harmony and structure, it can be dressed in an infinite variety of clothes.

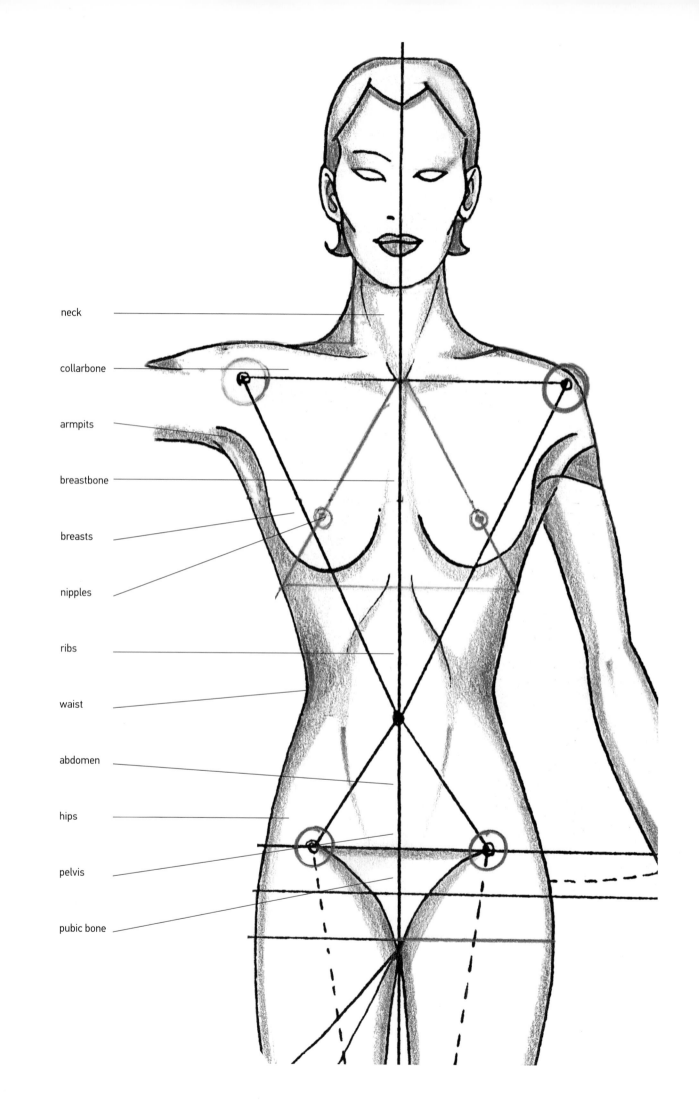

neck

collarbone

armpits

breastbone

breasts

nipples

ribs

waist

abdomen

hips

pelvis

pubic bone

chest area

pelvic area

Analysis and structure

Proportionally speaking, the upper body extends over two and a half units of the entire female figure, and is made up of two moving parts of different sizes; the chest area (or thorax) and the pelvic area. These anatomical features also constitute the main difference between the female body, which is rounder and more flexible, and the male body which is more muscular. The front view shows the following parts from top to bottom: the neck, which meets the upper body behind the collarbone; the shoulders, narrower than those of the male and as wide as the hips; the collarbones, which meet in the pit of the neck.

Then we have the chest, or thorax, which is the single largest structure in the body, made up of the ribs, the breastbone, the breasts and the armpits. To find the exact position for the nipples, draw two lines at 45° from the pit of the neck outwards across the ribcage. The shape of the breasts is similar to an upturned goblet. The upper body connects to the hips at the waist, which is much narrower and slightly higher than a man's waist. The pelvic area is made up of the abdomen with the navel slightly hollow, the hips and the pubic bone. The back view shows the shoulder blades, which follow the movement of the arms, and the spine, which supports the upper body and enables it to move in an infinite number of ways. The lower part of the upper body is made up of the pelvic wedge, which is tilted slightly backwards, the sacrum and the buttocks, the medium and large muscles of which create a butterfly shape, as seen below. In profile we can see the forward projection of the chest area, and the backward projection of the pelvic area.

Angled views

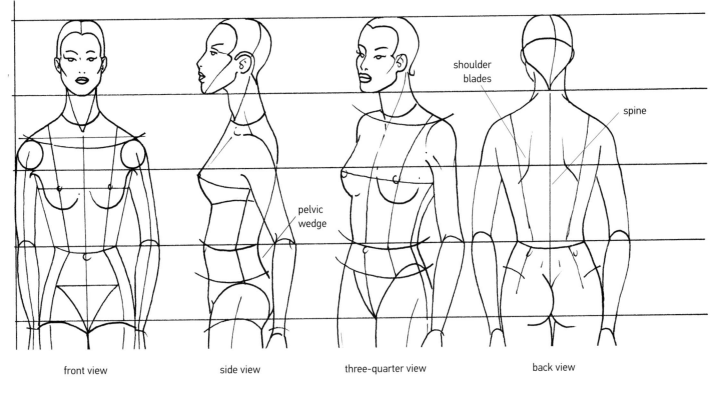

front view side view three-quarter view back view

Rough sketches of the upper body

The basic shape of the torso is made up of two moving structures, the chest area and the pelvic area. The chest area is drawn from the front and back using a trapezium shape (fig. 1, 4 and 5), whereas in side and foreshortened views, it will be rounder and almost barrel-shaped (fig. 2 and 3). The pelvic area is drawn from the front and back using a more compressed trapezium, the base of which is as wide as the shoulders (fig. 1, 4 and 5). In side and foreshortened views, the pelvis is more of a wedge-shaped box containing the buttocks (fig. 2 and 3). We have shaded in the hips and waist to draw attention to the dynamics of both areas (fig. 6 through 10).

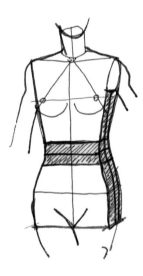
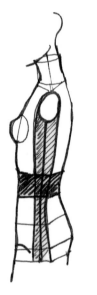
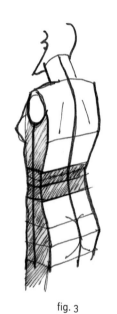

fig. 1 fig. 2 fig. 3 fig. 4 fig. 5

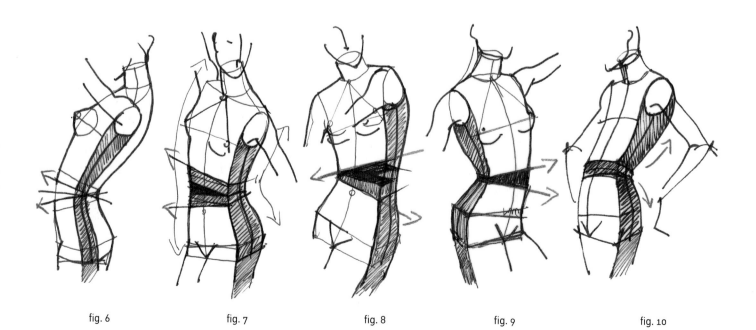

fig. 6 fig. 7 fig. 8 fig. 9 fig. 10

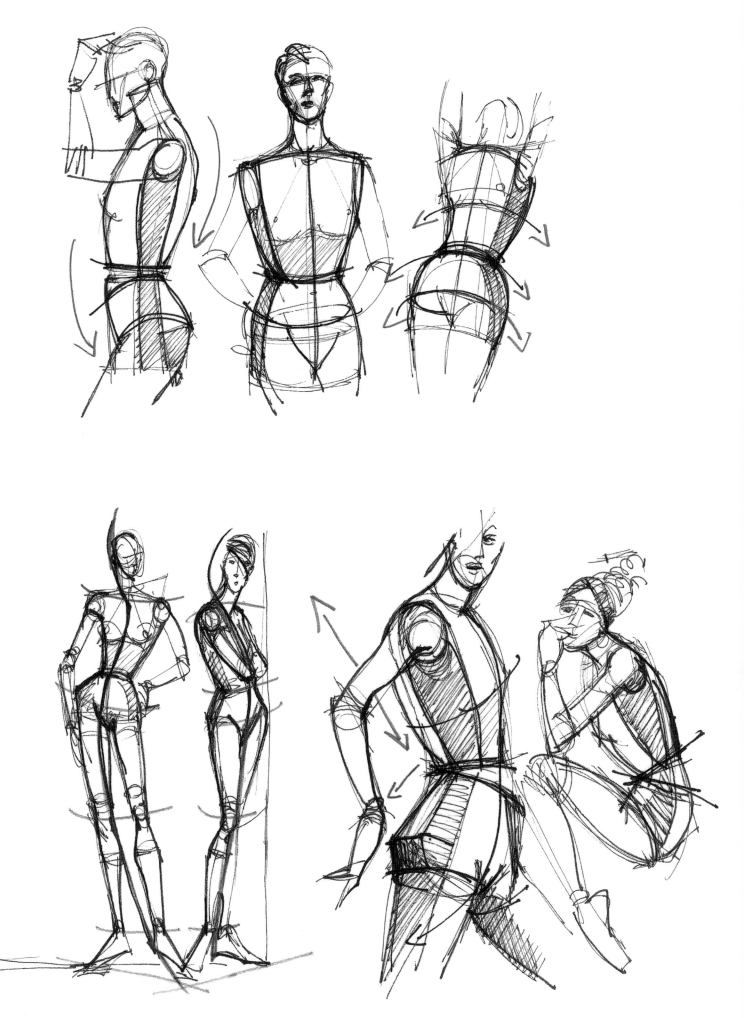

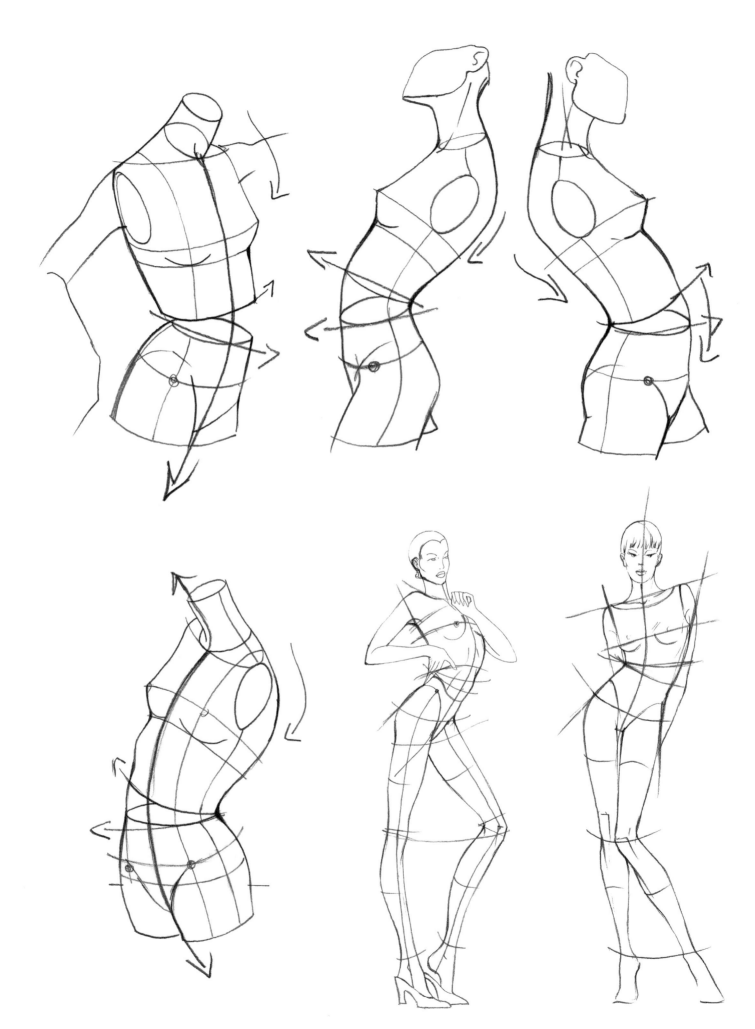

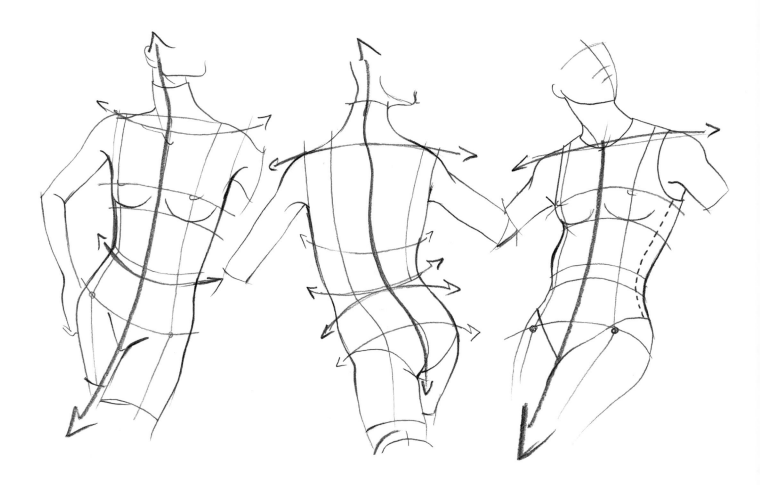

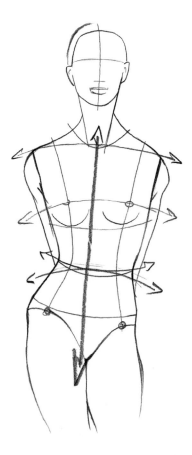
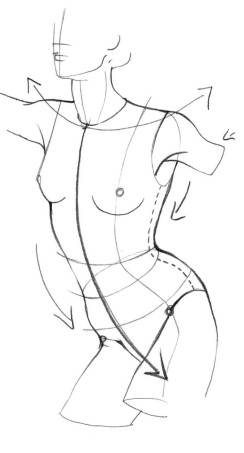
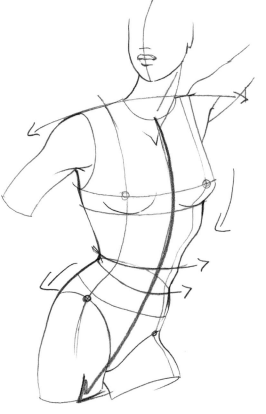

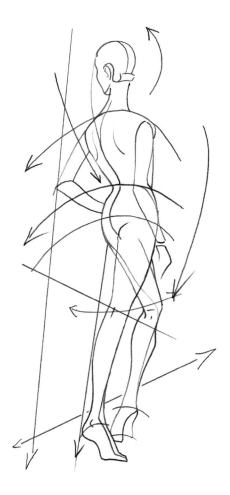

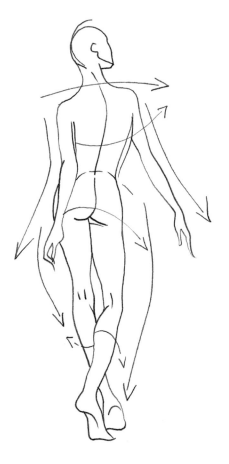

The full body
Keyline or structural flow

The 'keyline' or 'structural flow' is the main structure line. It is a very important line, as it establishes the pose assumed by the body, and changes as the body alters position. In a back pose, it corresponds to the spinal column. The keyline in a static, straight figure, corresponds to the height line. Visually, it is drawn as a line crossing the length of the entire body and bisecting the face, forehead, nose, mouth, chin, hollow of the neck, breastbone, navel, and pubic bone, and finally dropping to the ground.

N.B. The keyline always crosses these points, however the body is moving. The balance line, showing the centre of balance, drops straight down from the pit of the neck.

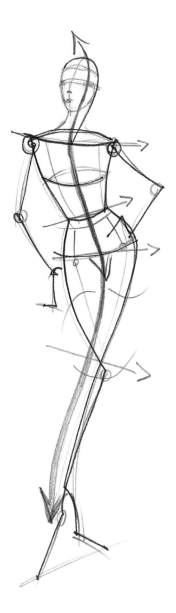

Rough sketch with keyline.

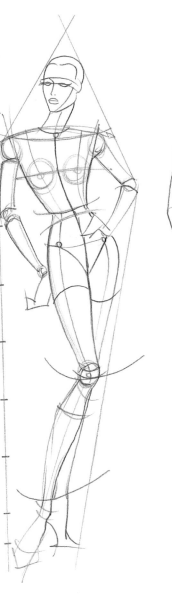

Geometrised sketch with basic areas of the body.

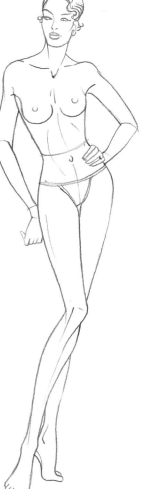

Female figure with realistic outlines. **Fashion figure.**

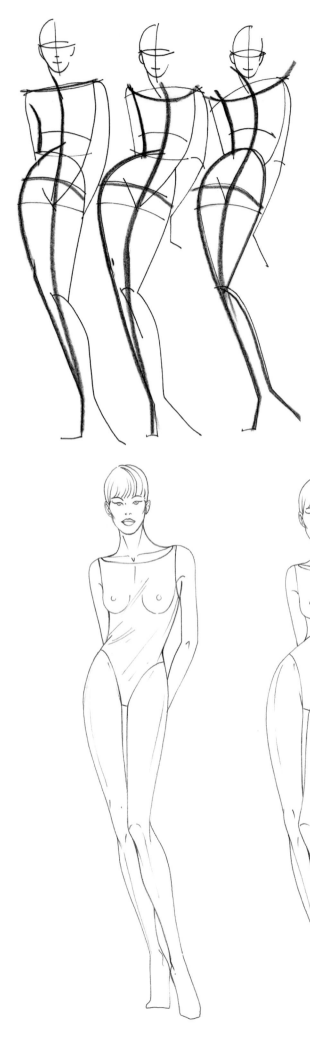

Dynamic series of movements

Starting from two rather static poses, we have added movement to the bust by twisting the spine. Notice how the back arches as the shoulders and pelvis bend back, and how the structural flow changes in the three drawings. To obtain striking poses, you will have to apply this rule of thrusts and counter-thrusts of the bust and pelvis, which will take a little practice.

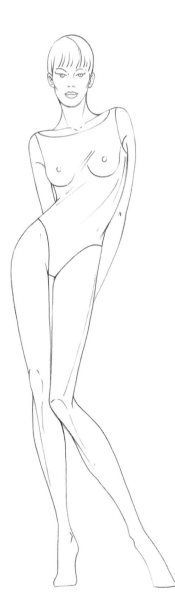

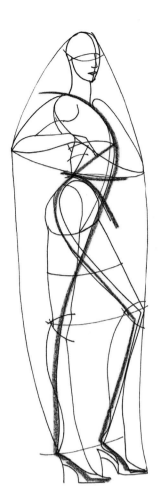
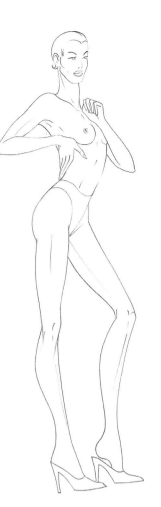
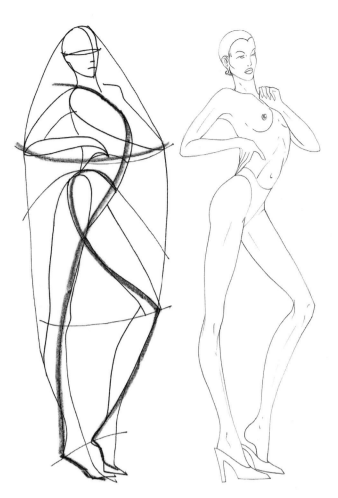
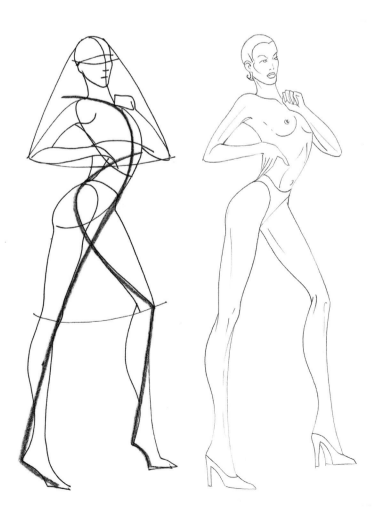

Outline drawings of the figure

The outline figure is a pared-down drawing of the human figure, showing the shoulders, waist, hips, bust and limbs, using horizontal and vertical strokes.

The drawings in this chapter and the next clearly analyse the body, starting from both the anatomical form and the outline drawing. They give clear and comprehensive examples that you should study carefully. Look at the drawings, think about them and reproduce them as precisely as you can.

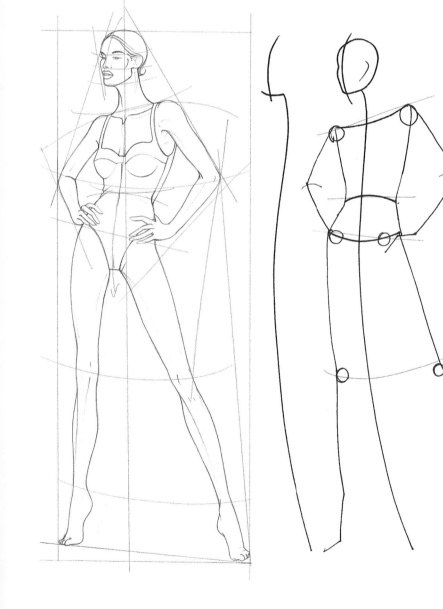

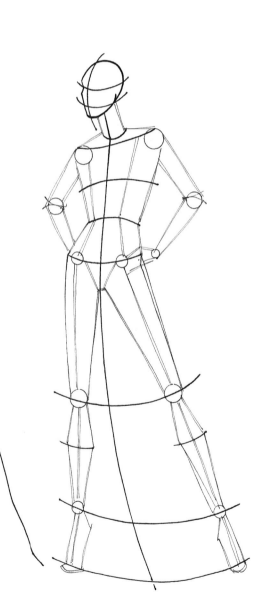

Basic figure to be reproduced.

Identification of the keyline or flow.

Schematic drawing of the main parts of the body.

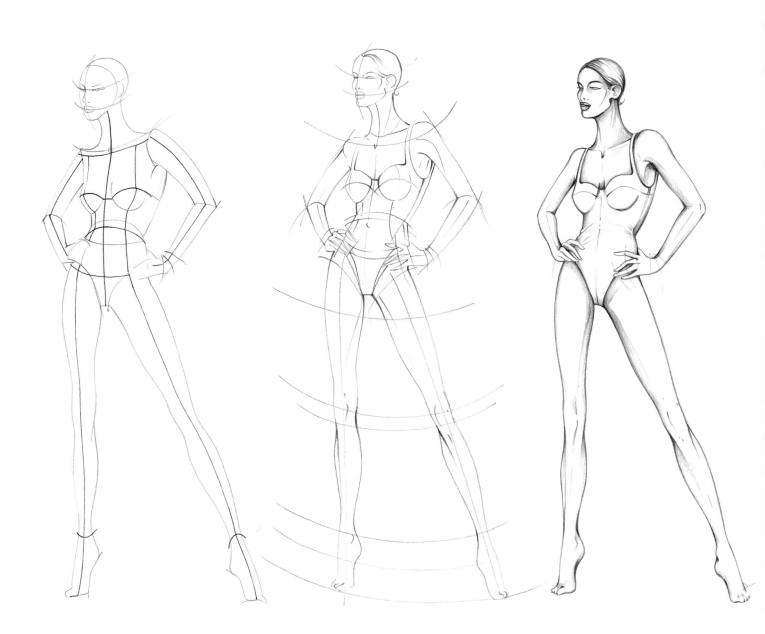

Rough outline sketch of the whole figure.

Detailed analysis of the various parts of the body.

Tracing of the figure from the previous outline.

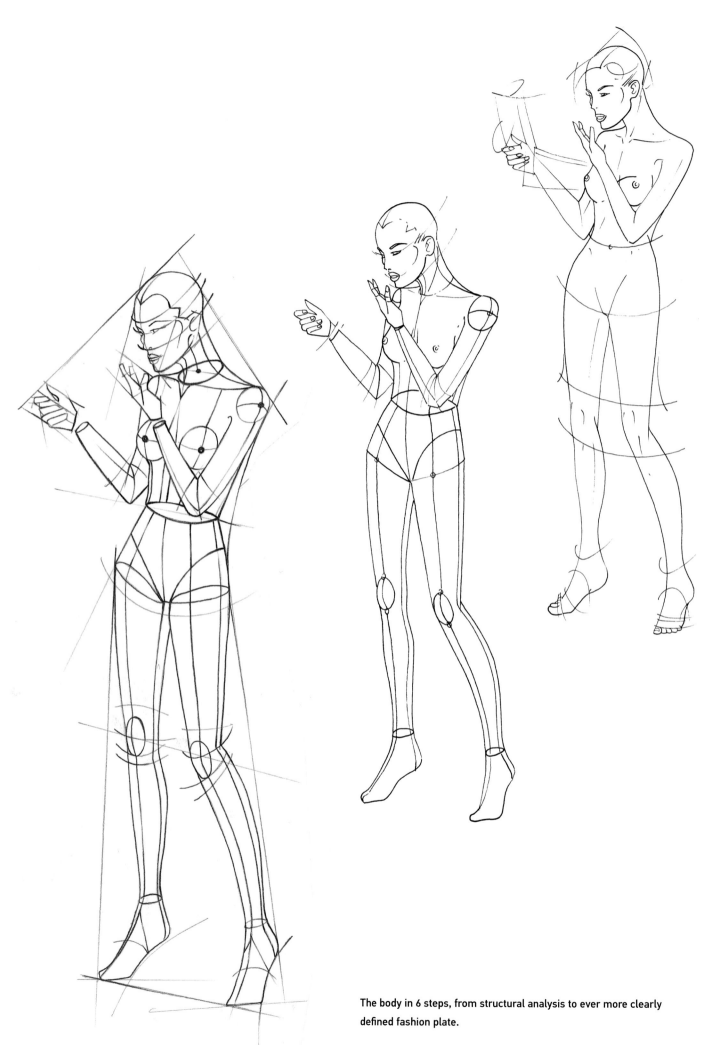

The body in 6 steps, from structural analysis to ever more clearly defined fashion plate.

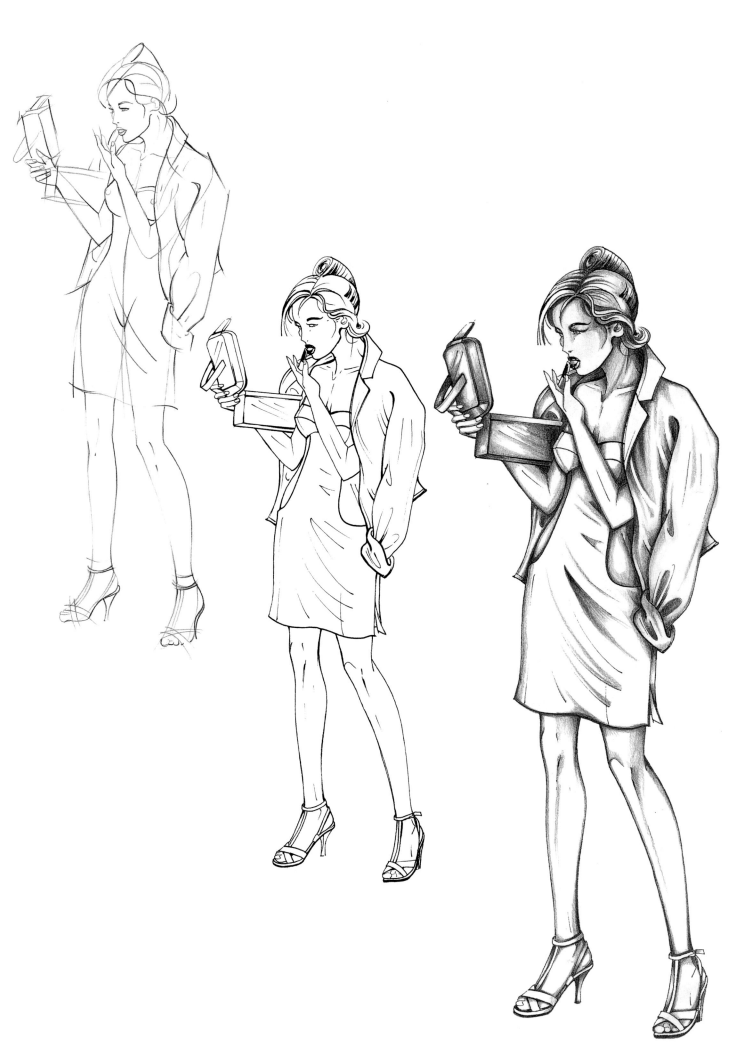

Positive and negative space

As in all disciplines, drawing also has rules to be followed to faithfully reproduce any subject. One of these rules is the relationship between positive and negative space. The positive space is the actual subject itself – in our case, the body – whereas the negative space is the area around the body. The visual field around the figure is only negative in appearance. In fact, it is a complex structure of dynamic forces, tensions and structural relationships. It is essential to take account of the positive and negative space if you are going to analyse and reproduce the subject being studied.

This section includes drawings of a number of poses, showing the elements of construction we have covered so far. We will start by highlighting the space around the body, by drawing the regular shape, the irregular shape, the keyline or structural flow, the outline shape, the balance line and the various areas of the body.

We have split the process into steps to make it easier to understand.

front view

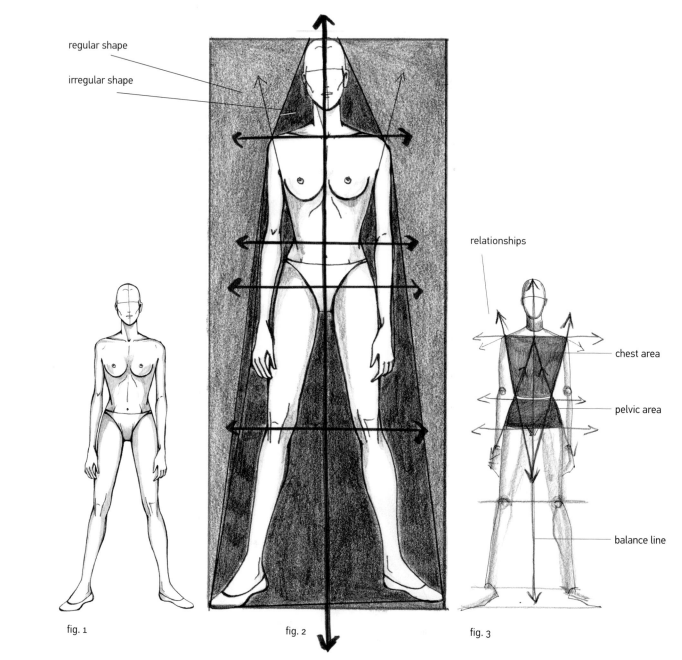

regular shape

irregular shape

relationships

chest area

pelvic area

balance line

fig. 1

fig. 2

fig. 3

back view

regular shape

irregular shape

relationships

chest area

pelvic area

balance line

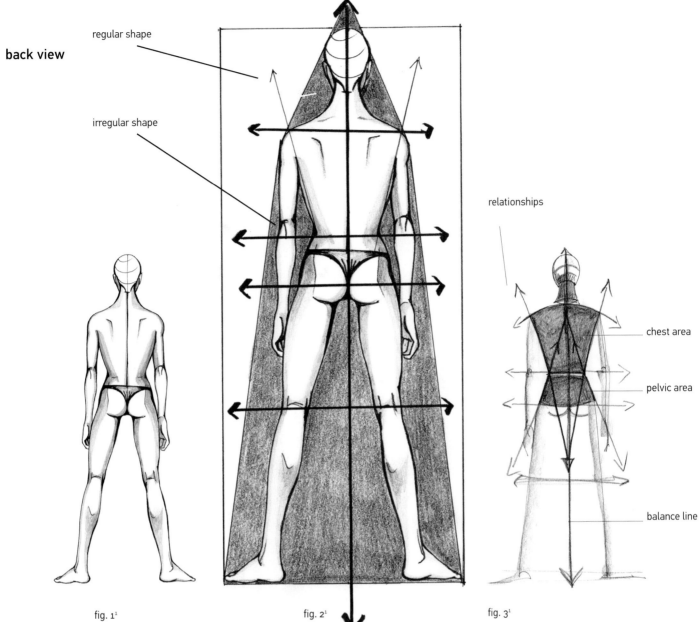

fig. 1¹ fig. 2¹ fig. 3¹

1 Trace the model on tracing paper using a black felt-tip pen. See fig. 1 (enlarge the image on a photocopier if necessary).

2 Draw a rectangle around the figure, the sides of which should touch the parts that extend the furthest, in this case, the tip of the head, and the toes. This rectangle is called the 'regular shape'. See fig. 2.

3 To find the 'irregular shape', draw lines connecting the extremities of the body (head, shoulders and toes) as shown in fig. 2.

4 Highlight these two spaces using two shades of grey, then draw the balance line, the keyline and the main construction lines. In this case, the keyline and the balance line are in the same place.

5 Take a fresh sheet of tracing paper and highlight the main areas of the body (chest and pelvis) using an 8B pencil. Finally, lightly draw the limbs and joints and intensify all the construction lines, as in fig. 3.

Now turn your attention to examining each detail, thinking about each process before you begin to draw. At this point you may be forgiven for thinking: "Will I have to do all this work on the proportions every time I draw a new body?" The best response is to reassure you that the more accustomed you become to drawing using these proportions, the more confident you will be, and eventually you will be able to draw any anatomical position instinctively and skilfully. Remember that even the best illustrators had to go through the very same learning process as you before they could apply those rules to their work.

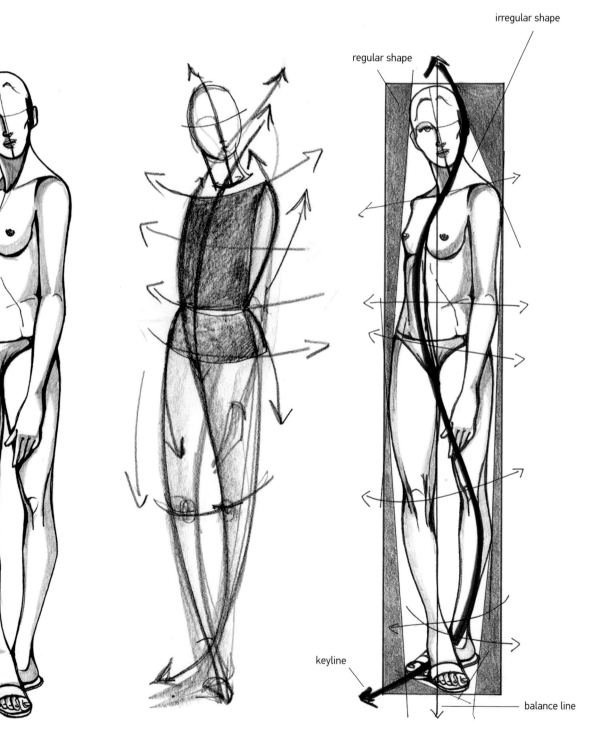

fig. 1

front view of figure

fig. 2

main areas

fig. 3

regular shape, irregular shape and construction lines

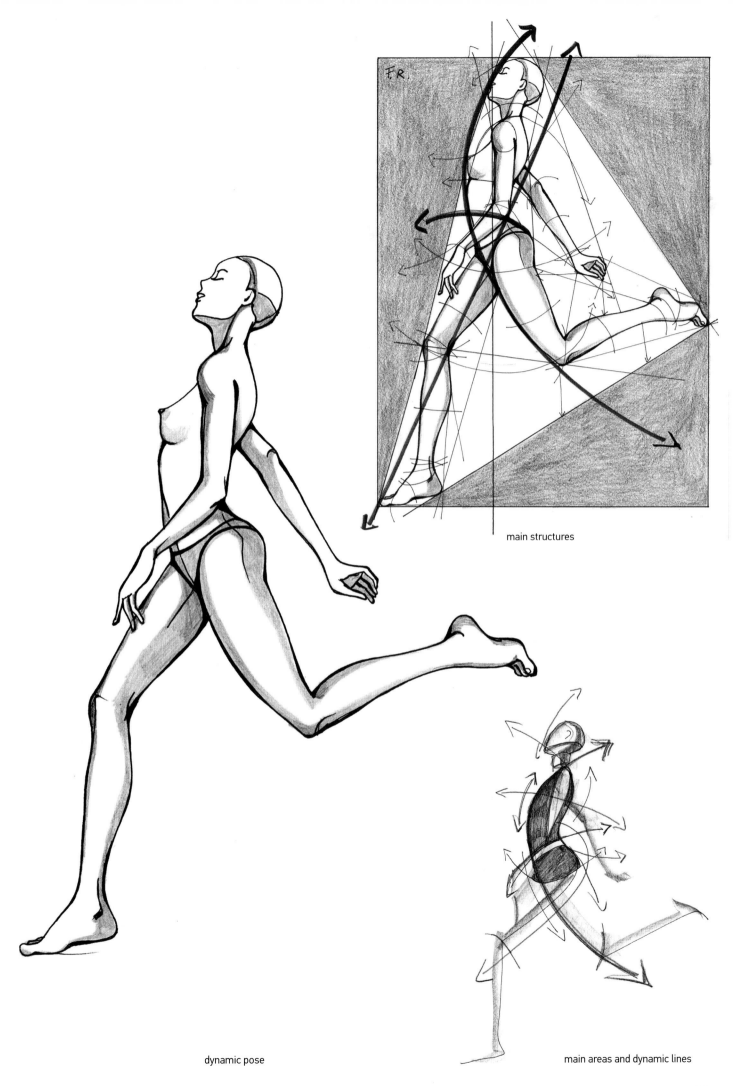

main structures

dynamic pose

main areas and dynamic lines

113

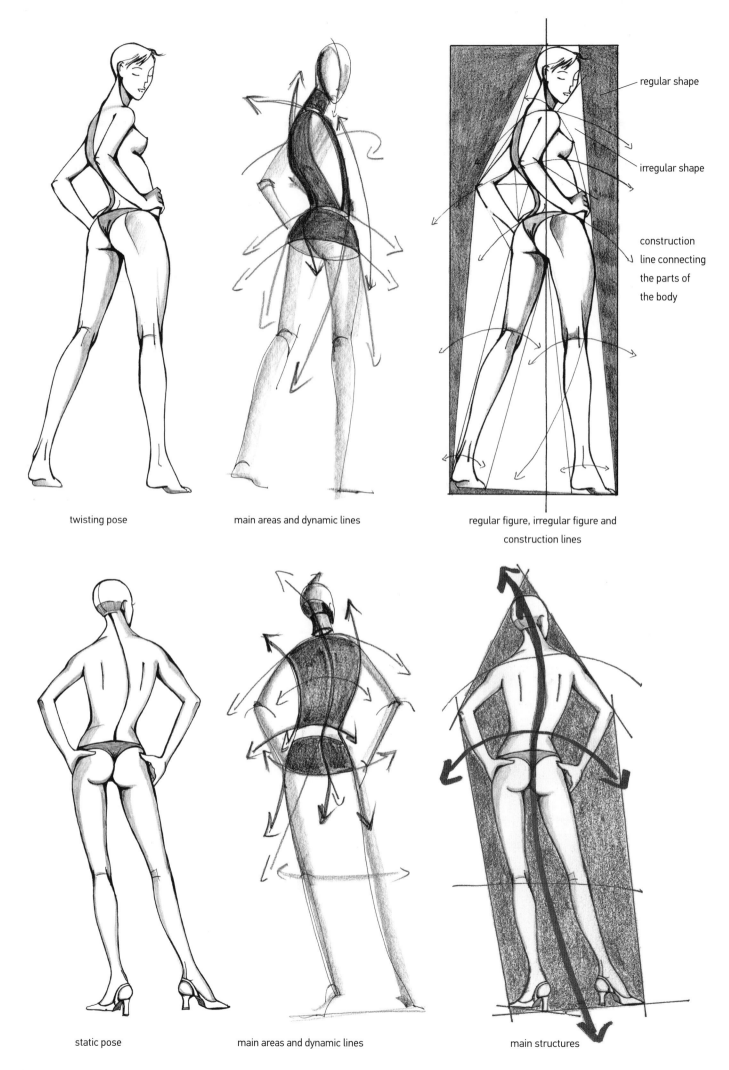

twisting pose

main areas and dynamic lines

regular figure, irregular figure and
construction lines

regular shape

irregular shape

construction
line connecting
the parts of
the body

static pose

main areas and dynamic lines

main structures

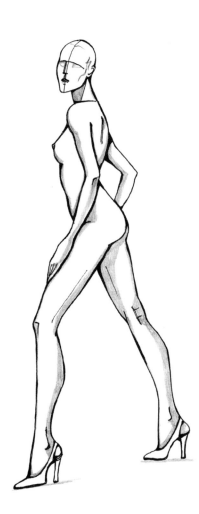

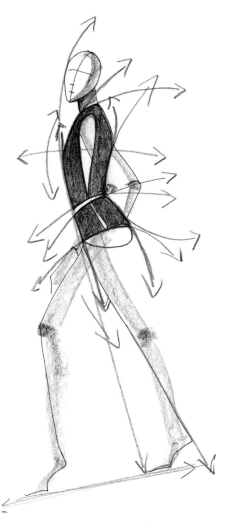

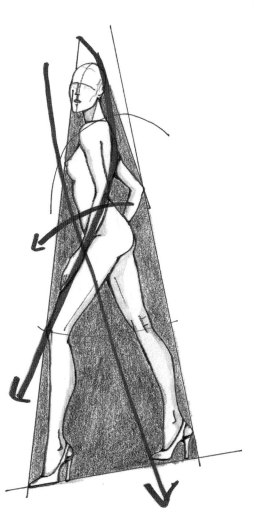

pose in profile

main areas and dynamic lines

main structures

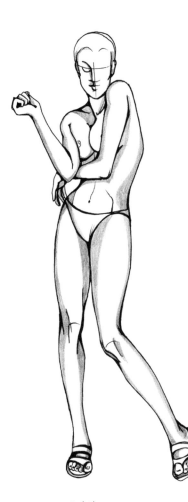

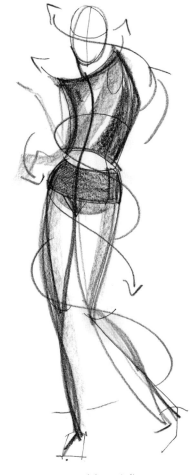

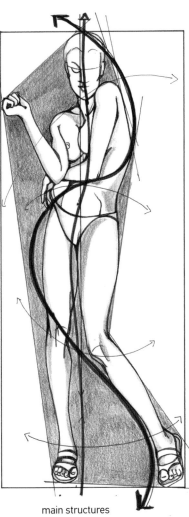

twisting pose

main areas and dynamic lines

main structures

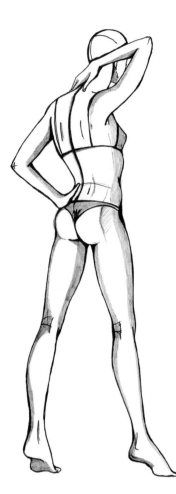
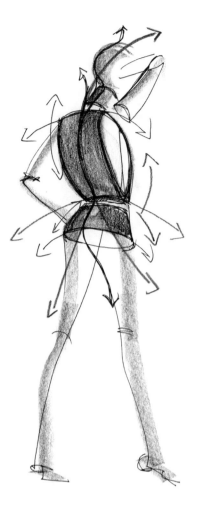
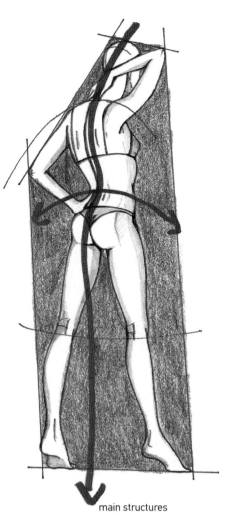

static pose main areas and dynamic lines main structures

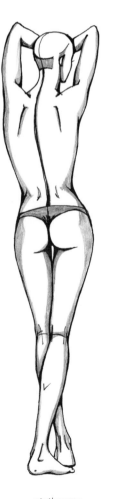
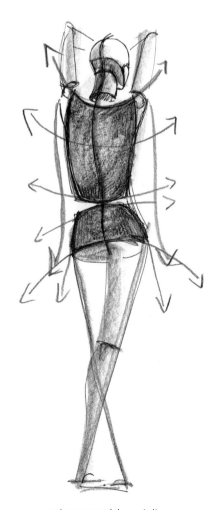
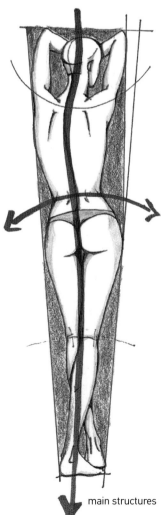

static pose main areas and dynamic lines main structures

The draping of folds on the clothed figure

In fashion drawings, folds and drapes are used to make the various garments appear three-dimensional and to convey other aesthetic effects. This section (pages 119-145) looks at some of the most commonly used systems of complex folds, divided into categories, to show the relationship between a fabric and the kinetic movement of the body beneath the fabric. Examples of complex folds are draping, pleating, folding and gathering. These folds are dense and vary in thickness. Drawing these folds requires plenty of practice in sketching the various depths.

Technically, the stroke will be light when a fold is superficial, whereas a thicker line is required for deeper folds. To acquire this sophisticated drawing technique, copying and tracing practice is needed, using photographs and drawings suitable for this purpose. Fashion students need to understand that folds, drapes and pleats are not independent of the body but, on the contrary, interact with it. Depending on its structure and quality, the fabric will cling to the body like a second skin, creating appealing harmony, subtle sensuality or dynamic three-dimensionality.

The outline drawing on this page, drawn with a size 2 rapidograph, has been left as a single line for demonstration purposes. In this way, the fold becomes a graphic stroke, producing a visual or pictorial effect of the outline of the body. The image on page 120 shows the same variety of folds rendered by the light and shade created with 2B and 3B pencils.

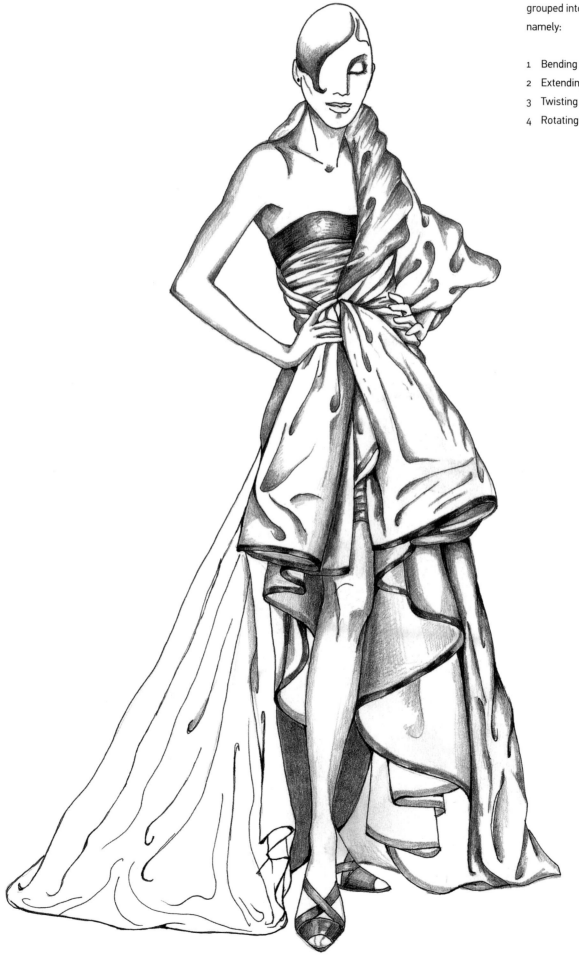

Basic body movements

The body's main articulations can be grouped into four essential actions, namely:

1. Bending
2. Extending
3. Twisting
4. Rotating

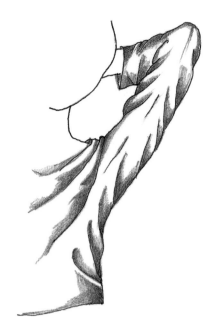

Bending

Occurs when a form flexes or closes up. The fabric is compressed and corrugated, showing small, close-set folds.

Extending

Occurs when the figure or part of it straightens or stretches in a direct thrust. The fabric is pulled in the direction of the action.

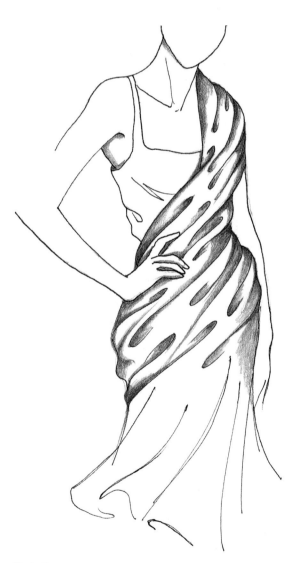

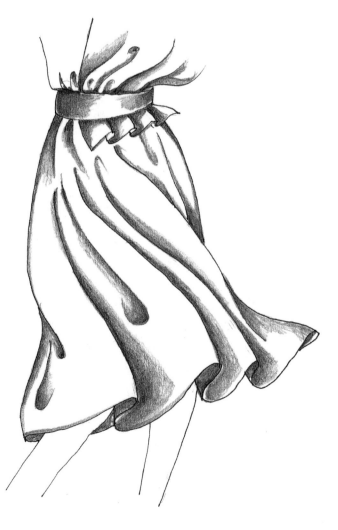

Twisting

Occurs when the body makes opposing movements. For example, torso to the right, pelvis to the left, etc. The fabric moves in a spiral motion.

Rotating

Occurs as the various parts of the body turn. The fabric opens up in swirling movements.

Anchor points on the body

The motion of the fabric at the various anchor points on the body dictates the different sorts of folds and draping. The anchor points are those flexible areas of the body where clothing clings most closely to the skin. This is where the different types of folds are generated, depending on the type of movement and the fullness of the fabric. Before we explore this topic, let's try to understand which anchor points give us the different types of fold.

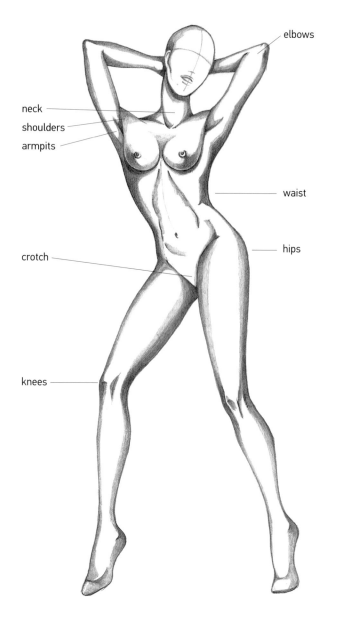

neck
shoulders
armpits
crotch
knees

elbows
waist
hips

Fabric draped over the breasts and the buttocks will create greater emphasis.

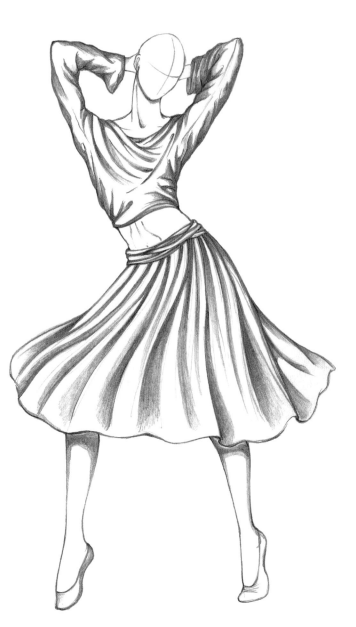

The figure shows how the fabric moves with the body. In a top, the main anchor points are the shoulders, the elbows, and the extension of the arms, whereas in a skirt, the anchor point is the waist area. The opposing motion of the torso and the pelvis generates a complex system of folds that we will analyse by type in this section.

Main types of folds and pleats

Folding
Wide, sweeping, three-dimensional folds.
Gathering
Flat, fragmented, fine folds, at times parallel to each other and tacked in place.
Draping
Crossing, dense and fine folds.

Flounces and ruffles
Free-falling folds of various length, sometimes overlapping, that gather the fabric into decorative motifs and spectacular movement (pages 142-143).
Pleating
Regular vertical or diagonal folds, formed by doubling the material repeatedly on itself (pages 144-145).

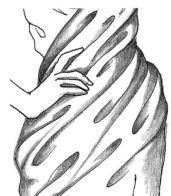

Spiral or S-shaped folds
These are folds generated when the body twists (page 127).

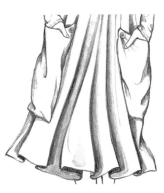

Flying and organ-pipe folds
Usually free-falling folds generated by movement and by air underneath a loose-fitting garment (pages 128-129).

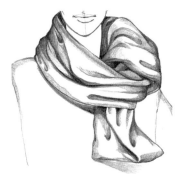

Trap and closure folds
Folds formed by fabric being wrapped around the figure, for example by a belt around the waist or by stitching (pages 130-131).

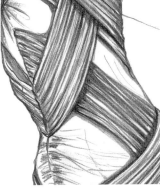

Compressed and fine folds
These are folds generated by pleating or gathering the fabric (pages 132-133).

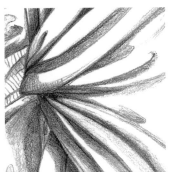

Radial folds
Folds made when the fabric is fixed in position at one point and then radiate out in dynamic lines (pages 134-135).

Fragmented, angular and crossing folds
Folds mainly formed by corrugation of the fabric. The folds are small, cross over one another and flow irregularly (pages 136-137).

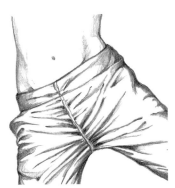

Direct thrust folds
Folds generally created as the legs or the arms open and extend (pages 138-139).

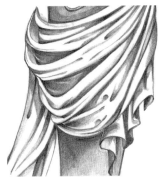

Draped and hanging folds
The classic draped fabric fold, secured on either side and left to fall to the centre or diagonally (pages 140-141).

How to draw complex folds using rapidograph pens

Some of our drawings have been done using professional rapidographs, but the disposable ones found at fine art stores are also fine. Make sure that you use a pen in good working order - it should be almost new as they tend to dry out quickly, and the nib can wear.

To achieve neat drawings like these you should first make a rough pencil sketch, then when it is complete trace the sketch onto a sheet of tracing paper using a size 0.2 rapidograph. Then thicken the deepest folds to highlight the three-dimensional effect with larger nibs, such as 0.5 and 0.8. Finally, scan the images and print them out to process them, or else take the original pencil sketch and trace it on the light table onto a smooth sheet using the same technique. It is probably better to start off with a 2B propelling pencil and only move on to the rapidograph when you are satisfied with the proportions and judge that the main folds are perfect.

A little patience is required to obtain a confident stroke, so do keep practising. If it's any consolation, we too have thrown away plenty of material.

The three images seen here show a sequence of movements: a static clothed figure (fig. 1) a moving figure (fig. 2) and finally a turning figure (fig. 3).

Notice how the fabric seems to come alive as the movement increases, forming a network of complex drapes and folds.

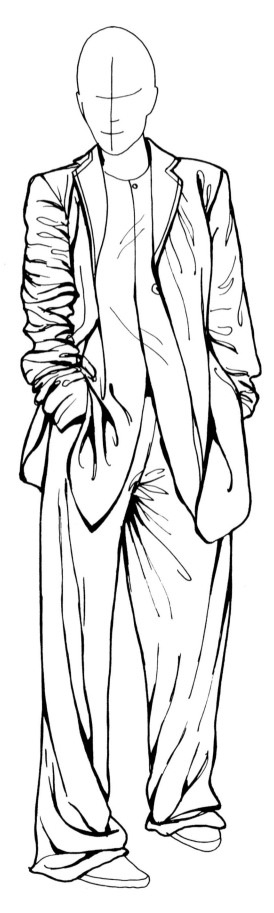

fig. 1

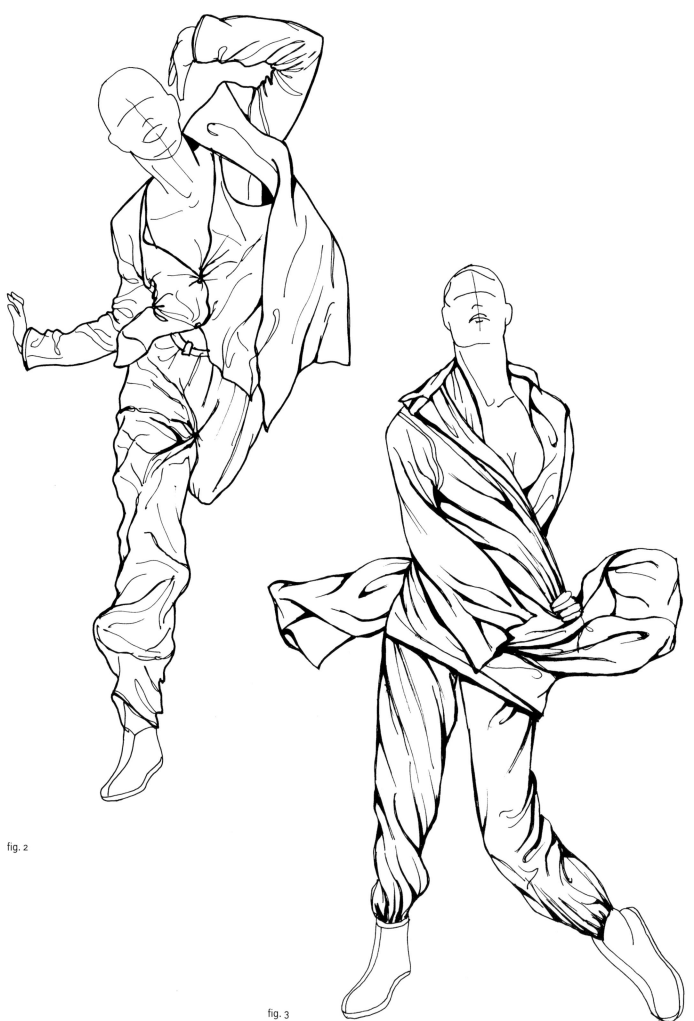

fig. 2

fig. 3

Giving volume to folds with pencil-shading techniques

The pencil-shading technique is essential for giving volume to a clothed figure. The ability to apply varied light and shade to a drawing produces more attractive and realistic images. More or less pressure can be used on the pencil, mixing up overlapping strokes to build an interesting tonal balance. Rather than using single lines, this shading technique blends to highlight the graded tone. It is quite a difficult technique at first and, as ever, you need to be patient while learning to press just enough to give the right amount of shading and thus the right volume to the various parts of the garment and the body. An important rule for visually "lifting" a fold off the page is to darken the part underneath the fold, adding no shading to the part most exposed to the light. The image on this page shows how to do this. It has been drawn using a variety of pencils. The basic drawing was done with a 2H to mark out faint lines, then shading was added gradually using 2B and 3B pencils. To apply black to a drawing, use softer leads such as 4B and higher. These should be used very sparingly, however, because as you know the higher the lead number, the thicker and darker the line will be. Always remember to sharpen your pencils often to keep your lines clean. Don't be discouraged if your drawings don't turn out well at first. Keep trying until your strokes become faster and more confident.

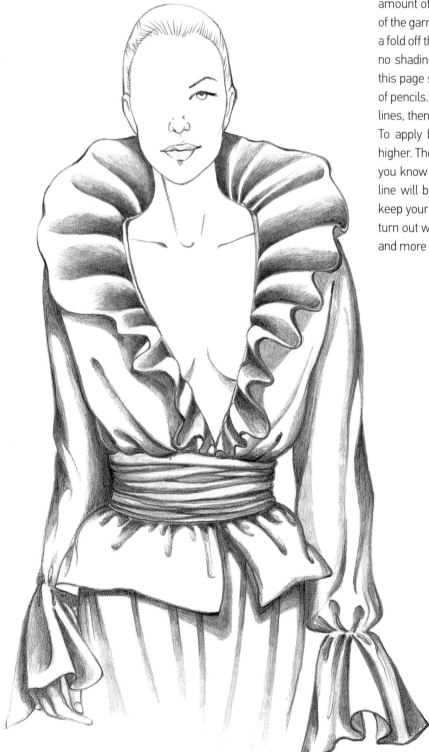

Spiral or S-shaped folds

Spiral or S-shaped folds are free falling in the sense that they are not sewn, but derive from the bending and twisting of the body or by wrapping fabric around the limbs or the bust. The lighter and the closer fitting the material is, the denser and more compressed the folds will be. Spiral or S-shaped folds flow in a dynamic, sinuous way. On this page you can see these folds at the bust, in the sleeves and around the waist.

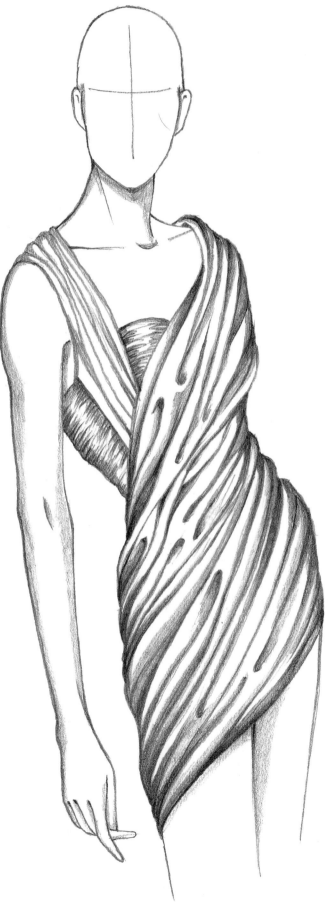

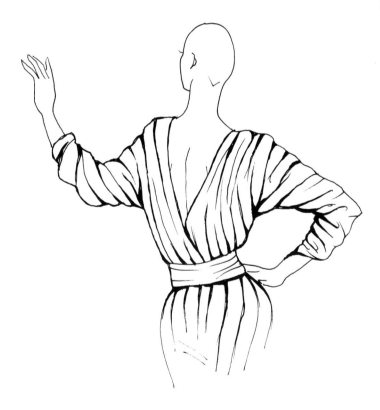

Flying and organ-pipe folds

A combination of air and body movement, fabric volume and fabric weight will create free and sinuous three-dimensional waves. The fabric opens and flutters into soft waves in the shape of organ-pipes or fluctuating lifting motions.

N.B. These are useful movements when you want to show the fullness of the fabric and they are also very helpful to the person making up the garment. Reproduced in this way, the sketch is not only more attractive, but it also indicates the softness of the fabrics very well.

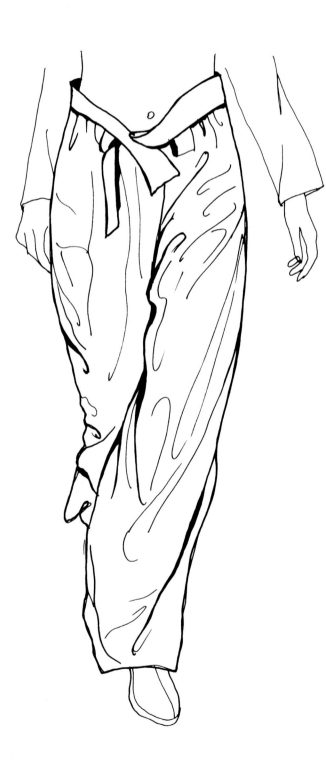

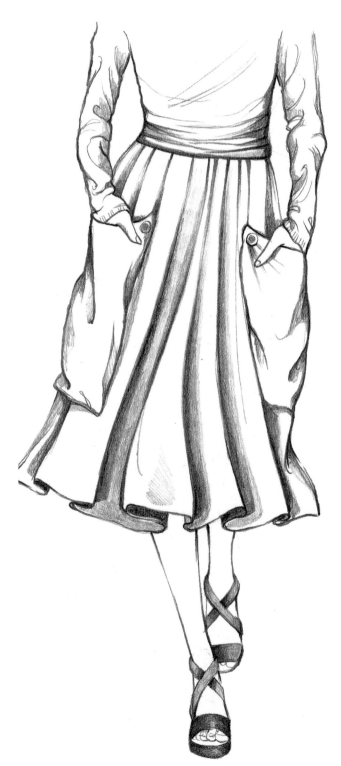

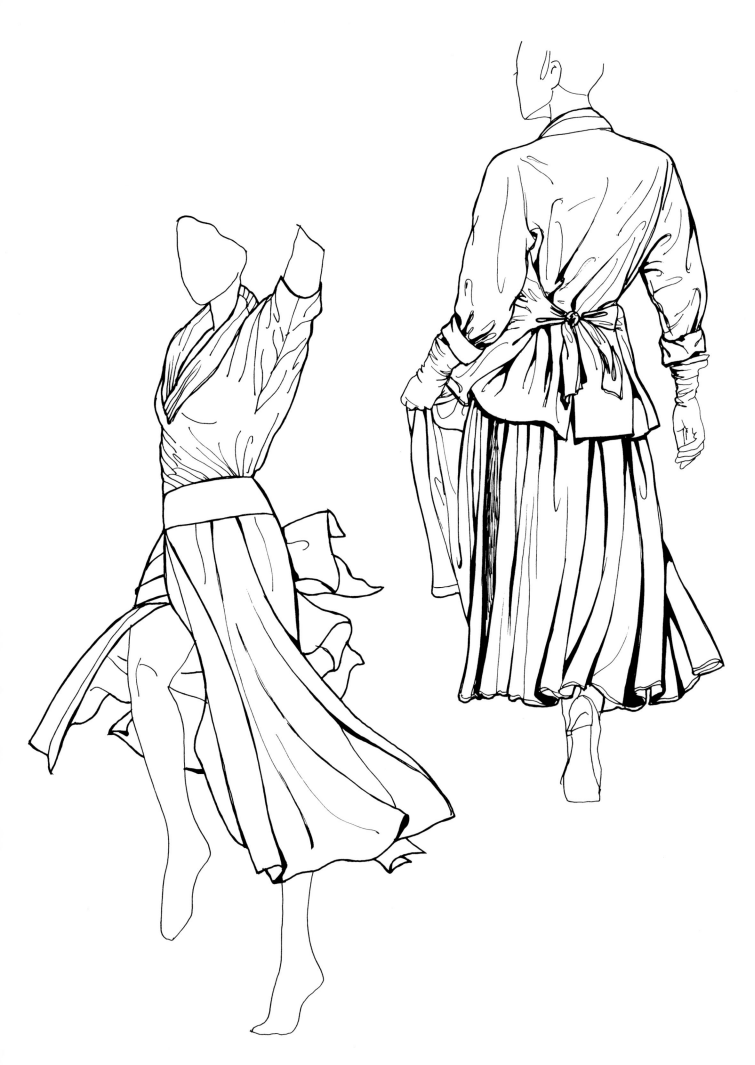

Trap and closure folds

This type of fold occurs when a fabric is gathered by a belt and is forced to change direction or when it wraps over itself, for example when knotting a scarf or in the turn-up of a wide or shawl collar. These images show a few examples of these folds. Note how the folds become deep and contrasting and how they run closer together at the points of closure.

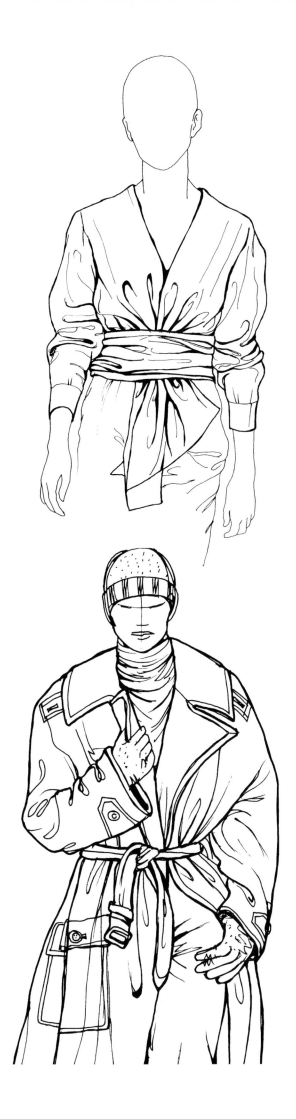
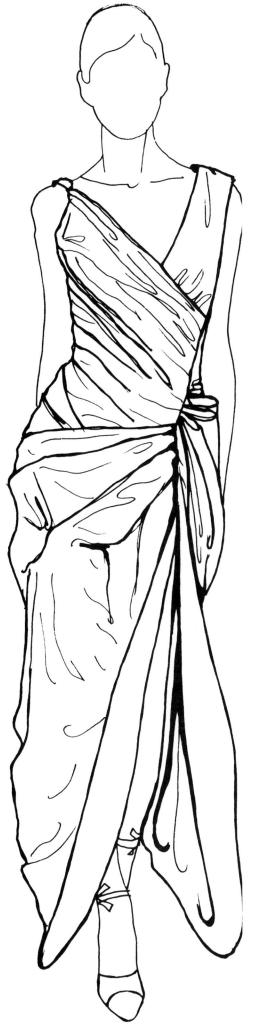

Compressed and fine folds

Compressed and fine folds are generated not only by movement but also by the way a fabric is treated and the type of stitching. Draping and gathering, for example, are two types of decorative motif that create dense and free-falling folds, held by stitches at opposite ends of a piece of fabric. They are drawn very close together and cross over one another slightly. They act like a second skin, adapting to the body's movement and highlighting the silhouette. Different thicknesses of line are drawn to highlight the different depths. The nearer the surface the fold is, the finer the line needs to be, and vice versa. You can see the compressed and fine folds in the evening dress shown here.

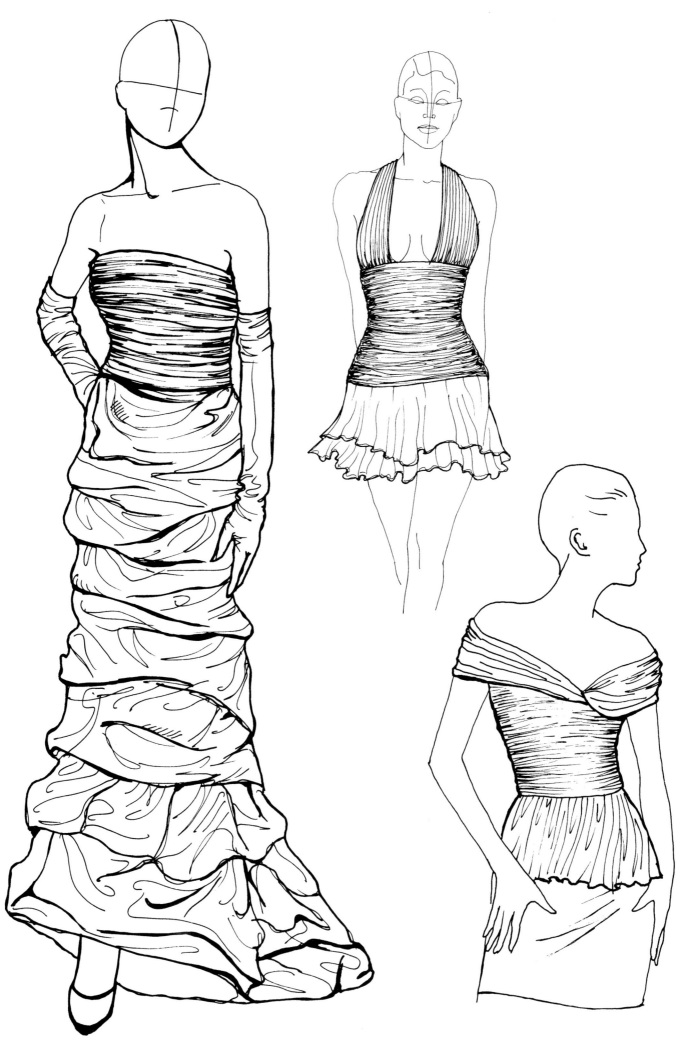

Radial folds

Radial folds are created from a point at which the fabric is trapped, which may be the waist or other anchor points such as the shoulders and hips. The fabric is cut on the bias so, since it cannot fall by the pull of gravity, in this instance it opens in a radial fashion along the entire garment, or most of it. These folds are three-dimensional and decorative, and make the garment softer and more feminine. When drawing these folds, pay attention to the light and shade in the deeper areas. Use the rapidograph to accentuate the lines of the deeper folds, leaving the others lighter.

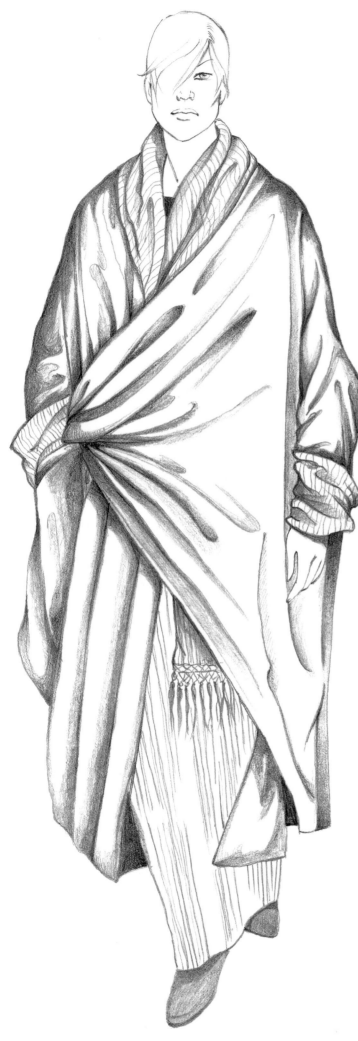

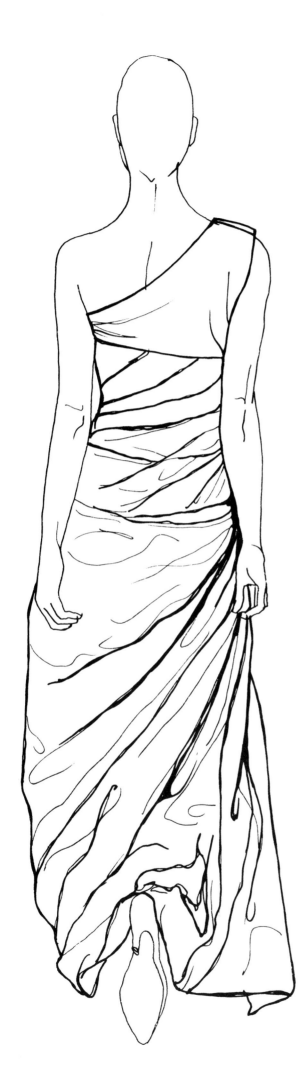
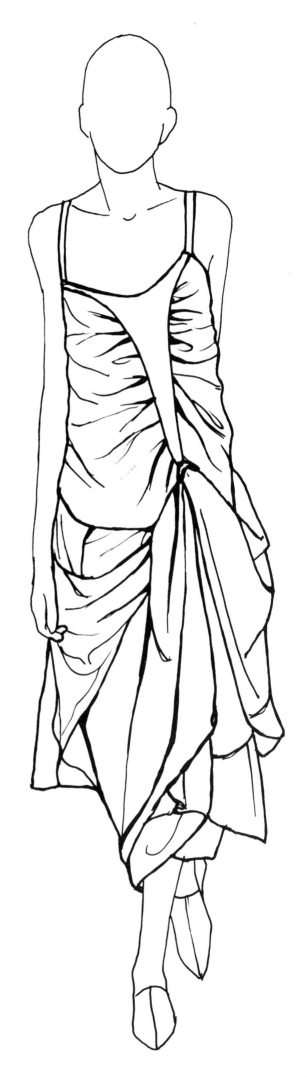

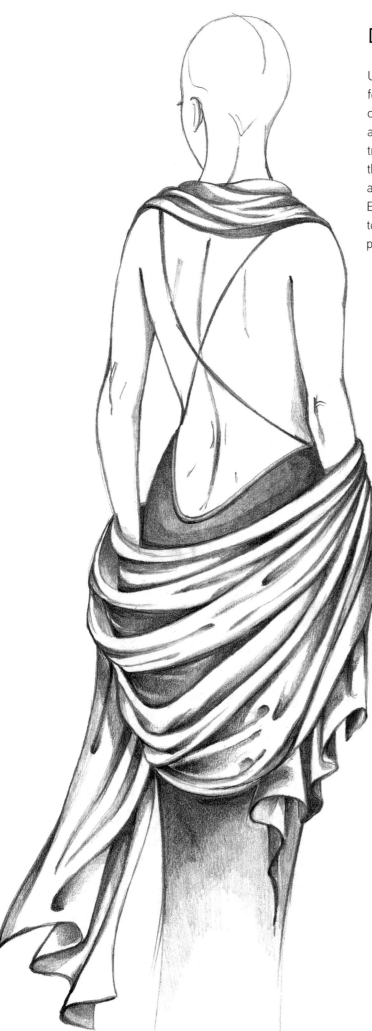

Draped and hanging folds

Unlike the folds caused by body movement, draped and hanging folds are generated by the force of gravity causing the fabric to cascade down into sweeping curves. These folds begin at precise anchor points such as the shoulders or hips. They are similar to trap and closure folds in that they originate from a point at which the fabric is trapped, but unlike these, they create beautiful light and shade effects in the centre before rising to the opposite side. Examples of these folds can be found on Ancient Greek tunics (chitons), which were long pieces of cloth wrapped around the body, pinned at the shoulders and left to fall freely in soft hanging folds.

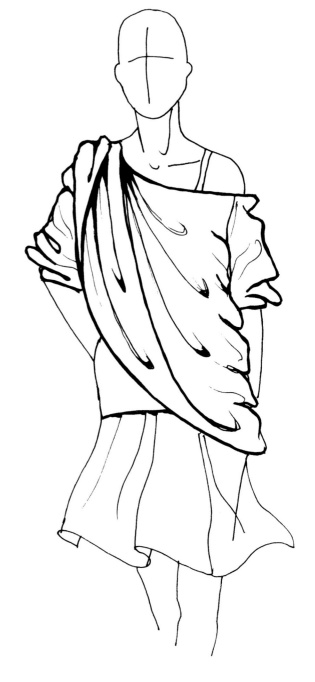

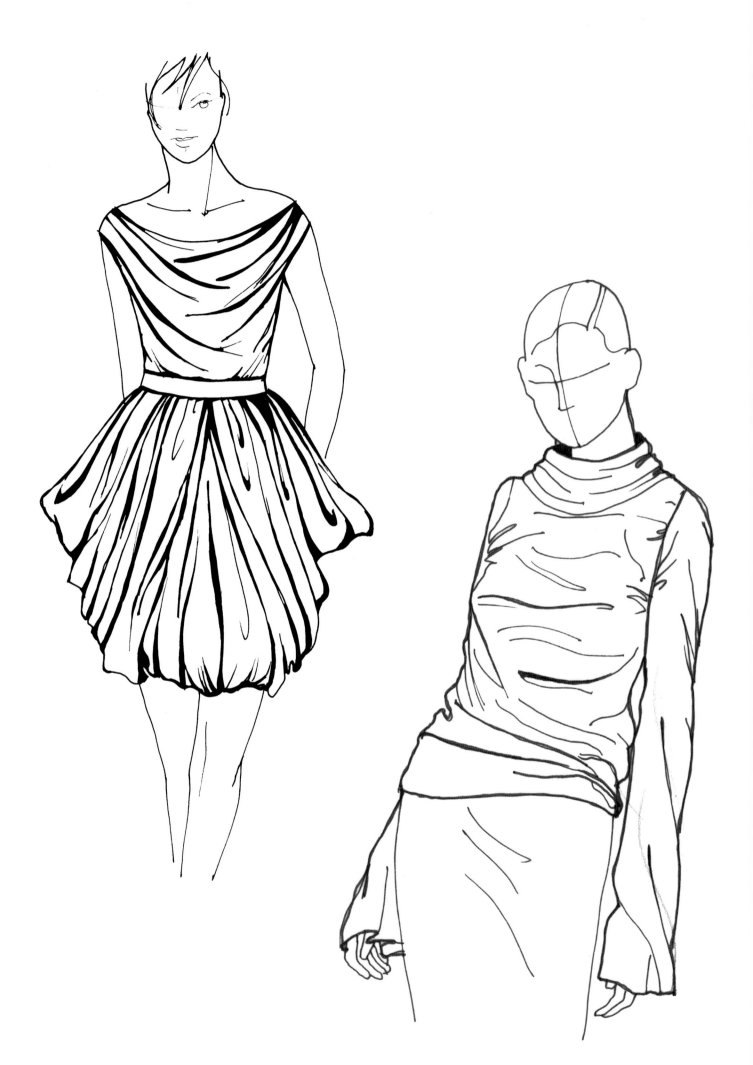

Flounces and ruffles

These are widely used in fashion as they add grace, delicacy and a romantic retro feel to clothing.
The fabric gathers at the stitched end and expands at the other end, producing delicate and harmonious movements.

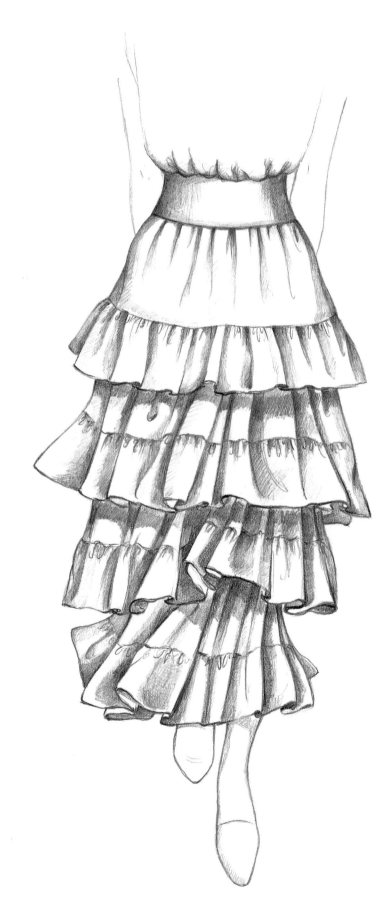

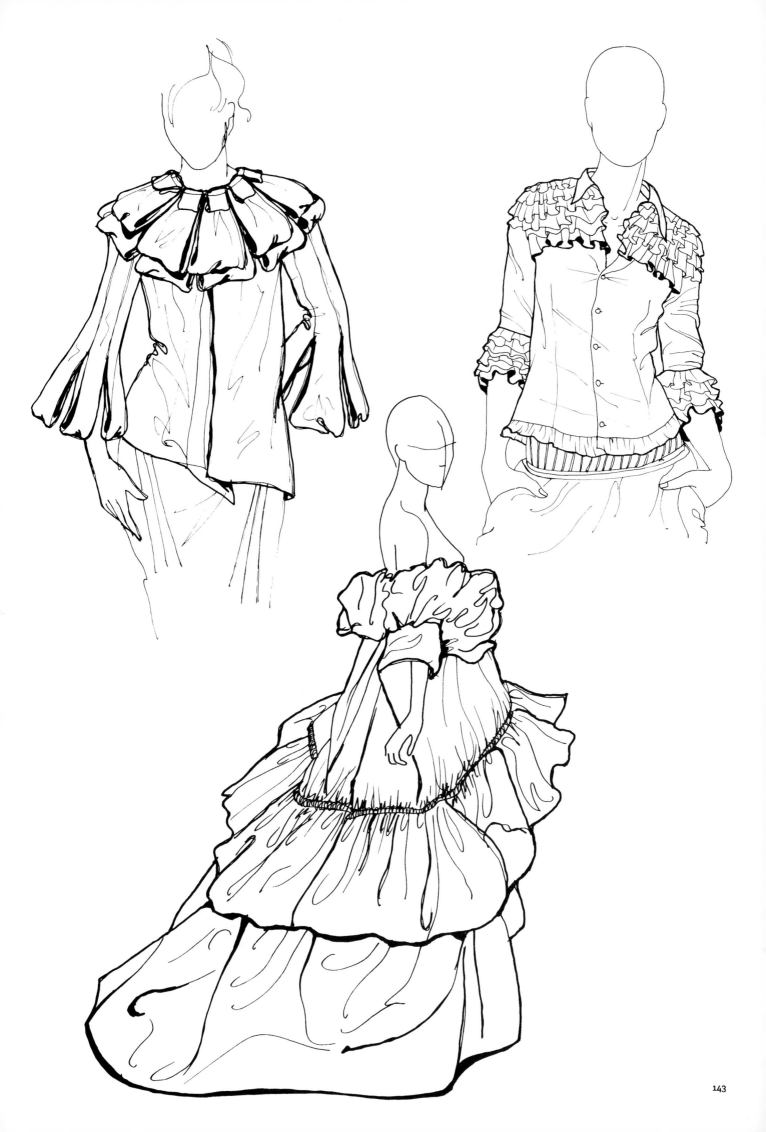

Flat folds and pleats

Flat folds and pleats look stiff and give a geometric feel to clothing. They are drawn with very clear light and shaded areas. They do not lose their shape even when affected by air or wind movement and are usually used on lightweight or stiff, medium-weight fabrics such as taffeta.

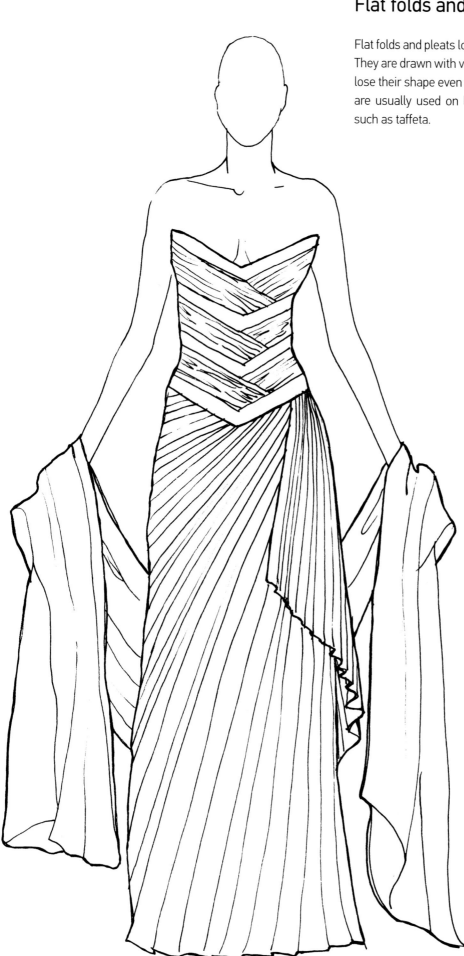

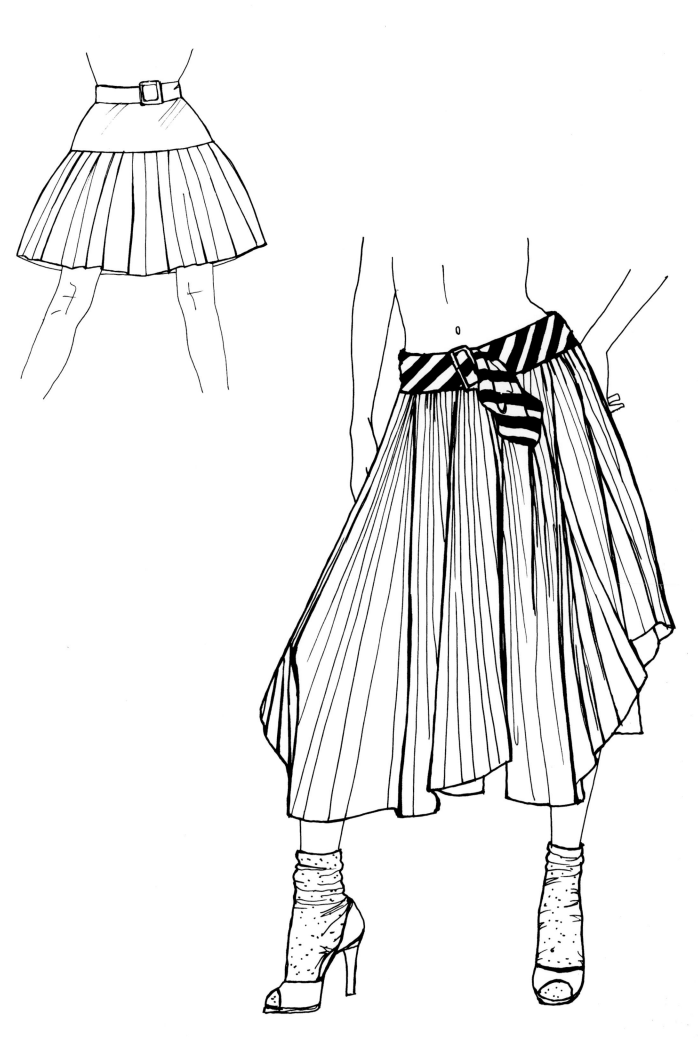

Chapter 2

The figure in fashion

The fashion figure

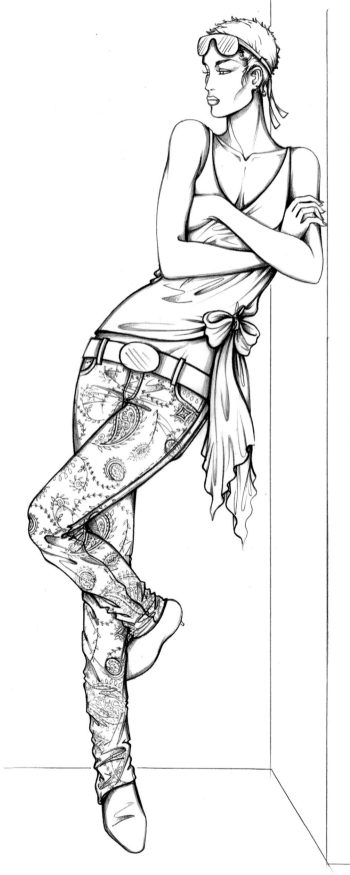

The human body is a living thing, and this has to show through in a fashion illustration. Fashion models move smoothly and sinuously, they have a unique way of walking, they pivot and sway wonderfully, and manage to hold gravity-defying poses. Watching fashion models at work can be a dazzling and overwhelming business. So much elegance and beauty make them look as though they come from another planet, even the moodier ones like the one on the left here!

Graphic interpretation

In this chapter we will take a close look at how to render sculptural and dynamic movements. Just as the fashion model is the best way of showing clothing on a catwalk, the fashion drawing is the ideal way to represent graphically an outfit or an entire collection. It must have impact, swift-moving lines, dynamic movement and elegant poses, as well as striking the right tone for the type of clothing being worn. The poses drawn should reflect the feeling of the design. Remember that the model's body is just a vehicle for the clothes, so it should not overshadow them. The pose then should be dynamic to highlight movement, sophisticated and modest for a more classic line and casual for a more youthful style.

Stylisation

The term stylisation means paring down the structure of the body to a few essential strokes. There are various ways of stylising the figure, one of which is extending the height by one or two units of measure; see the illustration on the right. On pages 149-152 three methods of stylisation are shown.

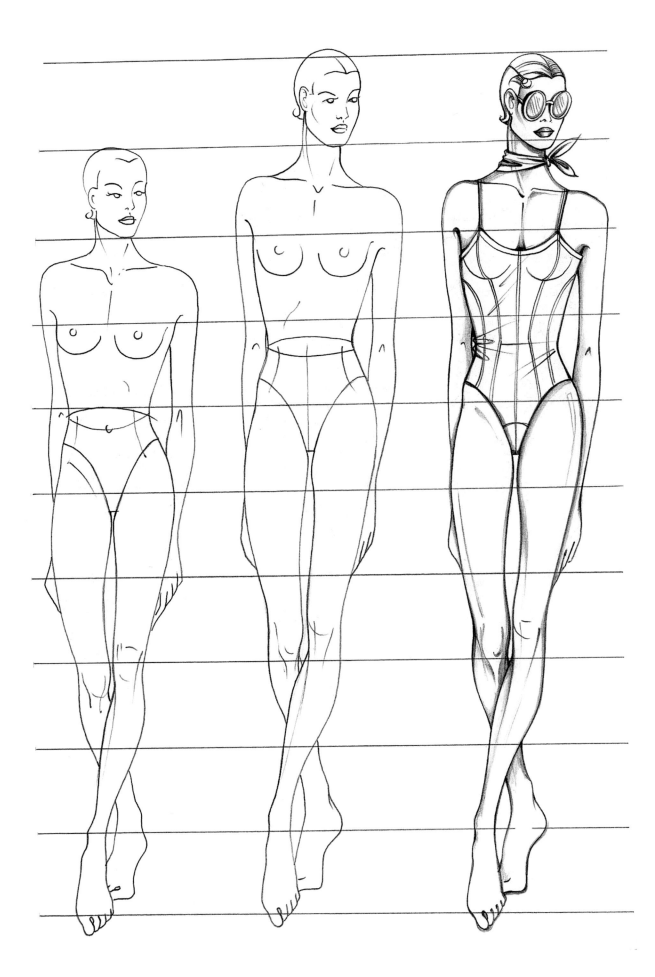

First method

As you can see, in the two drawings on pages 149 and 150 the proportions are the same, but the limbs and the main areas of the body are longer. The head has more or less the same dimensions, the shoulders are slightly wider than the pelvis and the neck has been slightly elongated. The chest is broader, while the pelvic area is shorter and the pubic bone higher.

The waist is narrower and the limbs have kept the same proportions. The feet are naturally longer to match the extension of the body.

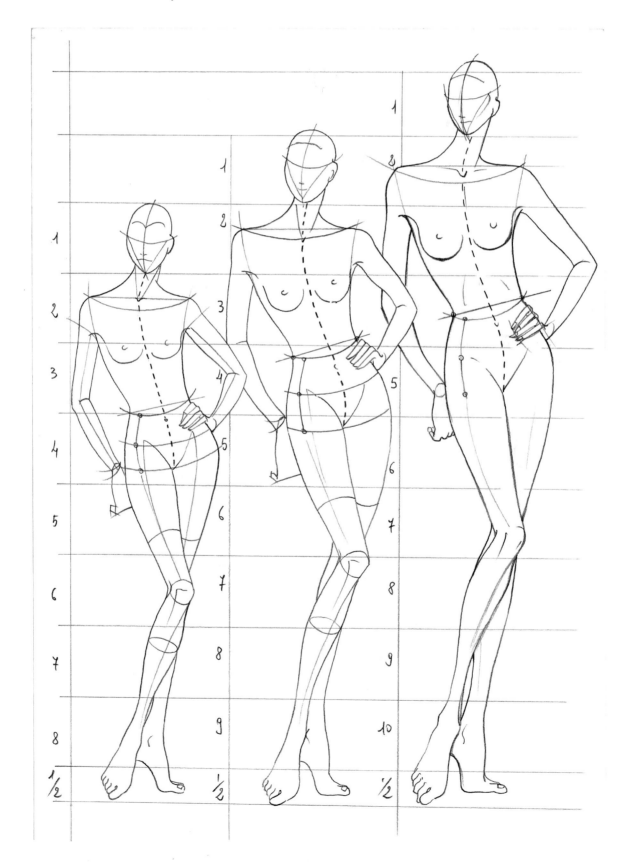

Second method

Here the pose has been further simplified to a few essential strokes.
The result is very similar to the outline drawing but has more energy and vitality. The strokes are more marked and dynamic.

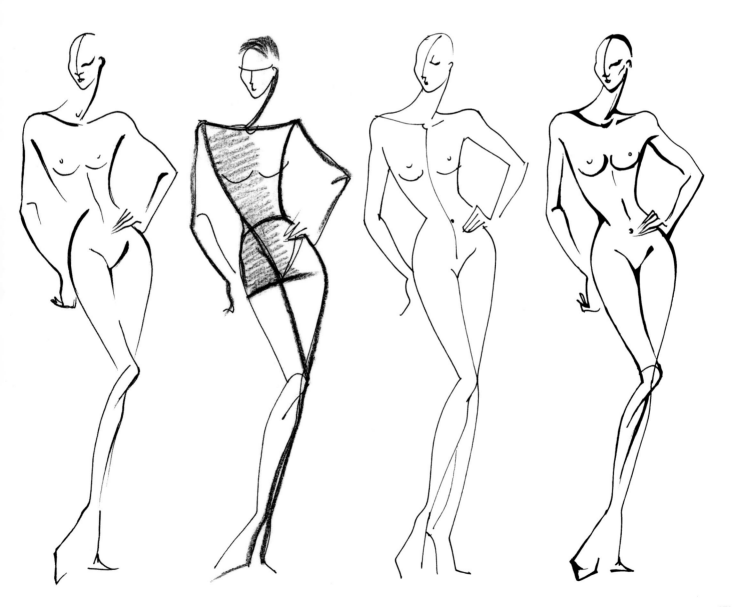

Third method

Another way of producing a fashion figure is to make a real figure thinner and longer, leaving the basic proportions almost unchanged. This illustration clearly shows the changes that have been made. We have made the waist and hips narrower, the legs longer and slimmer, the neck more slender and the entire figure a little taller.

This method is done directly on sheets of tracing paper over images taken from specialist magazines. This is a very useful method, especially in the initial learning stages.

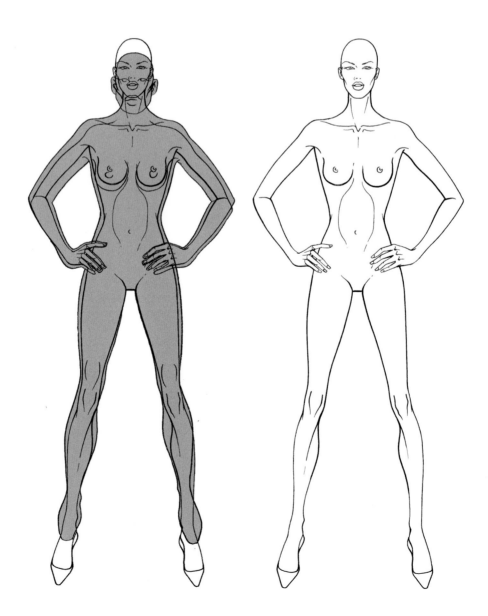

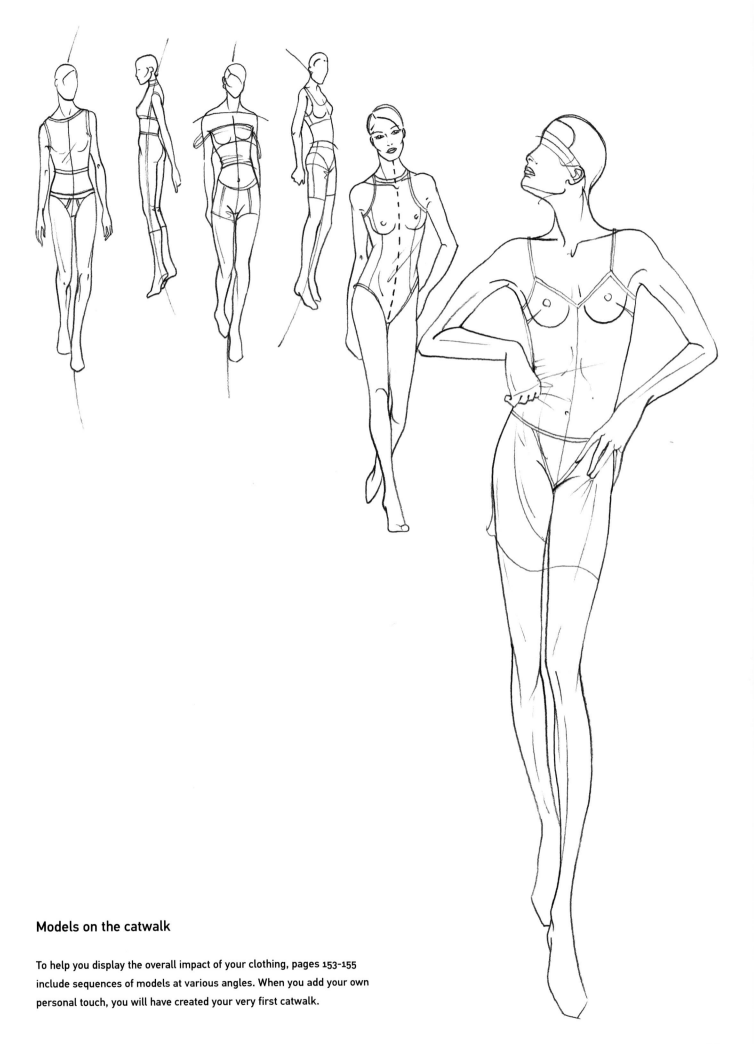

Models on the catwalk

To help you display the overall impact of your clothing, pages 153-155
include sequences of models at various angles. When you add your own
personal touch, you will have created your very first catwalk.

Multiple poses with a fixed upper body

Students often think they have to memorise a great number of poses for their projects and this can be very stressful for some. Don't worry. To simplify the learning process, try out the method we use. Begin by choosing a simple and effective pose like the one shown here. Then, keeping the upper body fixed, move just the arms and legs. You could move the head too, if you like, though that is more difficult. Draw the various movements on tracing paper and then trace the drawing onto normal paper. This way you will obtain an array of different poses from only one basic figure.

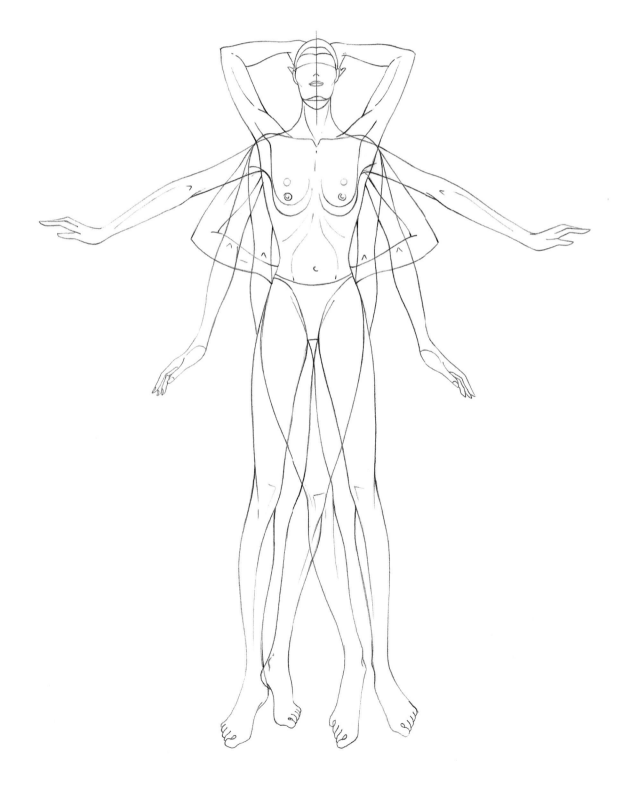

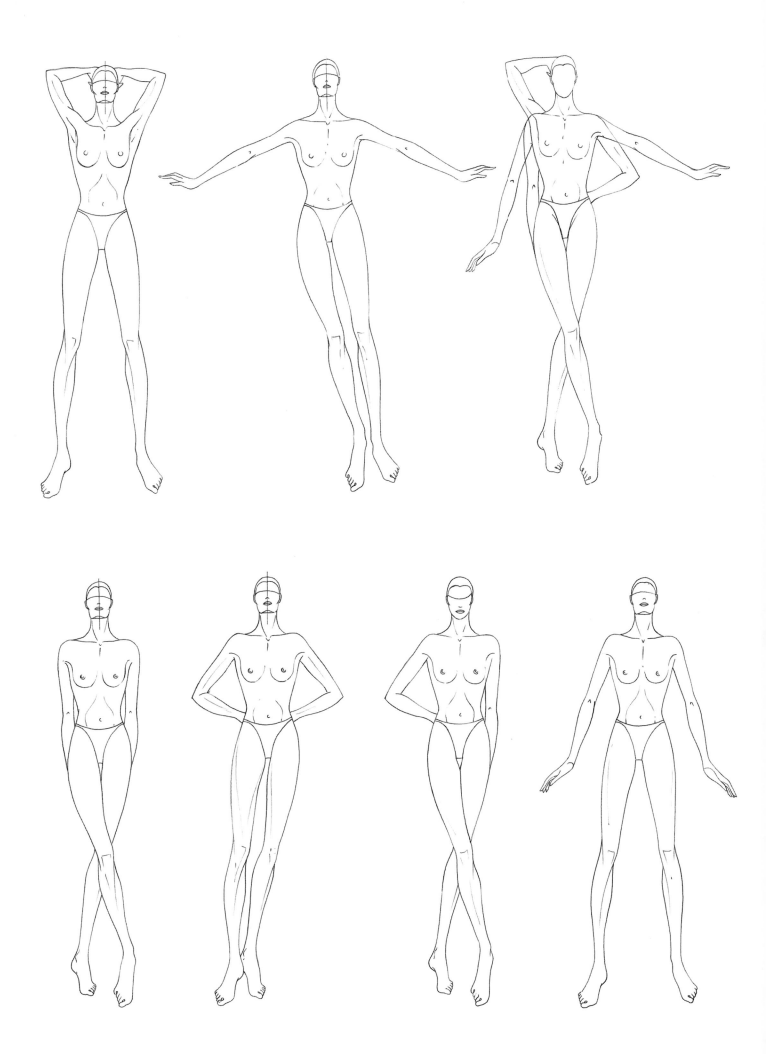

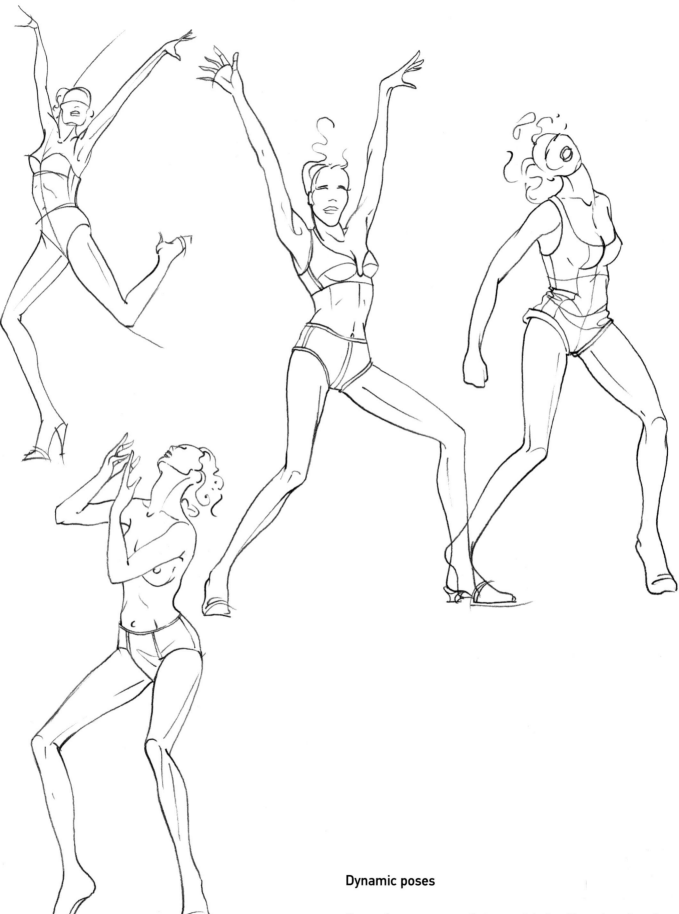

Dynamic poses

Here we have some poses that are useful when illustrating a line of active sportswear for the young.

Stylistic variations

As opposed to technical drawings – which must be clear and detailed without altering the proportions to act as a guide for production teams (see more about this in chapter 4) - fashion drawings may be very stylised and proportions may be altered. The style may be adapted to the mood the designer wishes to convey and top fashion illustrators are sought after because of their signature methods of drawing. Stylised fashion drawings may be in black and white or in colour, and can be used instead of photographs in specialist magazines. The illustrations on pages 159-161 show stylistic variations on the same basic image.

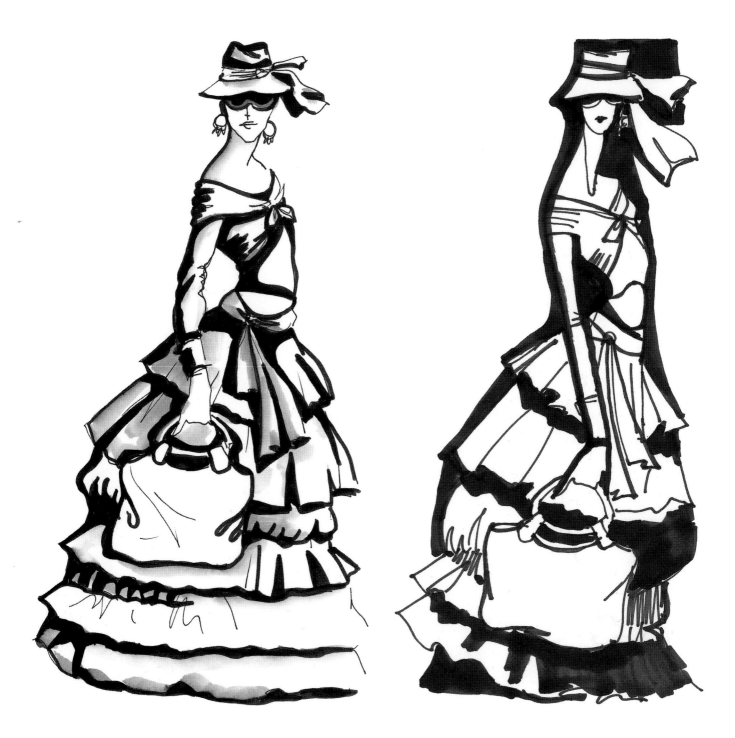

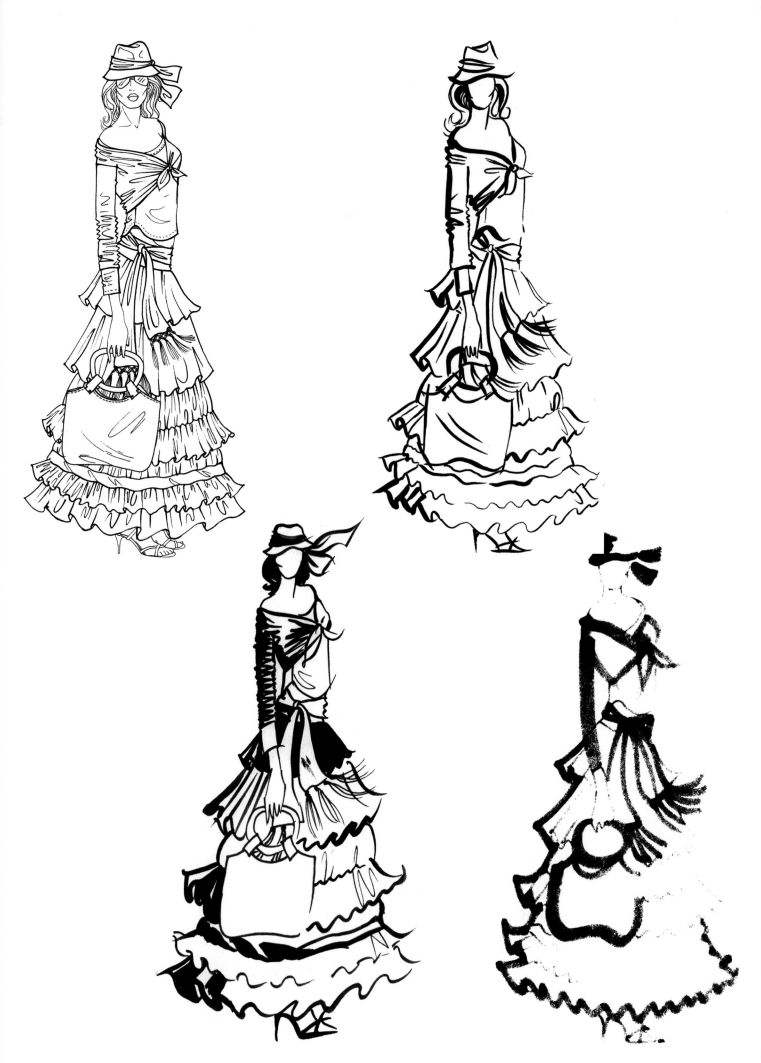

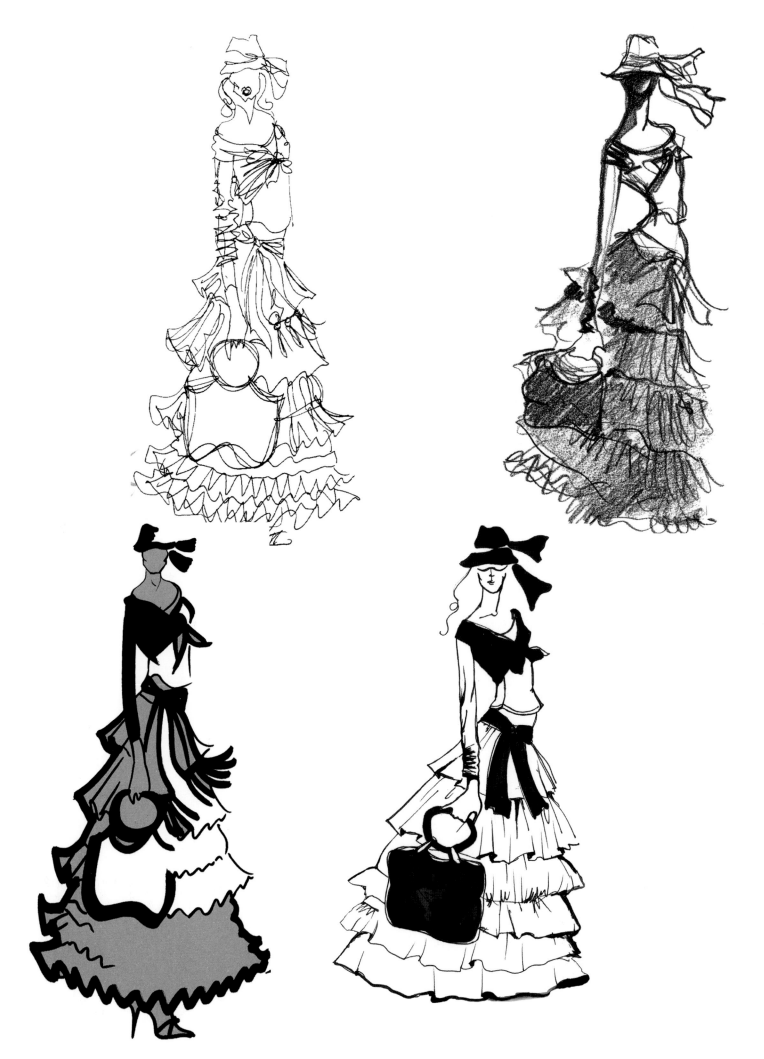

Focus technique

Photographic shots, used mainly in film and photography, help to get an image's message across. Fashion illustrators use them to make clothing and accessories easier to observe.
The shots most used in fashion are as follows:

1 Full shot
Shows all or most of the figure.

2 Medium shot
Also known as the American shot because it was widely used in Hollywood films. This shot shows the figure from the knee up.

3 Knee shot
The knee shot is used from the waist down to focus on skirts or trousers.

4 Waist shot
Shows the body from the waist up.

5 Close-up
Shows the head and part of the shoulders.

6 Extreme close-up
Shows the face and is used to highlight a particular face or make-up detail.

7 Detail shot
Enlarges a small area for particular focus.

Using these shots is very useful both for creatives, who will be able to study their patterns in plenty of detail, and pattern makers, who will be able to translate the project faithfully without having to invent anything.
Don't forget that prototypes are not usually made by the stylist. All designs must be clear, from a single pattern to the entire collection, which is where photographic shots come in.

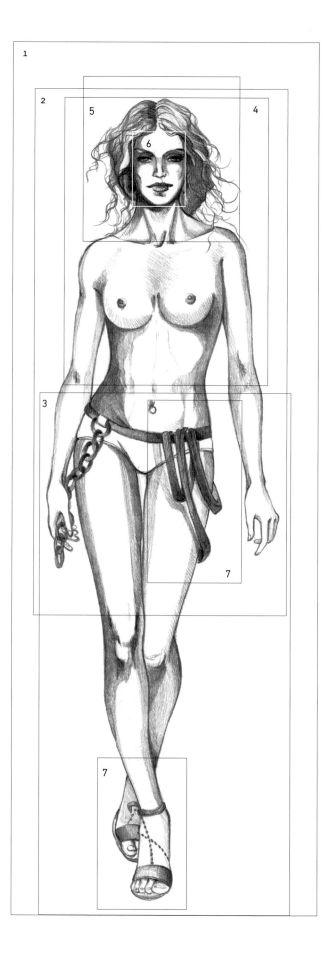

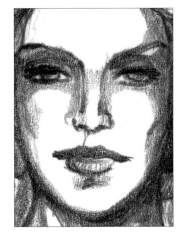

extreme close-up

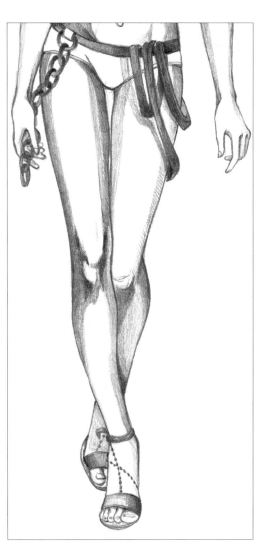

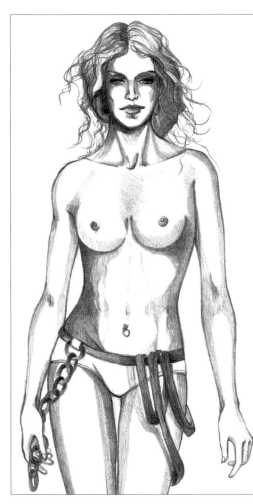

medium short or American shot

detail shot

knee shot

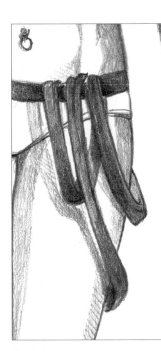

waist shot

detail shot

close-up

163

Medium shots

When you want to focus on a particular garment, it's a good idea to enlarge only the relevant part of the body, picking out all the details of the garment from the front and back. So when drawing trousers, you will show the bottom half of the body, while for a skirt, the drawing can end just below the hemline.

To help you gain a better understanding of this subject, we recommend creating a repertoire of your own images, choosing from specialist magazines that show the features of each garment in the various shots. Practise by tracing the different shots on tracing paper. It sounds easy, but it isn't. A shaky hand or smudged stroke means you'll have to start from scratch.

The models illustrated on pages 164-171, all in medium shot, are shown at various angles so that the garments can be seen clearly.

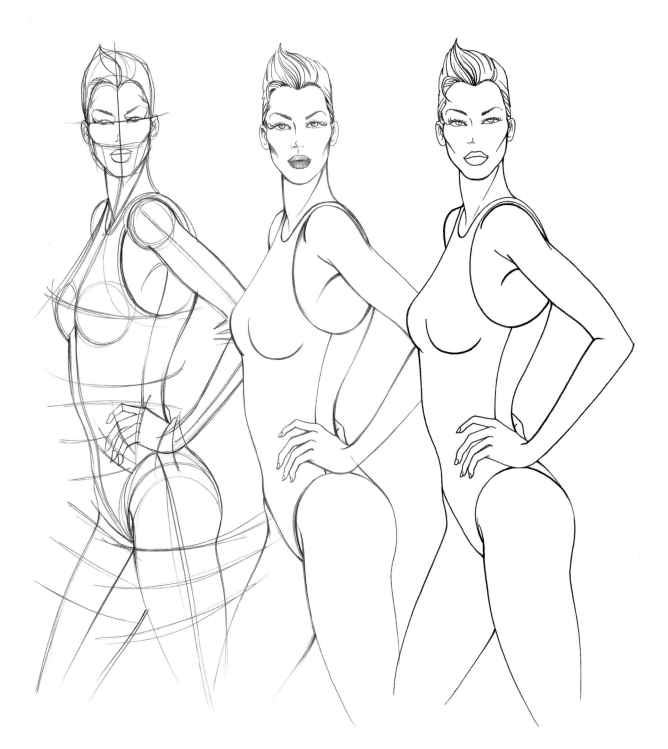

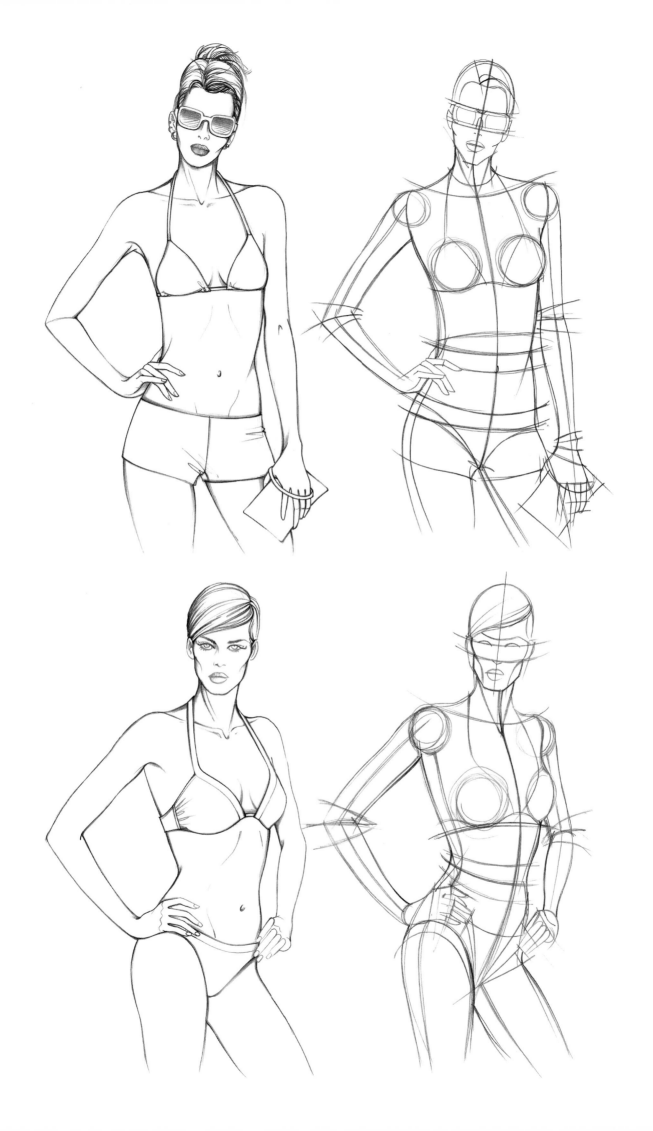

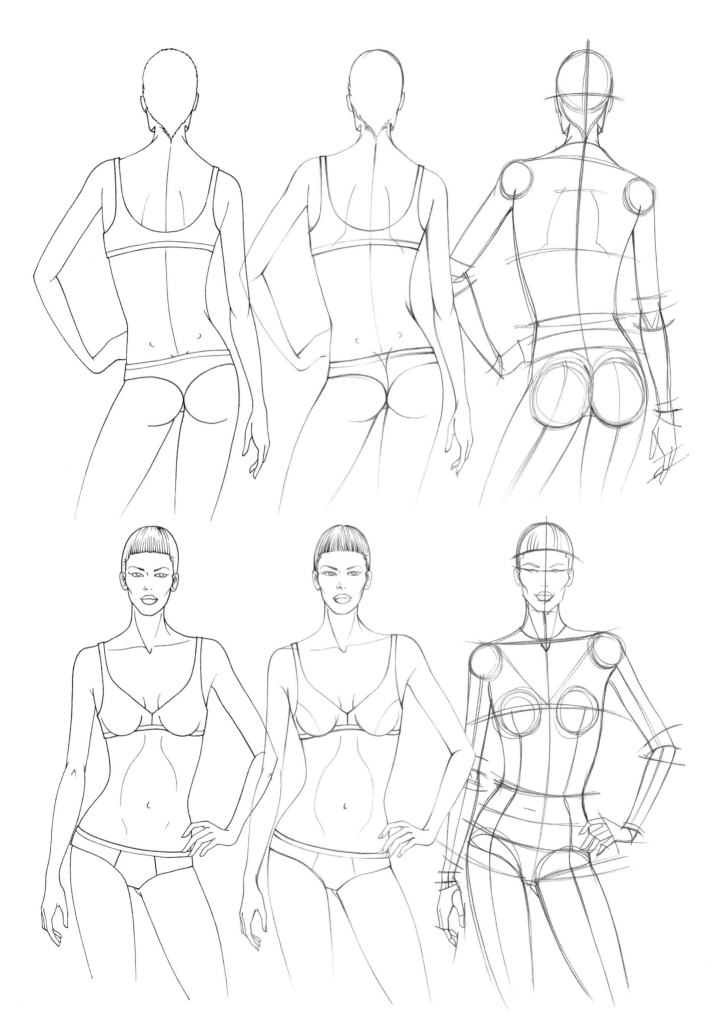

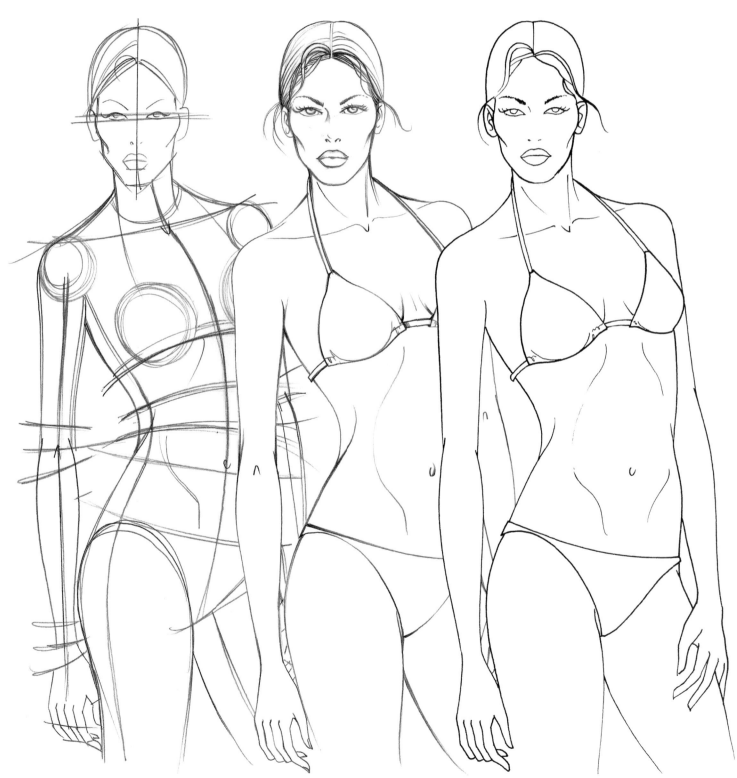

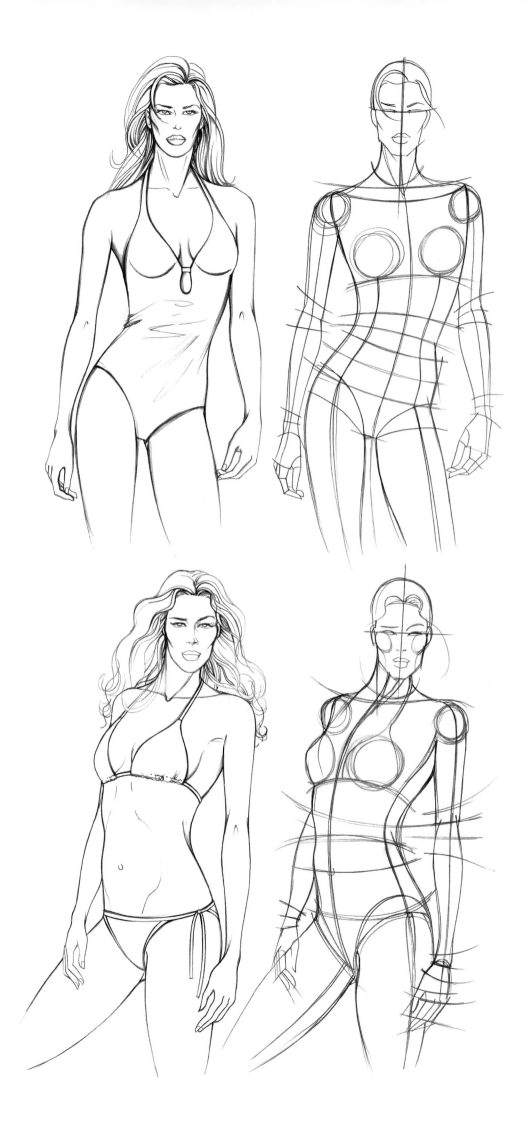

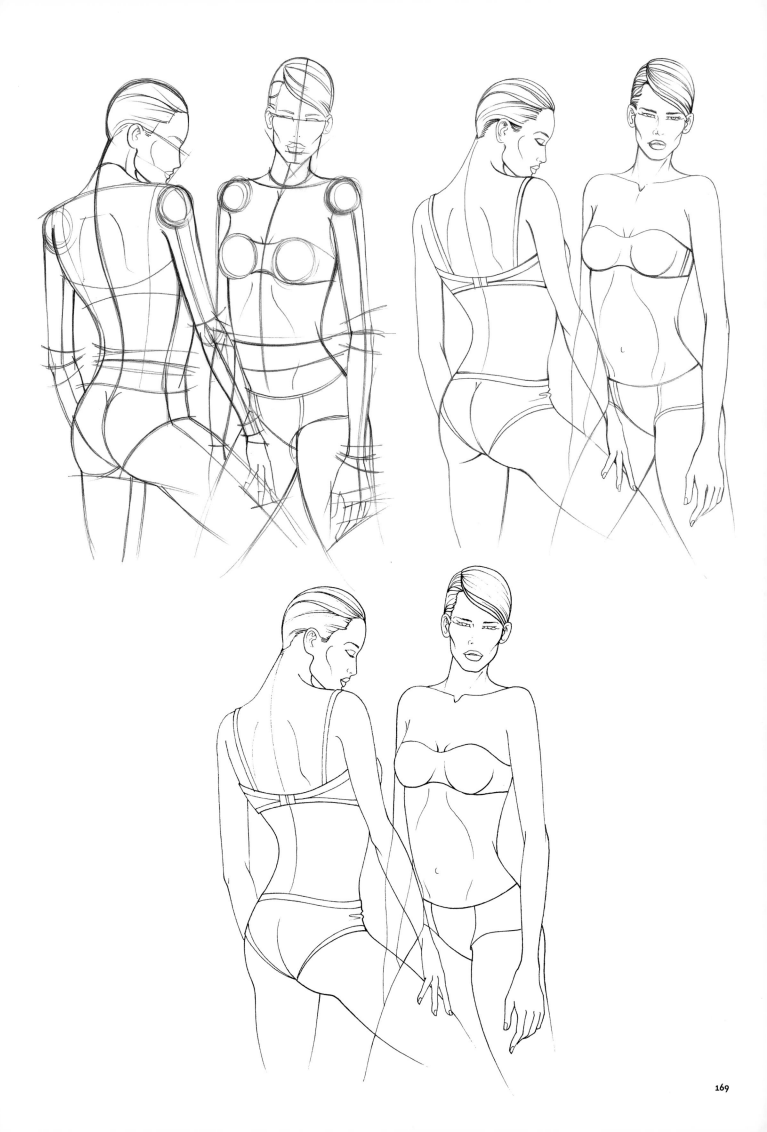

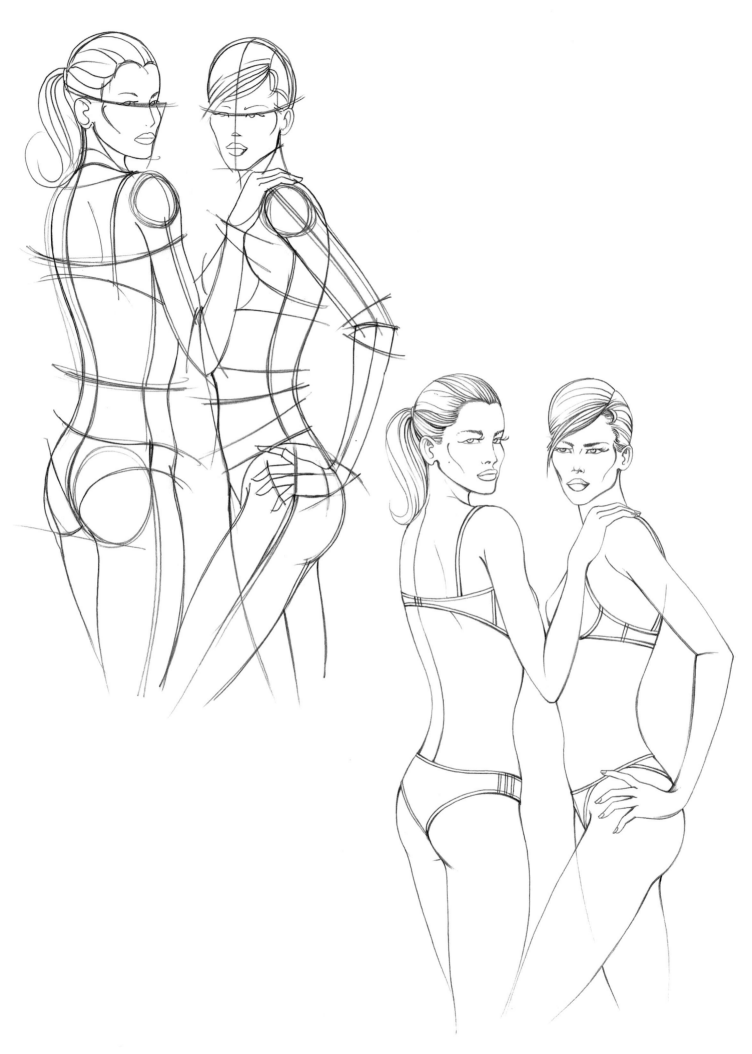

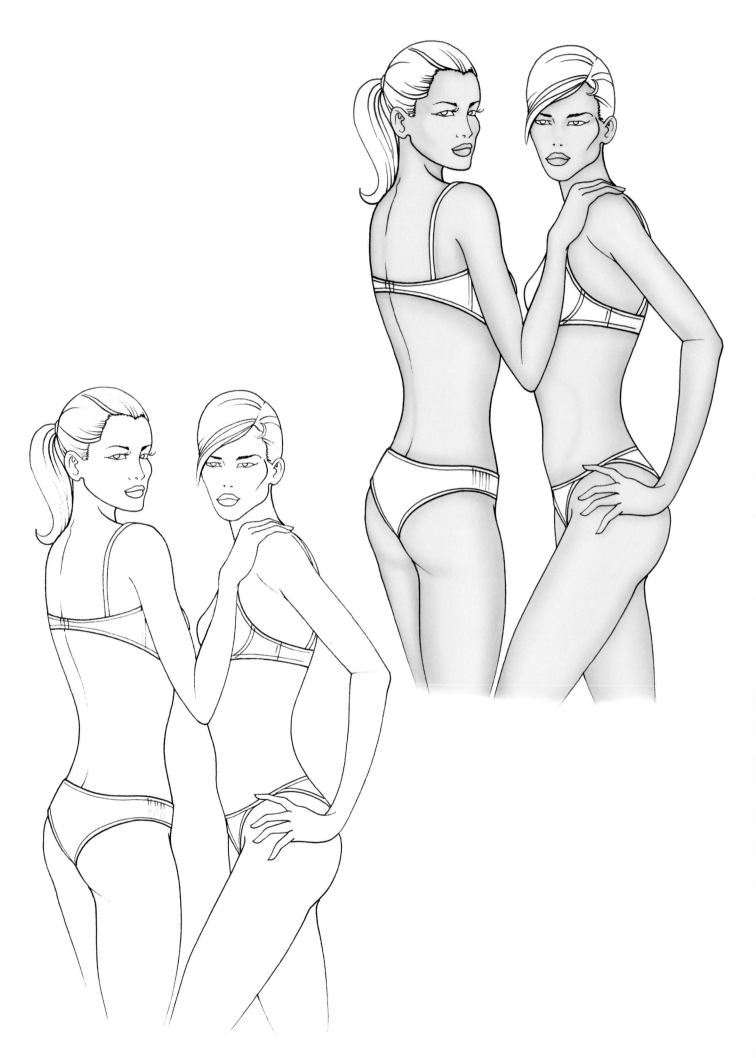

Fifteen complete poses

From rough sketch to drawing

All illustrated figures begin life as a sketch. Once that is complete, it is traced with 02, 05 and 08 felt-tip pens, and then coloured in on the computer or by hand. For hand colouring, we recommend using Pantone Tria markers.

To accentuate the texture and softness of the skin, areas to be darkened can be gone over again using Pantone markers or pastels.

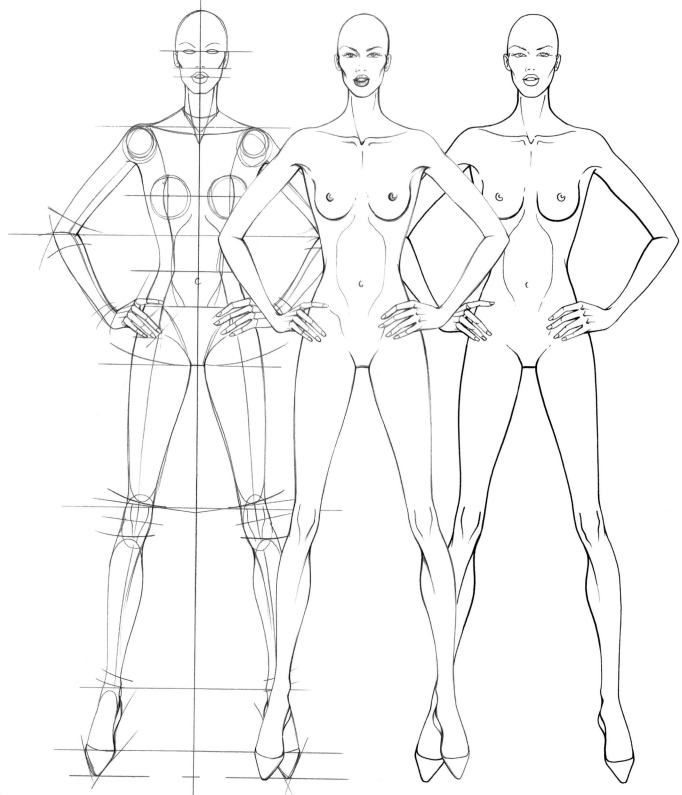

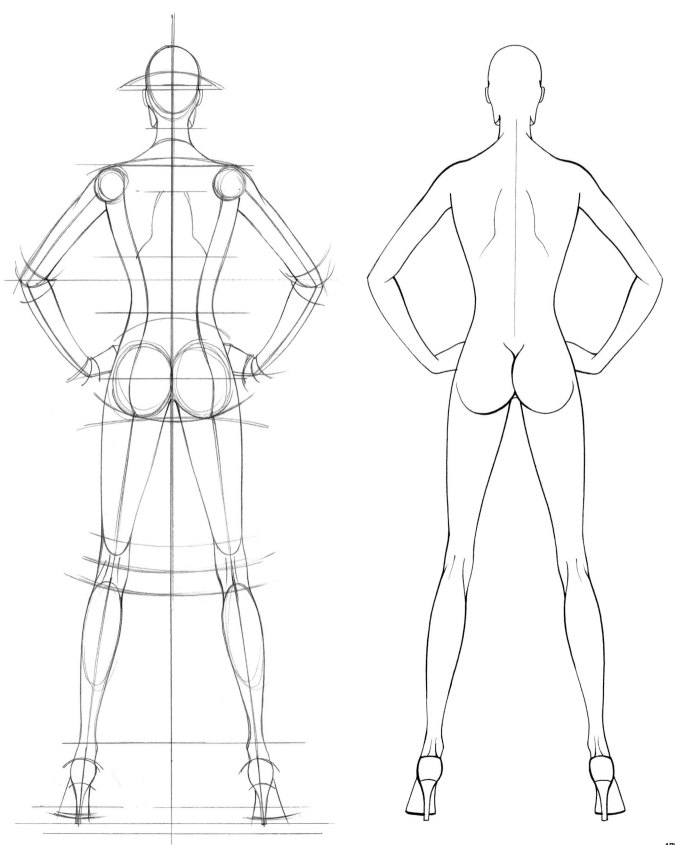

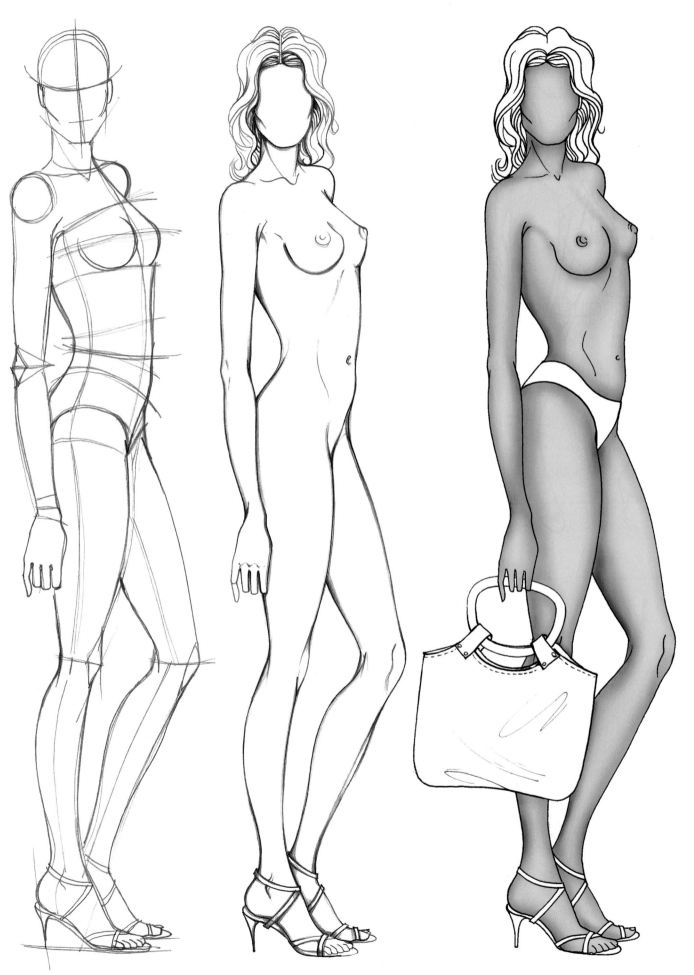

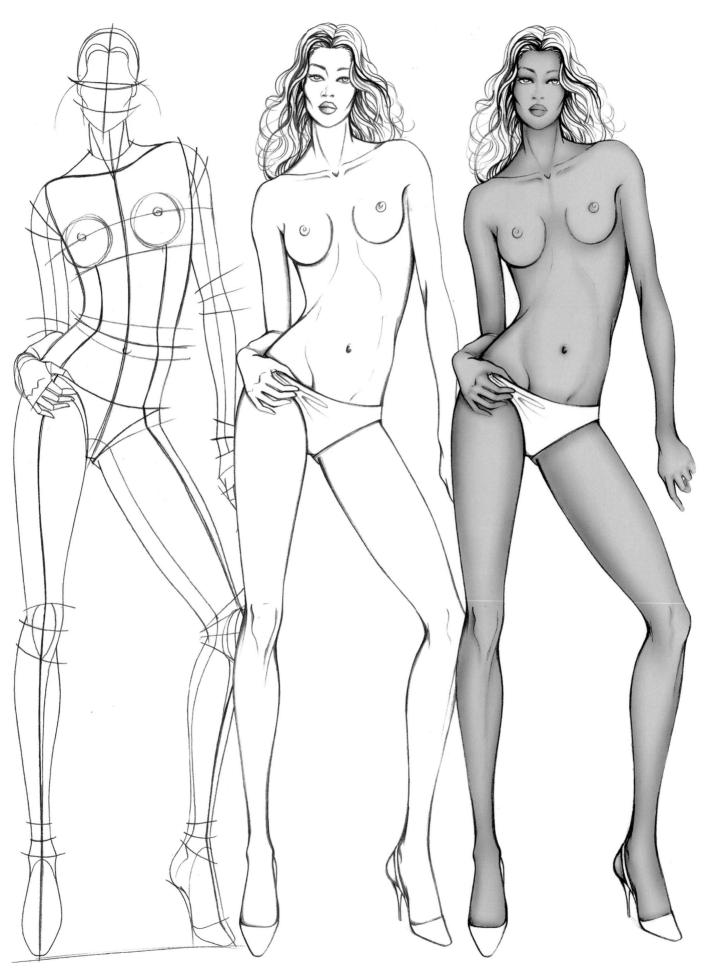

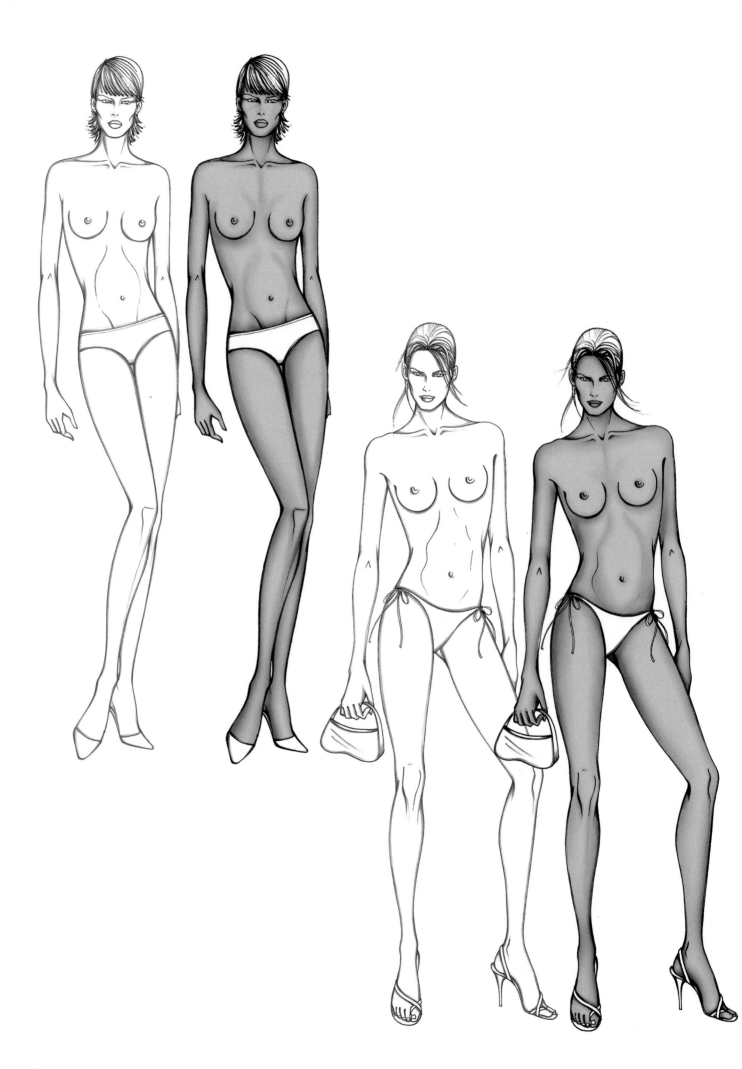

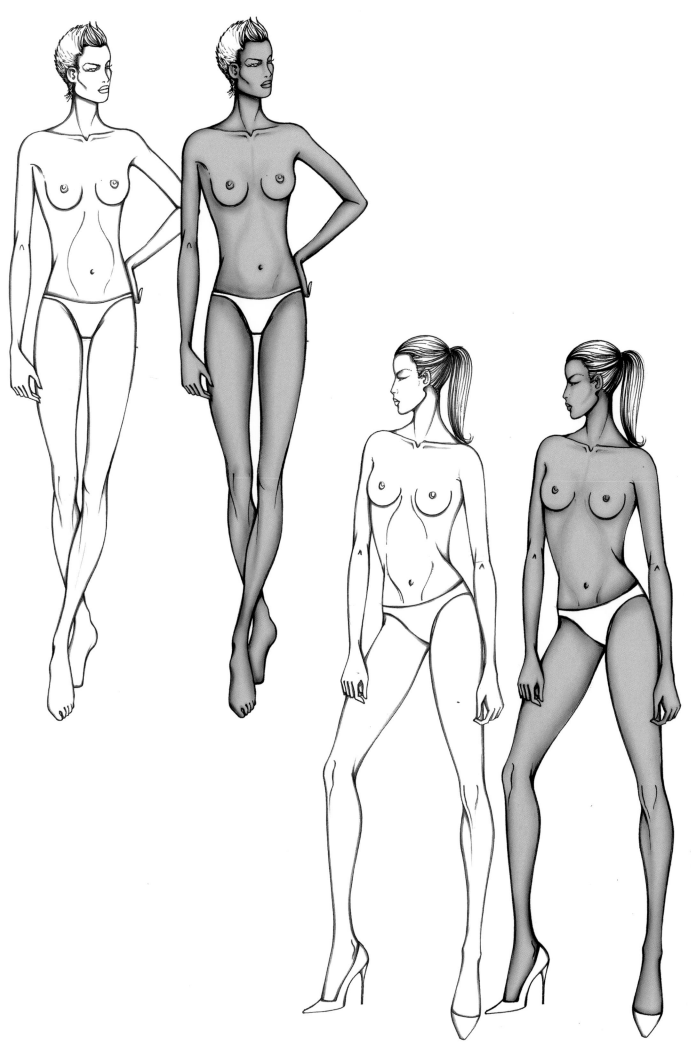

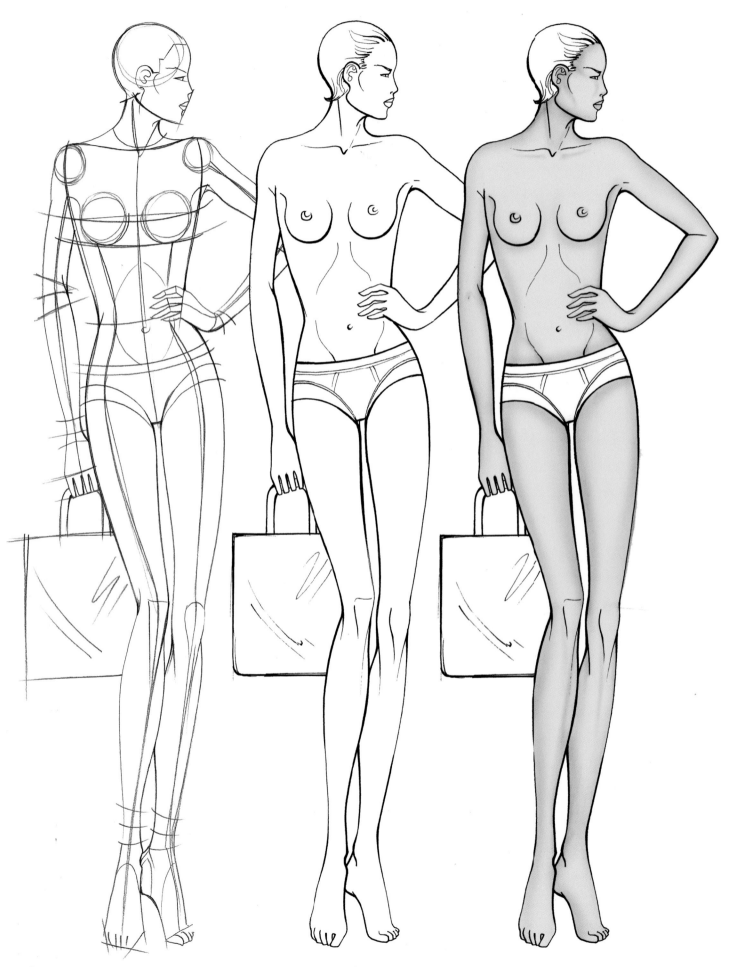

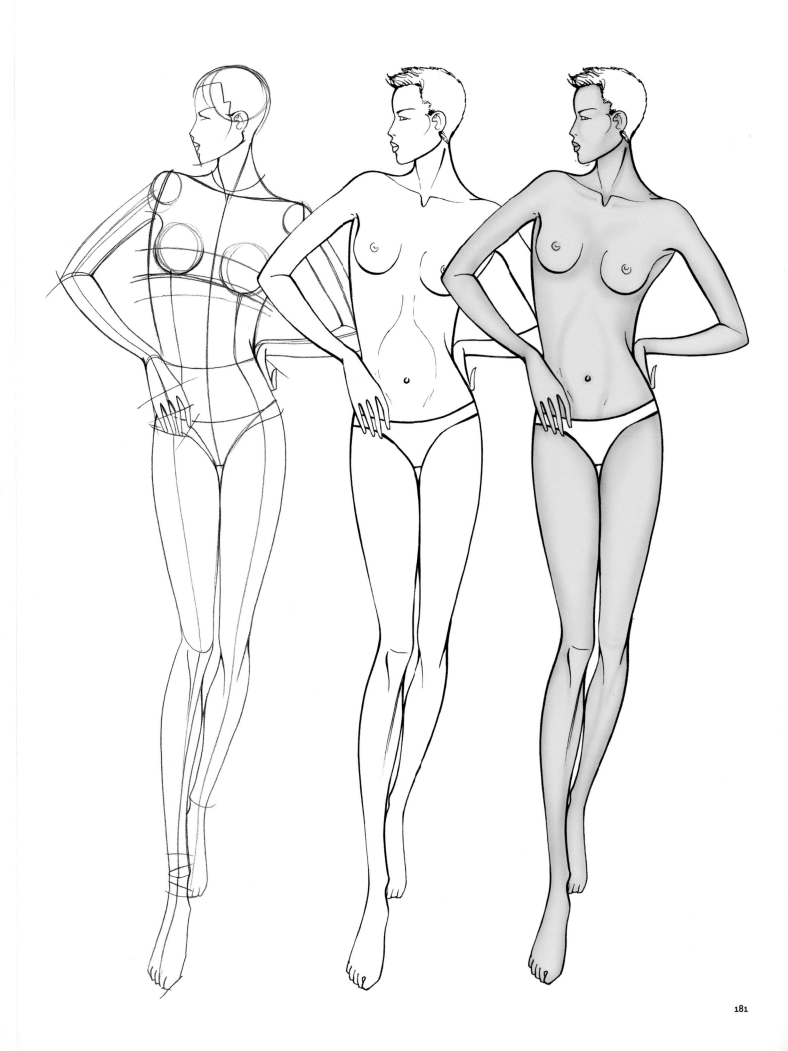

Adding colour

Pencil and colour techniques

Before we begin discussing this fascinating topic, we should point out that design drawing techniques are normally more pared down than those used for fashion drawing, as a quick pencil or felt-tip pen sketch is often all that's needed when creating a collection of samples. Fresh and fast colour techniques will also have to be applied to indicate the various tones in patterned and solid colour fabrics. The ten illustrations included in this chapter provide a small example of the different pencil and colour techniques used for the purposes of study and in business. Each image indicates the type of technique, with specific reference to the tools used. The same figure was used in all the illustrations to show how much the same image can vary just by changing the technique.

This is another exercise that you should keep practising. Always begin with pencil and work up gradually to colour.

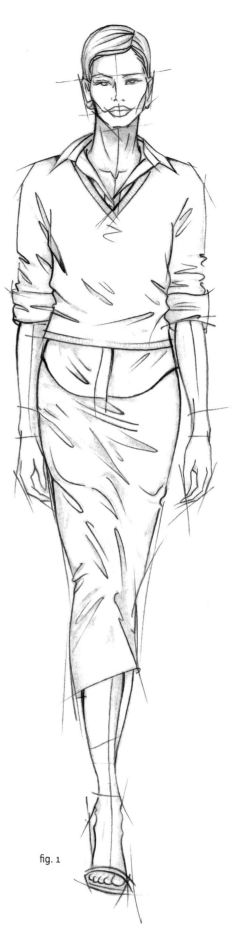

fig. 1

fig. 1 Basic sketch done with a 2B pencil, with quick, linear strokes. The movement folds are essential and three-dimensional. For all the subsequent drawings, the basic drawing was traced using a 2B mechanical pencil. Photocopies and a light table can also be helpful.

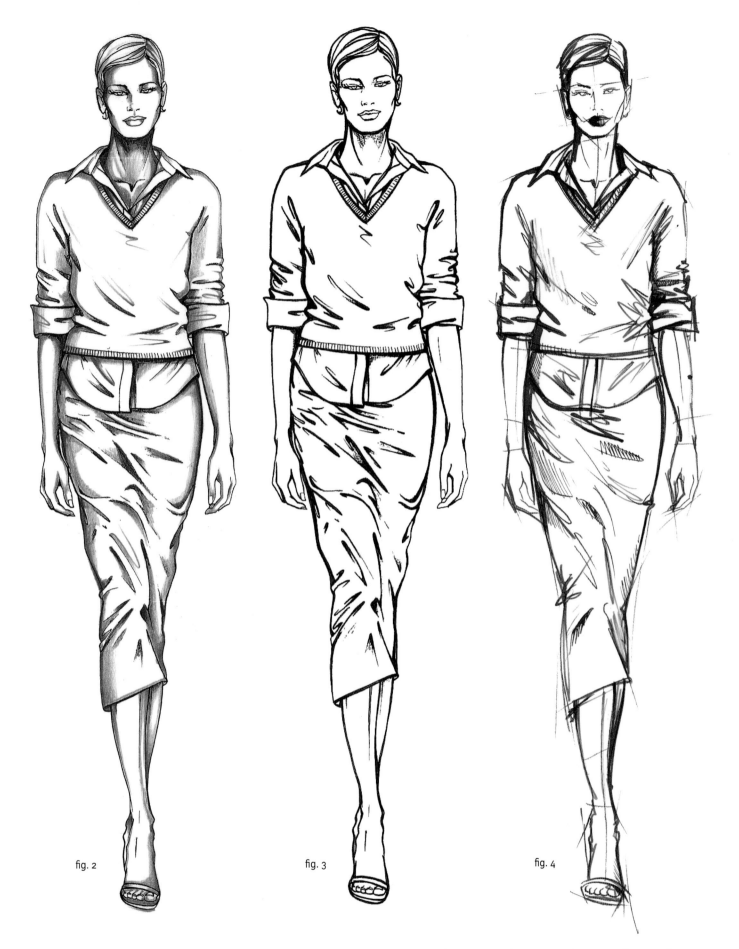

fig. 2 Sketch drawn using a 2B and a 3B pencil. A little more shade is added to flesh out the figure. The stroke is thicker and the shading darker to indicate greater depth.

fig. 3 Sketch drawn using a fine and a medium permanent black felt-tip pen. Ordinary felt-tip pens will do.

fig. 4 Sketch drawn using Indian ink and dip pen. You will produce some extraordinary strokes by varying the pen nib, but a skilled, steady hand is needed as these strokes cannot be erased.

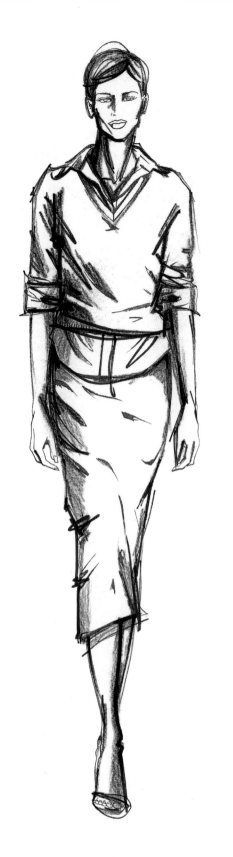

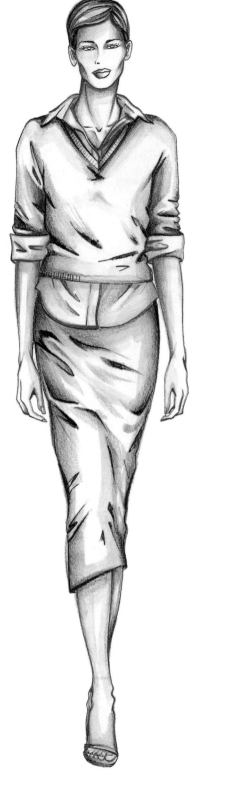

fig. 5

fig. 6

fig. 7

fig. 5 Sketch drawn using an 02 black felt-tip pen for the base, plus charcoal pencil. Take care while drawing with charcoal as it can be very messy.

fig. 6 Sketch drawn using an 02 felt-tip pen for the base, finished off with brush and black Ecoline. Ecoline are liquid watercolours that come in glass jars ready for use.

fig. 7 Sketch drawn using a 2B mechanical pencil for the base, plus burgundy and primary red pastels (not water soluble). As you can see, just enough colour is applied to highlight the contours.

fig. 8 Sketch drawn using a 2B pencil for the base, but an 02 black felt-tip will also do. Grey and pale blue Pantone Tria markers are used for the clothing. Pastel light and shade is added in the overlapping layers, in the same shades as the felt-tip pen.

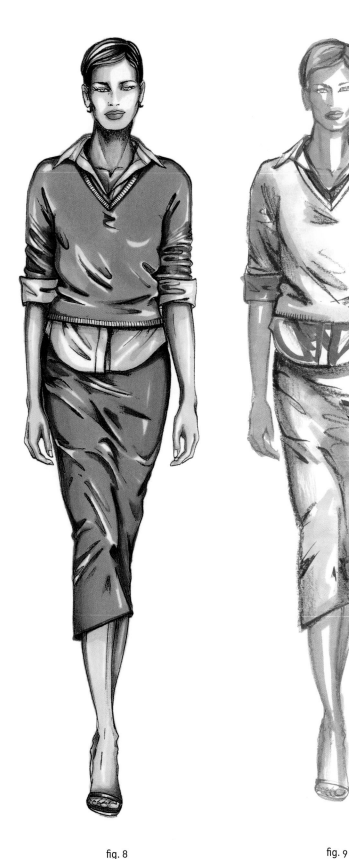

fig. 8

fig. 9

fig. 10

Pantone Tria markers are a very effective illustration tool, available in an extensive range of tones and colours. They also have the added bonus of not showing the joins between colours. They are very popular with fashion illustrators because of their malleability.

fig. 9 Sketch drawn using an ochre pastel for the skin, plus water-soluble wax crayons to colour the clothes. After applying the colour, it may be necessary to redefine the contours of the figure using a pastel crayon.

fig. 10 Sketch drawn using a 2B mechanical pencil for the base, plus ochre Ecoline for the skin, and pale blue and yellow for the clothes. When the first coat of Ecoline is dry, the movement folds are highlighted in a more intense shade of the same colour, using a very fine felt-tip pen. Once that is done, the contours are finished off while holding the pen vertical and pressing very lightly to obtain a very fine stroke.

Now try copying our images, repeating the same technique several times.

Ecoline and watercolours

normal and water-soluble pastels

pencil shading

charcoal

wax crayon

Pantone colours

water-soluble wax crayon

Indian ink and dip pen

Chapter 3

Fashion design

Modern fashion

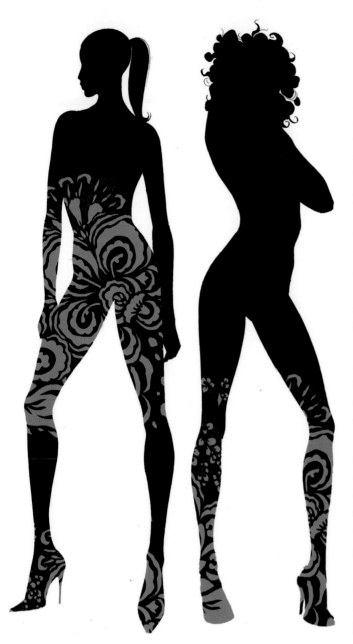

René König, (1906-1992, German sociologist and author of *A la mode* on the social psychology of fashion, 1967) defines fashion as: 'a fundamental force in social life, that has profound roots in the collective unconscious, not only in wealthy societies, but in all types of civilisation'

The role of fashion in society has increased dramatically over the past century, especially since the end of the Second World War. Fashion houses have grown tremendously, offering a large variety of products to satisfy the constantly changing demands of the market. In the '70s and '80s, the fashion industry came to rely more and more on established 'labels' to publicise their products. As a result, the relationship between designers and industry became more significant and there has been a strong focus on building brand names.

Like many other consumer products, clothing transcends its merely functional role. In addition to simply covering the body, clothes can express an individual's social standing and may be an extension of the wearer's personality, It is evident that fashion is one of the great indicators of social change.

Recent years have seen considerable investment in new technologies that could create ever more comfortable and futuristic materials. 'Intelligent' fabrics, cyber jeans and luminescent and colour changeable yarns already exist. Perhaps the fashion of the future will make more use of high-tech gadgets, such as pockets that flash when an e-mail arrives or a chiffon evening dress that can be rustled up with a remote control...

But this is not a book about fashion trends but a teaching manual, so the examples you find here are used to help you hone your professional knowledge and drawing skill.

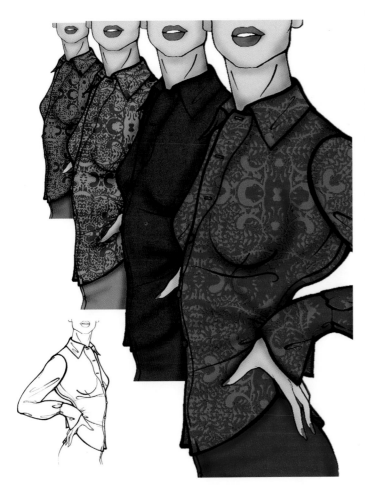

Terminology

Collection
A range of garments presented each season by designers, dress-makers and industries.

Target
Intended use, objective, market or consumer.

Theme
Subject that acts as inspiration.

Print/Pattern
In fashion, the term 'print' refers to images printed onto a fabric or other surface. 'Pattern' refers to a decorative motif that is repeated on the surface of the fabric. An 'all-over pattern' is one that covers the entire surface of the fabric.
A placed design is one located at a precise point on the garment, e.g. on the front centre, on the sleeve, on the trouser seam, etc.

Mood
The expression of atmosphere or emotions through form, colour and sound. It is usually displayed on 'mood boards', covered with a collage of pictures, landscapes, architecture, travel souvenirs, samples of fabrics, yarns, accessories, etc. It is the input behind a collection, and is used as the basis for researching trends.

Trend
The direction in which style is developing; what is currently in favour and what is expected in the near future.

Look
The look or line refers to the general style of one or more garments within the same fashion trend. The cut, volume, fabrics, trimmings and accessories are similar within the same look or line.
On pages 194-199 are three very different styles: the first ('new romantic') is very feminine, the second ('city') unisex with jackets and trousers, and the third ('sport and leisure wear') young and dynamic.

Catwalk of basic garments

A basic garment is one that has been simply cut without any additional design features. It may be smart or casual, depending on which fabrics are used.

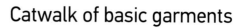

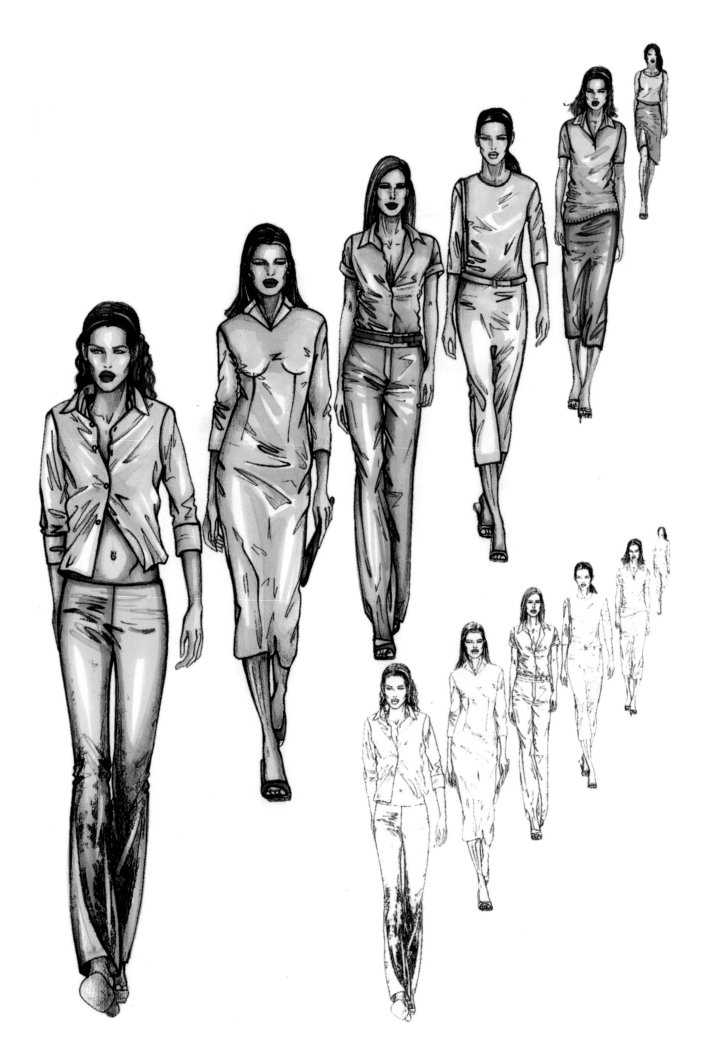

Focus technique

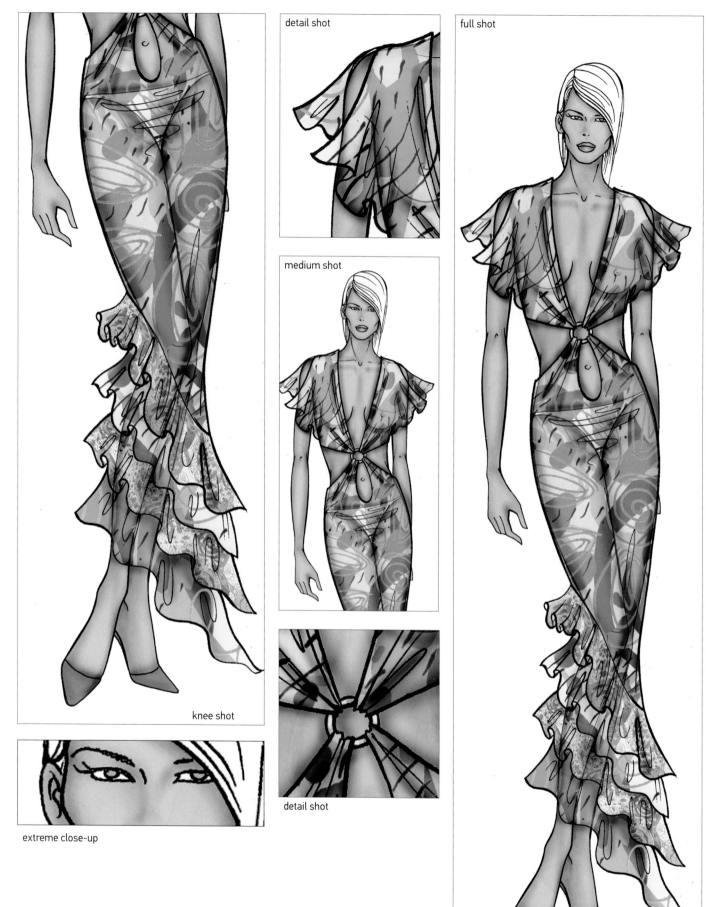

detail shot

full shot

medium shot

knee shot

detail shot

extreme close-up

medium shot

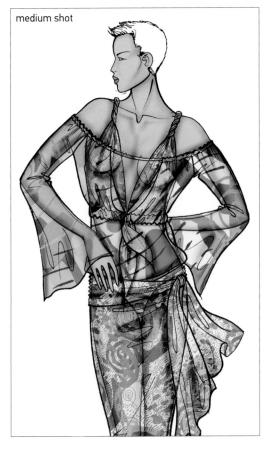

close-up

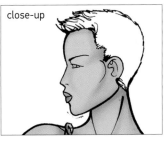

detail shot

full shot

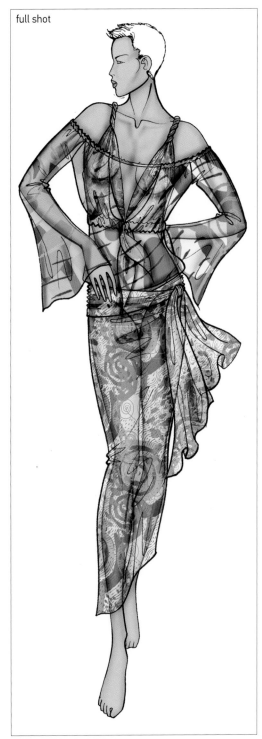

detail shot

City - a new twist on a man's suit

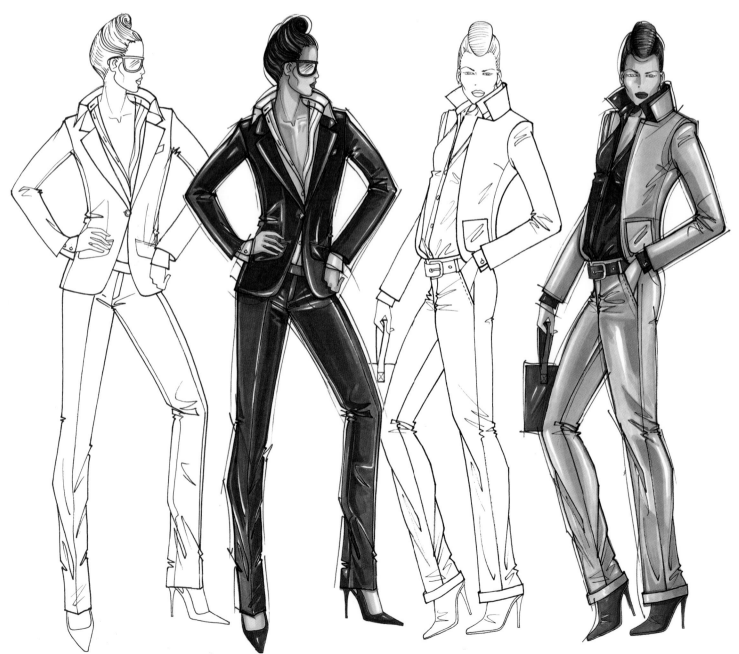

Sport and leisure wear

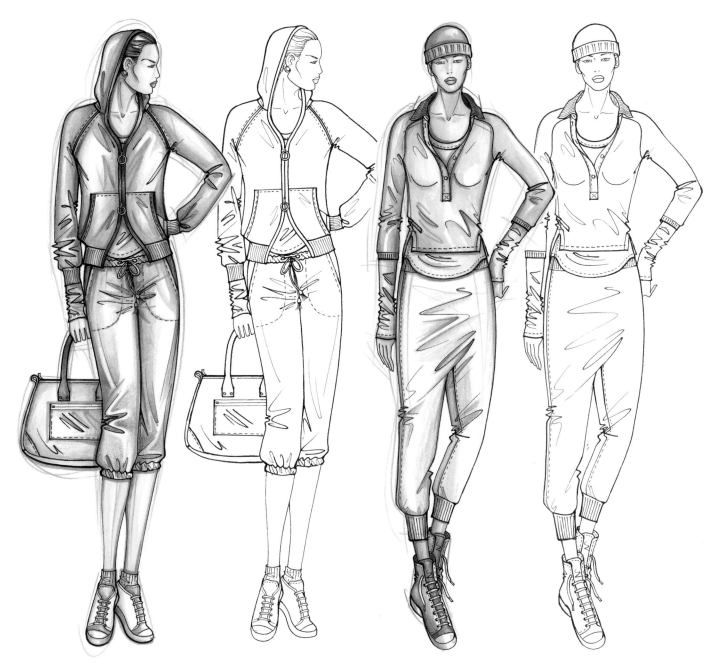

Sportswear

Sportswear needs to be drawn in dynamic poses, as shown in these illustrations. Begin with the basic drawing using a 2B mechanical pencil. Then trace the drawing using either a light table or tracing paper. Use 0.2 and 0.5 felt-tip pens for the outlines and a medium tip permanent marker for the darker lines and shades.

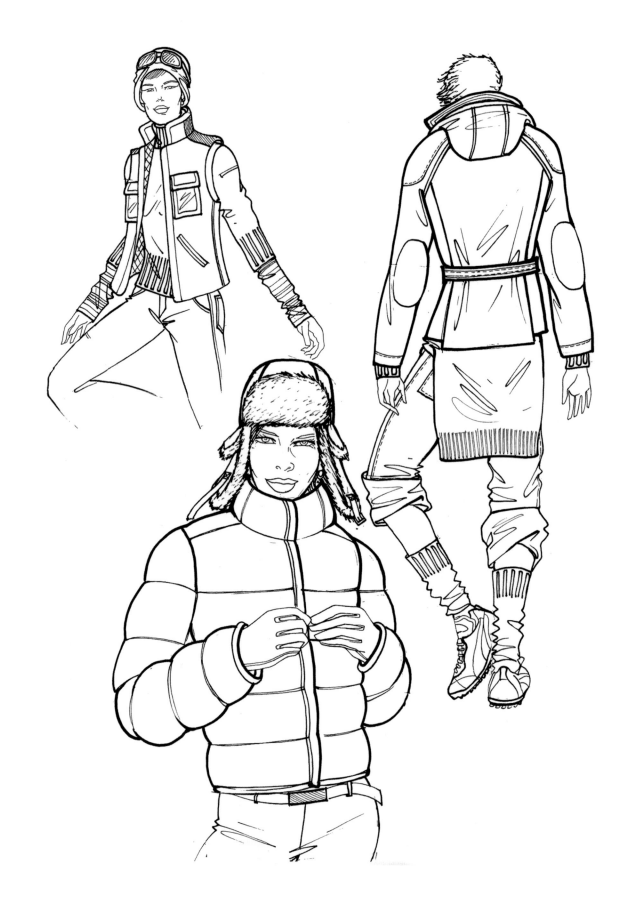

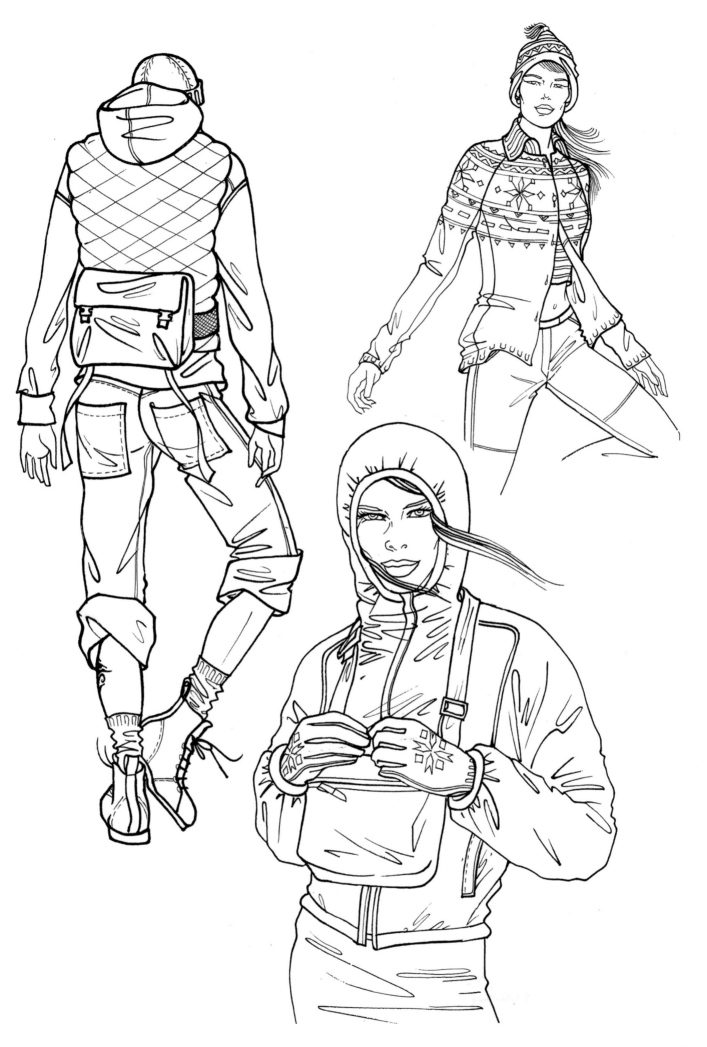

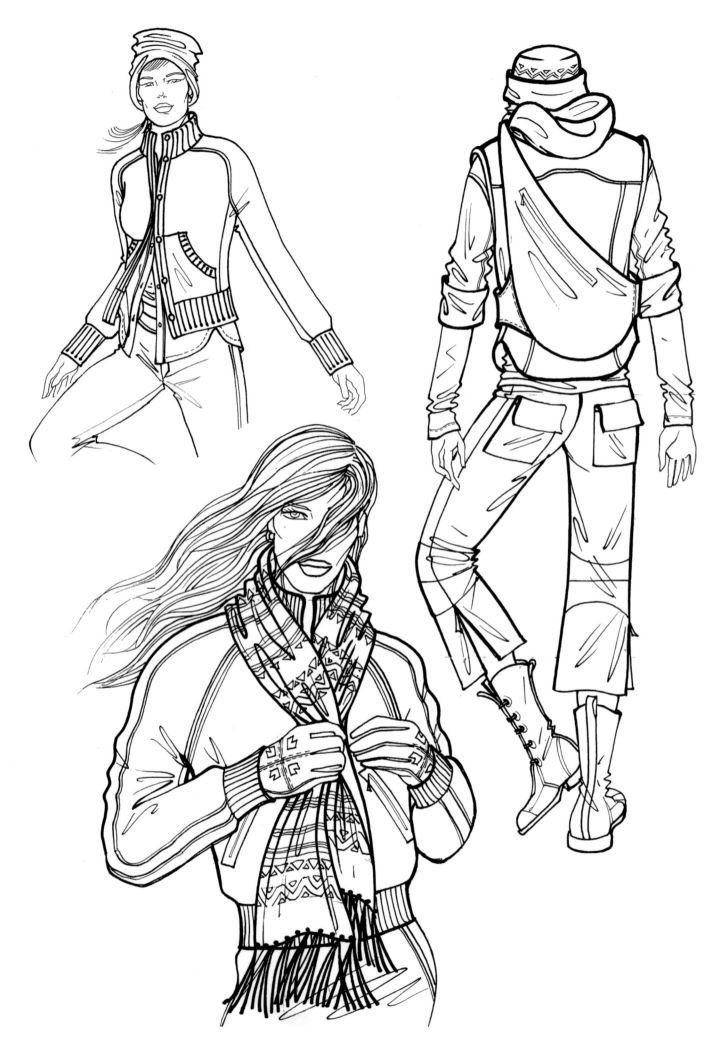

Lacing and drawstrings

Lacing and drawstrings can be used to drape and give movement to clothing, as well as to anchor the fabric in all sorts of ways. They are very useful techniques for a primary design process, as you can start with existing clothes and alter them as you wish. Start by using a basic garment, then cut, replace, shorten and cross over at the anchor points on the body and create a new design by adding lacing and drawstrings. As you practice your skills, don't worry about the fashion content; just concentrate on the best use of lacing and drawstrings.

Take great care with your drawing technique. Drawstrings form little detailed drapes, and the folds are closer set and deeper at the closure points, while lacing must be drawn carefully using neat strokes. Go back over the section on folds (pages 119-145) to remind yourself of how they should be drawn.

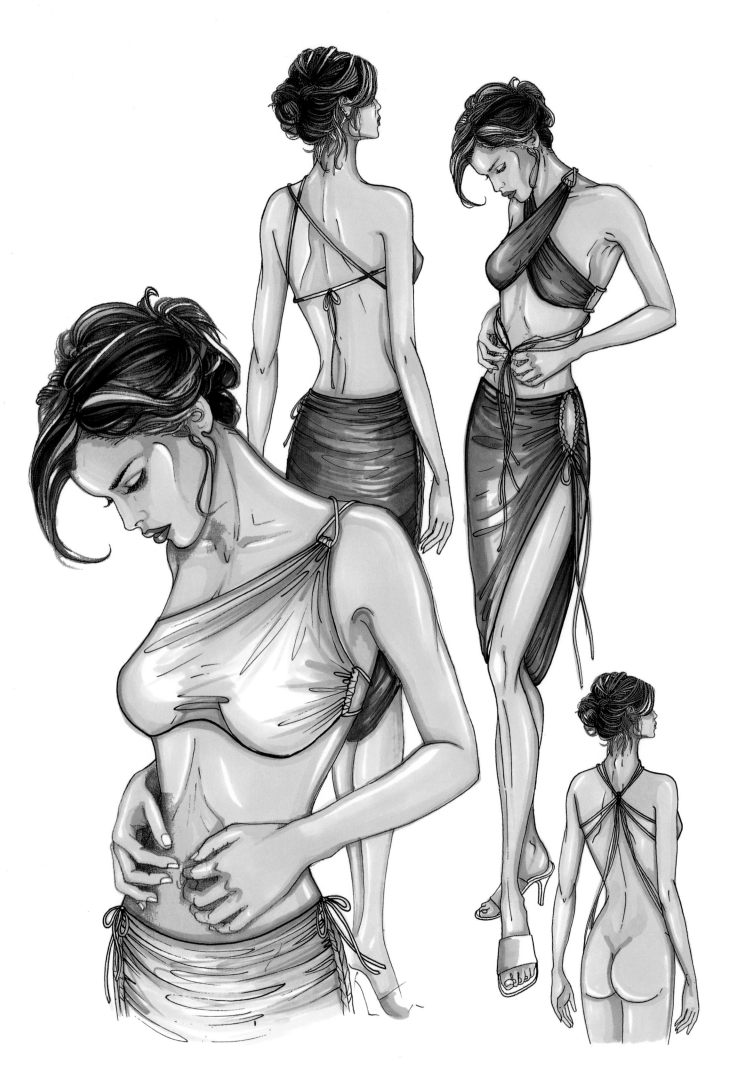

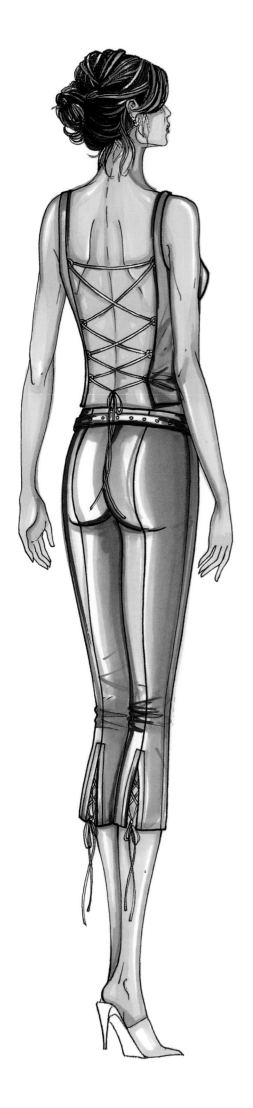
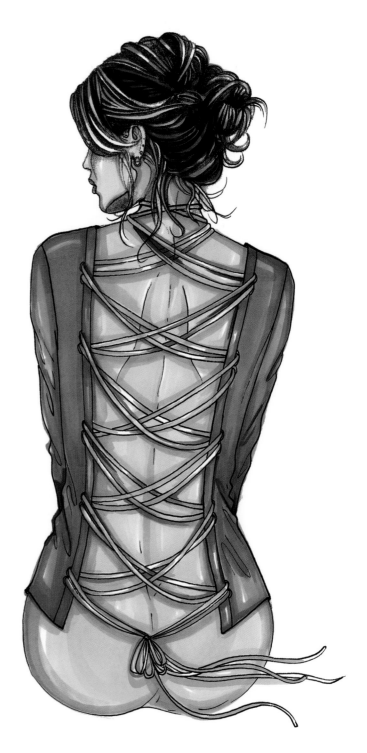

Mini-collections

On the next pages (206-239), we show a number of examples of how to make drawings of clothes that belong to a collection and thus share a theme. The style of the drawings should be in keeping with these themes and each garment must match in with the others in terms of line, fabrics, colours and accessories, and combine with other garments in a number of ways. For example, the same skirt can be worn with a T-shirt, top or shirt from the same collection, and so on. The themes illustrated here are: 'Gypsy', Marock ' Roll', 'Native American', 'Floral', 'Op Art', 'Jewellery' and 'Lace

and Chains' - they progress from very youthful en sensual to quite formal and elegant. You can practise by adding your own designs to the mini-collections, while keeping to the initial style.

The nudes in this section were drawn with a 2B pencil and coloured with Pantone markers and coloured pencils. The clothes were done with pencils, F-tip Staedtler pen and 0,2 rapidograph. The elements were combined, elaborated and colour-adjusted in Photoshop®.

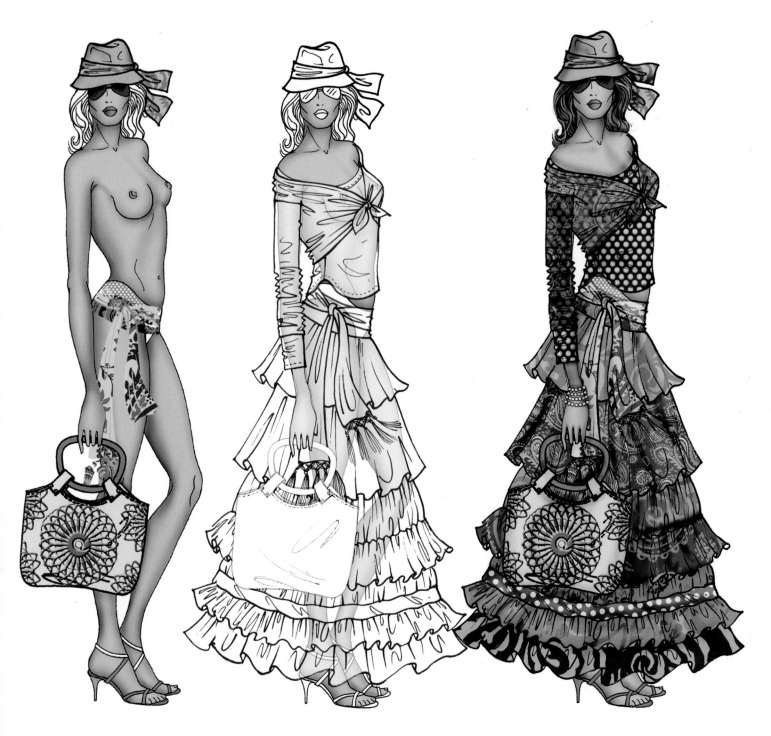

Gypsy

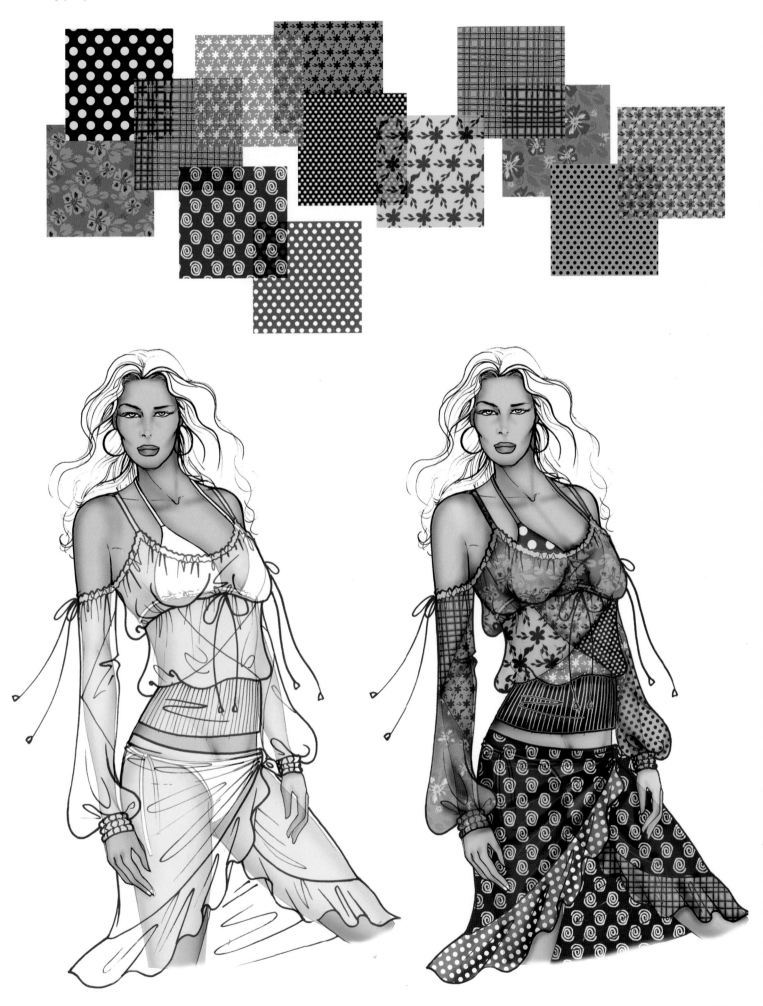

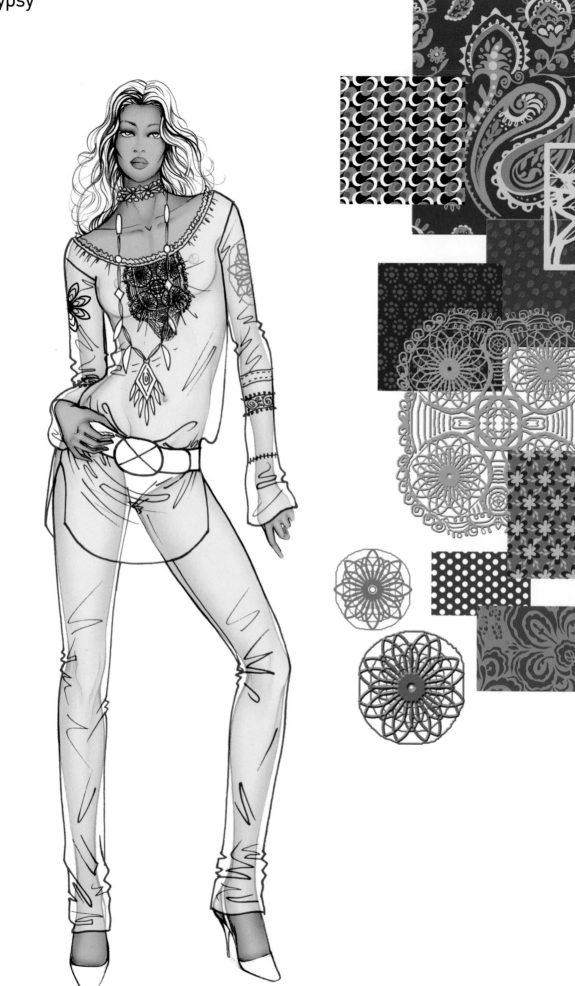

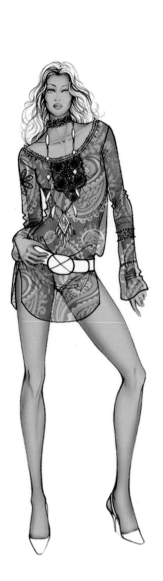
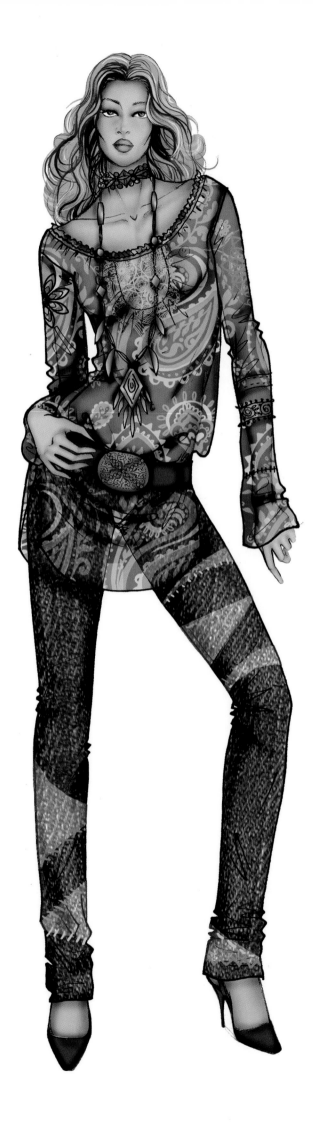

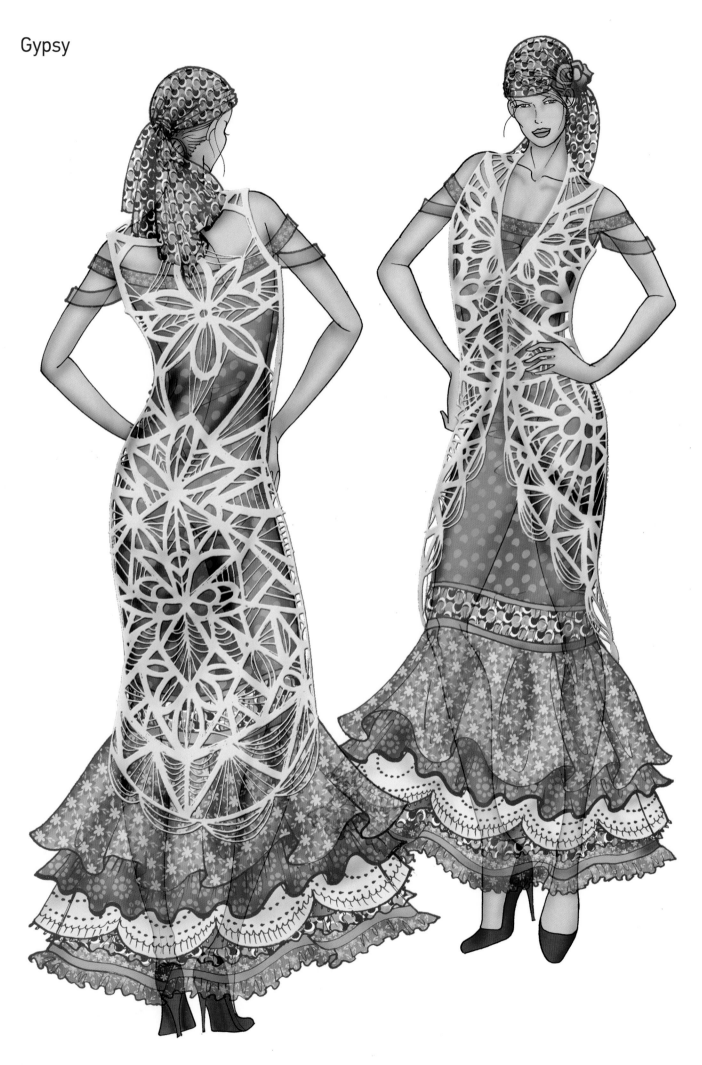

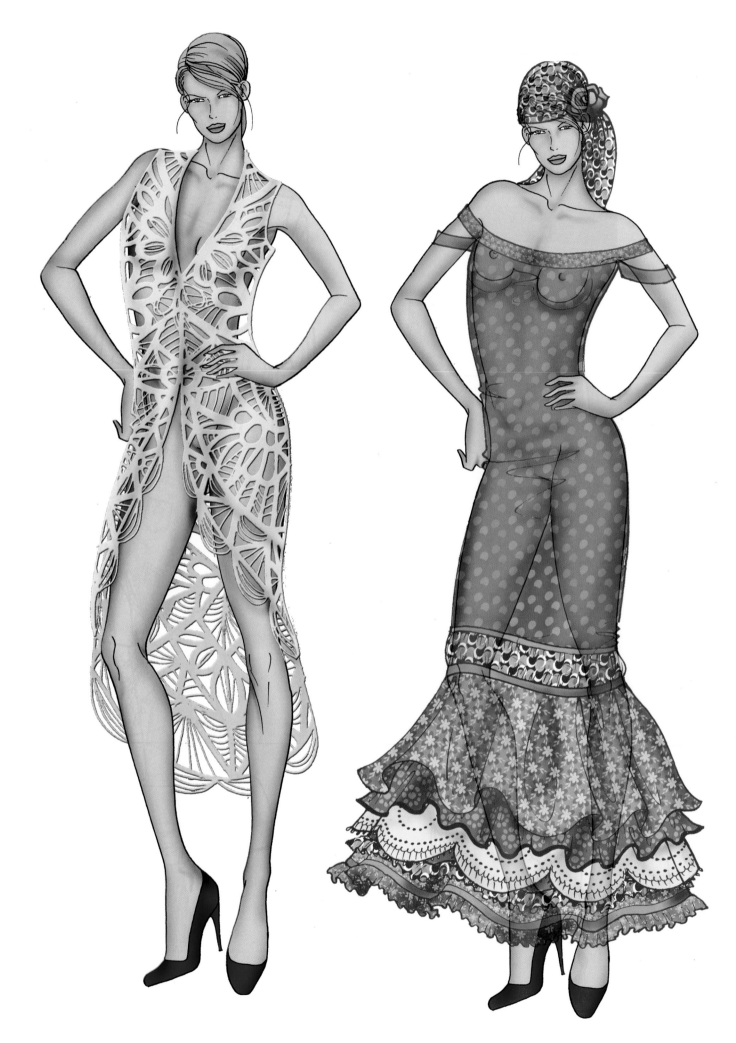

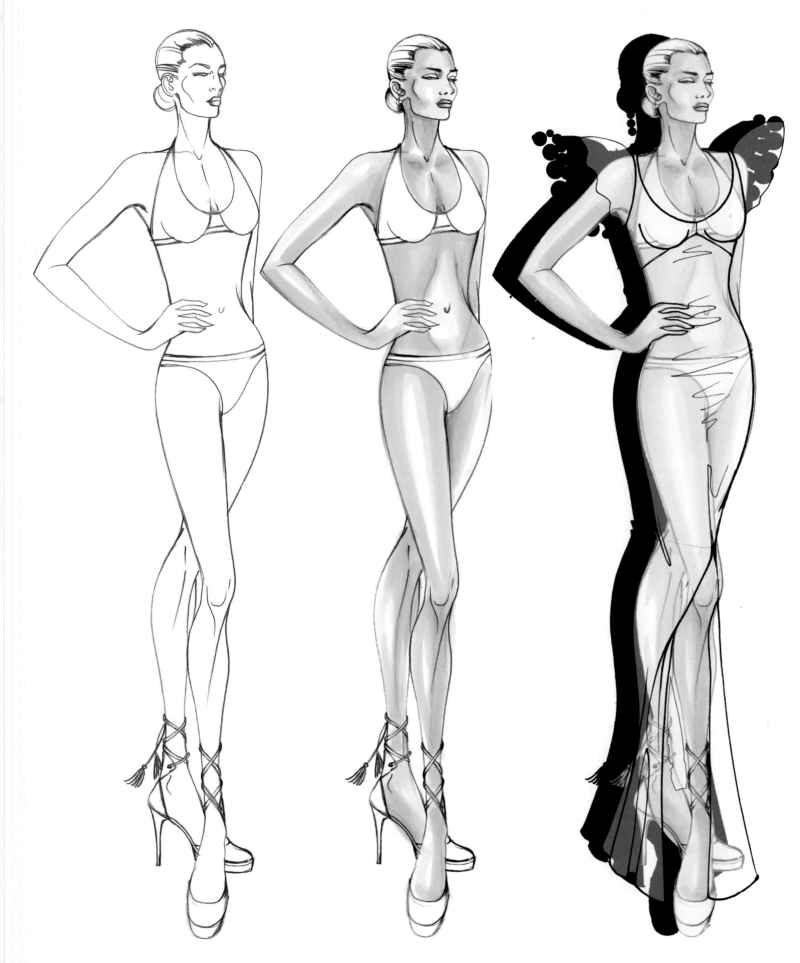

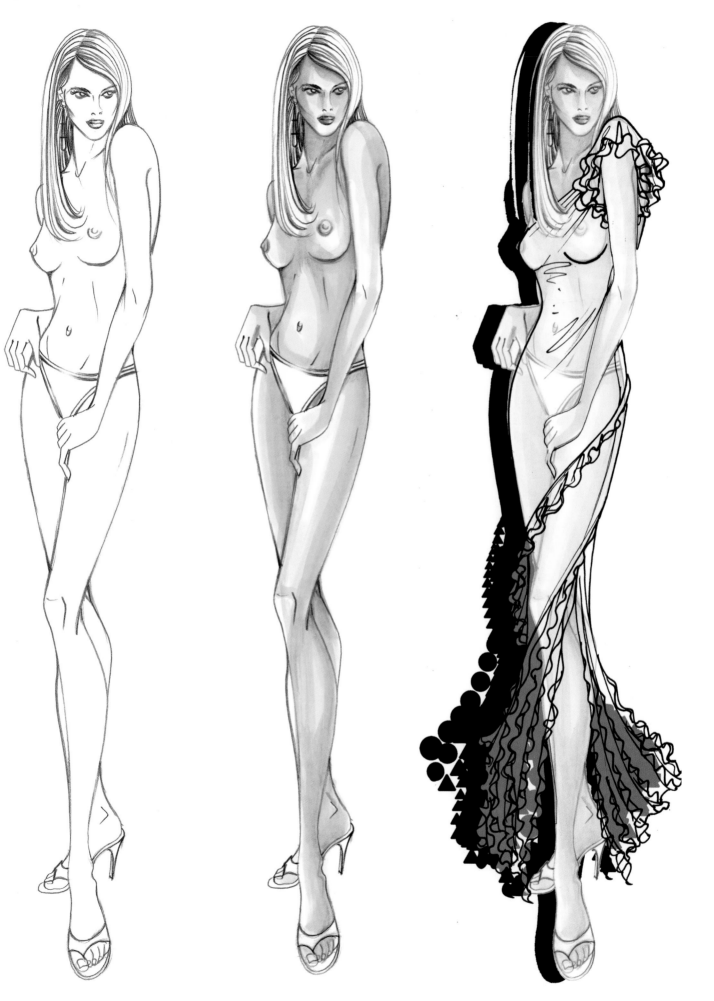

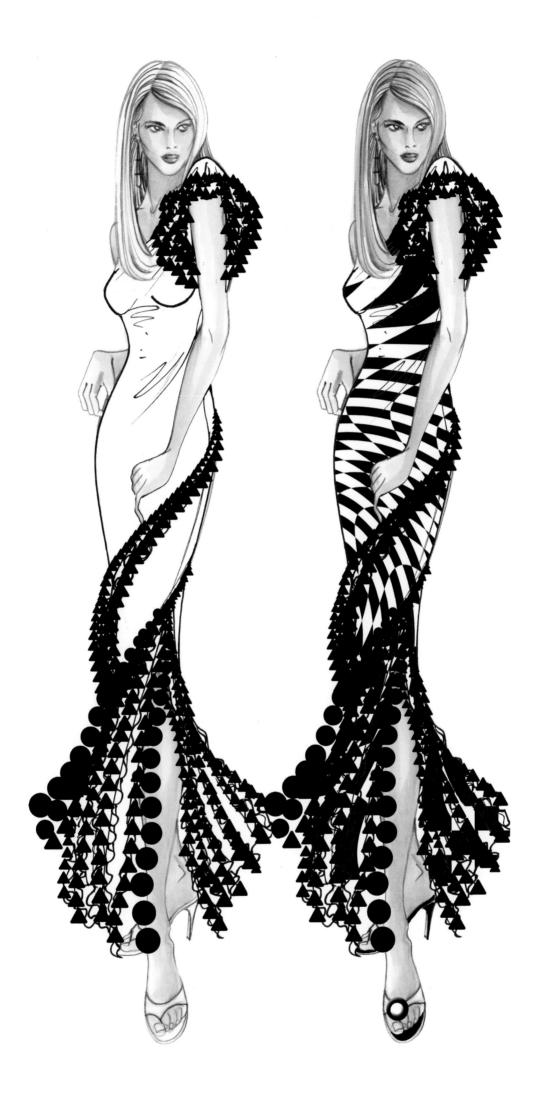

Jewellery

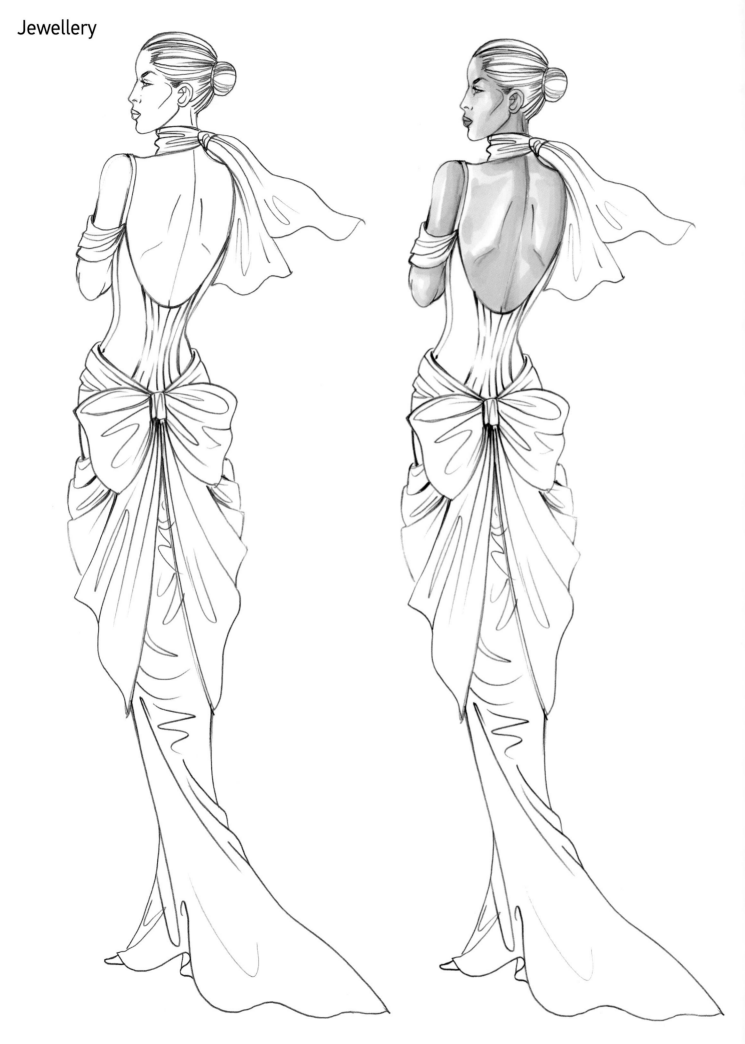

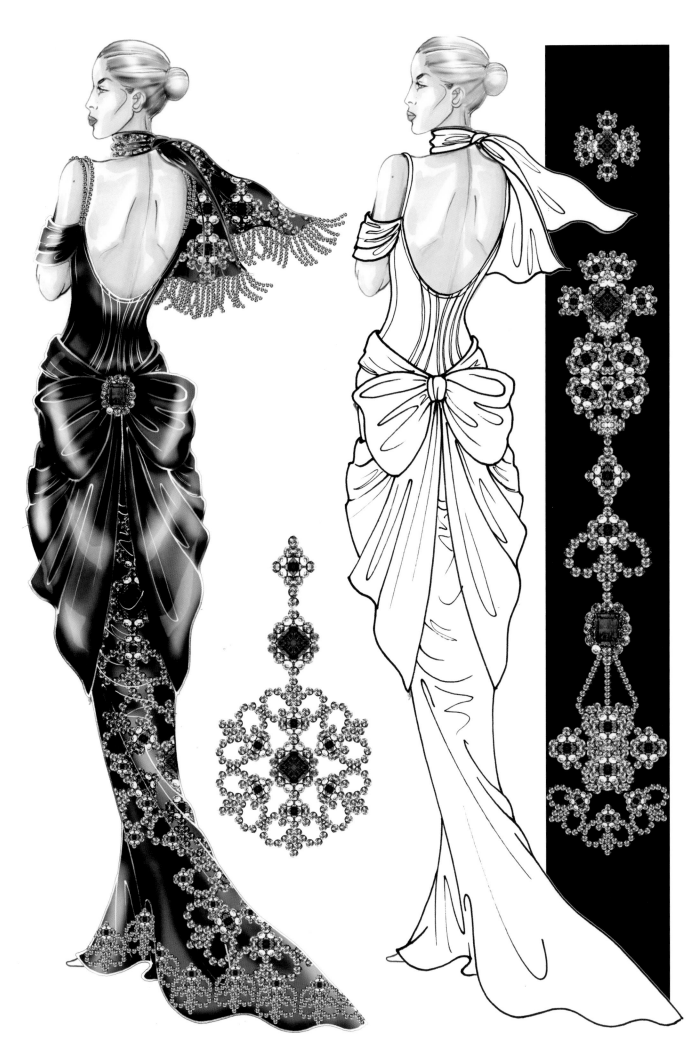

229

Lace and chains

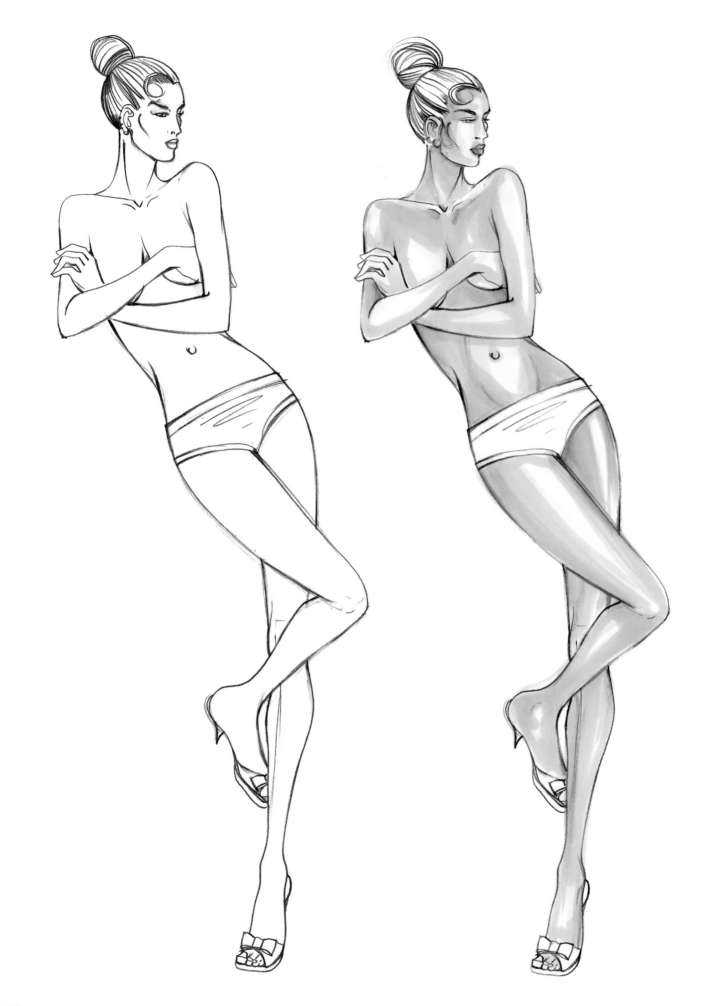

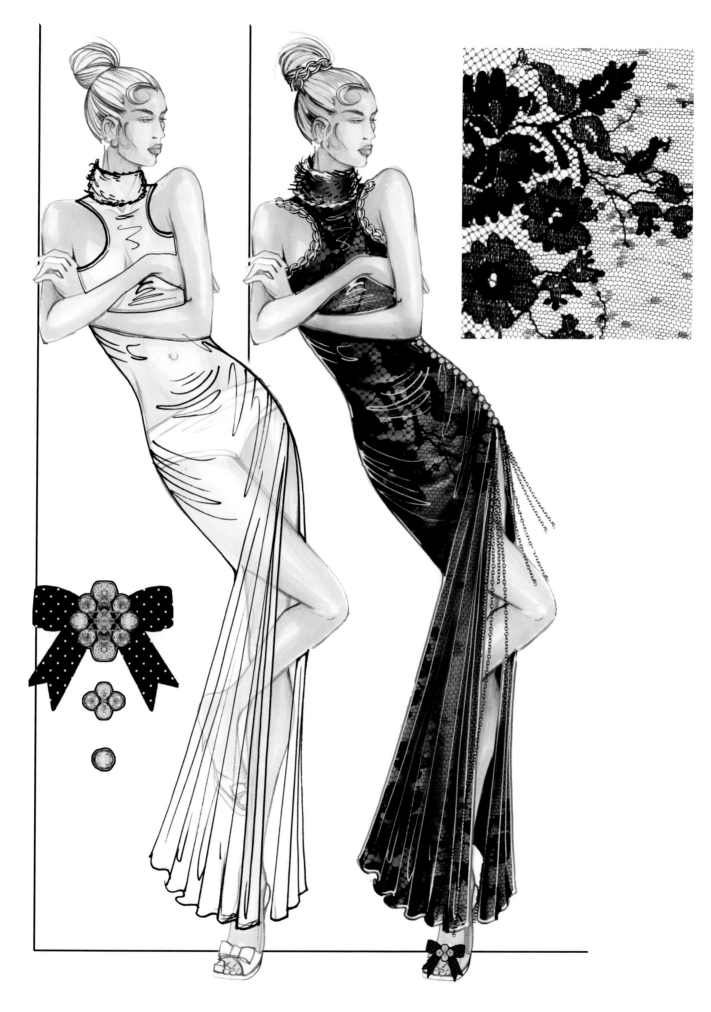

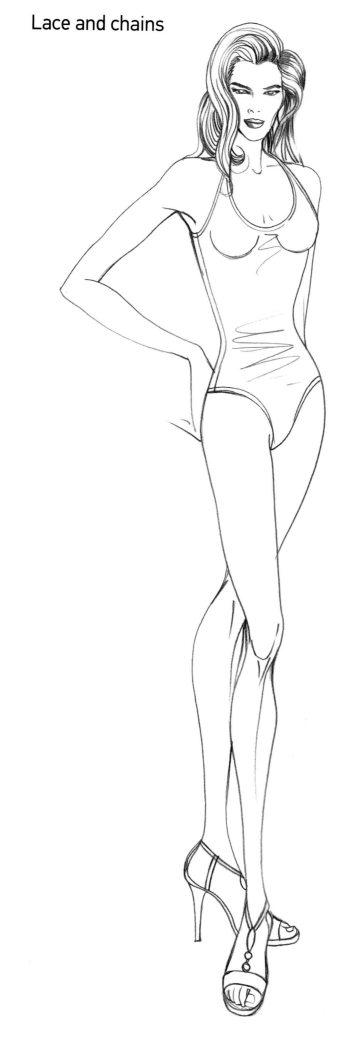

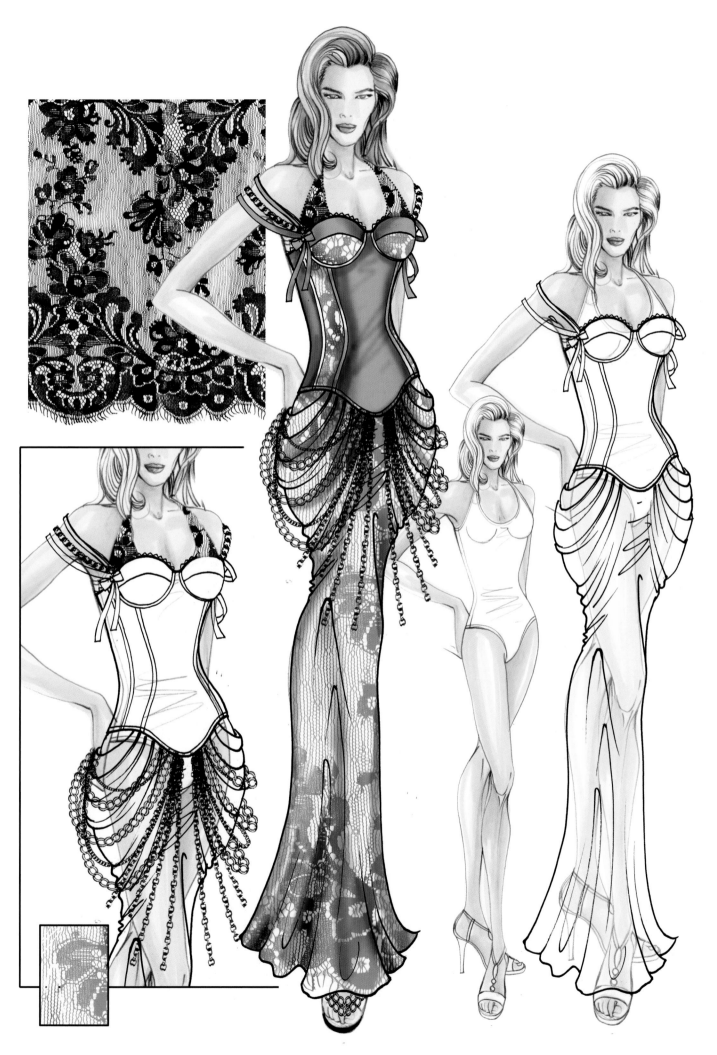

Lace and chains

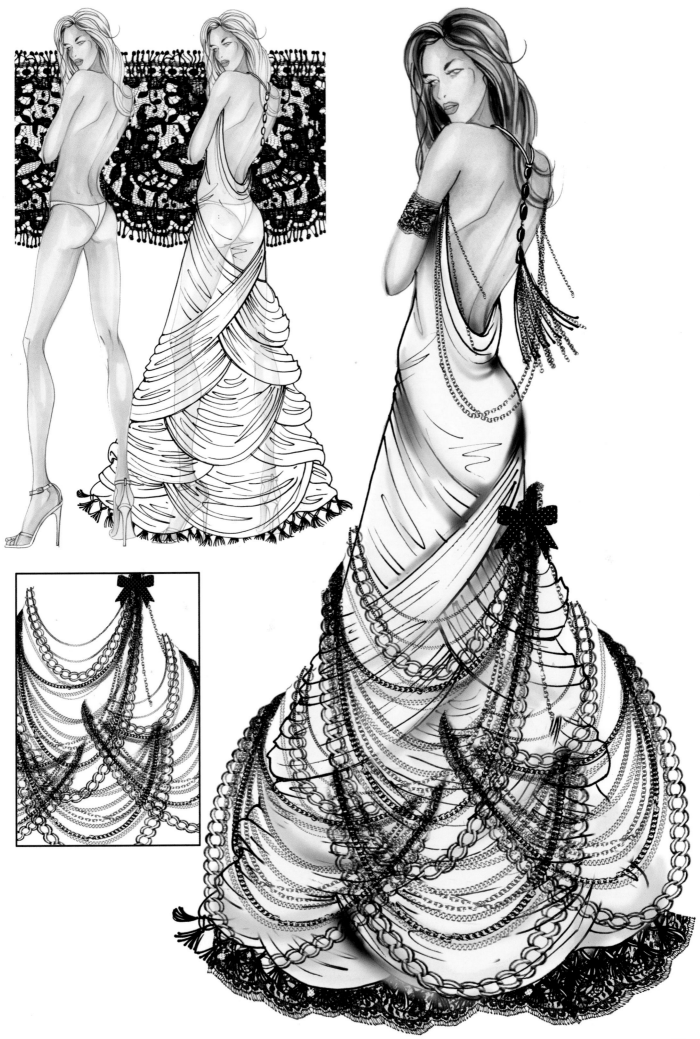

'60s/'70s interior elements:

1 framed pictures
2 lounge chair
3 stool
4 lamp
5 curtain
6 vase
7 fern
8 vase
9 arums
10 table

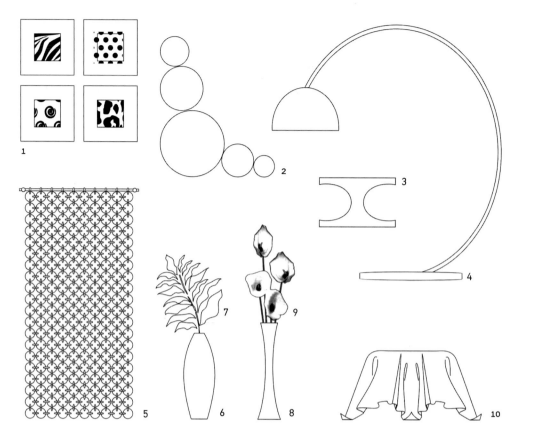

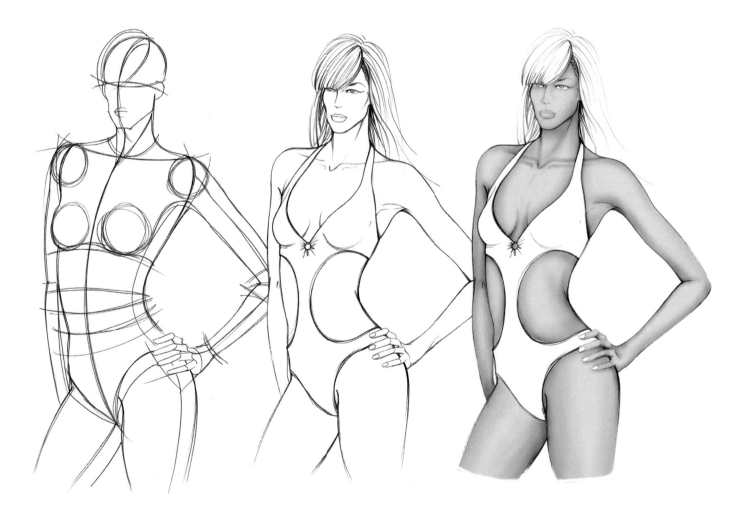

240

Inspiration

Inspiration for fashion design can come from many different sources, such as the decorative arts from other cultures and applied art and design from other periods. For this section, we have chosen interior design of the '60s and '70s.

To see the link between interior design and fashion, simply imagine that dressing a room is like dressing a body. In reality, of course, it's not that simple. But to help you begin thinking about the connection, we deal with the subject in a basic way, focusing on the visual process, rather than the conceptual aspects.

Process

The image on page 240 shows typical interior elements from the '60 and '70s, pared down to graphic shapes. Each element can be used as the basis for designing clothing and fashion accessories. For example, the vase (fig. 6) became a bag, necklace and beading on a belt (see pages 245, 246 and 248). The stool (fig. 3) was turned into a wrap halter top, bikini bottoms and backless mini-dress (page 244). The framed pictures (fig. 1) became patterned fabric for patchwork shirt and tops (pages 242 and 243). The circle elements in the lounge chair (fig. 2) have been turned into coats, tops and various accessories (see pages 250 and 251).

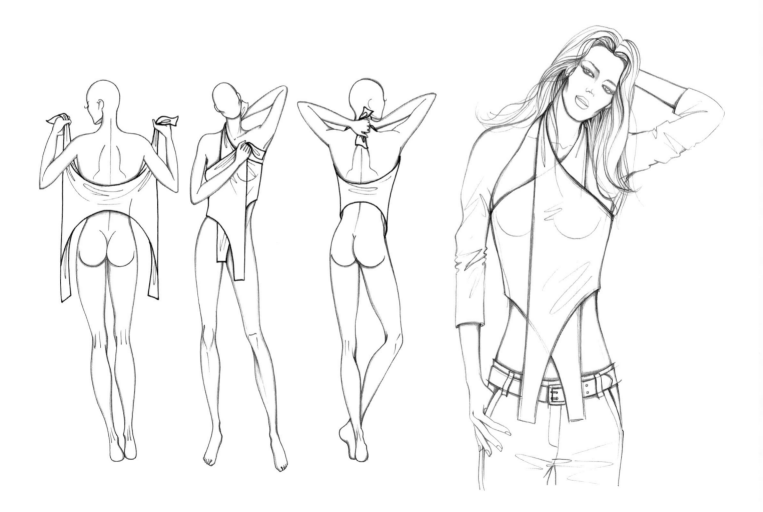

Here is an example that the stool (fig. 3) can be used for: a wrap halter top crossed over at the front.

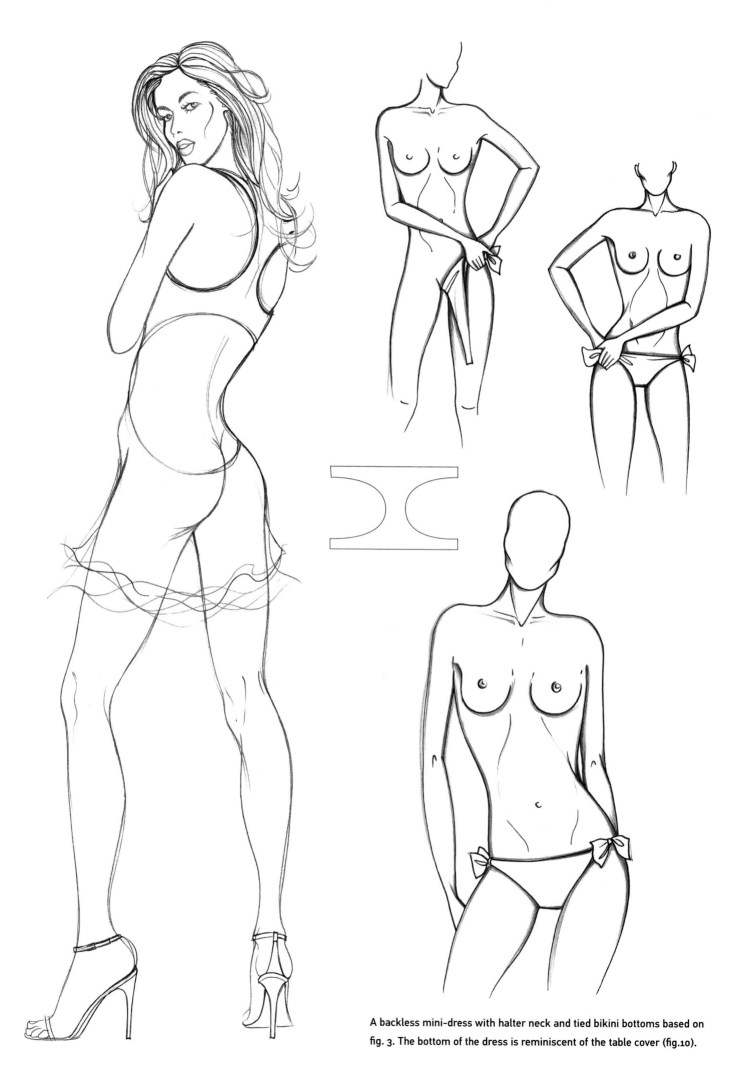

A backless mini-dress with halter neck and tied bikini bottoms based on fig. 3. The bottom of the dress is reminiscent of the table cover (fig.10).

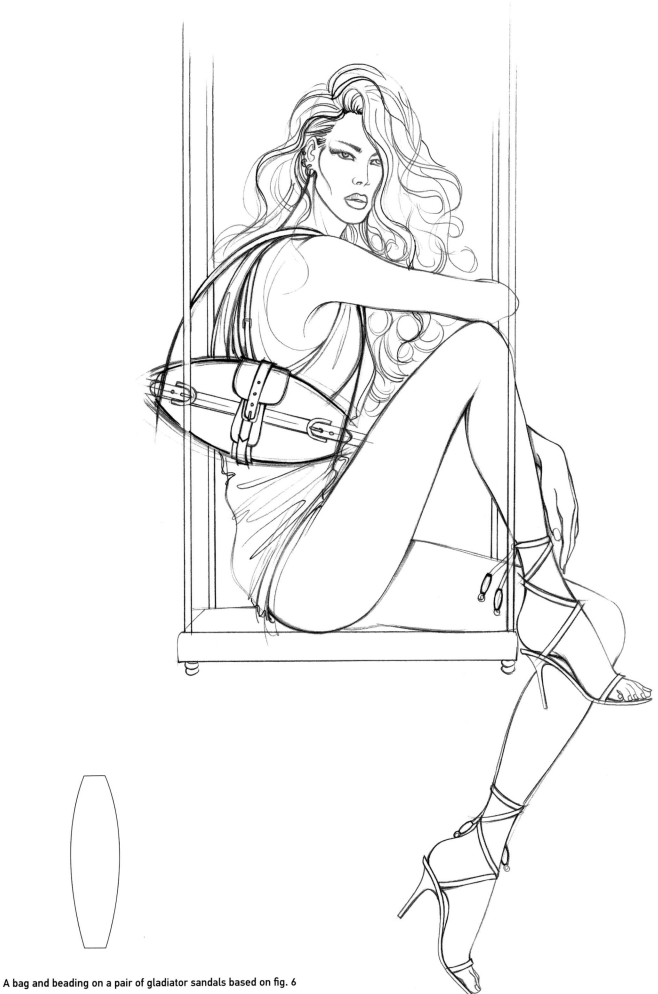

A bag and beading on a pair of gladiator sandals based on fig. 6
(page 240).

Glasses and a beaded necklace based on fig. 6 (page 240).

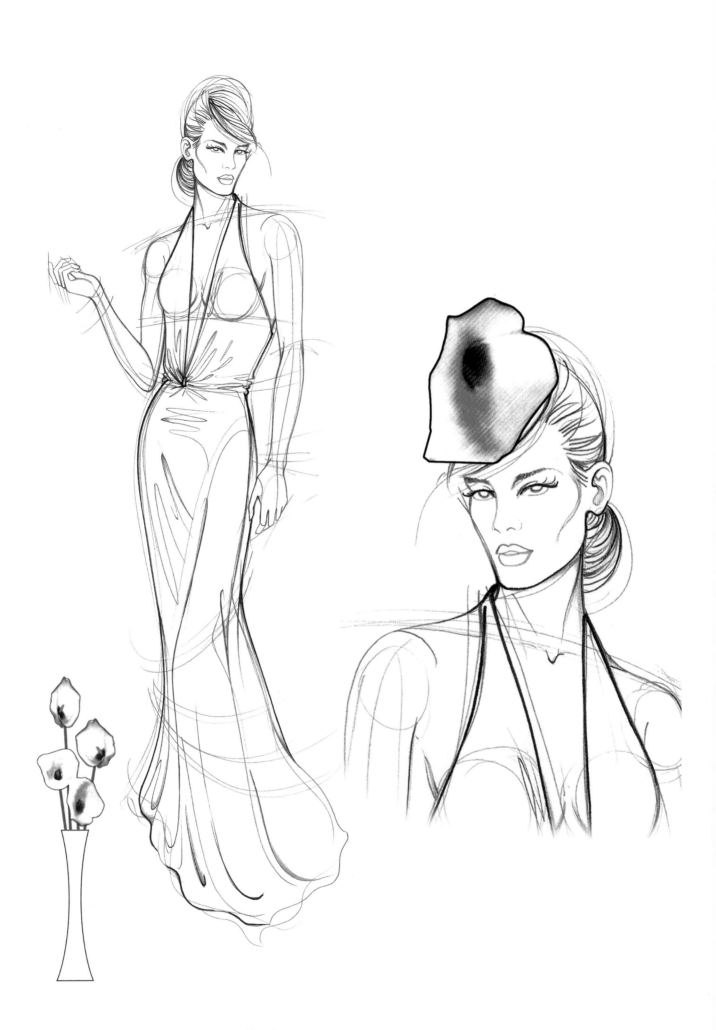

An elegant headdress based on the arum on page 240 (fig. 9).

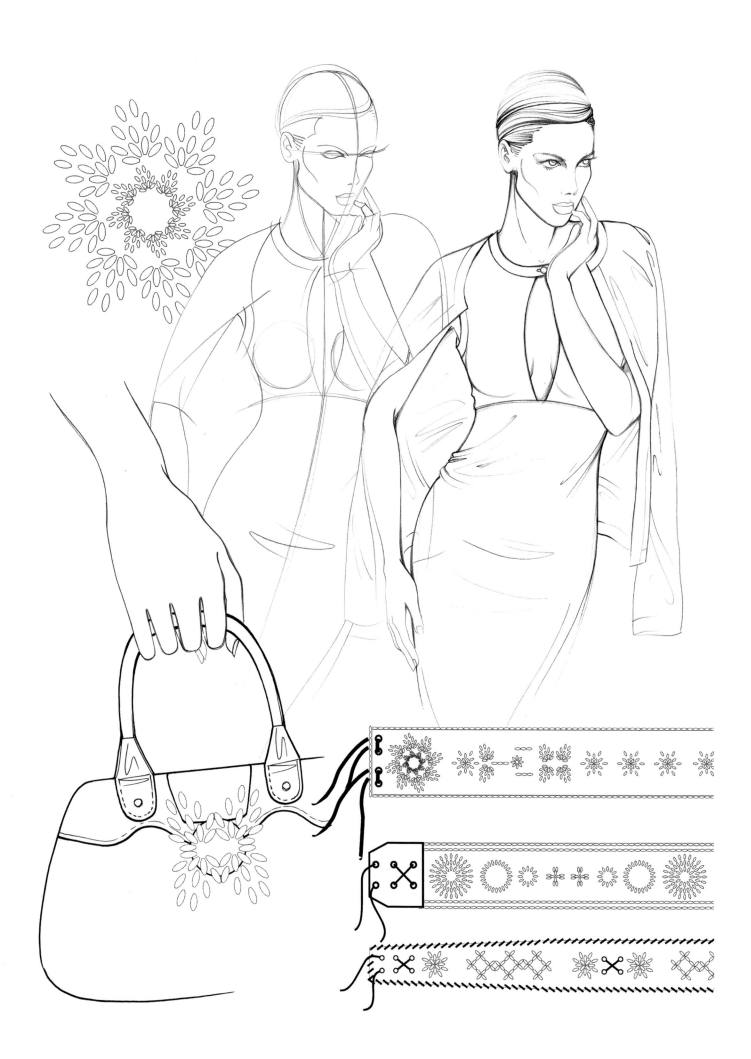

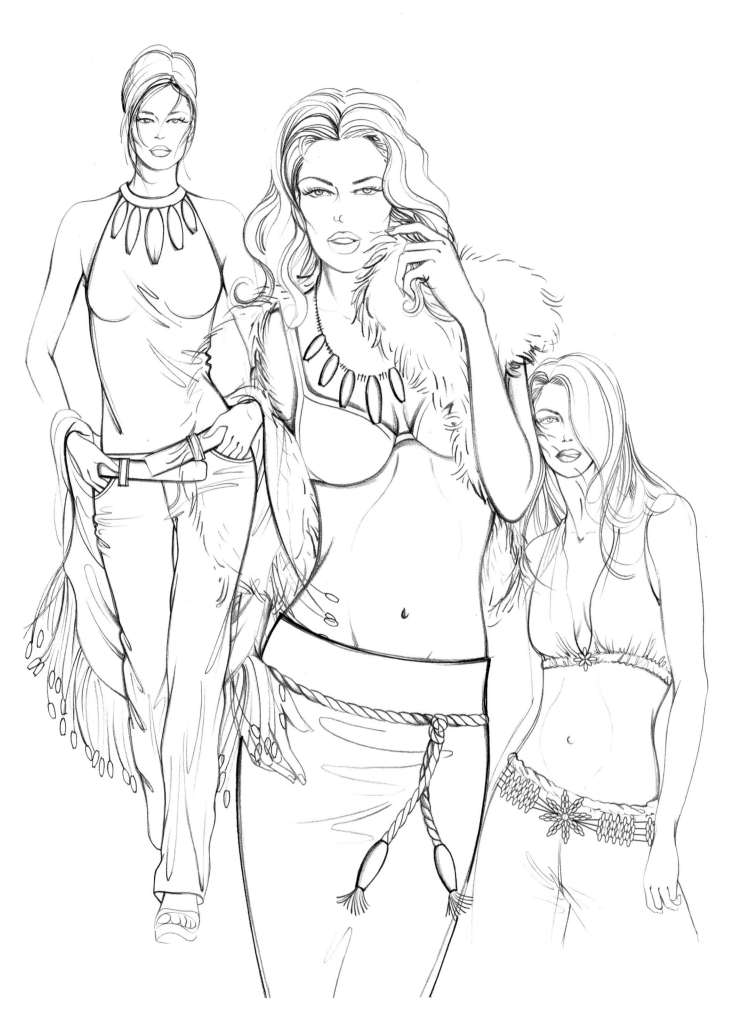

Garment drawing and design

Types of drawings

The fashion drawing is done by skilled fashion illustrators or fashion designers. It may be very stylised and the proportions may be altered. Such drawings, as we have seen in the preceding chapters, are made to convey a certain mood and style, and can be used instead of photographs in specialist magazines.

For the communication between designers and people involved in the production of clothes, more precise drawings are needed: technical drawings and working drawings. The technical drawing is done by the production stylist, producing a clear and detailed image that shows the technical representation of a garment, as if it were resting on a flat surface (throughout this chapter there are many examples of technical drawings, among others on pages 282, 292 and 311). It is usually a neat line drawing showing front, profile and back views. Creases and folds are left out or reduced to a minimum to highlight the cut, line and details. Interior details

such as linings or trimmings can also be shown. This type of drawing is very useful to the designer, who must highlight every detail of the garment, and for the pattern maker, who has to create the garment exactly as the designer has indicated. The technical drawing is a link between the fashion sketch and the finished garment, and many creatives prefer it to the fashion illustration. A less constrained variant of the technical drawing is in the style used for fashion books, as illustrated on pages 339–352.

The illustrations below of a classic blazer and a safari jacket can be labeled working drawings. They include three-quarter views and a little more detail in creases and folds. Such illustrations can be drawn hung on a hanger or tailor's dummy. Note the attention to detail and the perfection of the drawing, which has been executed with an 0.3 black felt-tip pen.

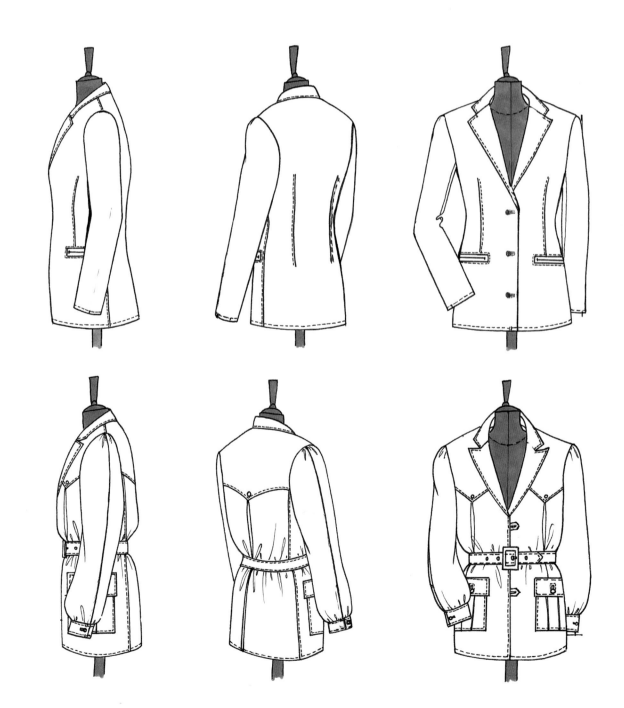

Production sheet

The production or specification sheet is a chart used in the fashion industry to define all the technical aspects of a garment. Ours is a hypothetical sheet for the creation of garments made from a plain woven fabric. It is not suitable for knitted or jersey garments, as these fabrics need special technical terms of their own. The grid layout is universal, and can be applied to any type of garment. The area containing the bomber jacket is used for the technical drawings. Each detail must be clear and understandable. If the garment includes any particularly complex or (half) hidden details, these can be enlarged and explained on an additional technical drawing attached to the sheet. Boxes can be added and compiled according to the specific requirements of the company. Once the sheet is complete, it is handed to the design room so it can be processed and the test sample checked.

Line/collection	Season	Design department	Sheet code	Date
Item code	**Garment description**			
Material code	**Material colour**	**Composition**	**Thread type**	**Thread colour**

EMBROIDERY	
PRINT	

☐ outerwear ☐ dress ☐ shirt ☐ bodice	
shoulder width	
chest circumference	
hip circumference	
total length	
hemline width	
sleeve type	
sleeve length	
sleeve width	
cuff height	
neckline	
neckline depth	
neckline width	
collar type	
collar height	
back neck binding	
hem height	
hem type	
topstitching type	
pockets	
lining	
adhesive	
kick tape	

☐ trousers ☐ skirt	
waist circumference	
hip circumference	
crotch length	
total length	
cuff/hemline width	
waistband	
hem height	
hem type	
topstitching type	
pockets	
lining	
adhesive	
kick tape	

How the cut influences the design

The basic garments shown here emphasise how the cut can influence the proportions of any type of design. The cut can make a body look slimmer, wider, taller or shorter. This should be taken into consideration, particularly where you are looking for a specific body shape and style. The final design is influenced not only by the basic cutting lines, but also by the use of darts, the treatment of collars, sleeves and pockets, fabric colour and quality, the combination of styles, the types of stitching and trimming such as fringing, flounces, pleats, etc.

basic shape

narrows

lengthens and narrows

widens and thickens

lengthens

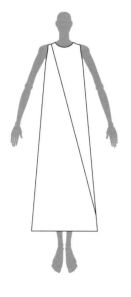

lengthens

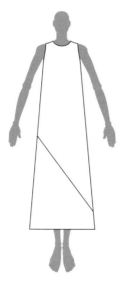

lowers and thickens

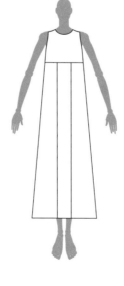

extends

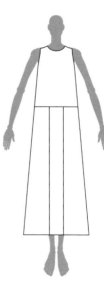

widens

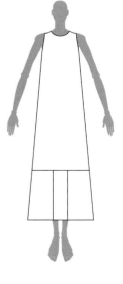

lowers

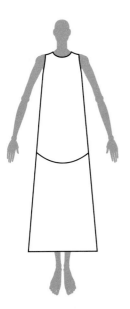

lowers and widens

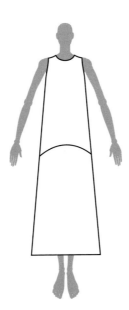

lengthens and narrows

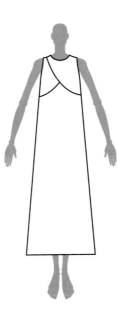

lengthens

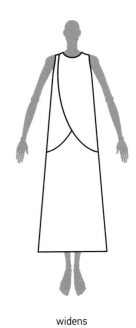

widens

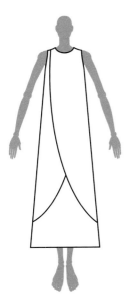

shortens

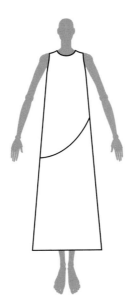

widens and shortens

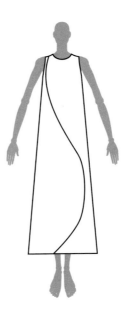

widens and shortens

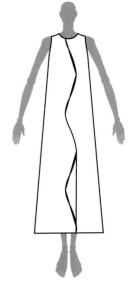

slims

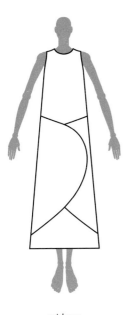

widens

slims

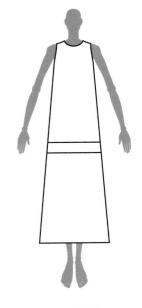

lengthens

lowers and thickens

The basic bodice and darts

Darts are triangular folds sewn in the fabric to give shape to a garment, fit the fabric over curves and enhance the body.

They are often used on the bodice, which is joined to a skirt to make a one-piece garment, or separates. The position and direction of the darts vary depending on the pattern but they are generally vertical or horizontal. It is useful to remember that darts are used to fit the fabric around the fullest or roundest parts of the body. Darts may be visible, inserted in the cuts, or absorbed into the fullness of the garment. To show some examples of how darts are rotated, inserted and moved, we have illustrated the entire bodice from the main angles to help you draw bodices of your own.

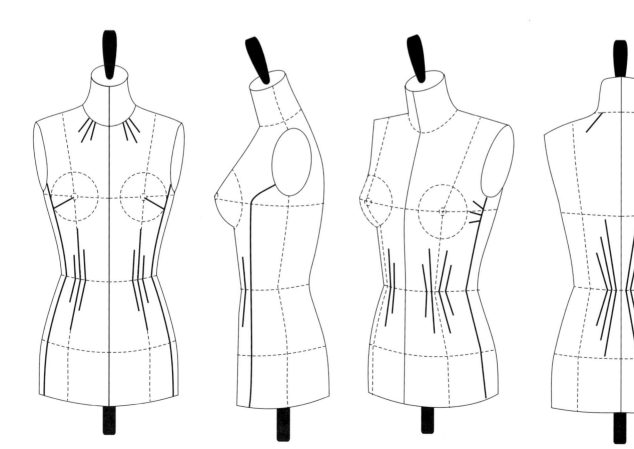

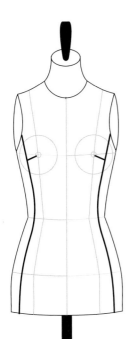
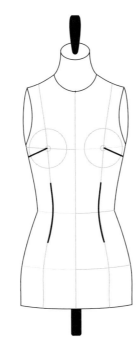
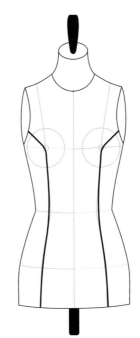
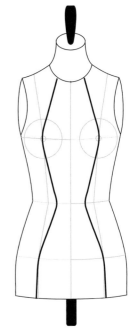

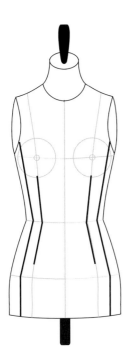
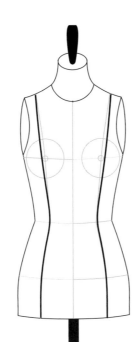
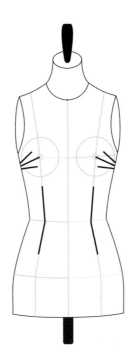
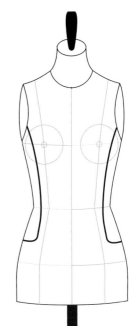

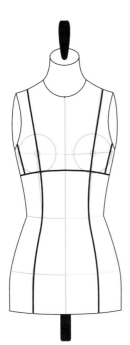
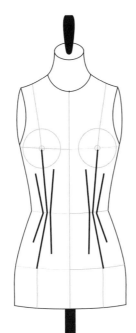
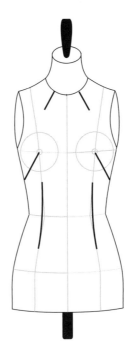
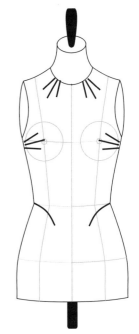

Size 10

Basic measurements

This mannequin shown here is displaying the lengths, sleeves and necklines used in garments. This is a useful guide for getting the proportions right.

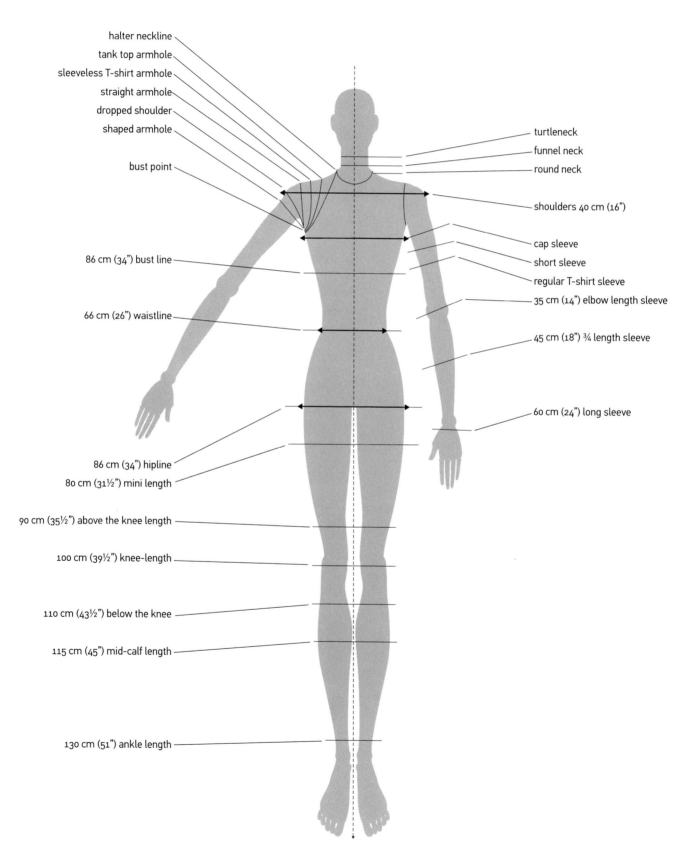

halter neckline
tank top armhole
sleeveless T-shirt armhole
straight armhole
dropped shoulder
shaped armhole

bust point

86 cm (34") bust line

66 cm (26") waistline

86 cm (34") hipline
80 cm (31½") mini length

90 cm (35½") above the knee length

100 cm (39½") knee-length

110 cm (43½") below the knee

115 cm (45") mid-calf length

130 cm (51") ankle length

turtleneck
funnel neck
round neck

shoulders 40 cm (16")

cap sleeve
short sleeve
regular T-shirt sleeve
35 cm (14") elbow length sleeve

45 cm (18") ¾ length sleeve

60 cm (24") long sleeve

Different types of fit

Fit refers to the relationship between the amount of space between the garment and the body inside it. It is the room for movement that exists between the body and the fabric. It is expressed in centimetres or inches to be added at the points where the garment is nearer to or further away from the body. The various types of fit are expressed in specific tables that, depending on the type of fabric and line, give more or less space to the garment being made. The stretchier a fabric is, the closer the type of fit will be. Conversely, a non-stretch fabric will give a looser type of fit.

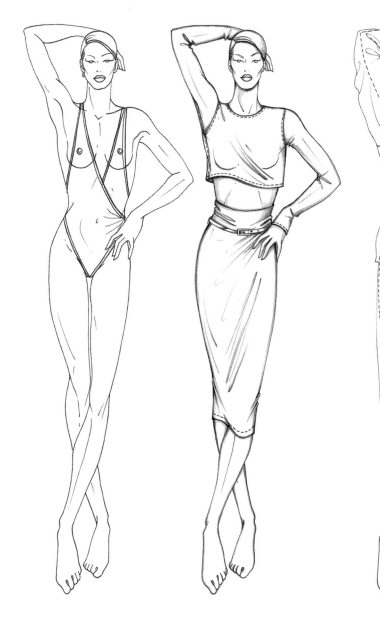

Stretch garment,
narrow fit

Close-fitting top and skirt,
slim fit

Loose-fitting sweat top and skirt,
wider fit

Fit and shape

On these pages we show basic garments with the main types of fit highlighted in shades of grey. The dress below: 1 close-fitting, 2 soft, looser fitting, 3 very loose fitting. The trousers: 1 slim fit, 2 straight fit, and 3 wide fit. The length, the height of the waist and the greater fullness in the leg will vary, depending on the type of garment you are designing.

The illustrations on the right page show that as the fit of an upper garment loosens, the armhole gradually moves down, away from the shoulder and the armpit. The length of the sleeves and the width of the necklines can be modified individually, according to personal taste or prevailing style.

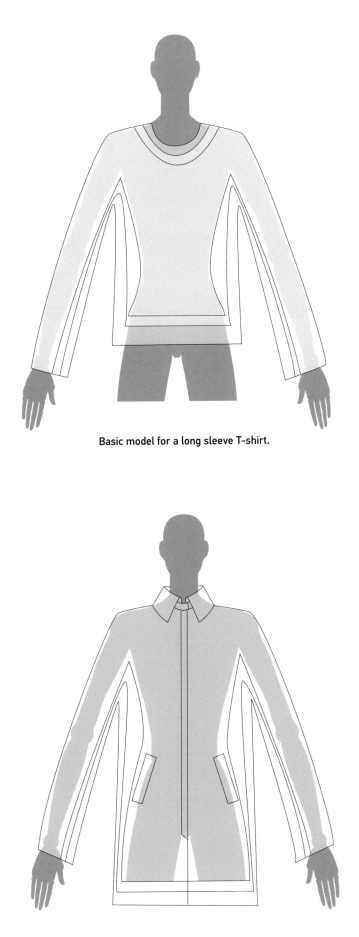

Basic model for a long sleeve T-shirt.

Basic model for outerwear.

Finishings and trimmings

Finishings are all the details that characterise the design of a garment, such as pleats, folds, gathers, ruffles, drapes, pockets, collars and cuffs. Trimmings are all the accessories that can be used to add something special to a design. They can include: fasteners, lapels, stitches, seams, buttons, appliqués, etc. A garment can be completely transformed by changing or adding a few finishings or trimmings. Altering the fabric as well will totally change the initial design.

The examples on the following pages illustrate the various types of finishings and trimmings. Technical drawings are used together with the correct technical terminology. Fashion design students will initially find it hard to make the best use of trimmings. The tendency is to either over-simplify or go over the top. With experience you will learn how to use these elements skilfully.

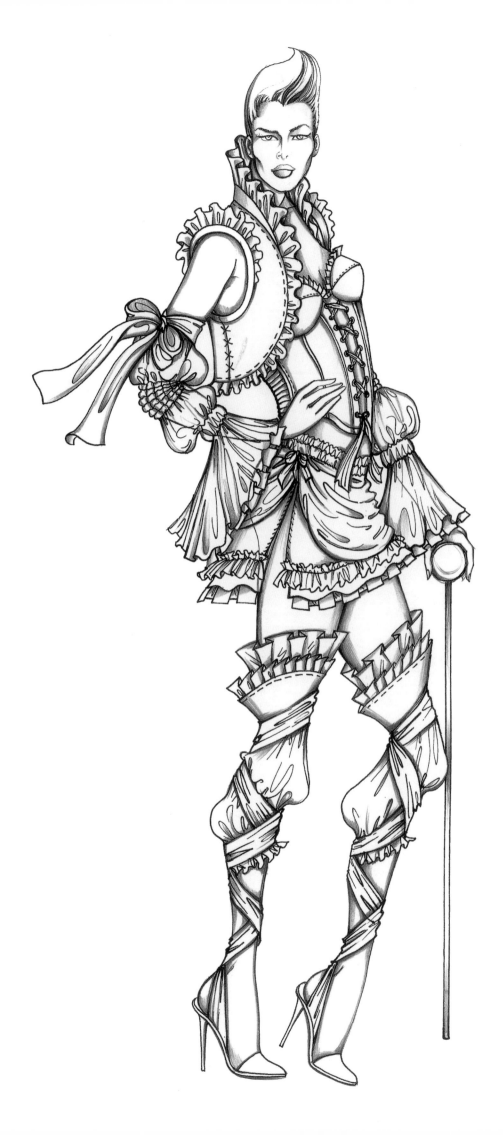

Types of pleats

Pleats are used to gather the fabric around the body in regular folds and as a trimming on a garment. The box pleat is formed by; a supporting background, two folded panels and the pleat depth (A-B-C-D). The various types of pleats can be used to create attractive effects. They can be spaced far apart from one another, plissé, pressed or left loose, topstitched or have another fabric on the inside. They can also be given a diagonal or horizontal rhythm with side stitches. The best effect is obtained by creating the pleats on the grain of the fabric, as they will hang better.

movement of pleats in perspective

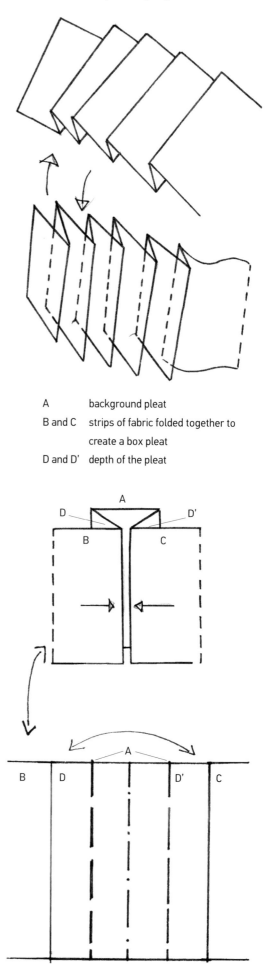

A	background pleat
B and C	strips of fabric folded together to create a box pleat
D and D'	depth of the pleat

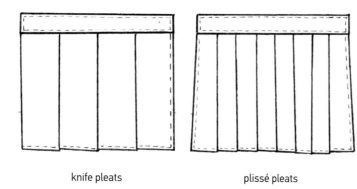

knife pleats

plissé pleats

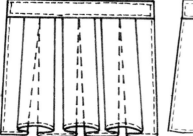

stacked box pleats

inverted box pleat

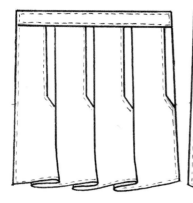

stitched knife pleats

stitched box pleats

Types of flounces and ruffles

The purpose of using flounces, ruffles and frills is to gather the fabric decoratively and give it a softer and more feminine look. They are ideal for creating a romantic and sophisticated style. A flounce is a wide strip of fabric, sewn along the edge of a garment. A ruffle is a more slender strip of fabric compared with a flounce. A frill is a long, narrow strip of fabric. When these strips are sewn along the edge, small or wide gathers can be used to create waves.

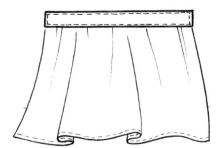

simple flounce

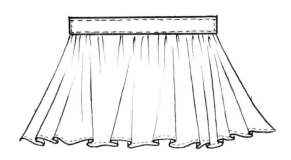

gathered flounce

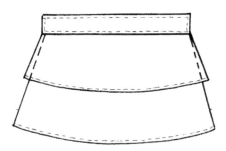

double flat flounce

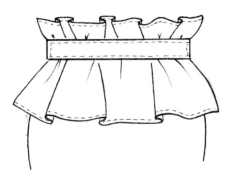

flounce with crest

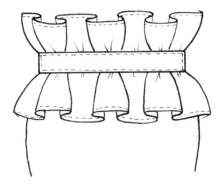

double ruffle with soft stacked box pleats and waistband

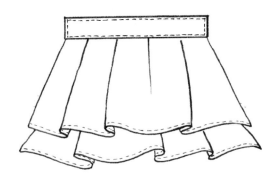

double flounce with gathers

Circular flounces, gathers and drapes

A circular flounce is made from a strip of fabric cut in a circle, and is often used around the neck, on cuffs and on skirts. Used in light fabrics, it makes the garment more striking and appealing. Gathers will accentuate the silhouette. They are very small, parallel folds and are preferably made from fine or stretch fabric. The drape is formed by securing fabric at the sides and leaving it to fall in the centre. For more details on how to draw these examples, see the section on folds in chapter 1 (page 119).

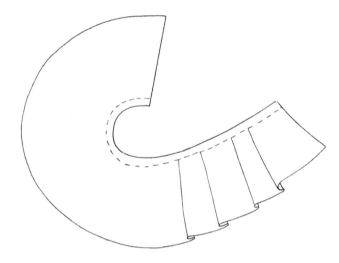

circular flounce

gathers

drape

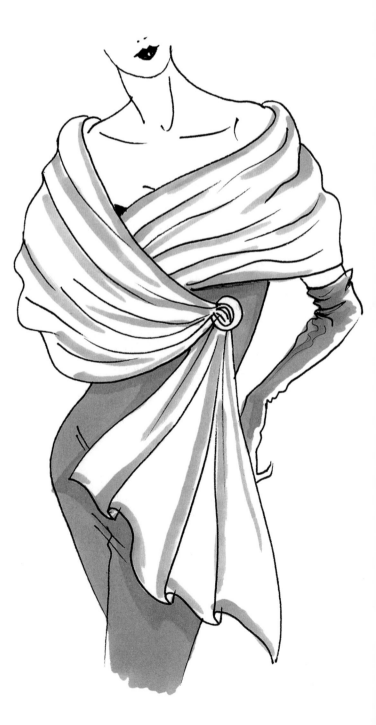

Pockets

This section includes examples of many basic and elaborate finishings and trimmings. Each technical drawing is in the right proportions and accompanied by the correct terminology. Fashion makes use of a whole range of styles and details so it would pay you to absorb as much of this as you can.

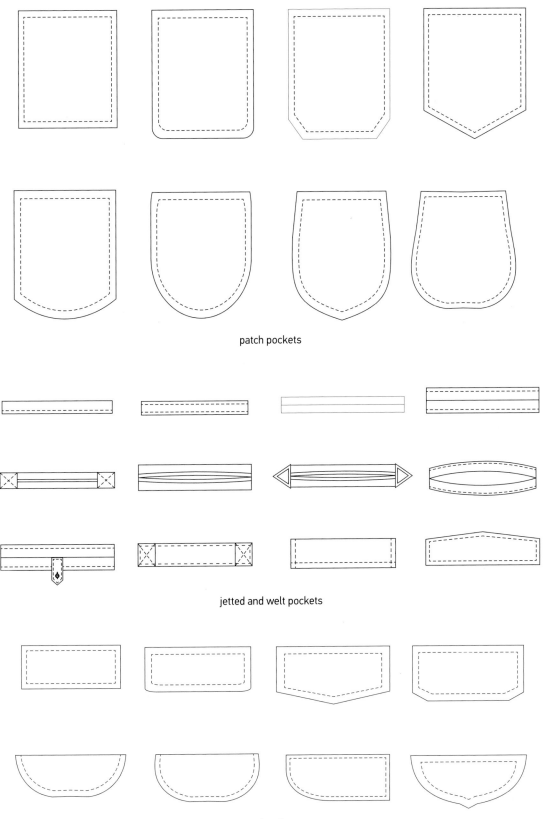

patch pockets

jetted and welt pockets

pocket flaps

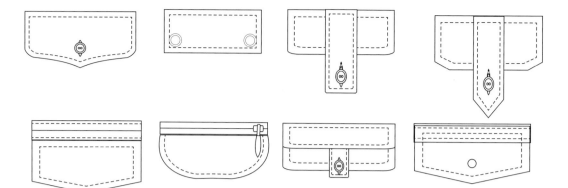

pocket flaps with buttons, tabs and zips

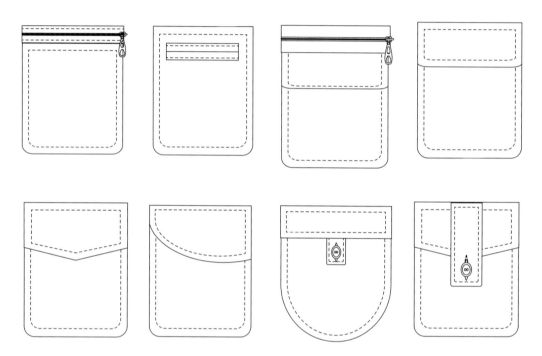

patch pockets with zips, flaps, buttons and tabs

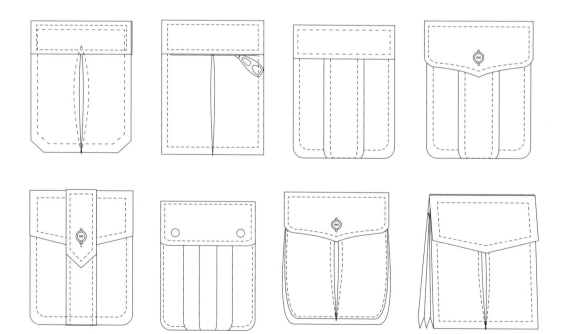

cargo pockets with inverted and regular box pleats, flaps, zip, buttons and accordion pleats on the side

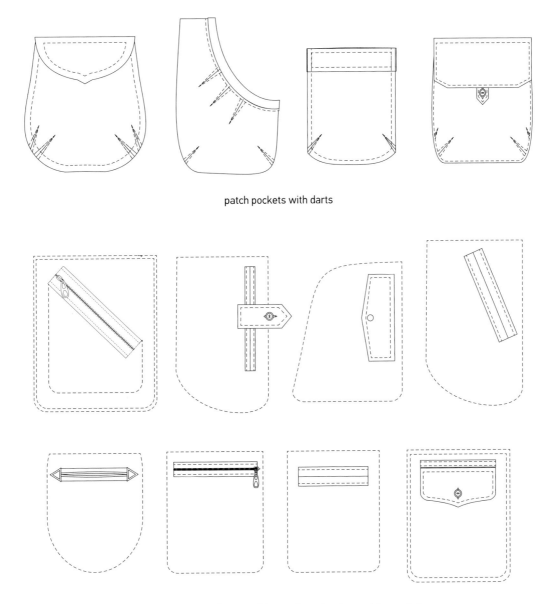

patch pockets with darts

inside pockets with topstitching to show the shape of the pocket

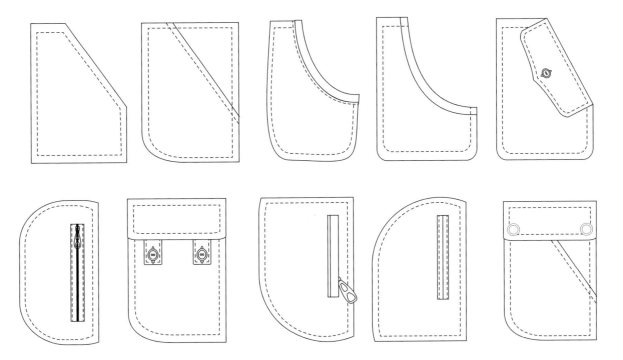

asymmetrical topstitched patch pockets

Metal fittings and small accessories

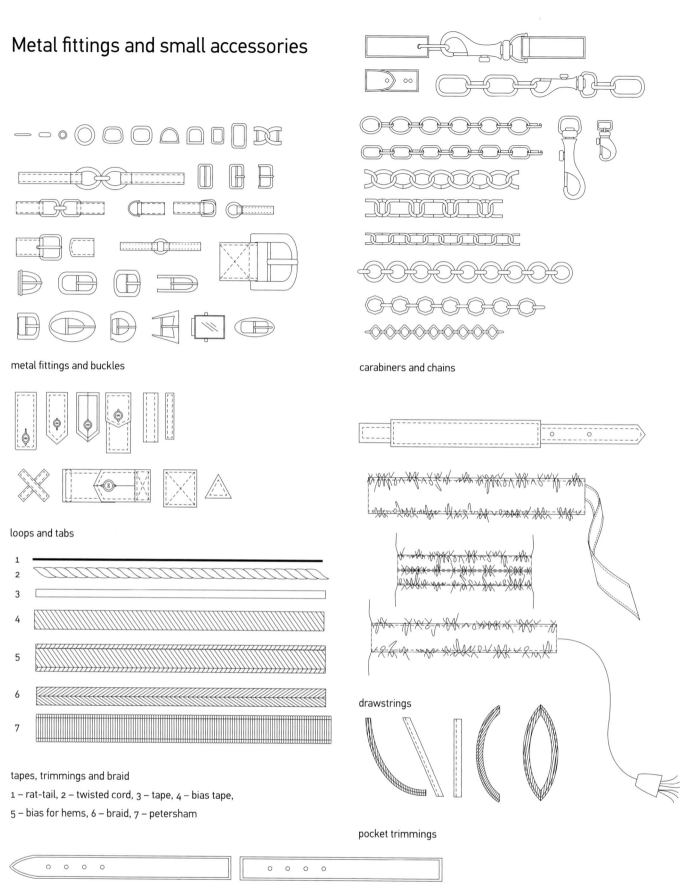

metal fittings and buckles

carabiners and chains

loops and tabs

tapes, trimmings and braid

1 – rat-tail, 2 – twisted cord, 3 – tape, 4 – bias tape,
5 – bias for hems, 6 – braid, 7 – petersham

drawstrings

pocket trimmings

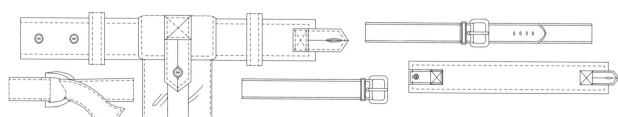

belts and straps

Basic stitches

 = stitches photographed from real fabric samples

 = drawn stitches

straight single stitch

narrow twin needle stitch with overlock

narrow twin needle stitch

wide twin needle stitch with overlock

wide twin needle stitch

short zigzag stitch

three needle stitch

large, wide zigzag stitch

three needle stitch with overlock

long, tight zigzag stitch

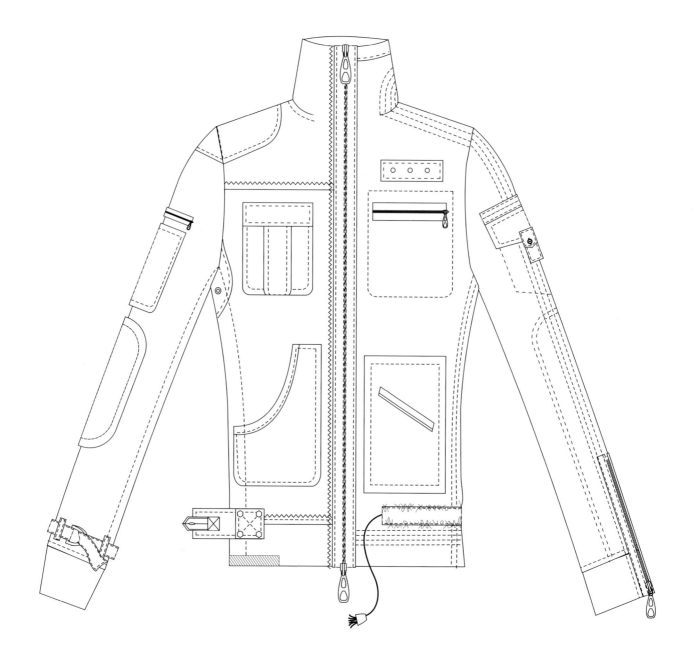

Accessorised jacket

Biker jacket with added trimmings to enhance the style.

Drawn using 0.05, 0.2 and 0.8 felt-tip pens.

Skirts

shapes and lengths

Technical drawings for representing drapes in various shapes and lengths.

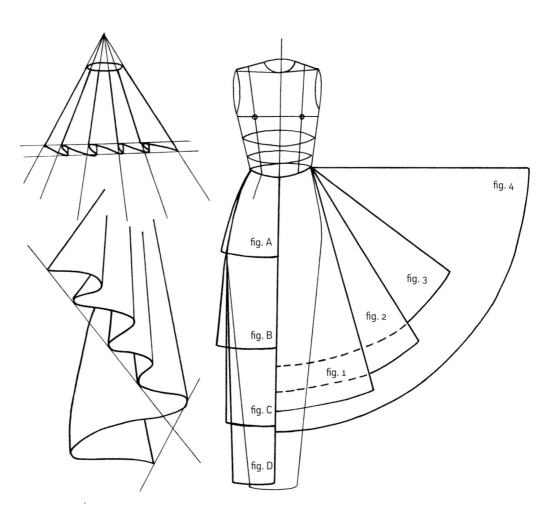

Basic skirt shapes:

fig. 1 A-line skirt

fig. 2 quarter circle skirt

fig. 3 third circle skirt

fig. 4 full circle skirt

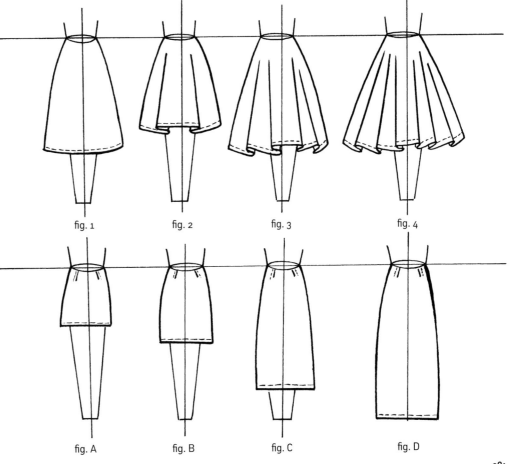

Basic skirt lengths:

fig. A basic miniskirt

fig. B knee-length skirt

fig. C mid-calf skirt

fig. D full-length skirt

Basic skirts

classic straight slim skirt

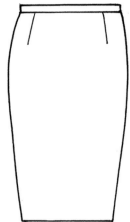

pencil skirt

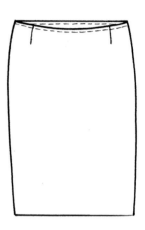

straight drop waist skirt

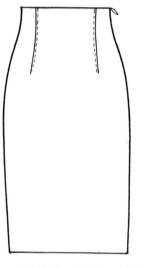

straight high waist skirt with darts

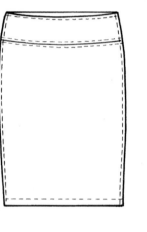

straight drop waist
topstitched skirt with yoke

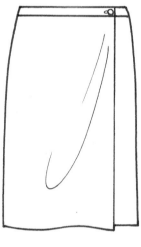

wrap skirt with small waistband

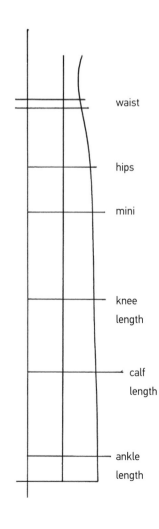

waist

hips

mini

knee
length

calf
length

ankle
length

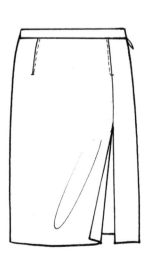

straight skirt with side split at front

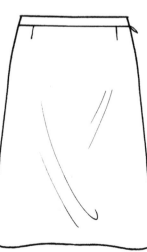

A-line skirt

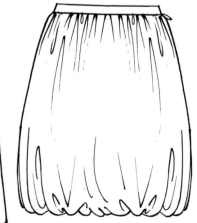

bubble or puffball skirt

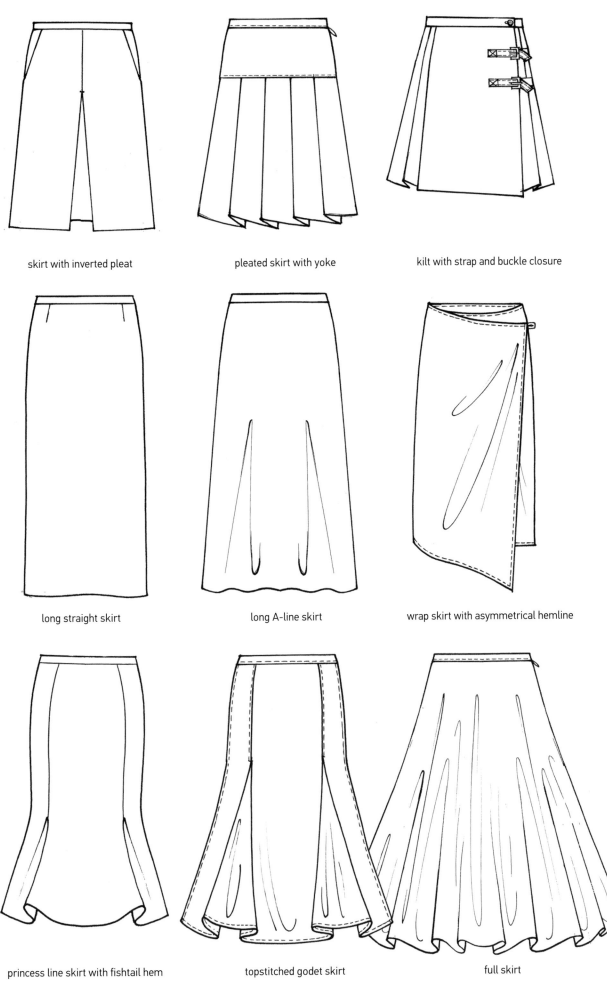

skirt with inverted pleat

pleated skirt with yoke

kilt with strap and buckle closure

long straight skirt

long A-line skirt

wrap skirt with asymmetrical hemline

princess line skirt with fishtail hem

topstitched godet skirt

full skirt

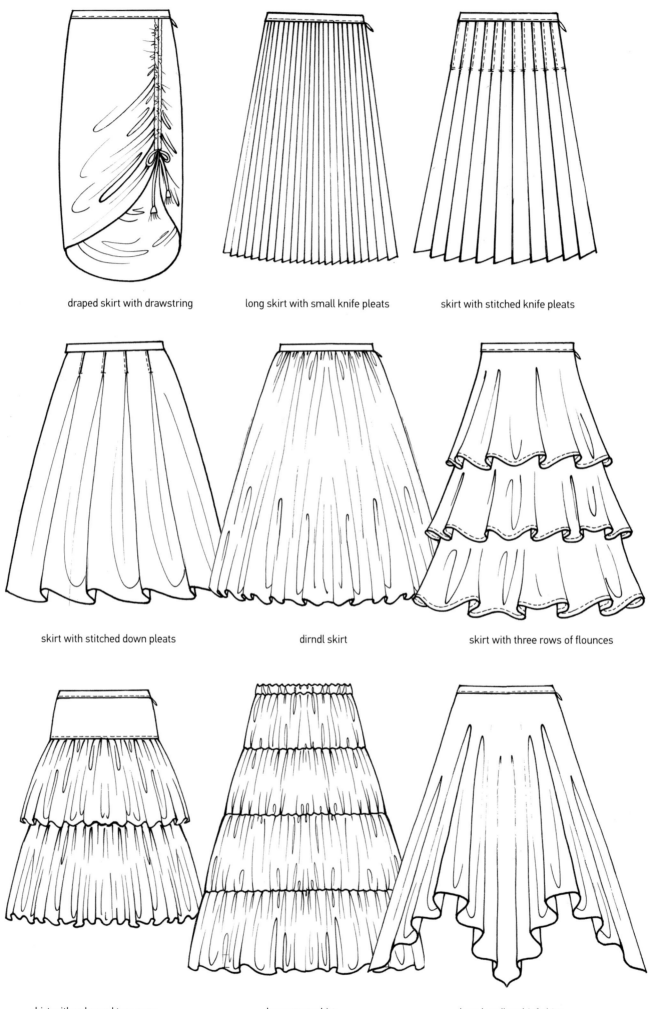

draped skirt with drawstring

long skirt with small knife pleats

skirt with stitched knife pleats

skirt with stitched down pleats

dirndl skirt

skirt with three rows of flounces

skirt with yoke and two rows
of gathered flounces

long gypsy skirt

long handkerchief skirt

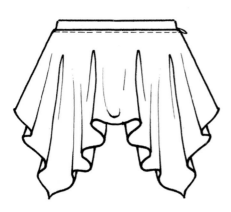

mini handkerchief skirt

denim mini skirt

knee-length denim skirt

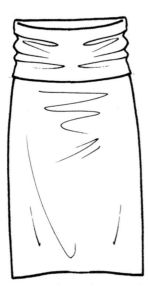

jersey skirt with fold-over waistband

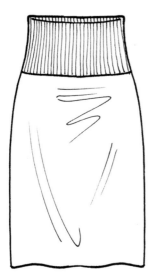

jersey skirt with ribbed waistband

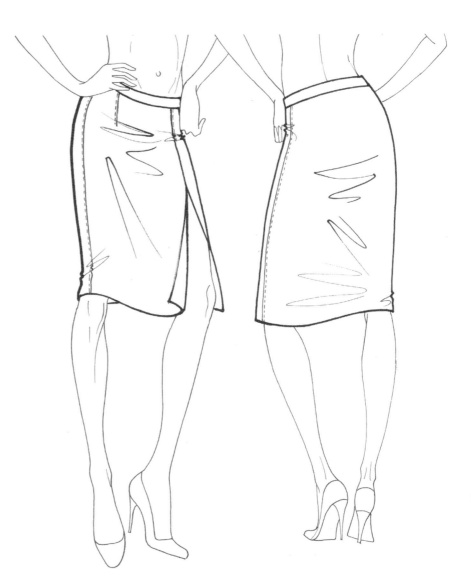

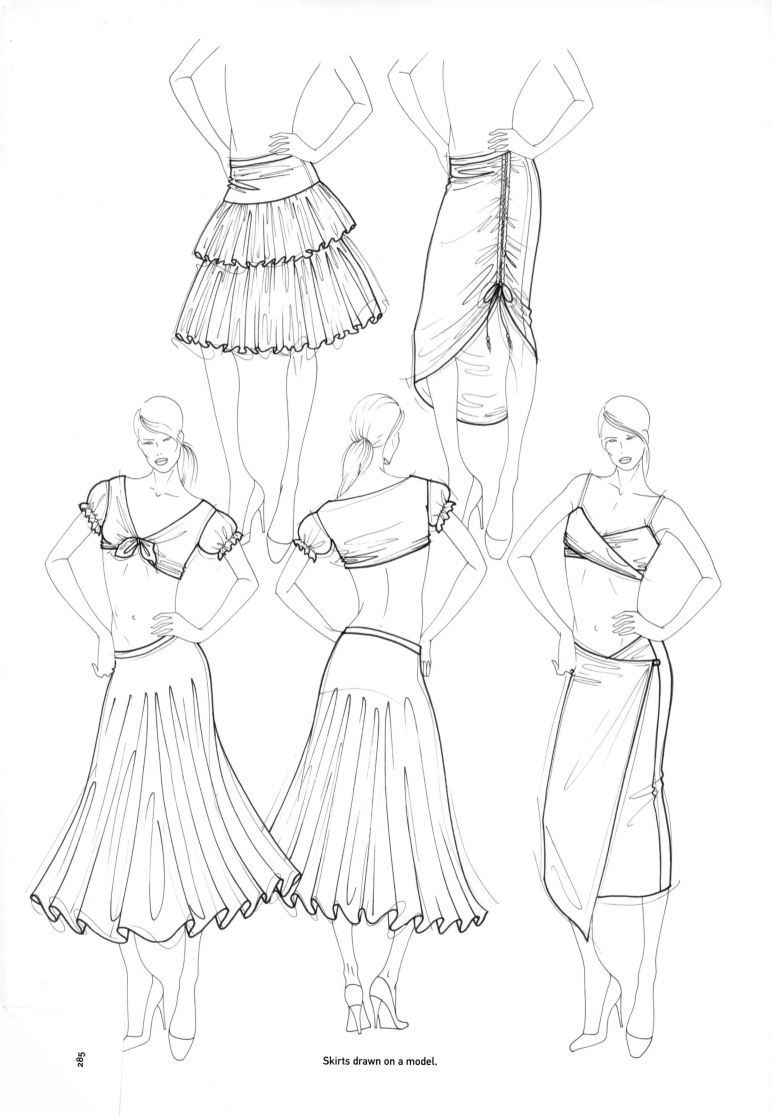

Skirts drawn on a model.

Dresses

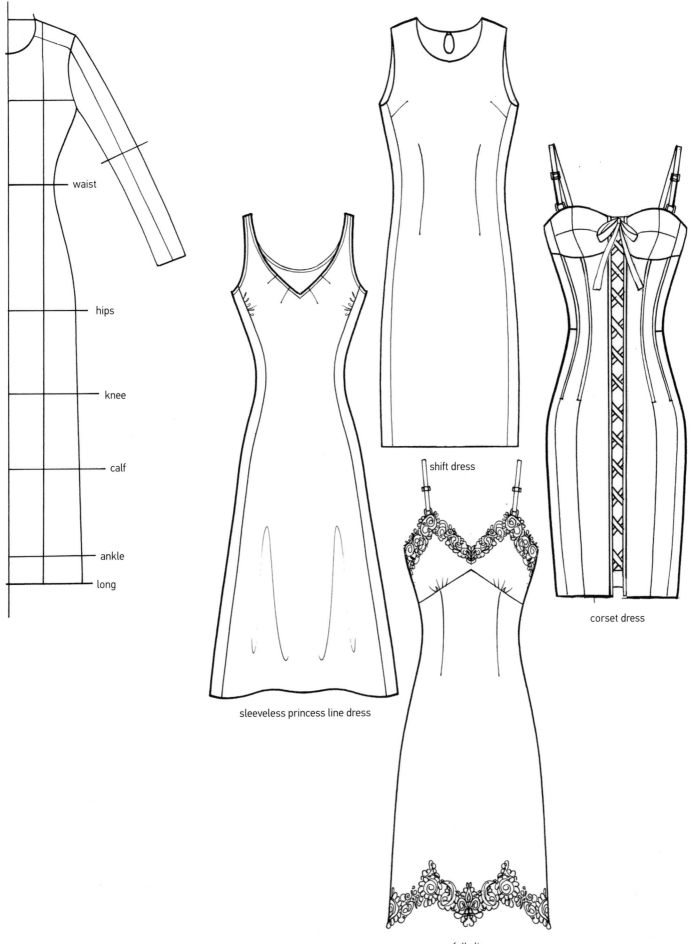

waist

hips

knee

calf

ankle

long

sleeveless princess line dress

shift dress

corset dress

full slip

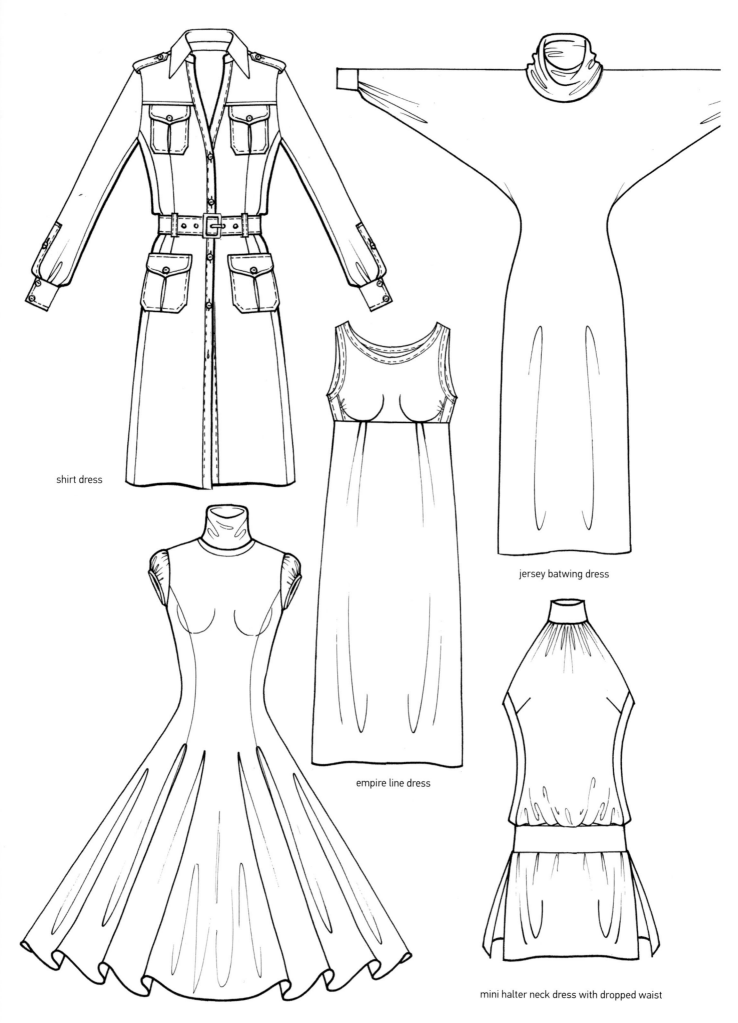

shirt dress

jersey batwing dress

empire line dress

jersey dress with full skirt

mini halter neck dress with dropped waist

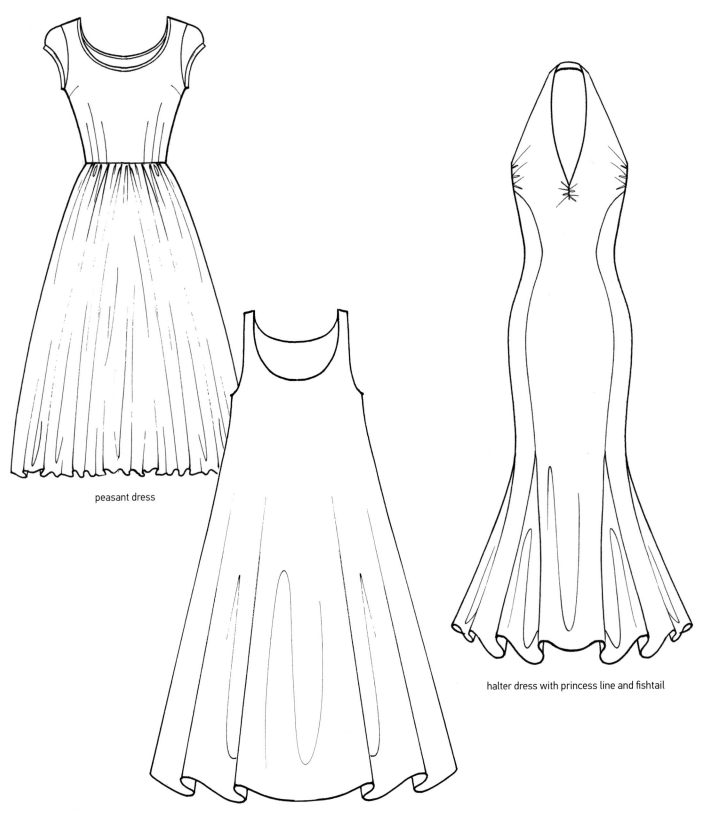

peasant dress

half-circle trapeze dress

halter dress with princess line and fishtail

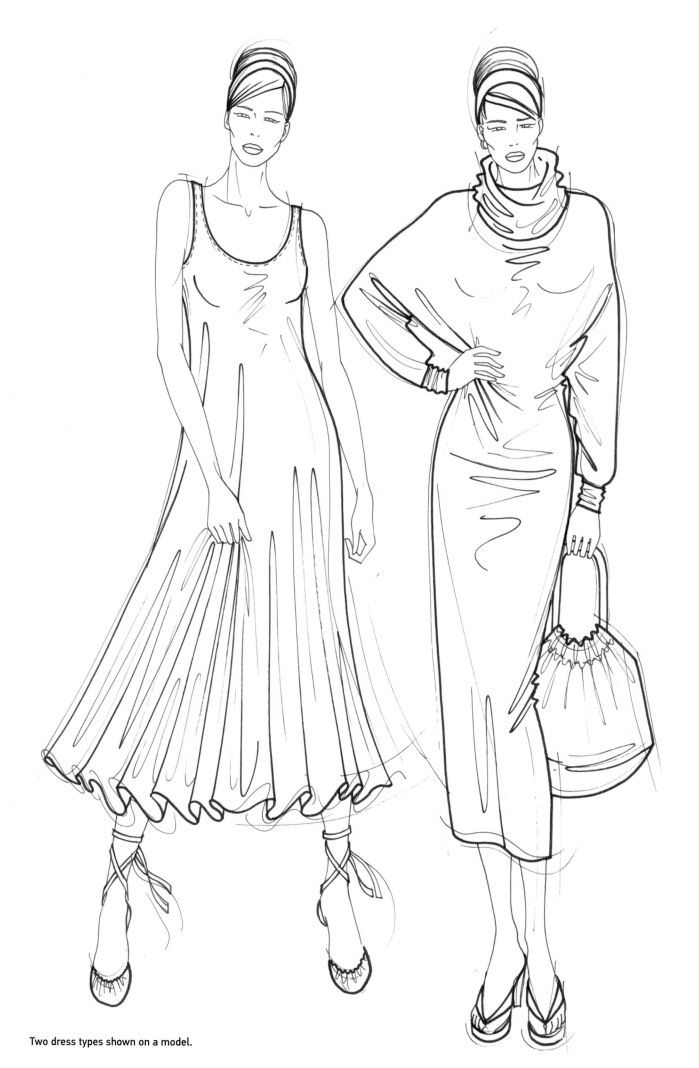

Two dress types shown on a model.

Shirts and blouses

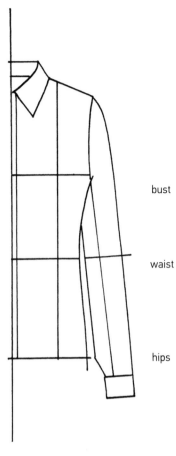

bust

waist

hips

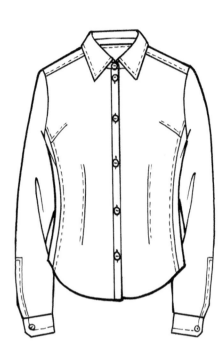

classic men's style shirt

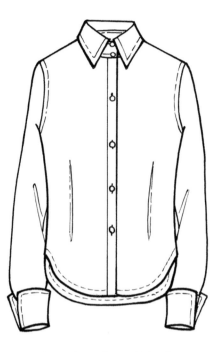

shirt with two-button high collar
stand and French cuffs

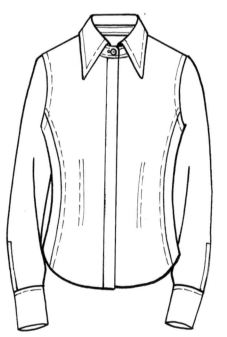

'70s style shirt with long collar points

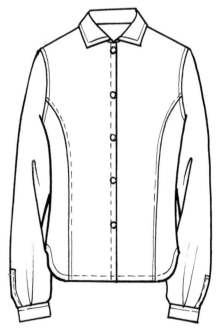

shirt with classic collar and princess seams

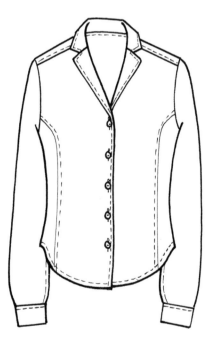

shirt with lapels and princess seams

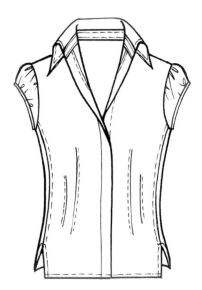

blouse with cap sleeves, darts and short side vents

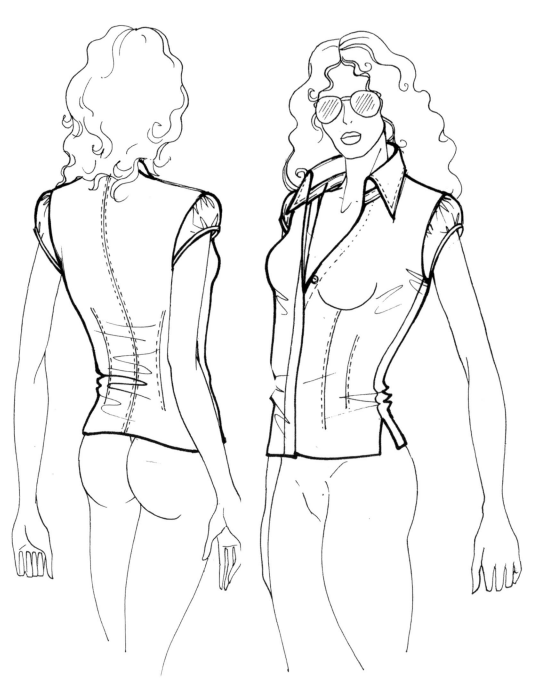

Sleeves

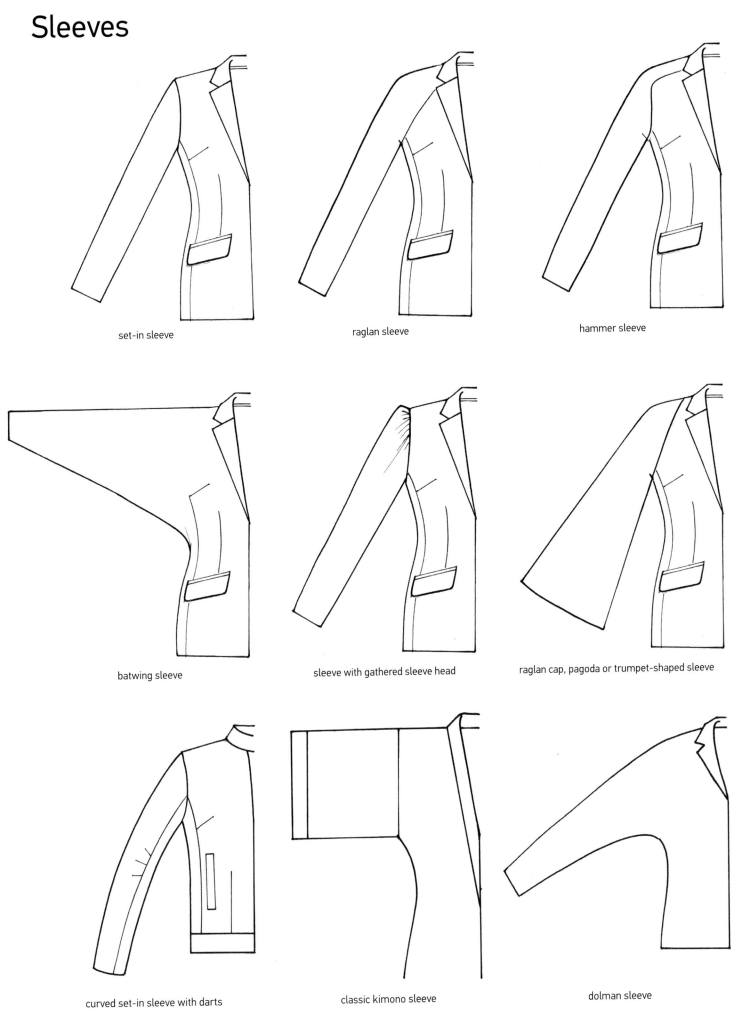

set-in sleeve

raglan sleeve

hammer sleeve

batwing sleeve

sleeve with gathered sleeve head

raglan cap, pagoda or trumpet-shaped sleeve

curved set-in sleeve with darts

classic kimono sleeve

dolman sleeve

Collars on a model

stand collar

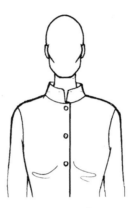

Mandarin collar

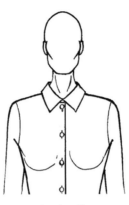

classic collar

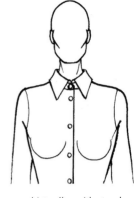

shirt collar with stand

jersey one-piece high collar

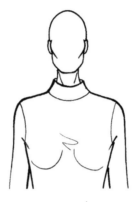

crew neck

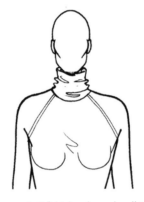

14 cm (5 ½") high polo neck collar

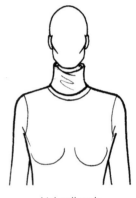

high roll neck

hood

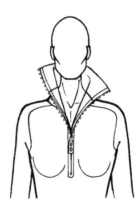

standing zip collar

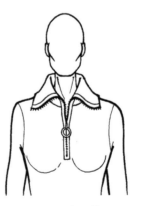

turnover zip collar

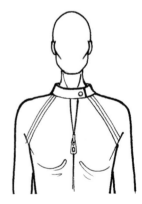

press stud band collar

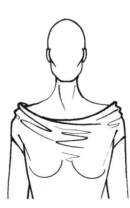

loose-fitting wide neck

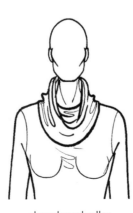

deep draped collar

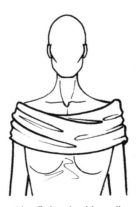

wide off-the-shoulder collar

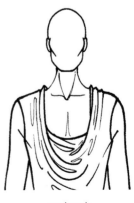

cowl neck

Basic necklines front view

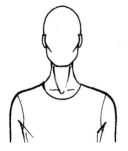

round neck

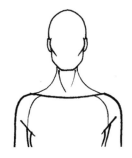

boat neck

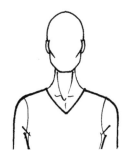

V-neck

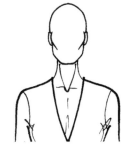

deep V-neck

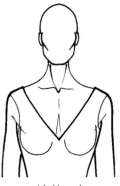

wide V-neck

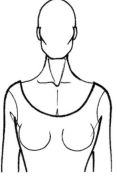

scoop neck

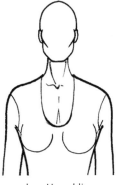

deep U-neckline

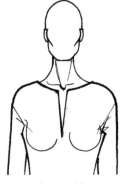

kaftan neckline

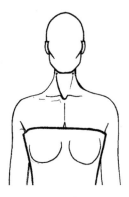

boob tube

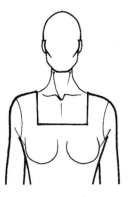

square neckline

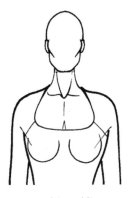

round A-neckline

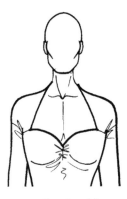

sweetheart neckline

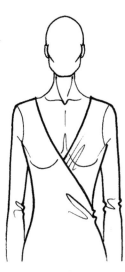

wrap or cache-coeur

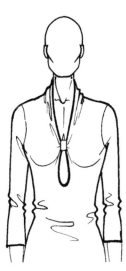

keyhole neckline with clasp

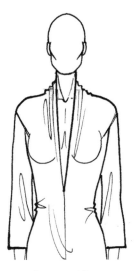

plunge neckline

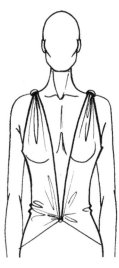

deep plunge neckline

Basic necklines back view

basic neckline

round neck

boat neck

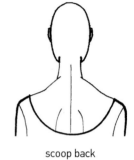

scoop back

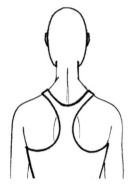

racer back

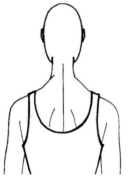

tank top back

halter-neck back

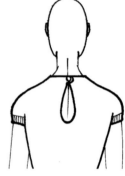

keyhole with button back closure

one-shoulder

camisole

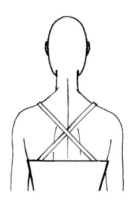

crossed back camisole

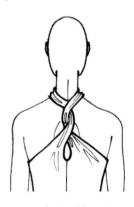

racer back with twist

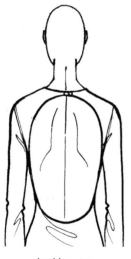

backless top

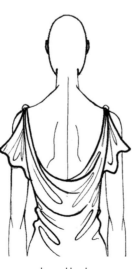

draped back

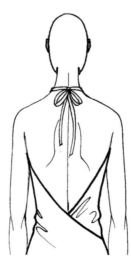

wrap over back

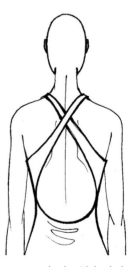

cross over back with keyhole

Hoods from various angles

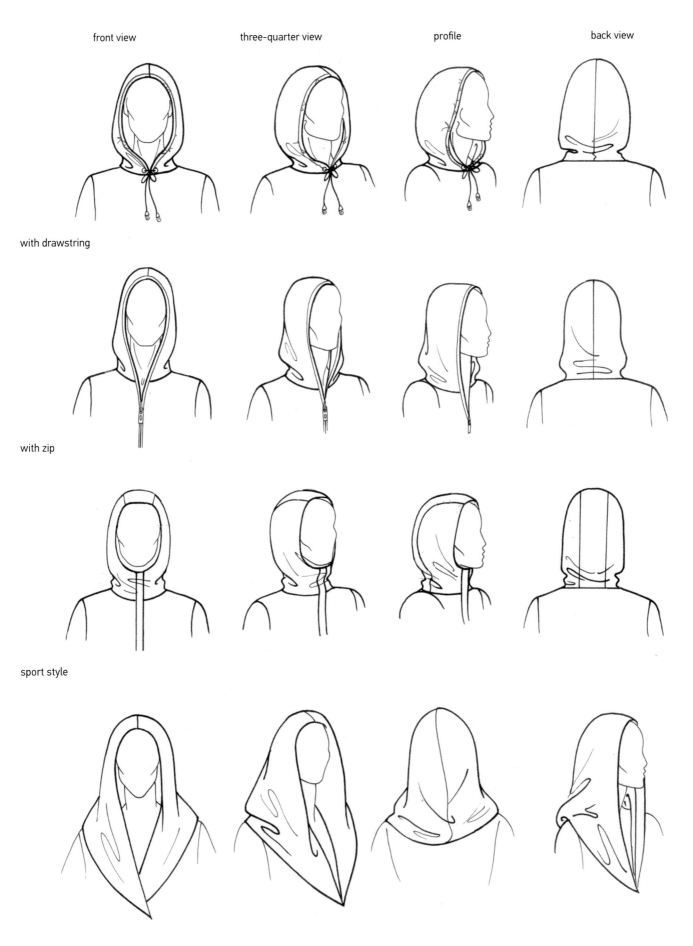

front view　　　three-quarter view　　　profile　　　back view

with drawstring

with zip

sport style

shawl style

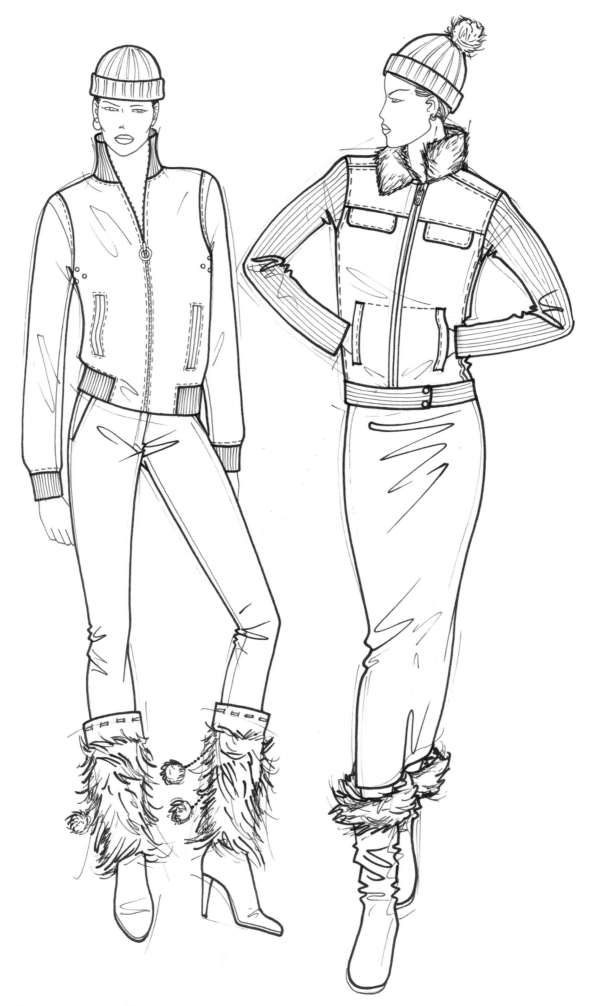

Two bomber jackets shown on a model.

Sport collars and details

These pages show examples of the most commonly used finishings and trimmings on sportswear, including zips, drawstrings, collars, pockets, underarm detailing, seams and stitches. Note the clarity and precision of the details.

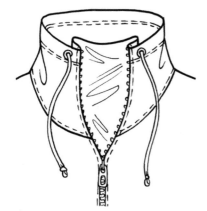
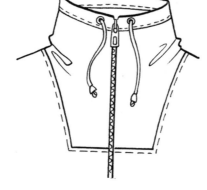
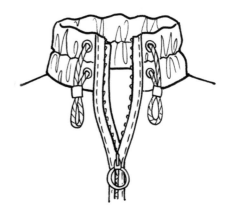

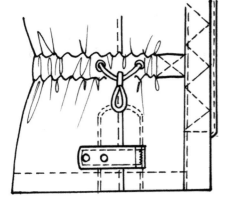
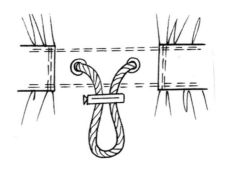
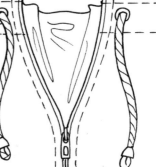
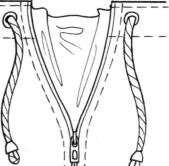

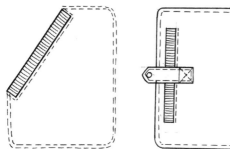

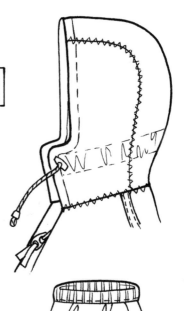

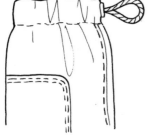
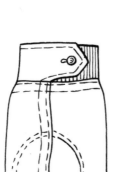
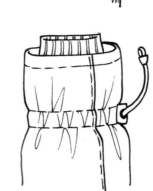

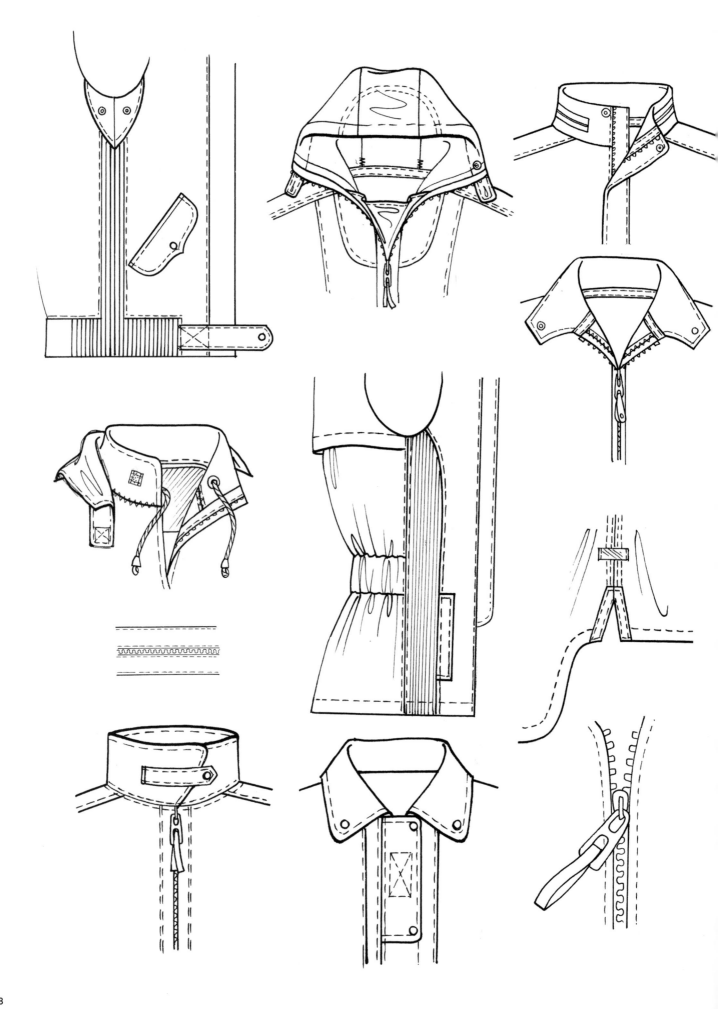

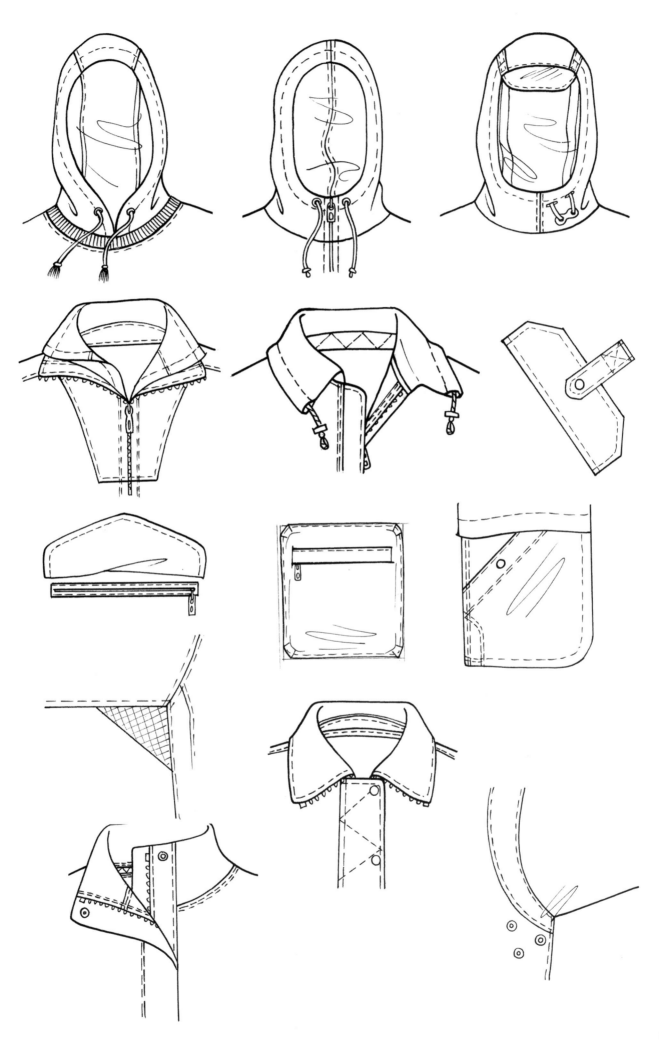

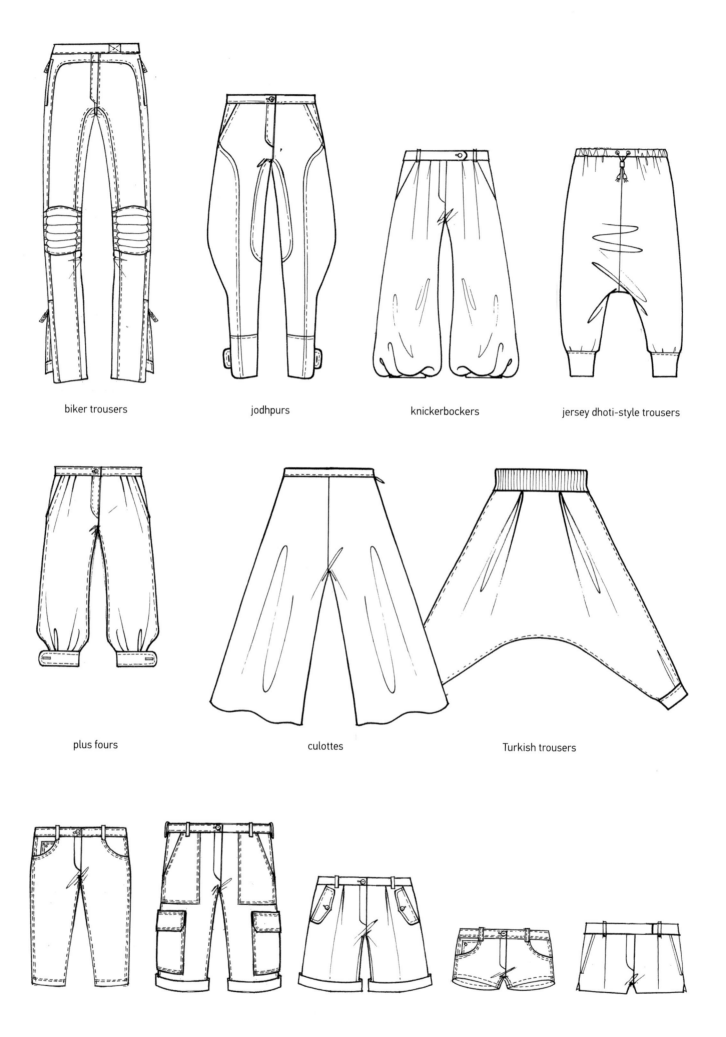

biker trousers

jodhpurs

knickerbockers

jersey dhoti-style trousers

plus fours

culottes

Turkish trousers

knee-length jeans

cargo shorts

city shorts

hot pants

classic shorts

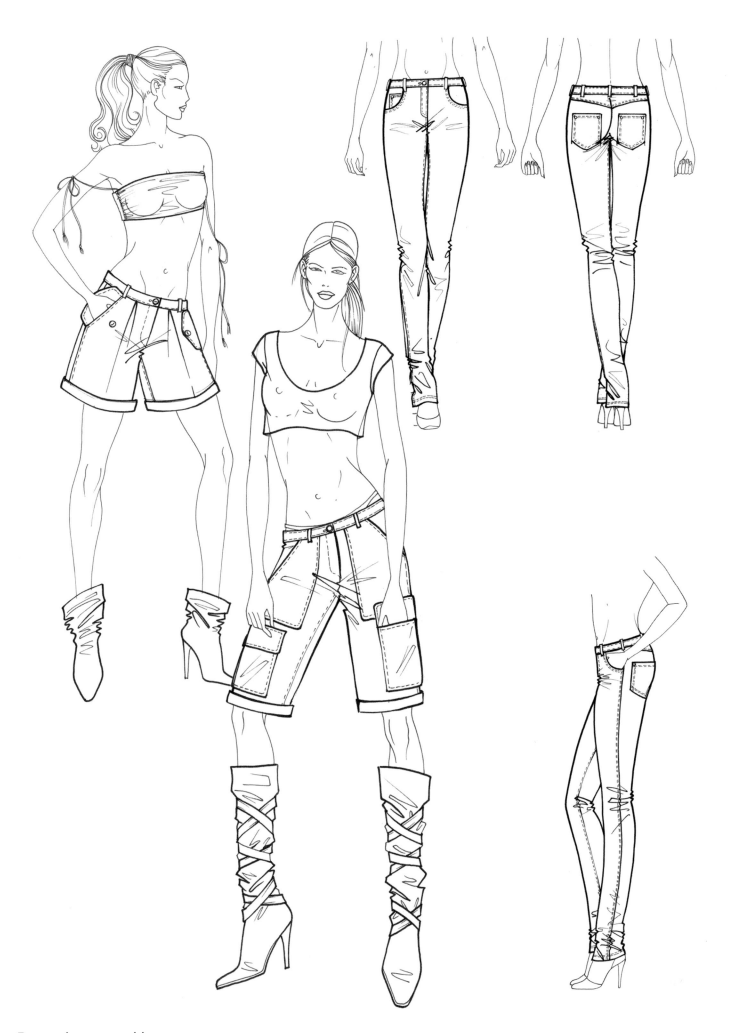

Trousers shown on a model.

Jackets and waistcoats

Classic jackets

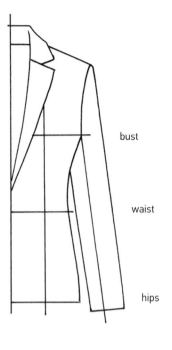

bust

waist

hips

classic single-breasted jacket

two-button double-breasted jacket

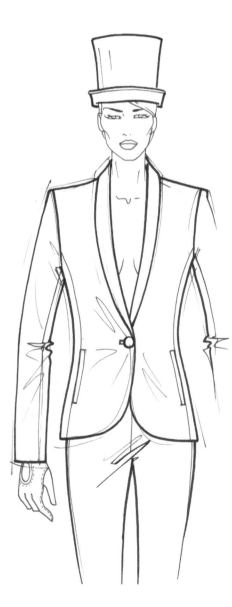

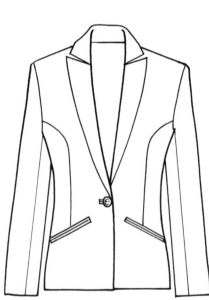

dinner jacket with peak lapels

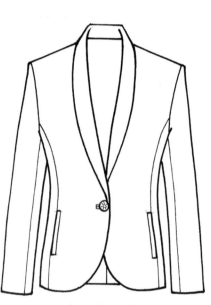

jacket with shawl lapels

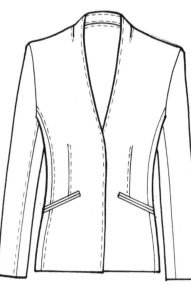

jacket without lapels

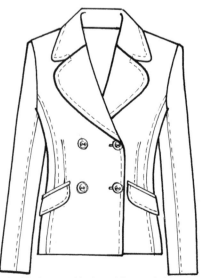

double-breasted jacket with rounded lapels

The various parts of a jacket

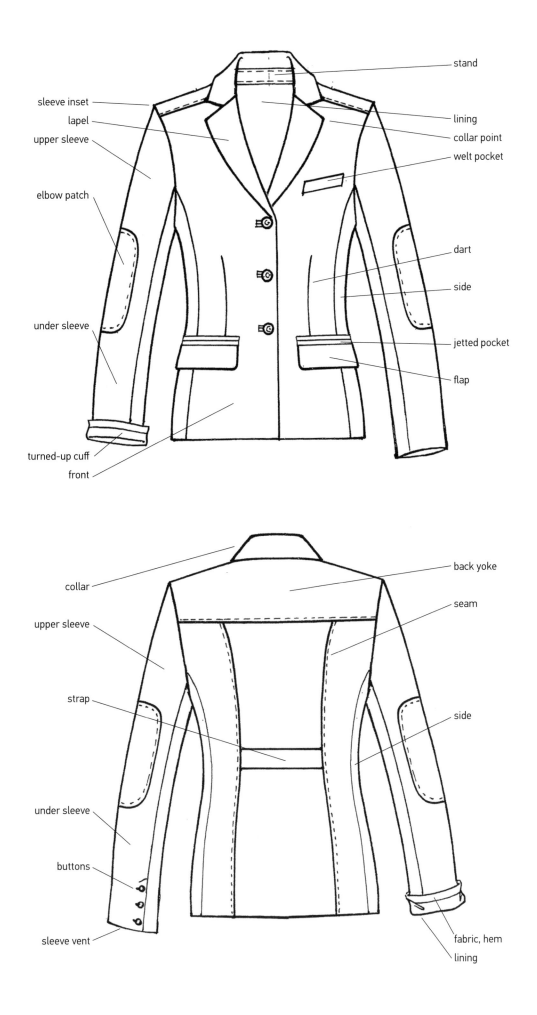

stand

sleeve inset

lapel

upper sleeve

lining

collar point

welt pocket

elbow patch

dart

side

under sleeve

jetted pocket

flap

turned-up cuff

front

collar

back yoke

upper sleeve

seam

strap

side

under sleeve

buttons

sleeve vent

fabric, hem

lining

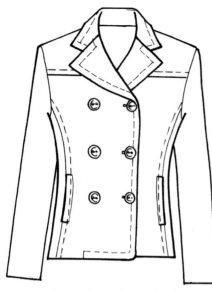

six-button double-breasted jacket

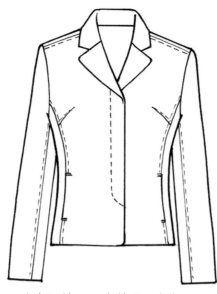

jacket with concealed button placket
and seam pockets

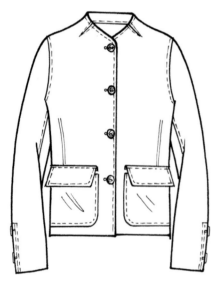

collarless jacket with patch pockets

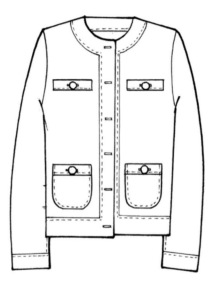

Coco Chanel style jacket

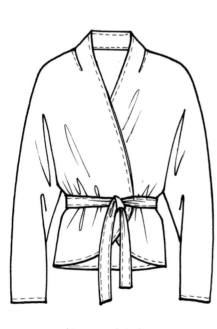

kimono style jacket

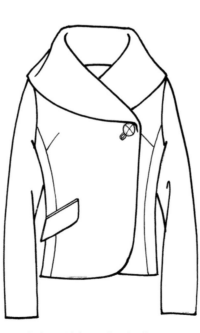

jacket with large shawl collar

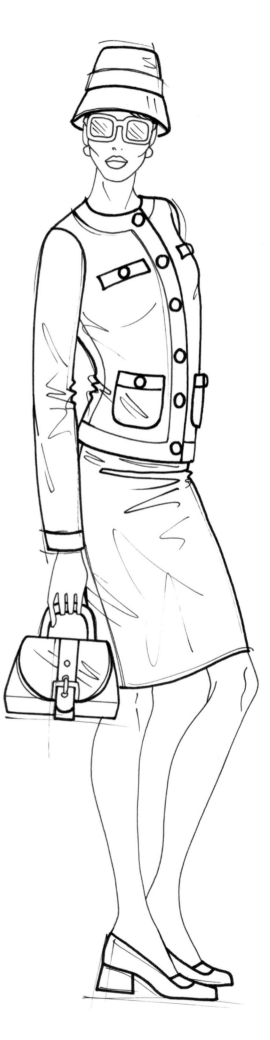

white tie morning coat

white tie evening coat

spencer jacket

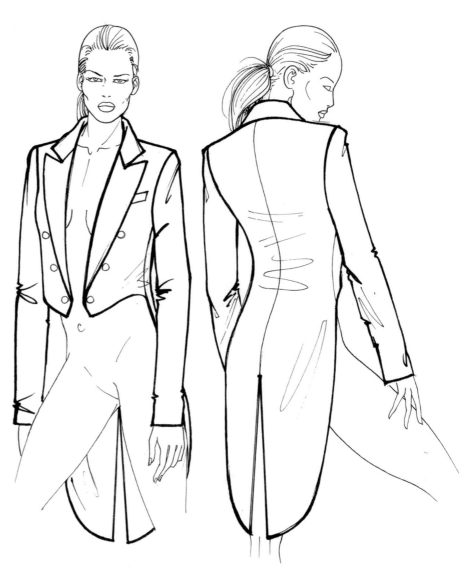

Waistcoats

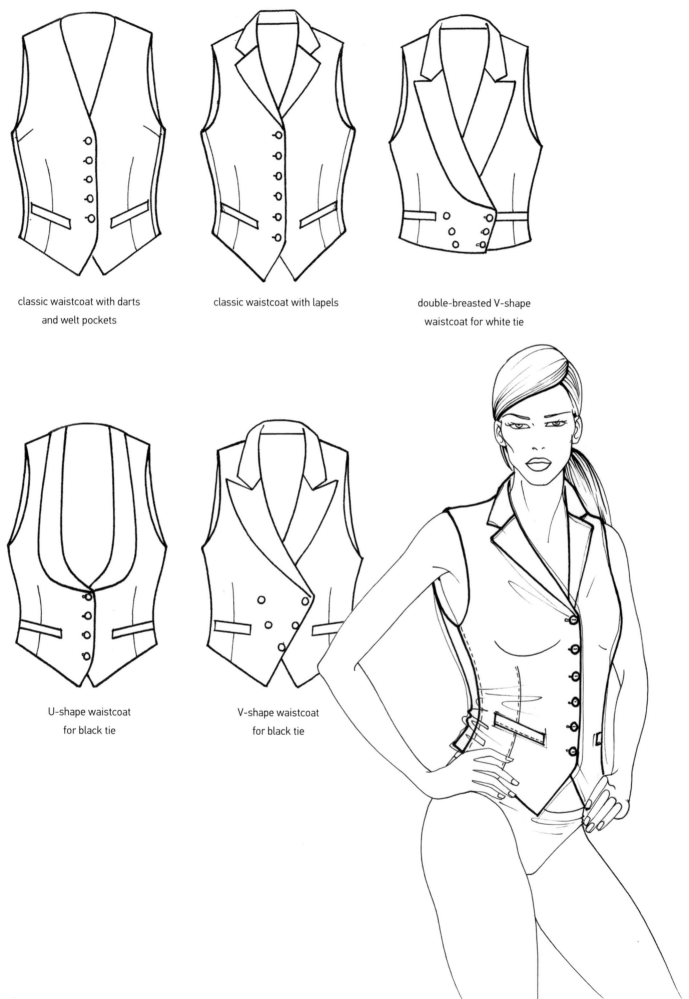

classic waistcoat with darts
and welt pockets

classic waistcoat with lapels

double-breasted V-shape
waistcoat for white tie

U-shape waistcoat
for black tie

V-shape waistcoat
for black tie

Jacket collars

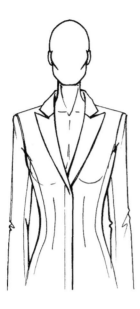
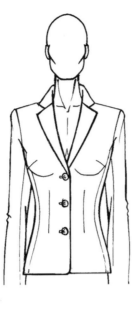
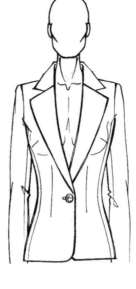
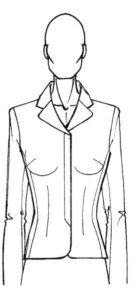

peak collar points classic collar points '70s style collar short lapel collar

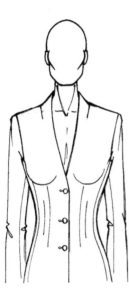
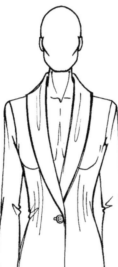

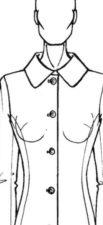

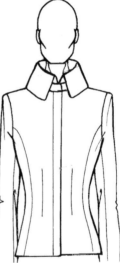
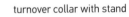

collarless shawl collar shirt collar turnover collar with stand

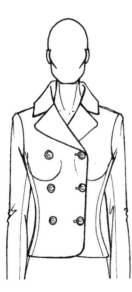
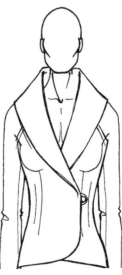
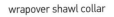

double-breasted turnover
collar with short lapels double-breasted turnover
collar with sailor lapels double-breasted turnover
collar with peak lapels wrapover shawl collar

Basic jackets and bomber jackets

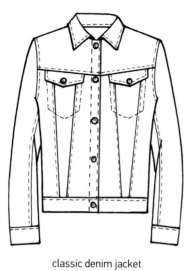

classic denim jacket

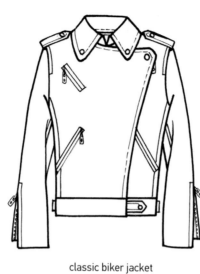

classic biker jacket

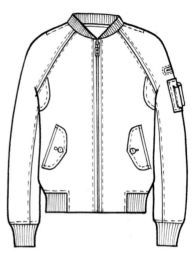

raglan sleeve bomber jacket

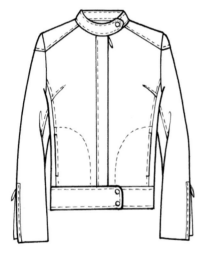

biker jacket

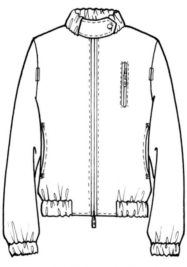

casual jacket with elasticated
waistband, cuffs and collar

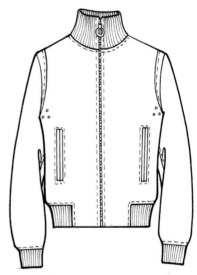

bomber jacket with set-in sleeves
and high knitted collar

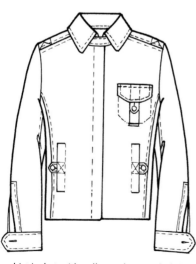

shirt jacket with collar and concealed zip

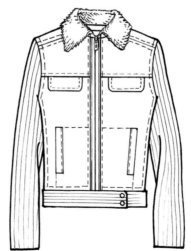

jacket with leather front and
knitted sleeves

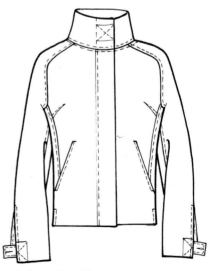

jacket with saddle sleeves, hidden button
placket and Velcro tabs

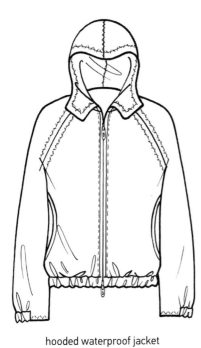

hooded waterproof jacket

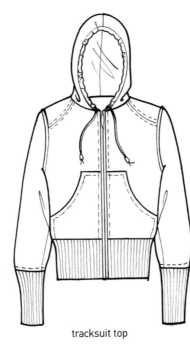

tracksuit top

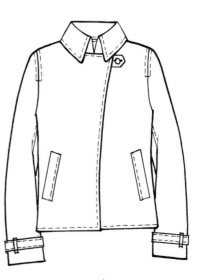

city jacket

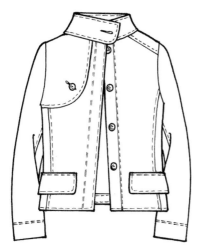

short trench

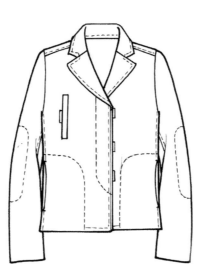

jacket with lapels and topstitching

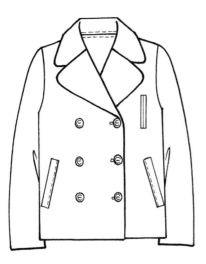

nautical style jacket

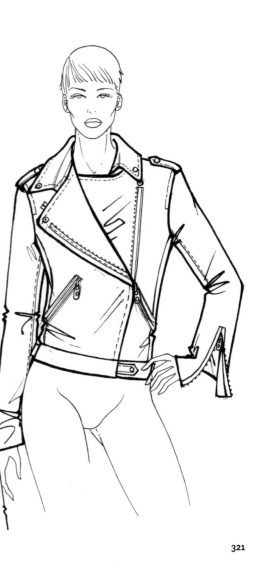

Coats and cloaks

Basic coats

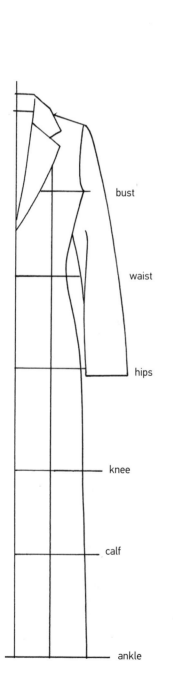

bust

waist

hips

knee

calf

ankle

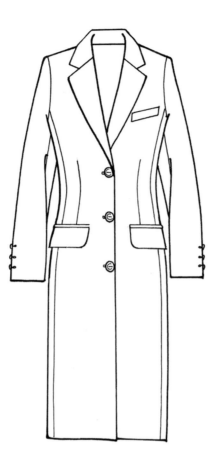

waisted, classic, single-breasted coat

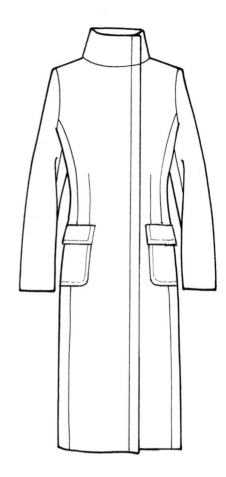

minimalistic coat with funnel collar and
concealed closure

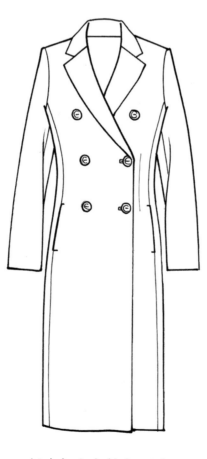

waisted, classic, double-breasted coat

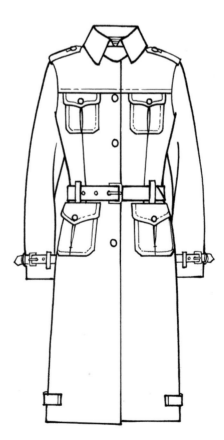

military style coat

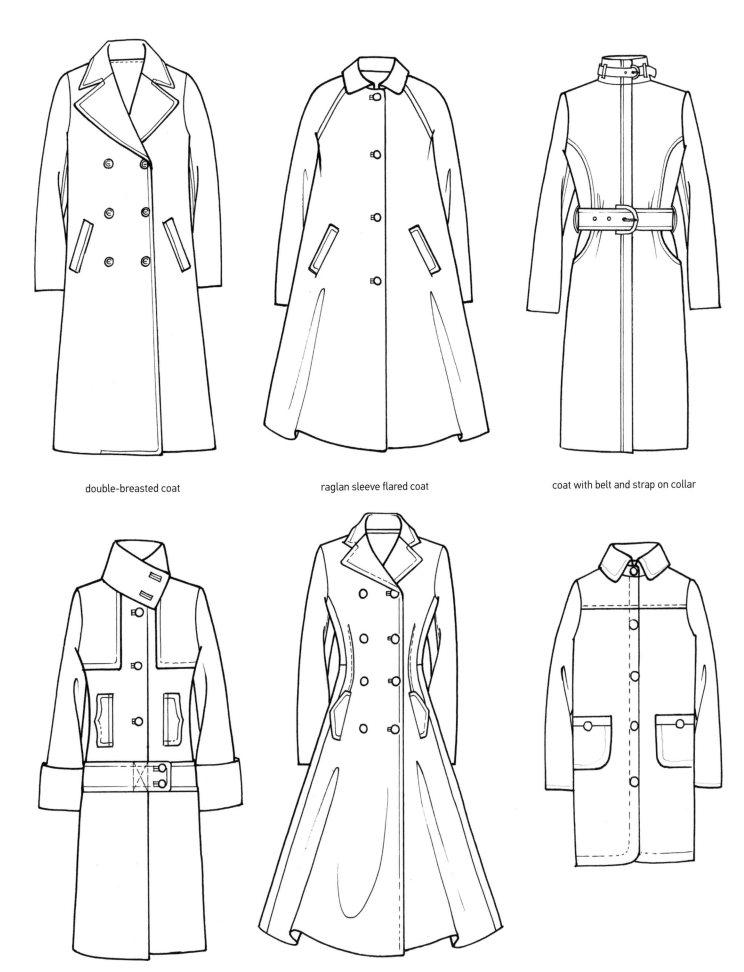

double-breasted coat

raglan sleeve flared coat

coat with belt and strap on collar

coat with high collar and low waistband

classic riding coat

straight '60s style coat

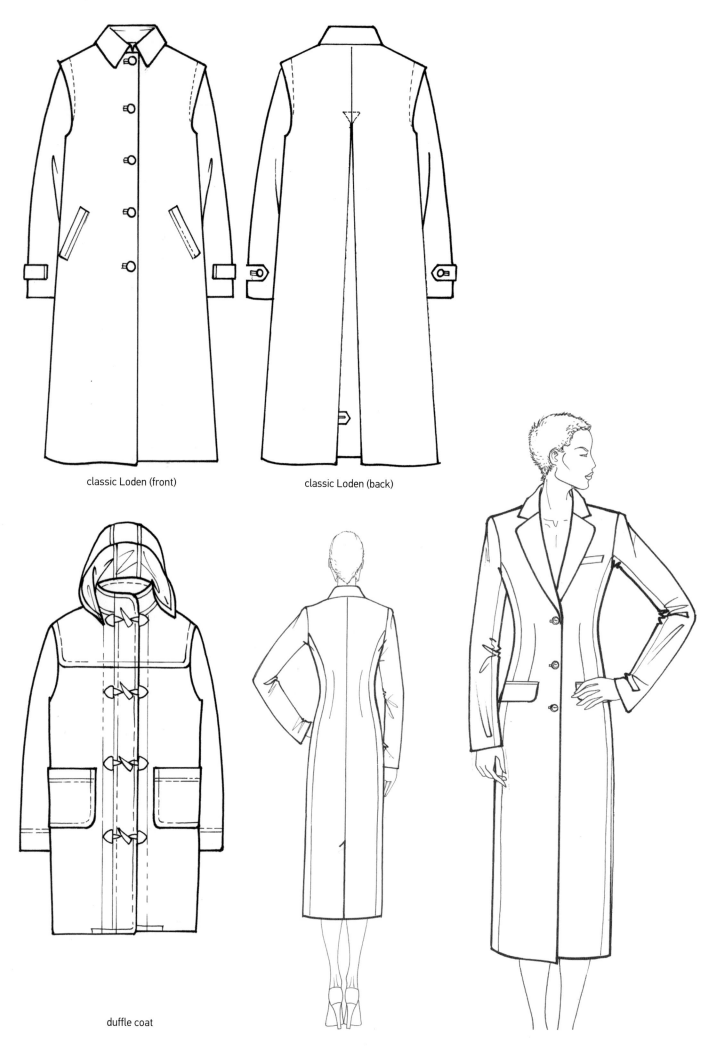

classic Loden (front)

classic Loden (back)

duffle coat

Trench coats

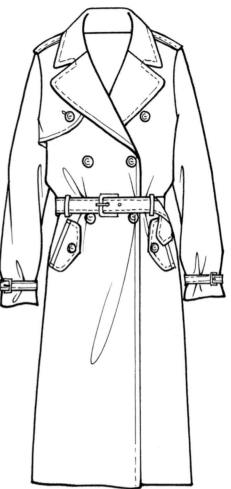

classic double-breasted Burberry-style coat

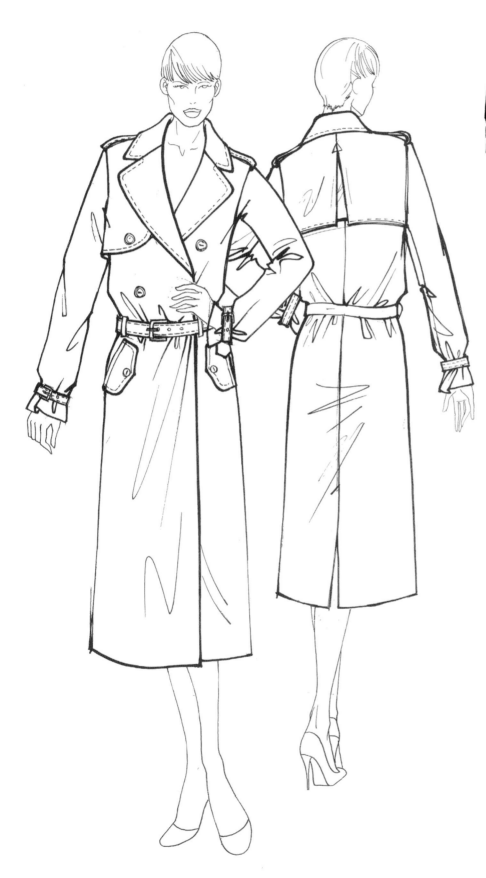

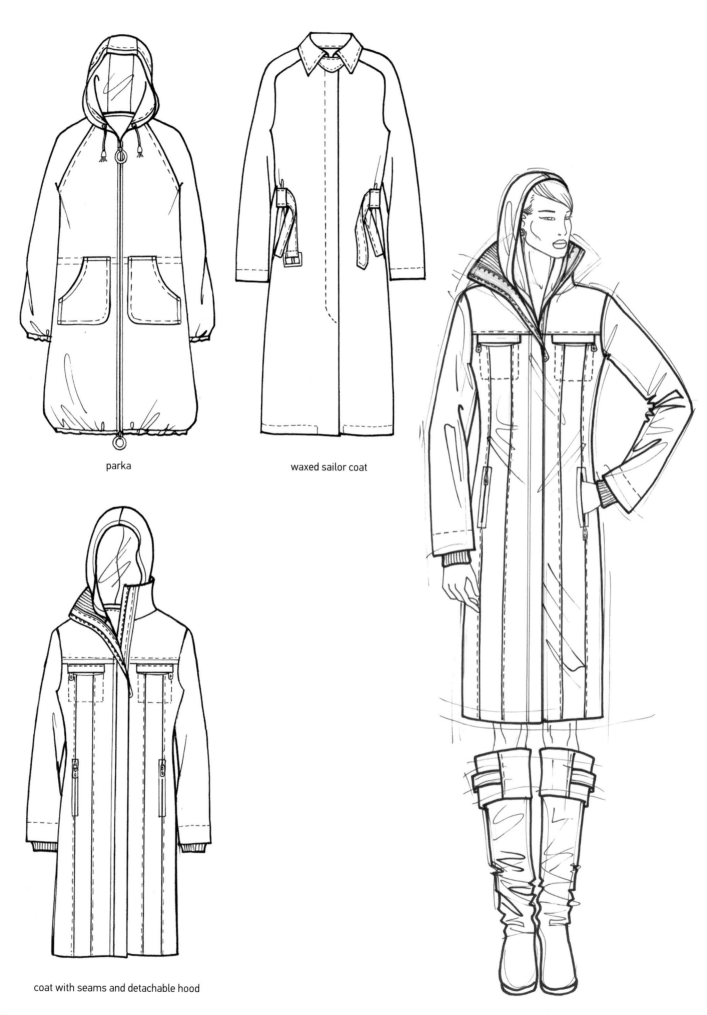

parka

waxed sailor coat

coat with seams and detachable hood

Cloaks

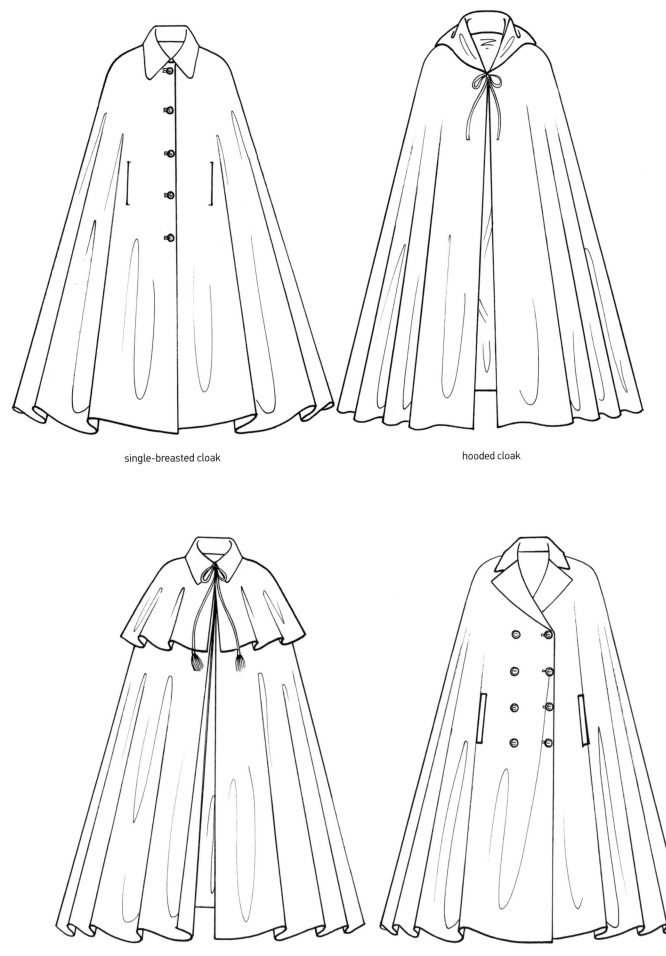

single-breasted cloak

hooded cloak

cloak with cape

double-breasted cloak

Ponchos and capes

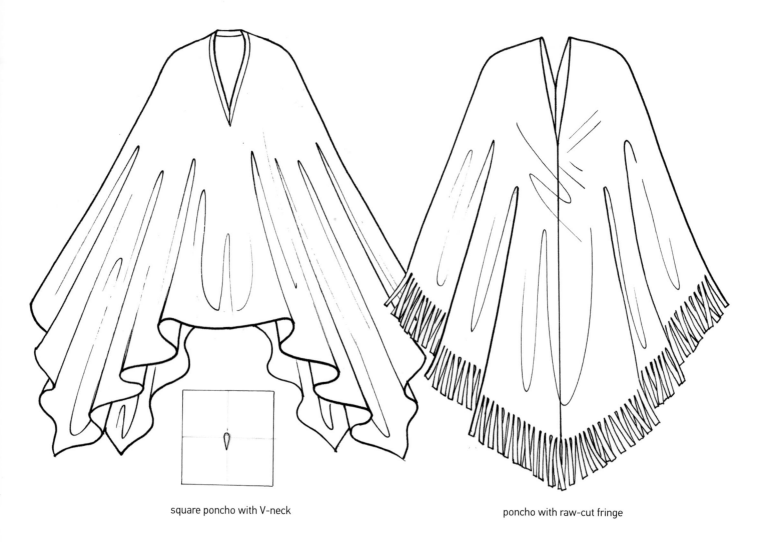

square poncho with V-neck

poncho with raw-cut fringe

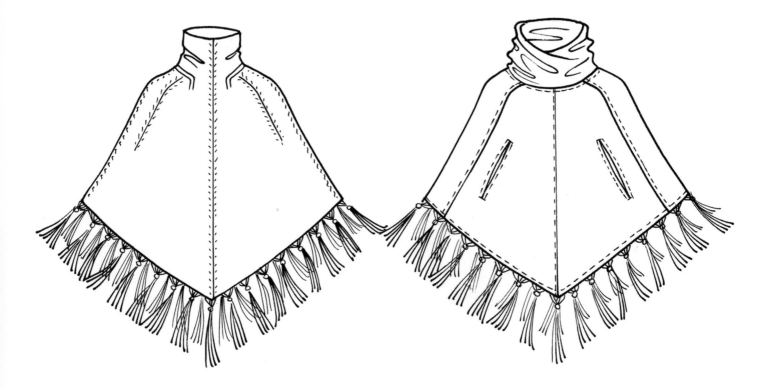

knitted mini-poncho

fabric mini-poncho with knitted collar and fringe

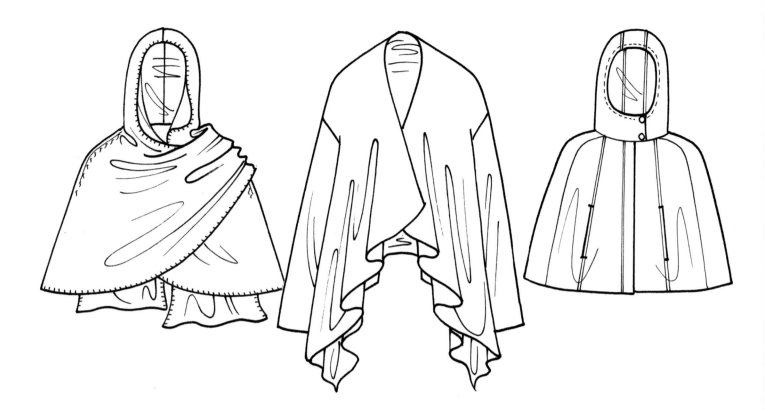

knitted hooded cape edged in blanket stitch

waterfall cardigan with sleeves

shaped cape with hood

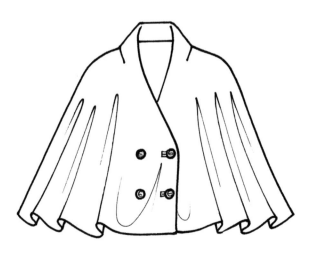

double-breasted cape with one-piece collar

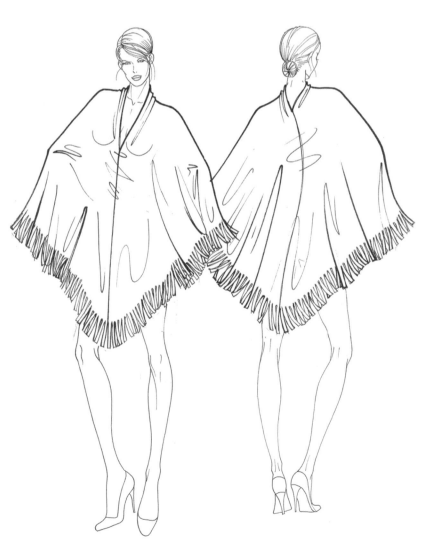

Cover-ups

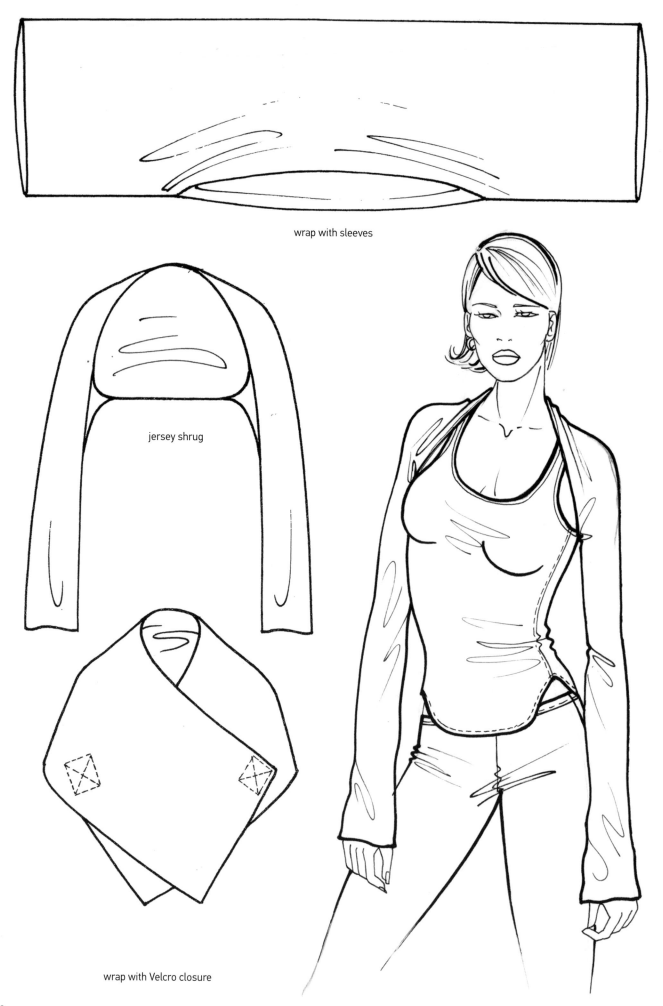

wrap with sleeves

jersey shrug

wrap with Velcro closure

Accessories

The examples on pages 331–338 show a variety of accessories, including footwear, and intended to go with all types of styles. It's fair to say that you cannot have a collection without accessories to enhance the style and emphasise the overall look. Try finishing off your illustrations with the accessories that best show off the inspiration behind your ideas.

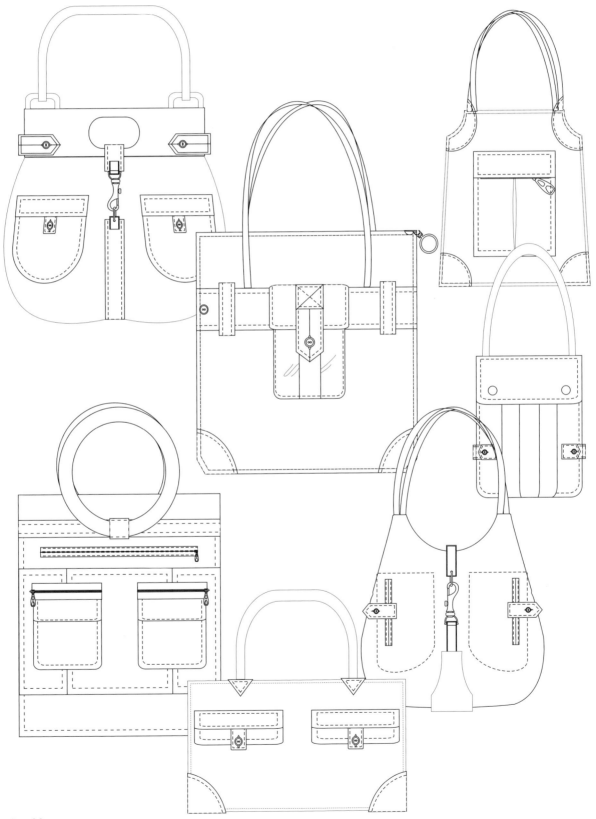

Accessorised bags

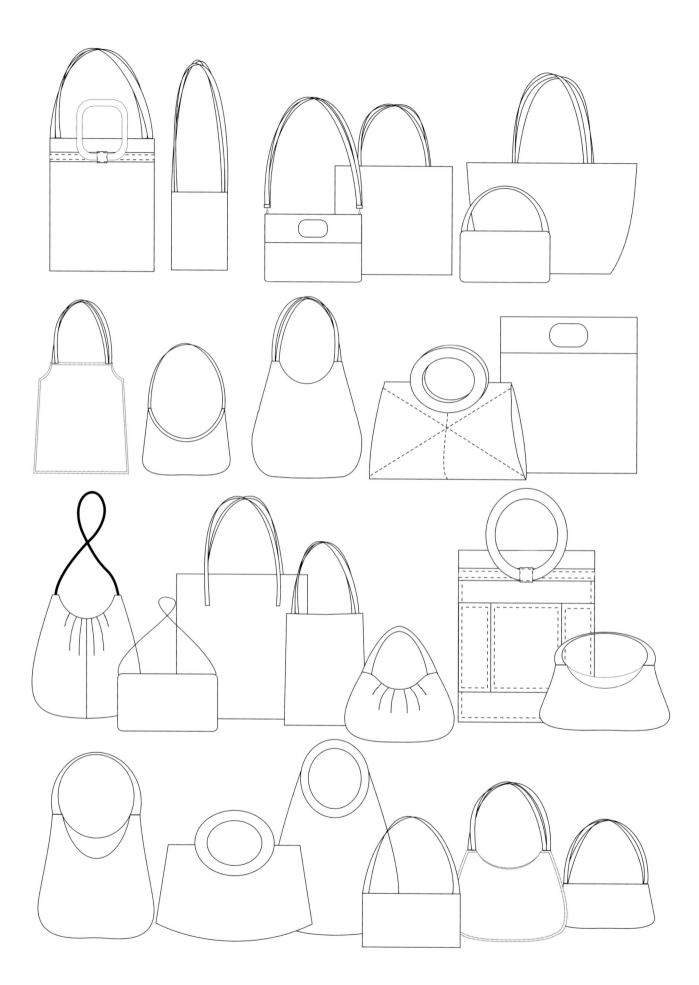

Technical drawings of bag shapes

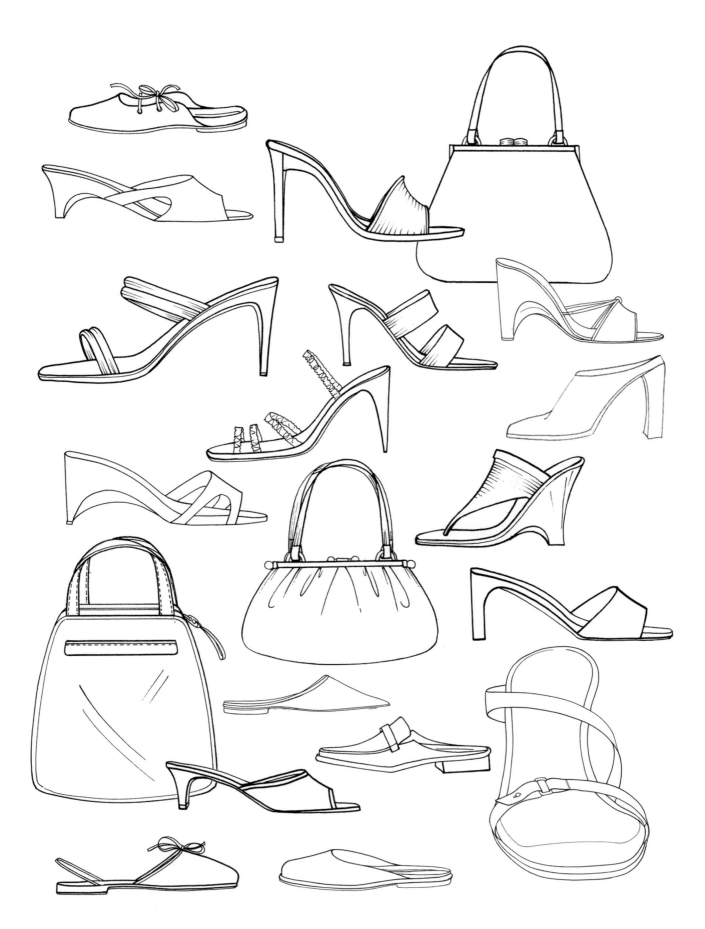

Sandals, mules and bags

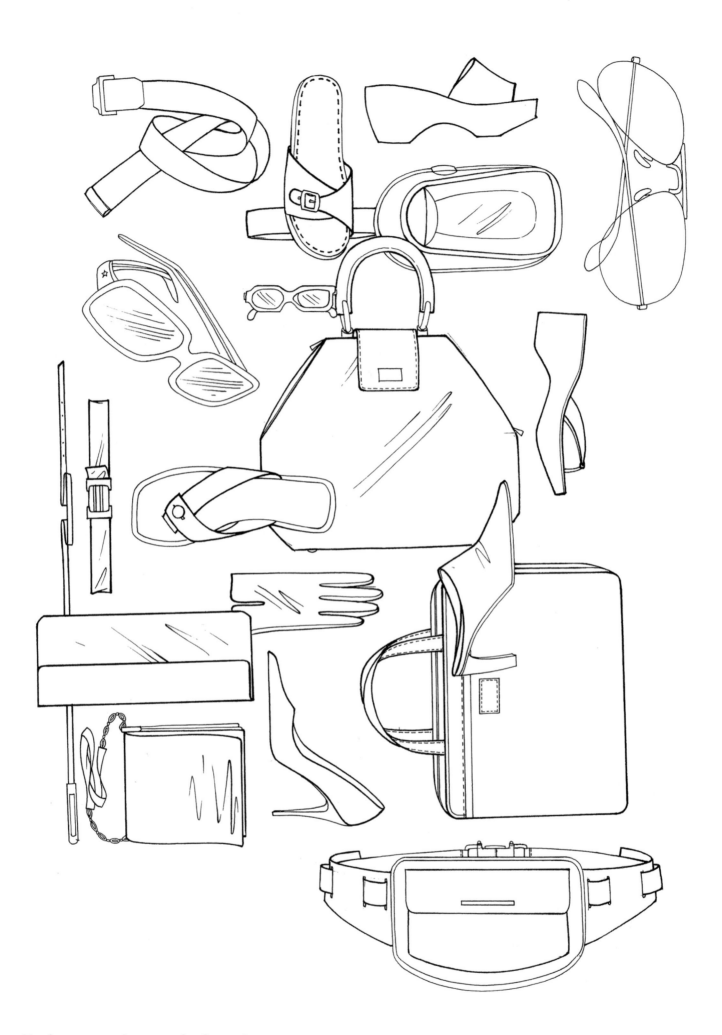

City footwear and accessories for spring–summer

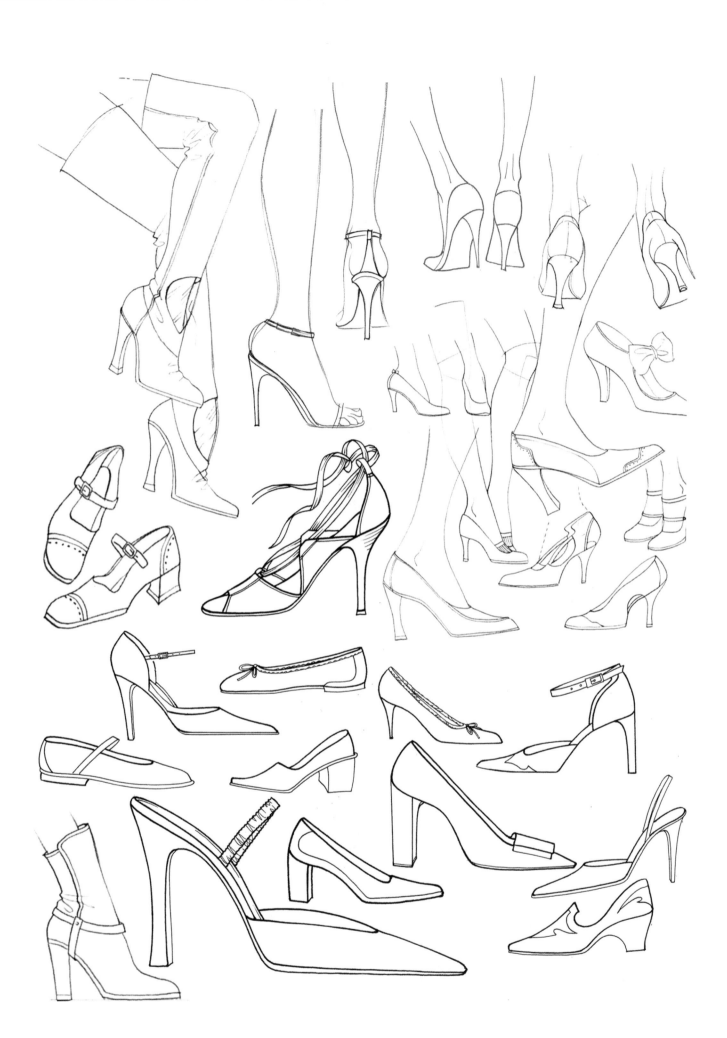

Heels and ballerinas

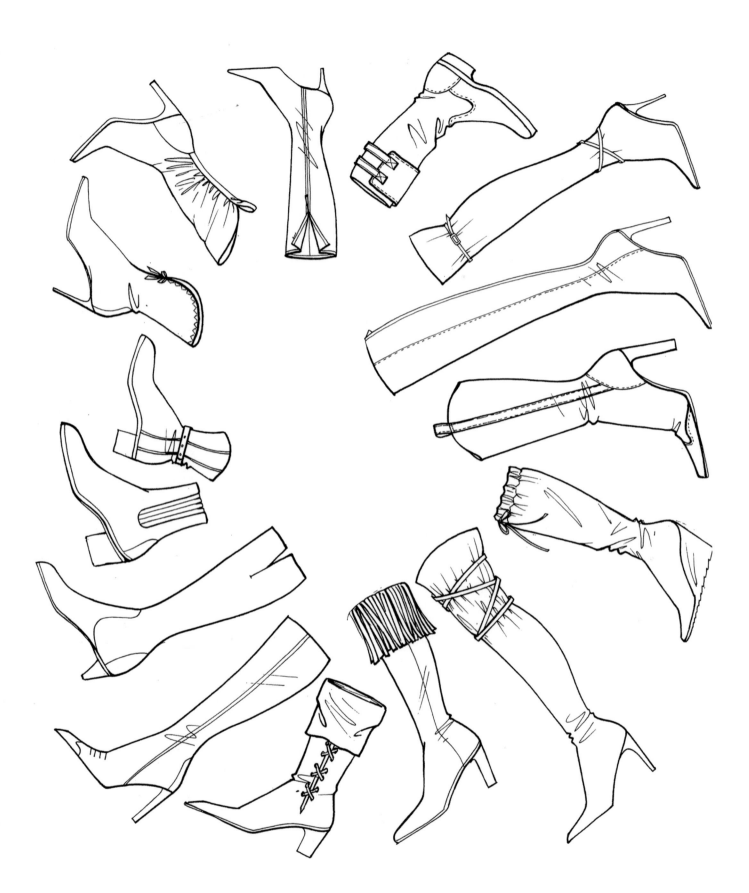

Boots

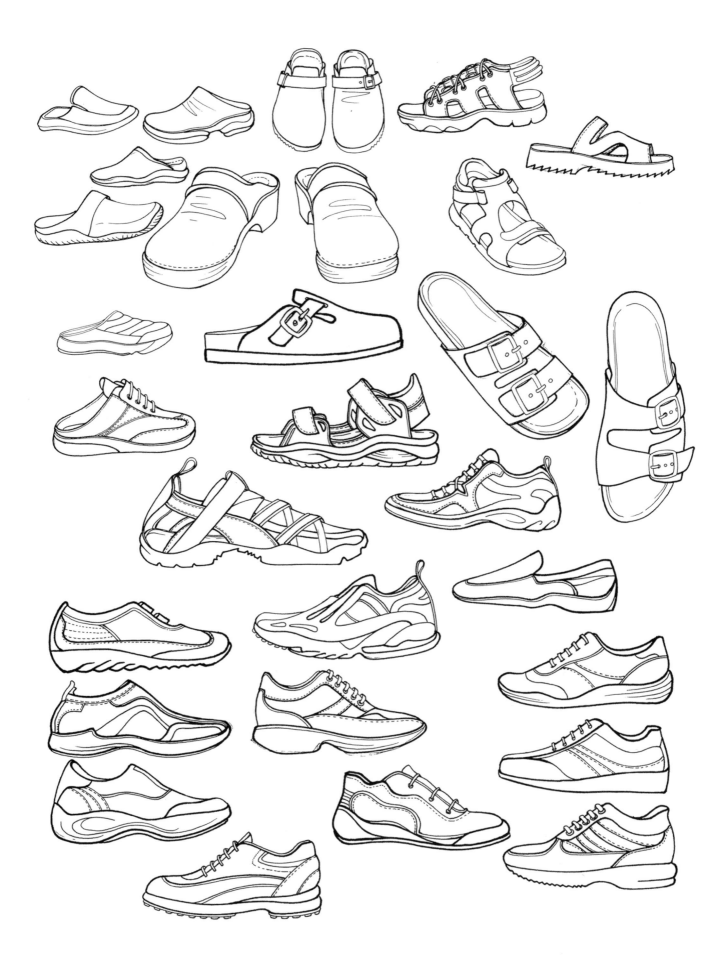

Casual footwear sandals, clogs, mules and trainers

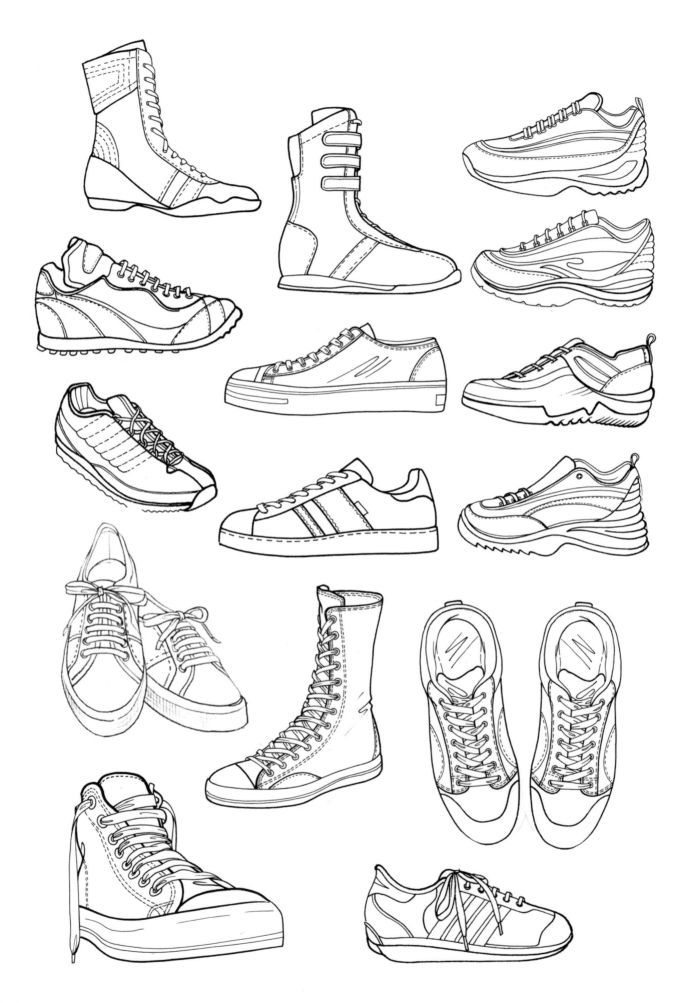

Trainers

Technical drawings for fashion books

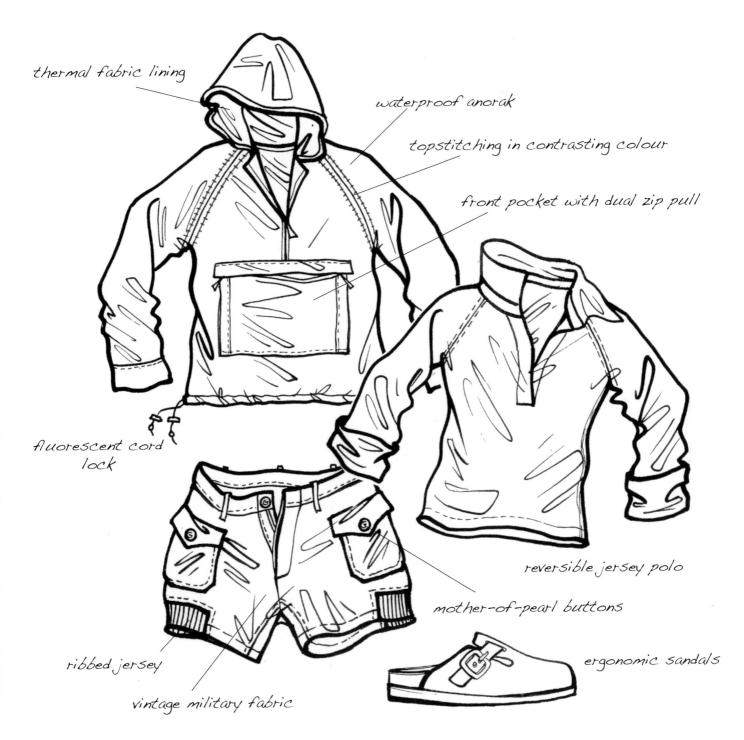

thermal fabric lining

waterproof anorak

topstitching in contrasting colour

front pocket with dual zip pull

fluorescent cord lock

reversible jersey polo

mother-of-pearl buttons

ribbed jersey

ergonomic sandals

vintage military fabric

This type of drawing is useful for producing livelier technical drawings with more depth. They are more useful to the designer than the pattern maker, as the details are not shown thoroughly. It's a different way of illustrating garments without using a model, and is widely used in 'fashion books' (presentations of a collection or style). These pages (339–352) show some sportswear items, together with accessories and footwear. The garments are drawn as though they are resting casually on a flat surface.

Drawing technique

A thicker stroke is used to show the contours while the seams and movement folds are drawn using finer lines. Use 0.2 and 0.3 felt-tip pens and a medium tip permanent marker for the contours. To practise this technique, try enlarging the images and tracing them using an 0.2 mechanical pencil. Initially, it will be hard to draw with swift-moving lines, but the more you practise the more confident you will become.

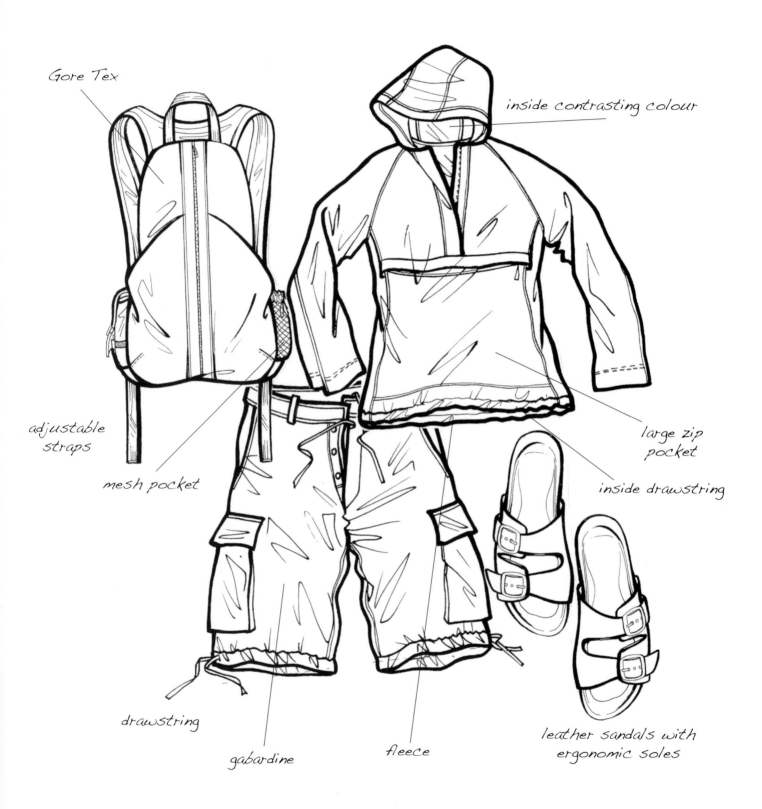

Gore Tex

inside contrasting colour

adjustable
straps

mesh pocket

large zip
pocket

inside drawstring

drawstring

gabardine

fleece

leather sandals with
ergonomic soles

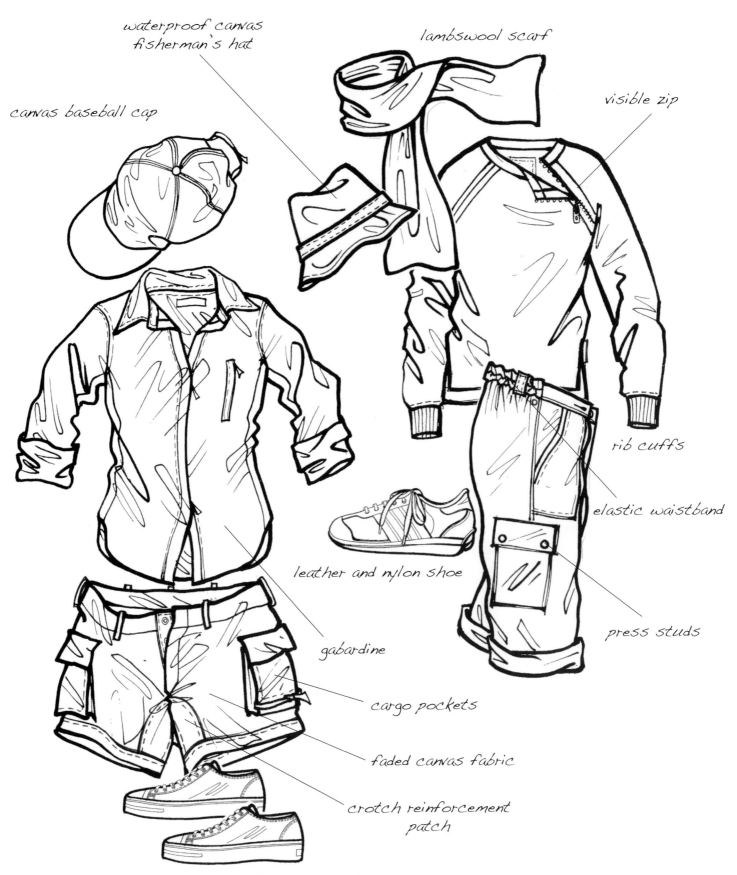

waterproof canvas
fisherman's hat

lambswool scarf

canvas baseball cap

visible zip

rib cuffs

elastic waistband

leather and nylon shoe

gabardine

press studs

cargo pockets

faded canvas fabric

crotch reinforcement
patch

ivory colour leather trainers

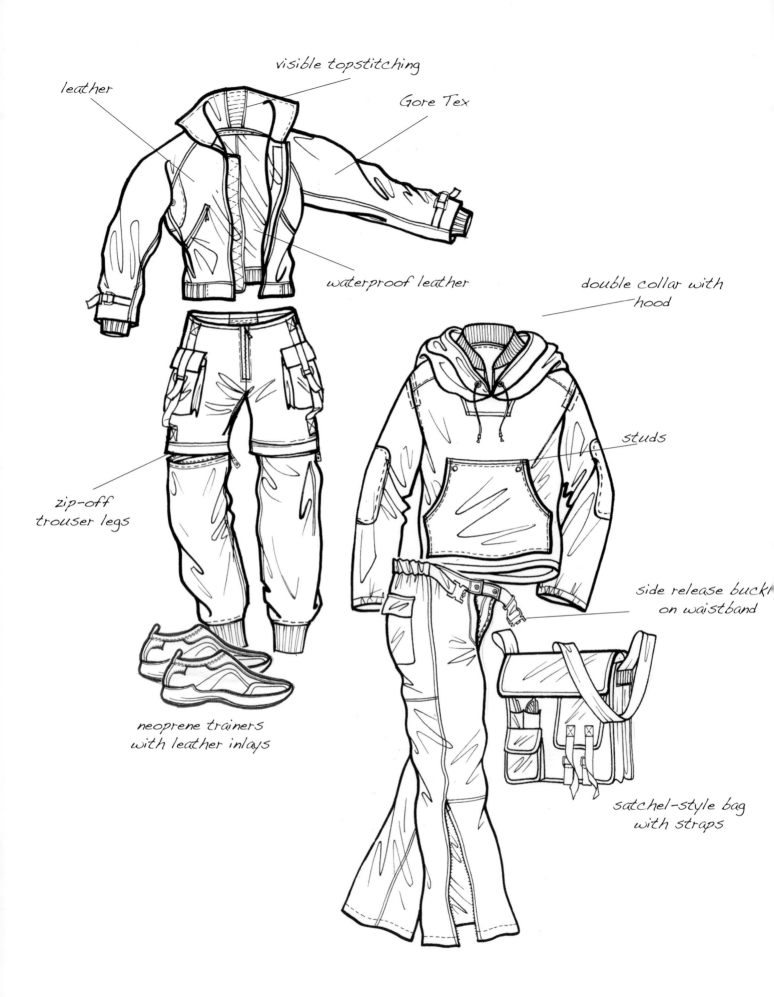

visible topstitching

leather

Gore Tex

waterproof leather

double collar with hood

studs

zip-off trouser legs

side release buckl' on waistband

neoprene trainers with leather inlays

satchel-style bag with straps

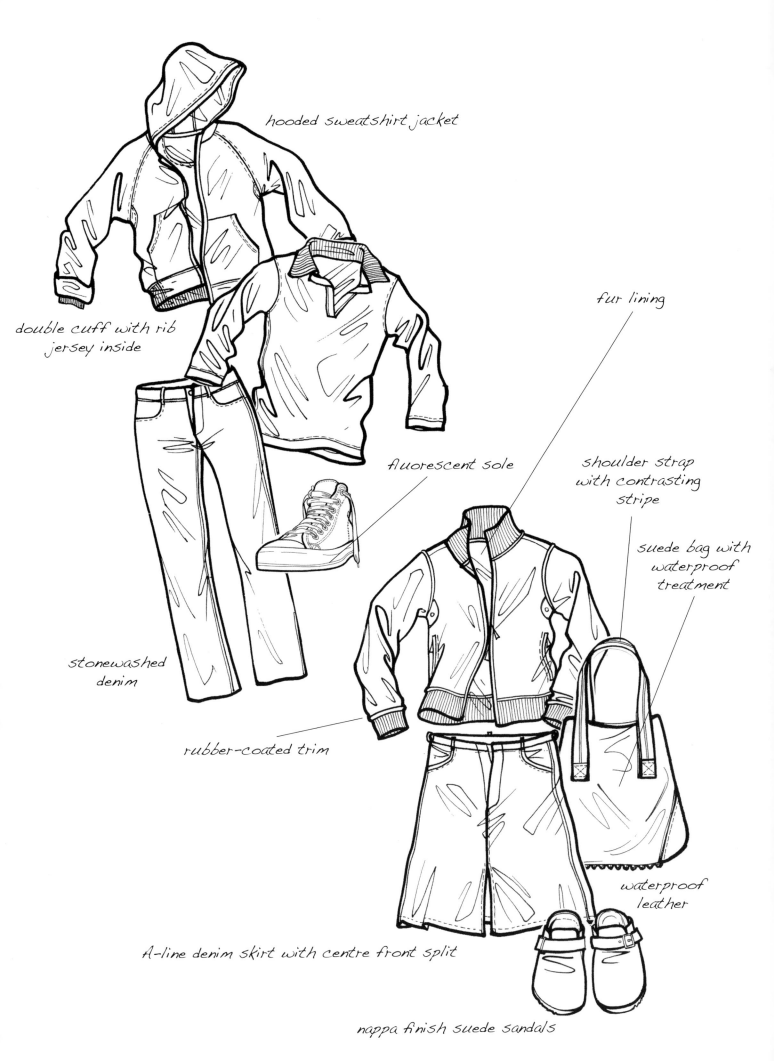

hooded sweatshirt jacket

double cuff with rib
jersey inside

fur lining

fluorescent sole

shoulder strap
with contrasting
stripe

suede bag with
waterproof
treatment

stonewashed
denim

rubber-coated trim

waterproof
leather

A-line denim skirt with centre front split

nappa finish suede sandals

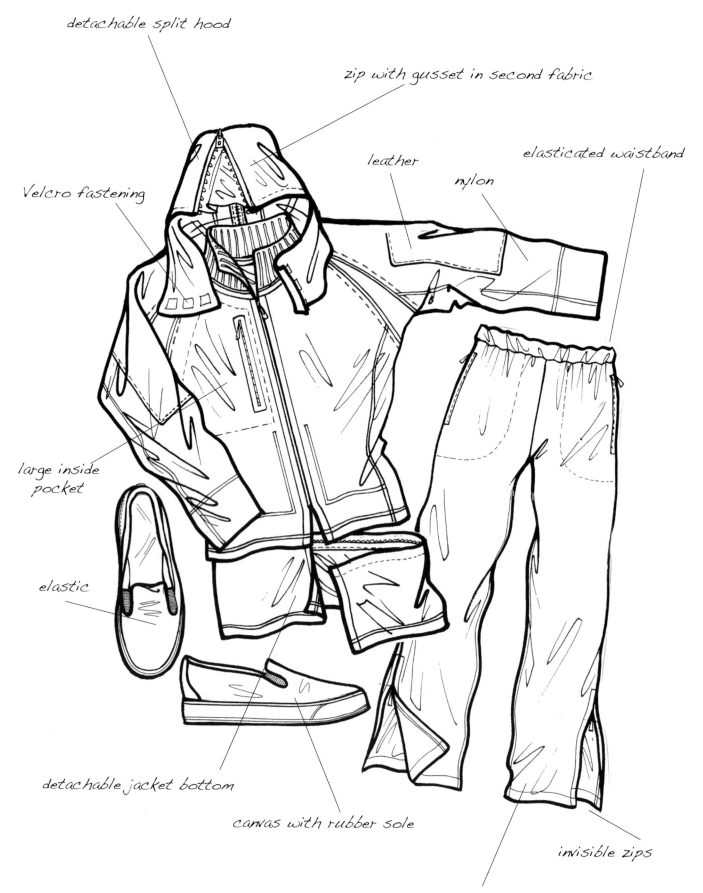

detachable split hood

zip with gusset in second fabric

leather

nylon

elasticated waistband

Velcro fastening

large inside pocket

elastic

detachable jacket bottom

canvas with rubber sole

reversible fabric

invisible zips

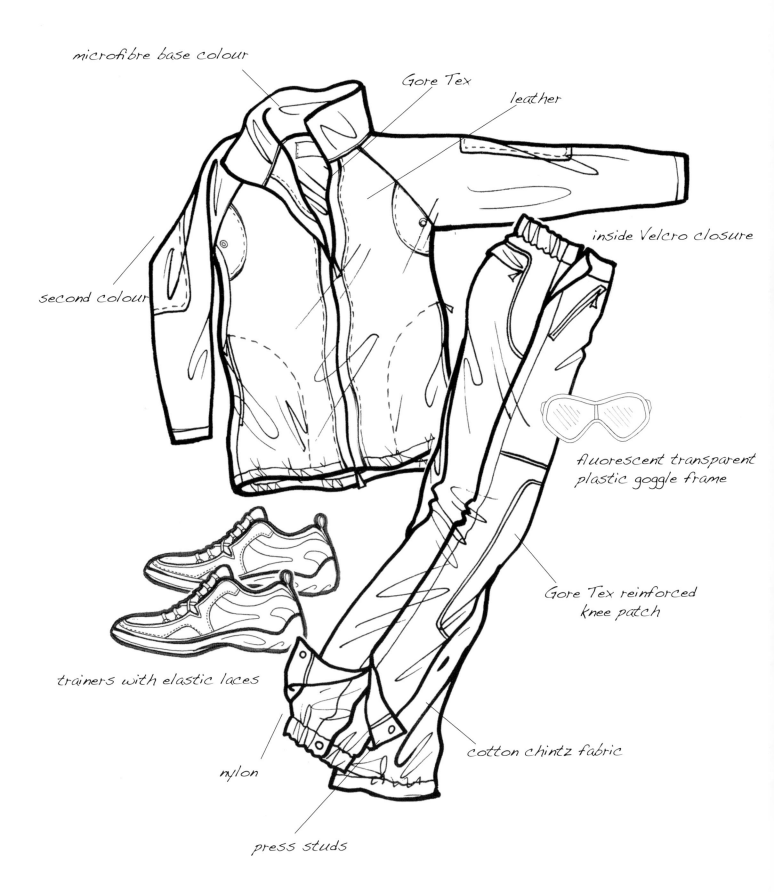

microfibre base colour

Gore Tex

leather

inside Velcro closure

second colour

fluorescent transparent
plastic goggle frame

Gore Tex reinforced
knee patch

trainers with elastic laces

cotton chintz fabric

nylon

press studs

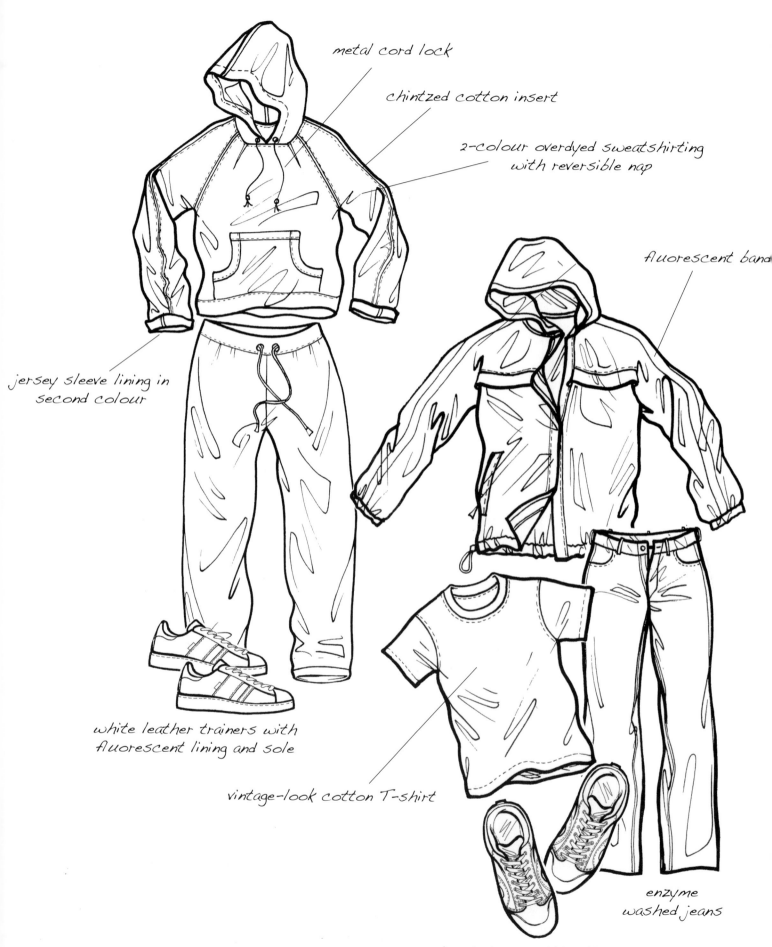

metal cord lock

chintzed cotton insert

2-colour overdyed sweatshirting
with reversible nap

fluorescent band

jersey sleeve lining in
second colour

white leather trainers with
fluorescent lining and sole

vintage-look cotton T-shirt

enzyme
washed jeans

nylon trainers with shiny
leather details

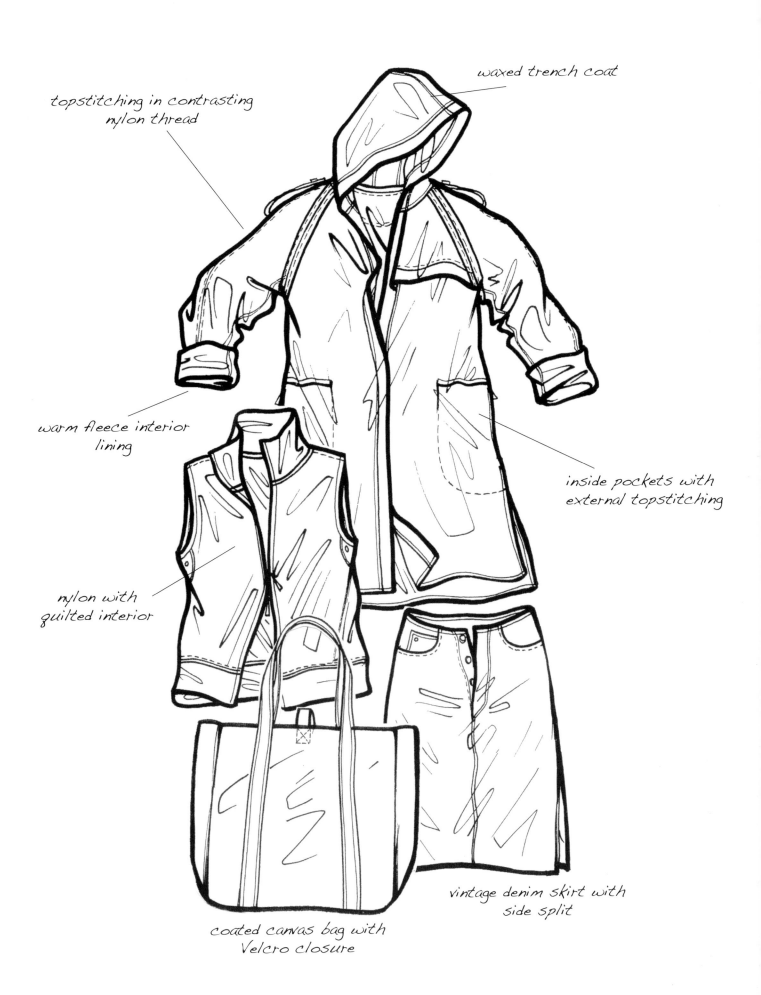

topstitching in contrasting
nylon thread

waxed trench coat

warm fleece interior
lining

inside pockets with
external topstitching

nylon with
quilted interior

vintage denim skirt with
side split

coated canvas bag with
Velcro closure

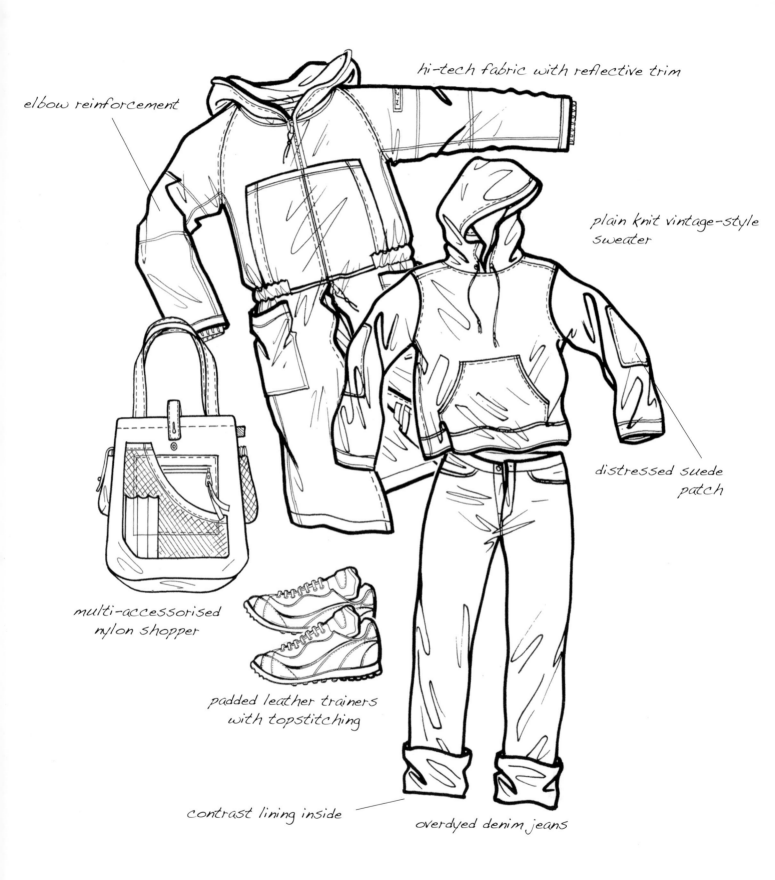

elbow reinforcement

hi-tech fabric with reflective trim

plain knit vintage-style sweater

distressed suede patch

multi-accessorised nylon shopper

padded leather trainers with topstitching

contrast lining inside

overdyed denim jeans

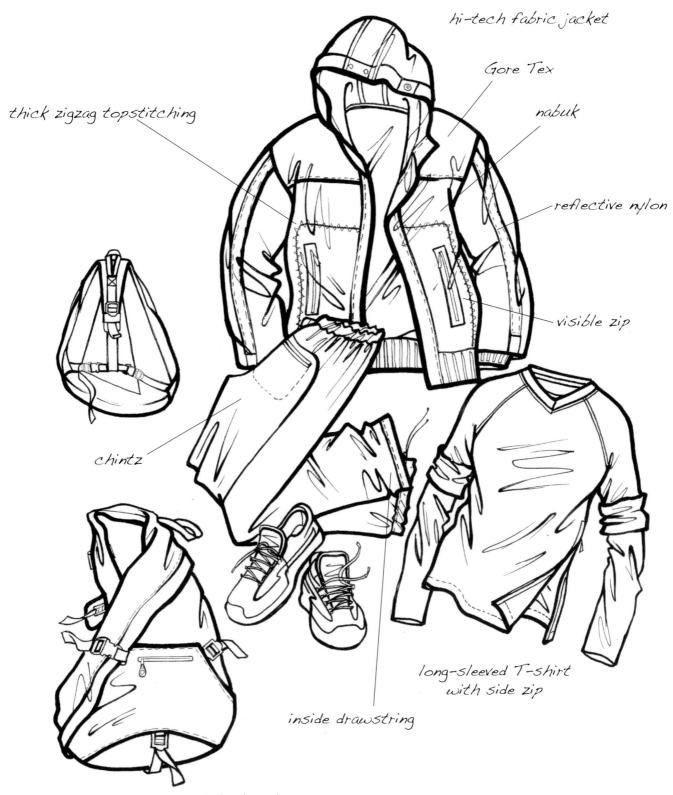

thick zigzag topstitching

hi-tech fabric jacket

Gore Tex

nabuk

reflective nylon

visible zip

chintz

long-sleeved T-shirt
with side zip

inside drawstring

asymmetrical backpack

349

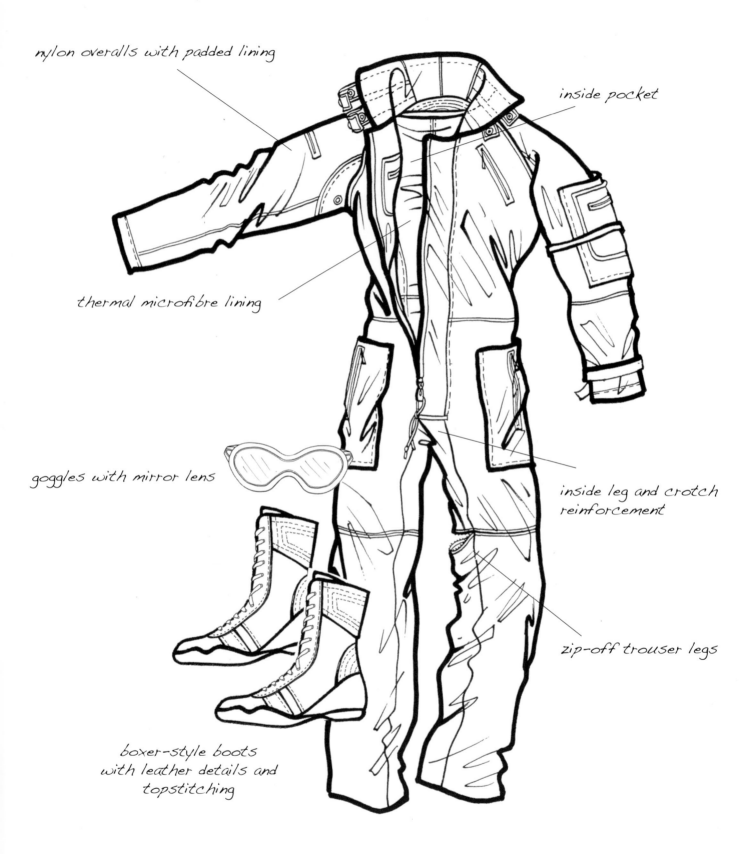

nylon overalls with padded lining

inside pocket

thermal microfibre lining

goggles with mirror lens

inside leg and crotch reinforcement

zip-off trouser legs

boxer-style boots
with leather details and
topstitching